JACOB
LAWRENCE
AMERICAN
PAINTER

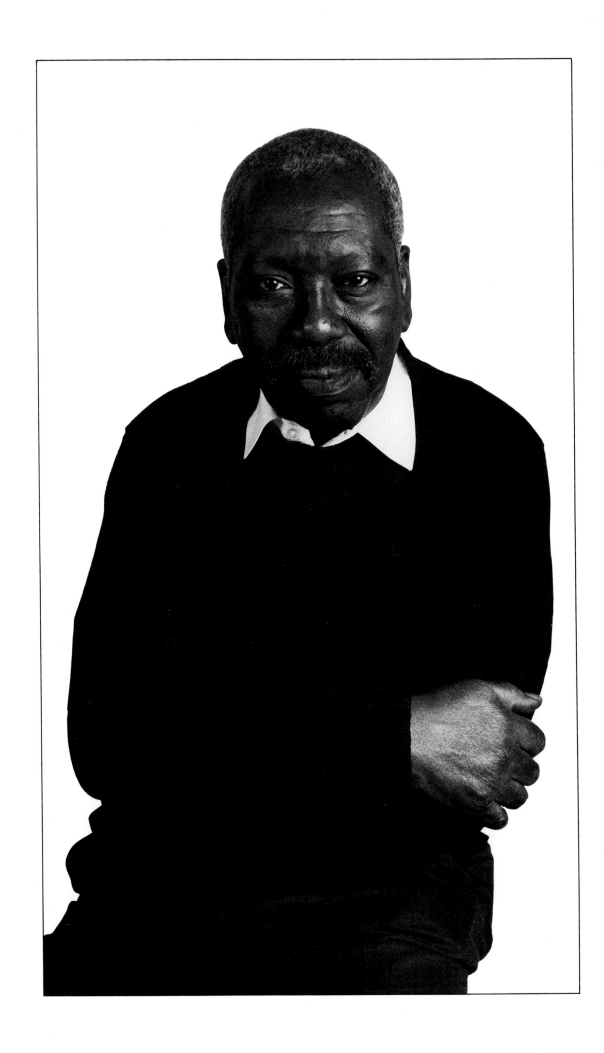

JACOB LAWRENCE
AMERICAN PAINTER

Ellen Harkins Wheat

with a contribution by
Patricia Hills

UNIVERSITY OF WASHINGTON PRESS
Seattle and London
in association with the
SEATTLE ART MUSEUM

This book was published on the occasion of a major
retrospective, *Jacob Lawrence, American Painter,*
organized by the Seattle Art Museum, 1986.

Copyright ©1986 by Ellen Harkins Wheat
"Jacob Lawrence's Expressive Cubism" copyright ©1986 by Patricia Hills
Second printing (paper), 1990
Printed and bound in Japan

Library of Congress Cataloging-in-Publication Data

Wheat, Ellen Harkins,
 Jacob Lawrence, American painter.

 Catalog of an exhibition organized by the
Seattle Art Museum.
 Biblography: p.
 Includes index.
 1. Lawrence, Jacob, 1917– —Exhibitions.
2. Afro-American artists—United States—Exhibitions.
I. Lawrence, Jacob, 1917– . II. Hills, Patricia.
III. Seattle Art Museum. IV. Title.
ND237.L29A4 1986 759.13 86-5497
ISBN 0-295-97011-1 (UWP paperback)

Produced by Perpetua Press, Los Angeles
Designed by Dana Levy
Typeset in Sabon by Continental Typographics, Chatsworth
Printed on 127 gsm U-Lite paper by
Toppan Printing Co., Japan

Note: All reproduced art works are by Jacob Lawrence, unless noted otherwise.
The captions in the book include data on dates, medium, support, dimensions,
and location of works when known. All dimensions are in inches, height
preceding width. All works on hardboard have gesso on the panel.

"One-Way Ticket" from *One-Way Ticket* by Langston Hughes, copyright 1948,
reprinted by permission of Alfred A. Knopf, Inc.

Frontispiece: *Jacob Lawrence,* 1986
Cover: *Bread, Fish, Fruit,* 1985 (Pl. 109) (photo by Paul Macapia)

CONTENTS

Illustrations

18. African sculpture. Kota reliquary figure, Gabon, and Kuba mask, Zaire.
19. William Edmonson, *Lawyer,* 1938.
20. Pieter Breughel, The Elder, *The Wedding Dance,* c. 1566.
21. José Clemente Orozco, *Zapatistas,* 1931.
22. Diego Rivera, *Agrarian Leader Zapata,* 1931.
23. Arthur G. Dove, *Ferry Boat Wreck,* 1931.
24. Charles Sheeler, *Church Street "El,"* 1920.
25. Giorgio de Chirico, *The Melancholy and Mystery of a Street,* 1914.
26. Aaron Douglas and Arthur Schomburg, 1934.
27. Ben Shahn, *The Passion of Sacco and Vanzetti,* 1931–32.
28. Jacob Lawrence at American Artists School exhibition opening, 1939.
29. Giotto, *The Lamentation,* Arena Chapel, 1305–06.
30. Jacob Lawrence speaking to students about his *Toussaint L'Ouverture* Series, 1941.
31. José Clemente Orozco working on *Dive Bomber and Tank,* 1940.
32. Francisco Goya, *The Disasters of War,* No. 36, *Tampoco,* c. 1811.
33. José Clemente Orozco, *El Ahorcado,* c. 1926–28.
34. Edith Halpert and Downtown Gallery artists, 1952.
35. Stuart Davis, *House and Street,* 1931.
36. Jacob Lawrence, 1944.
37. Jacob Lawrence at work painting aboard the *Sea Cloud,* 1944.
38. Captain Rosenthal, Carl Van Vechten, and Jacob Lawrence at the Museum of Modern Art opening, 1944.
39. Jacob and Gwen Lawrence, 1946.
40. Black Mountain College Summer Institute, North Carolina, 1946.
41. Gwen and Jacob Lawrence, Black Mountain College, 1946.
42. Pablo Picasso, *Three Musicians,* 1921.
43. José Clemente Orozco, *The Requiem,* 1928.
44. Jacob and Gwen Lawrence, 1947.
45. *One-Way Ticket,* 1948, and poem, "One-Way Ticket," 1948, by Langston Hughes.
46. Illustrations for *New Republic,* 1947 and 1948.
47. Jacob Lawrence at work on the *Hospital* paintings, 1950.
48. *Slums,* 1950.
49. Jacob Lawrence working, mid 1950s.
50. José Clemente Orozco, *The Trench,* 1926.
51. José Clemente Orozco, *The Table of Brotherhood,* 1930–31.
52. Jacob Lawrence, Ibadan, Nigeria, 1964.
53. *Nigerian* theme, 1964, *Market Woman.*
54. José Guadalupe Posada, *Calavera "El Morrongo,"* c. 1910–12.
55. Jacob and Gwen Lawrence with Terry Dintenfass, late 1960s.
56. Cover illustration for *Freedomways* Magazine, *Wounded Man,* 1969.
57. Romare Bearden, Charles Alston, and Jacob Lawrence, mid 1970s.
58. Jacob Lawrence teaching at Brandeis University, 1965.
59. *Self-Portrait,* 1965.
60. *Jesse Jackson, Time* Magazine cover portrait, 1970.
61. Illustration for *Aesop's Fables, Dog and Bone,* 1970.
62. Jacob Lawrence at California State University, Hayward, 1969–70.
63. José Clemente Orozco, *Science, Work, and Art,* 1930–31.
64. Jacob and Gwen Lawrence, 1975.
65. *Builders,* 1974, being presented to Pope Paul VI emissary, 1974.
66. Jacob Lawrence signing *John Brown* prints, 1977.
67. *Human Figure After Vesalius,* 1968.
68. Vesalius, *Figure Drawing,* c. 1547.
69. *Nude Study,* c. 1968–69.
70. Jacob Lawrence in his University of Washington studio, 1975.
71. Jacob Lawrence presenting *The Swearing In #1* to President Carter, 1977.
72. Jacob Lawrence and *Games* mural in place, 1979.
73. The production of the *Origins* mural, 1984.
74. Lawrence working on the *Theater* mural in 1984.
75. Lawrence supervising the hanging of the *Theater* mural, University of Washington, 1985.
76. *Carpenters* drawing No. 9, 1981.
77. *Builder—Woman Sewing* drawing, 1981.
78. Jacob Lawrence teaching, School of Art, University of Washington, October 1984.
79. Jacob and Gwen Lawrence, 1975.
80. Lawrence and his tool collection in his studio, 1984.

FOREWORD

THE SEATTLE ART MUSEUM IS HONORED TO MOUNT THIS RETROSPECTIVE exhibition acknowledging Jacob Lawrence's achievements over his fifty-year career. An artist of uniquely American vision, Lawrence has resided in Seattle since 1970, and with his artist wife, Gwendolyn Knight Lawrence, has been an active, important member of the civic, educational, and museum communities. It is appropriate that the Seattle Art Museum initiate and circulate a major exhibition of this significant artist and friend of Seattle.

This retrospective reflects the diligence and dedication of many people. I hope that all involved in this complex undertaking will take satisfaction in knowing that the successful organization and completion of this project is a direct result of their good efforts.

The University of Washington Press has joined forces with the Seattle Art Museum to produce this fine book on the occasion of the Jacob Lawrence exhibition. Ellen Wheat's important monograph, the fruit of long research and many hours of interviews with Lawrence, provides a comprehensive overview and shares valuable insights into the artist's work and career. Wheat has also acted as consultant to the exhibition in matters large and small.

Annexed to Wheat's text is the museum's illustrated checklist of the exhibition, which contains corrected and updated information about the paintings. The museum also extends thanks to Patricia Hills of Boston University for contributing her thoughtful observations on Lawrence's work. Suzanne Kotz, head of publications at the museum, deserves special acknowledgment for her extraordinary efforts in all phases of the production and supervision of this publication. Thanks also go to Dana Levy for the fine design of the book and to Lorna Price for her sensitive and thorough editing.

Many members of the Seattle Art Museum staff assisted me in the preparation of this exhibition. I should like to note with appreciation the contributions of Vicki Halper of the Modern Art Department; Evelyn Klebanoff, Registrar's Office; Paula Thurman, Publications Department; Helen Abbott, Public Relations; and Jill Rullkoetter, Education Department.

The organization of the exhibition was greatly aided by Mr. Lawrence's longtime dealers, Terry Dintenfass, New York City, and Francine Seders, Seattle. Their knowledge and counsel were invaluable throughout our efforts. For this and for the assistance of their gallery staffs, I extend my warmest thanks.

The high costs incurred in mounting an exhibition and producing an accompanying publication cannot be met by museums alone. We are therefore particularly grateful to the IBM Corporation for substantial and enthusiastic support of this exhibition and its national tour. A generous grant from the National Endowment for the Arts has further secured this project.

Thanks are also due the following institutions joining with us in this exhibition, and in particular their directors and curators: Julian T. Euell, Director, and Dr. Christina Orr-Cahall, Curator of Art, Oakland Museum; Gudmund Vigtel, Director, and Peter P. Morrin, Curator of Twentieth Century Art, High Museum of Art; Laughlin Phillips, Director, and Willem de Looper, Curator, The Phillips Collection; Harry S. Parker III, Director, and Rick Stewart, Curator of American Art, Dallas Museum of Art; and Robert T. Buck, Director, and Charlotta Kotik, Curator of Contemporary Art, The Brooklyn Museum.

A special debt of thanks is owed to the owners of works included in this retrospective for their willingness to share their often fragile and much-loved paintings over an extended period, and for their cooperation in the publication of this book. Special acknowledgment goes to the Southern Arts Federation, the Amistad Research Center, and Grant Spradling for making works from the *Toussaint L'Ouverture* series available. Jeanne Zeidler at the University Museum, Hampton University, facilitated the loan of paintings from the *Frederick Douglass* and *Harriet Tubman* series. The cooperation of the Museum of Modern Art, the Whitney Museum of American Art, the Detroit Institute of Arts, the Portland Art Museum, The Phillips Collection, and the Hirshhorn Museum and Sculpture Garden in lending important works from Lawrence's historical series is likewise gratefully acknowledged.

Finally, our heartfelt thanks and warm respect go to Jacob Lawrence for his wholehearted and essential participation in the exhibition, and for the creation of these compelling paintings. It has been an honor for all to work with him as a colleague.

Bruce Guenther
Curator of Contemporary Art

ACKNOWLEDGMENTS

ONE OF THE MOST CHALLENGING AND MEANINGFUL TASKS FOR THE ART historian is to conduct original research on a major living artist. I have been privileged to work with Jacob Lawrence on this project since 1979, and I am indebted to him for his cooperation. I am most grateful for the support and trust both Mr. Lawrence and his wife Gwendolyn Knight Lawrence have given me through the years. During the countless hours of taped interviews and conversations, the Lawrences graciously shared their history and ideas as well as their collection of letters, photos, clippings, and memorabilia. I am also indebted to them for reading the manuscript for accuracy.

Many people have contributed to this study of Lawrence's life and work, especially my associates at the University of Washington. I wish to express my deep appreciation to my teacher Martha Kingsbury for her rational viewpoint and longstanding support. Over the years, I have valued the friendly goodwill of painters Michael Spafford and Michael Dailey, who both reviewed an early version of the manuscript. I wish to thank in particular two readers of the manuscript, Patricia Failing and Wallace Weston (who is currently teaching at the University of Puget Sound, Tacoma) for their valuable editorial comments. I have benefitted from the knowledge and vision of Constantine Christofides, Director, School of Art, University of Washington, Seattle, at many points in the project, and I wish to note my gratitude to him.

The following persons are among those who were extremely helpful during the progress of my research. I extend sincere appreciation to William McNaught, Director of the New York area, Archives of American Art, Smithsonian Institution, and to Garnett McCoy, Senior Curator, Archives of American Art, Washington, D.C., for their imaginative and expeditious support; Terry Dintenfass, Lawrence's New York dealer, and her former assistant Mindi Katzman, for filling my numerous requests for photos and information on paintings; Francine Seders, Lawrence's Seattle dealer, and her assistant Trish Eden and the rest of the Francine Seders Gallery staff, who have been constantly responsive to my many research needs; Jeanne Zeidler, Director, University Museum, Hampton University, Hampton, Virginia, for

her assistance and her willingness to share the Hampton collection with me; Carolyn Davis, Manuscript Librarian, The George Arents Research Library, Syracuse University, New York, for her researching talents and efficiency; Julia Hotton, Director, and Deborah Willis-Thomas and Cheryl Shackelton of the Schomburg Center for Research in Black Culture, New York, for answering my questions and handling my many requests with dispatch; Edmund Barry Gaither, Director of the National Center of Afro-American Artists, Boston, for his insights into the history of American black art; and Carlton Skinner, one of Lawrence's commanding officers in the Coast Guard, for talking with me about the artist's service experience and for sharing his files and photographs.

I am enormously grateful to Carroll Greene, Jr., Executive Director, Maryland Commission on Afro-American History and Culture, who offered his personal insights into the Jacob Lawrence he knows and allowed me to draw at length from his important 1968 unpublished interview with Lawrence. Special acknowledgment also must be given to Alain Locke posthumously; his enlightening writings have been a significant source for my research. And I want to express special appreciation for the Archives of American Art, Smithsonian Institution, Washington, D.C., for the accessibility of the material they so carefully preserve.

Throughout my research, many other people extended themselves to help me: Patterson Sims, Curator, the Whitney Museum of American Art, New York; Bill Koberg, Preparator, The Phillips Collection, Washington, D.C.; David Driskell, Professor of Art, University of Maryland; Roy Leaf, Executive Director, John Eastman, Jr., Trustee, and JoAnn Chuba, Administrative Assistant, of the Skowhegan School of Painting and Sculpture, Maine; Ray Silverman, specialist in African art history, Seattle; Jenelsie W. Holloway, Chair, Art Department, Spelman College, Atlanta, Georgia; Carl E. Anderson, Vice President for Student Affairs, Howard University, Washington, D.C.; Joan Hendricks and the staff of the Studio Museum, Harlem; and Herbert Nipson of *Ebony* magazine. I am very appreciative of the cooperation of collectors and all those at museums, galleries, and libraries who assisted me in obtaining photographs, reproduction rights, and related data.

The publication of this book has been a cooperative venture between the University of Washington Press and the Seattle Art Museum. I wish to thank the entire staff of University Press for their enthusiasm for the publication of this book, and especially Don Ellegood, Director, and Naomi Pascal, Editor-in-Chief, for bringing this project to fruition. I am grateful to Lita Tarver, Managing Editor, for her good humor and careful attention to detail, and for ensuring that the manuscript was in order at each stage of production. Anne Venzon compiled the index, and I appreciate her effort. Special thanks are due to the museum's publications staff. I have great appreciation for the professional talents and integrity of Suzanne Kotz, Director, Media and Publications, who supervised the book's production and kept the project on course. Her assistant Paula Thurman deserves commendation for her help in obtaining vital but elusive photographs and information. It has been a pleasure to work with all of these capable people.

I particularly want to recognize the work of editor Lorna Price. Her experience and thoughtful objectivity have contributed immeasurably to the quality of the book. I am also full of praise for the creative and organizational abilities of photographer Chris Eden, whose work graces many of these pages; my thanks go also to his assistant Jim Fanning.

Research was supported by grants from the University of Washington's School of Art Special Projects Fund, Samuel H. Kress Foundation funding awarded by the Division of Art History, and the Graduate School's Minority Education Division. I am grateful to Dean Trevor Chandler of the Graduate School for his interest and backing.

This book is dedicated to my family: my husband Jim, my daughter Lauren, and my mother Jean Harkins, who always support me and patiently endure as I work.

ELLEN HARKINS WHEAT
University of Washington
January 30, 1986

Jacob Lawrence's Expressive Cubism

by Patricia Hills

THE CONSTANTS THAT MOVE THROUGH JACOB LAWRENCE'S ART FROM THE mid-1930s to the present are a collage cubist style, a format of narrative and often serial imagery, and a subject matter of black American history or contemporary life. These constants seem quite straightforward, almost formulaic. And on one level they are, because a kind of simplicity resides in the instant comprehensibility of the art: in its subject matter—everyday life in the black community and the historic struggles of oppressed people—and in the nonillusionistic shapes and colors. The simplicity, however, does not preclude the complex aesthetic decisions that Lawrence, even in the beginning of his career, made in composing the paintings, nor the richness of the results. Nor does it negate Lawrence's unique ability to engage his cultural consciousness and narrative choices with his flat, cubist style.

However, the engagement between cultural consciousness and subject matter on the one hand and style on the other is not so apparent. In Lawrence, as in any other artist, consciousness quickens, expands, and contracts with changing experiences, including, of course, artistic sources and influences. But to an artist as temperamentally sensitive to the social environment as Lawrence was and is, the outside world takes precedence. In other words, political, economic, and social forces were the primary factors shaping his personal and artistic decisions.

For Lawrence, those experiences began in the Harlem of the 1930s, an exciting place in which a teenager of his talents could grow and flourish in spite of the pervasive social effects of the Depression.[1] The achievements of the Harlem Renaissance still lent a glow to cultural life in upper Manhattan.[2] Moreover, the ideas and programs of radicals and communists in the area added a new, dynamic element to that life. This lively cultural ambience enriched the education of the young artist; Jacob Lawrence recalls the workshops, the Harlem Artists Guild, and Harlem Art Center with affection:

> People would come up to the centers. People like Katherine Dunham, Countee Cullen, Langston Hughes. They may not have talked to me because I was too young, but I would hear their conversations with each other. And not just blacks, but people from outside

the black community—very interested artists. There was this interchange. And, being a youngster, I guess subconsciously I was influenced by this. They would talk about their involvement in the arts and things like that.[3]

He did talk, however, with those closer to his own age, such as Bob Blackburn, who became a well-known printmaker, and painters Romare Bearden, Ronald Joseph, and his future wife Gwendolyn Knight. And he was drawn to the dynamic presence of the sculptor Augusta Savage and the articulate musings of Harlem Renaissance poet and writer Claude McKay, both of whom were black nationalists.

Meanwhile, Lawrence's style was evolving—beginning with the masks and the small stage set tableaux he made out of cardboard boxes at after-school community center art classes. By the time he reached the American Artists School in 1937, he was still working with color and shapes but had moved away from nonfigurative designs to genre scenes of Harlem.

Once Lawrence felt secure in his style of simplified, flat forms and had settled on the life of the black community as his subject matter, he turned to history as a source for more ambitious subjects and painted his *Toussaint L'Ouverture* series. He had learned the story of the revolution of the slaves in Haiti, led by Toussaint, as well as other accomplishments of black leaders, in the history clubs of his school and from talks at the Schomburg Library in Harlem.

The idea of painting in series events from the history of dissent, radicalism, and revolution was not new. In the early 1930s Ben Shahn had painted his *Sacco and Vanzetti* and *Tom Mooney* series, which were shown at the Downtown Gallery and which focused on the martyrdom of those historical figures. Perhaps, as Lawrence recalls, he did not know of Shahn's series directly—but the older Harlem artists surely did. They would also have known of the radical subject matter being developed at the time in mural painting—Diego Rivera's Rockefeller Center mural (subsequently destroyed), as well as his series of twenty-one fresco panels for the New Workers' School entitled *Portrait of America*, which focused on the contribution of the working class to American life. Discussions not only of murals, mural techniques, and the Mexican painters, but also of the radical subject matter of older artists, such as Käthe Kollwitz, and contemporaries, such as George Grosz, became vital topics at the centers.

Indeed, it was the radical content of the Haitian narrative that then appealed to Lawrence. He emphasized Toussaint not as a victim (as Shahn had done with Tom Mooney and Sacco and Vanzetti), but as a revolutionary. In a statement for the Harmon Foundation in 1940, he wrote:

> I didn't do it just as a historical thing, but because I believe these things tie up with the Negro today. We don't have a physical slavery, but an economic slavery. If these people, who were so much worse off than the people today, could conquer their slavery, we certainly can do the same thing. They had to liberate themselves without any education.
>
> Today we can't go about it in the same way. Any leadership would have to be of the type of Frederick Douglass. How will it come about? I don't know. I'm not a politician. I'm an artist, just trying to do my part to bring this thing about.[4]

If Lawrence did not know of Shahn's work as a precedent for his own, he surely was aware of Picasso's use of cubism as a vehicle for important social commentary. In 1937 Picasso had painted his mural-sized *Guernica*—a work inspired by his response to the Nazi bombing of that Basque town, a particularly vicious incident of the Spanish Civil War. Picasso's painting was widely publicized in those years when anti-fascist sentiment ran high. Moreover, cubism proved to be an appropriate vehicle for an art that aspired to epic statement.

In its beginnings cubism was another step in the move away from illusionism, a step that had begun in the late nineteenth century. At that time artists rejected the concept of painting as a window onto reality, and acknowledged that it could be a subjective construction of colors, lines, and forms on a flat surface. Thus, the French post-impressionists, particularly Cézanne, weaned the art public away from an attachment to illusionistic painting; the next generation—Picasso, Braque, Modigliani, Matisse—inspired by the rhythmically bold forms of African sculpture, pushed painting toward modernism and greater abstraction.

This is not the place to elaborate on the history of modernism, but it needs to be emphasized that early modernism went in two different directions. The first meant exploring the process, the *construction* of art, and is associated with the first phase of

cubism, called analytical cubism, and later with nonobjective painting. The second meant incorporating new approaches to form in order to *express* the artist's subjective feelings about the world. The early American modernists, influenced by such European theoreticians as Kandinsky (*Concerning the Spiritual in Art*), followed the expressive path. They composed their pictures using shapes like cut-out pieces of colored paper, hence the term "collage cubism" (also called synthetic cubism). Their goal was not design for its own sake, but, rather, design as a means to express an emotion about nature or the world.[5]

Examples of the expressive modernism then being developed by Americans can be noted in the catalogue essays of an exhibition of American modernists held at the Forum Gallery in 1916. In terms quite typical of the attitudes of many artists working in the collage cubist aesthetic, Oscar Bluemner declared:

> The painter to-day... aims at a liberation of feelings. Only the ideas of the present age create emotions wanting liberation through expression in form and beauty that are different from those of the past and are more varied; because man's intellect progresses, widens, deepens. Hence the arts become more manifold and freer, less bound by traditional and antiquating points of view.[6]

These early modernists had no ambition to paint the grand emotions engendered by a national epic. But Jacob Lawrence, influenced by the legacy of the Harlem Renaissance, which took pride in the achievements of black people, and also affected by the radical ideals of his time, selected the epic of Haiti as a most natural choice.

Moreover, in the *Toussaint* as well as in the later series, Lawrence's style of cubism suited his own quiet, often reticent, personality. Whereas the painterly brushstrokes of noncubist expressionism or the collapsing perspectives and bulging forms of the Mexican mural style could get out of control, reaching excesses of anger or pathos, Lawrence's cubism, with its flat shapes and controlled outlines, kept the emotion restrained and the sequences of images moving in measured cadences.

Decades later, in a speech delivered in 1962 on "The African Idiom in Modern Art," the artist praised what he viewed as the inherent rationalism of cubism:

> Of all modernist concepts and styles, cubism has been the most influential. Because of its rationalism, its appeal has become universal. And because cubism seeks basic fundamental truths, it has enabled the artist to go beyond the superficial representation of nature to a more profound and philosophical interpretation of the material world.[7]

Earlier, as a youth of twenty, he may not have been able to articulate such a statement with such eloquence, but even then he would have felt its rightness.

The importance of African art both to Lawrence's knowledge of the origins of cubism and to his developing sensibility cannot be stressed enough. In that same speech of 1962 he speculated about the reception that French artists gave to African art when they first saw it around 1900: "For here was an art both simple and complex—an art that possessed all of the qualities of the sophisticated community. It had strength without being brutal, sentiment without being sentimental, magic but not camouflage, and precision but not tightness."[8] He may also have recalled his own intuitive response to the West African sculpture he saw at the Museum of Modern Art in 1935 or his own readings on the subject.

The cubist collage aesthetic would also seem especially fitting for an epic narrative focused not just on heroes and heroines, but on particularly important moments in the chronicle of a people. In one of its aspects, collage cubism is reductive: simplified, flat shapes have an analogue in the exemplary or epiphanic points of the chronicle. In another, it is additive: overlapping shapes layered on the surface parallel the accumulation of incidents characteristic of epic narrative.[9] It is nonillusionistic: no tricks fool the eye, no felicities of chiaroscuro or cast shadows divert the spectator from the clarity of the story and the communication of its message. By eliminating illusionism Lawrence eliminated focus, texture, and, hence, the hierarchy of values that focus and texture entail. This lack of tonal values has its analogue in Lawrence's aversion to personalizing the features of Toussaint, or, later, Frederick Douglass, Harriet Tubman, and John Brown. To Lawrence, the heroes and heroines depicted in all his epics—*Toussaint L'Ouverture, Frederick Douglass, Harriet Tubman, John Brown*, and the later *Struggle* series—have importance as iconic embodiments of the experience of social and political struggle.

If directness characterizes each separate panel in his series, an intricate subtlety

reveals itself when they combine to form a coherent serial imagery. We might say that the panels are to the whole series as stanzas to a complete poem, or bars of music to a completed composition. Moreover, the written text guarantees that each series will be, like poetry or music, experienced in a particular order and in time.[10]

The written texts accompanying the pictures tend to be simple and factual. Lawrence employs them to tell the audience what happened, when, and how. Sometimes the texts point out causes and effects, acknowledging the roles of both villains and benefactors among the *dramatis personae.* The role of photojournalism, with its dual imperatives of picture and text, should not be discounted as a formative influence in Lawrence's perception of the function of captioning for his paintings. With the first publication of *Life* magazine in 1936, the era of photojournalism was in full swing. Furthermore photojournalism, like Lawrence's history series, was meant to instruct the public by focusing on the intrinsic humanity of any given situation.[11]

Lawrence's cubist style underwent changes, becoming more fractured in the late 1940s and 1950s as his experiences with the world changed. During the civil rights movement of the 1960s, his cubism reached an intense degree of expressionism as he struggled to give pictorial articulation to the taunts and humiliations that blacks were then experiencing in their struggles for social justice. Some of these works, such as *The Ordeal of Alice,* are the visual equivalent of Claude McKay's poem "If We Must Die":

> If we must die, let it not be like hogs
> Hunted and penned in an inglorious spot,
> While round us bark the mad and hungry dogs,
> Making their mock at our accursed lot.
> If we must die, O let us nobly die,
> So that our precious blood may not be shed
> In vain; then even the monsters we defy
> Shall be constrained to honor us though dead!
>
> O kinsmen! we must meet the common foe!
> Though far outnumbered let us show us brave,
> And for their thousand blows deal one deathblow!
> What though before us lies the open grave?
> Like men we'll face the murderous, cowardly pack,
> Pressed to the wall, dying, but fighting back![12]

McKay's poem, which continues to have a deep effect on Lawrence, was written not just with black people in mind but, rather, about all of oppressed humanity.[13] Indeed, it is the totality of humanity that continues to engage Lawrence's artistic sensibilities

And still Lawrence chooses the collage aesthetic. It seems the most appropriate and expressive style for his purposes. The *Hiroshima* series images, with their ragged, torn edges and flat, blasted reds, suggest both the color and the rawness of the "skin sloughed off," so graphically described in John Hersey's book. The optimistic *Builder* and *Carpenter* series combine primary colors and forms in precisely cut-out shapes of equal density with the content of racial integration—of men working in activities fundamental to human life. Above all, the collage aesthetic, informed by Lawrence's need to express the moral content of experience, results in paintings that are among the most memorable of our time.

Notes

The author has excerpted this essay from a longer critical assessment of the artist's work, considering its stylistic origins and development and its place in American painting. Thanks are extended here to Kevin Whitfield, and Robert Brown, Teresa Cederholm, Carolyn A. Davis, Terry Dintenfass, John Gernand, Liese Hilgeman, Brad Hills, Nathan I. Huggins, Julia Hotton, Beth Moore, Lowery Sims, David Sutherland, Mary Jane Thorpe, Mary Yearwood, Jeanne Ziedler, Judith Zilczer, and, especially, Gwen and Jake Lawrence.

1. Much of the biographical information contained in this essay is based on taped interviews with the artist on July 25, 1983, and May 20, 1985, and subsequent telephone conversations.
2. Regarding the Harlem Renaissance, see Nathan Irvin Huggins, *Harlem Renaissance* (New York: Oxford University Press, 1971), and David Levering Lewis, *When Harlem Was in Vogue* (New York: Alfred A. Knopf, Inc., 1981).

3. James M. Buell and David C. Driskell, interview with Jacob Lawrence in *The "Toussaint L'Ouverture" Series*, ed. James M. Buell (New York: United Church Board for Homeland Ministries, 1982), p. 28.

4. Statement issued by the Harmon Foundation, Inc., dated November 12, 1940, Downtown Gallery Papers, Roll ND5, Archives of American Art, Smithsonian Institution.

5. Marius de Zayas wrote an article, "Pablo Picasso," for *Camera Work* (April–July 1911), pp. 65–67, in which he interpreted Picasso's work as follows: "Picasso . . . receives a direct impression from external nature, he analyzes, develops, and translates it, and afterwards executes it in his own particular style, with the intention that the pictures should be the pictorial equivalent of the emotion produced by nature. In presenting his work he wants the spectator to look for the emotion or idea generated from the spectacle and not the spectacle itself." Quoted in Marius de Zayas, "How, When, and Why Modern Art Came to New York," introduction and notes by Francis M. Naumann, *Arts Magazine* 54 (April 1980), p. 102.

6. Quoted in Barbara Rose, ed. *Readings in American Art Since 1900: A Documentary Survey* (New York: Frederick A. Praeger, 1968), pp. 56–57.

7. Transcript ms., "The African Idiom in Modern Art," p. 12, Box 3, Jacob Lawrence Archives, The George Arents Research Library, Syracuse University.

8. Ibid., p. 9.

9. Among scholars of epic, particularly Greek epic, the word "parataxis" is used to describe the characteristic of the additive, nonsubordinating style. See references in Erich Auerbach, *Mimesis: The Representation of Reality in Western Literature* (Garden City, New York: Doubleday Anchor Books, 1957).

10. One might further explore these series in terms of qualities seen as characteristic of African-American literature and music, such as "call-and-response," the rhetorical patterns of the sermon, and the repeated phrase; see Huggins, *Harlem Renaissance*, pp. 229–30, and Henry Louis Gates, Jr., ed., *Black Literature and Literary Theory* (New York: Methuen, Inc., 1984).

11. One might say "manipulate" in the case of photojournalism; see William Stott, *Documentary Expression and Thirties America* (New York: Oxford University Press, 1973). Lawrence's ninth panel of the *Harriet Tubman* series has a close visual similarity to Margaret Bourke-White's *Hood's Chapel, Georgia,* a photograph captioned: "They can whip my hide and shackle my bones, but they can't touch what I think in my head." See Erskine Caldwell and Margaret Bourke-White, *You have Seen Their Faces* (New York: Modern Age Books, Inc., 1937), n.p. following p. 32.

12. According to Huggins, *Harlem Renaissance*, p. 313, note 10: "McKay's poem was first published in Max Eastman's *Liberator*, II (July 1919), p. 21, and later appeared in *Messenger*, II (September 1919), p. 4, and in McKay, *Harlem Shadows* (New York: Harcourt, Brace and World, 1922), p. 53." Huggins quotes the poem on p. 71.

13. Ibid., p. 72.

Jacob Lawrence American Painter

1. Introduction

The work of Jacob Lawrence is social, in content and in consciousness. Lawrence's paintings consistently portray the lives and struggles of the people he knows best, black Americans. In a career spanning five decades, the coherence of conceptualization in his art has been unbroken. Lawrence has manifested a persistent concern with everyday reality and the dignity of the poor, and all human effort toward freedom and justice, and he deals with these themes while extolling the value and diversity of human existence. Because of the universality of his themes as well as his accessible, colorful style, Lawrence's work has always interested a wide audience.

Jacob Lawrence received almost overnight acclaim when his *Migration of the Negro* series was shown at New York's prestigious Downtown Gallery in November 1941. With this exhibition, Lawrence became the first black artist to be represented by a New York gallery. He was only twenty-four years old. That same month, *Fortune* magazine reproduced twenty-six of the series' sixty panels in color in a lengthy article. Since these events, Lawrence's life story has been a record of achievements and accolades; his career has been singularly free of disappointment and controversy. By the time he was thirty, he had become widely known as the foremost black artist in the country.[1] In 1974 the Whitney Museum of American Art in New York held a major retrospective exhibition of his work that toured nationally. In December 1983, Lawrence was elected to the American Academy of Arts and Letters. For over thirty years he has also distinguished himself as a teacher of drawing, painting, and design. He is currently Professor Emeritus of Art, University of Washington, Seattle, where he is widely regarded with respect and affection.

FIG. 1. Jacob Lawrence, c. 1938.

Jacob Lawrence grew up in Harlem during the Depression, an experience that figured significantly in his evolution as an artist. That epoch of social awareness and burgeoning black consciousness, economic hard times, and government support of the arts nurtured this developing young painter. Harlem was a cultural nucleus of the nation in the 1920s and early 1930s. Lawrence felt the persistent influence of what was called the "Harlem Renaissance" all around him, in the artistic concentration thriving in Harlem, in his teachers, and in the people he met and the pursuits they shared. Lawrence's mother, a single parent, tried to support her three children with domestic work but was often on welfare. While juggling odd jobs to help out, Lawrence committed himself to painting as a young teenager and has never wavered in his disciplined productivity.

During his formative years, Lawrence was fortunate in being encouraged by artists in his community. He has said, "I never saw an art gallery until I was eighteen years old,"[2] so his awareness of art came from teachers and from books, local exhibitions, and frequent trips to the Metropolitan Museum. As a young teenager, he met artist Gwendolyn Knight; their friendship led to marriage, and their long relationship has been a vital factor in Lawrence's career. Some of the artist's first major works were produced as a result of his being a member of the Works Progress Administration (WPA) Federal Art Project. Lawrence considers "the Project" to have been a school for him in many ways: the interchange with many diverse artists, the opportunity to concentrate on work with all materials provided, and the dignity in having a good job in hard times.

When Lawrence began his career in the mid-1930s (fig. 1), his work assumed the character of what is broadly called Social Realism, the predominant style of that period in this country. His content was presented through the modes of historical narrative and genre, and always by means of representational imagery. Remarkably, Lawrence's work, having exhibited diverse manners and subtle influences of intervening styles, today remains unique and very much as it was when he began as a painter. It focuses on the human figure, presented in tableaux of expressive forms. His subject ranges from simple street scenes to emotional renderings of social inequities. Much of his art approaches but transcends historical documentation in its depiction of significant events and its poignant portrayal of lives. Lawrence's distinctive formal approach is dominated by an attempt to capture the feeling obtained from his subject. In his pictorial indictments of man's cruelty and injustice, Lawrence has frequently been compared to such artists as Francisco Goya, José Clemente Orozco, and Käthe Kollwitz. His discreet but often strong messages are readily apparent, obtained through distortion of shape, space, and color. His chosen iconography always clearly supports his aim of personal emotive expression. Lawrence's painstakingly crafted works, characteristically executed in water-base media, are notable for their vivid pure color and compelling design and pattern. He said about his work in a 1945 interview:

> The human subject is the most important thing. My work is abstract in the sense of having been designed and composed, but it is not abstract in the sense of having no human content. . . . [I] want to communicate. I want the idea to strike right away.[3]

While he has also produced drawings, prints, book illustrations, large murals, and even costume designs, Lawrence commonly makes small easel paintings. Although his work is meant to be viewed closely and experienced intimately, the impact of its form and content is often monumental.

The career of Jacob Lawrence is characterized by a continuing allegiance to his cultural heritage. In his work, Lawrence not only acknowledges an awareness of the influence of his environment, he celebrates it, by focusing on the history and hopes of his community members. Although his work always speaks of the black experience from an emotionally autobiographical position, his imagery has universal appeal. Lawrence is a humanist with a moral vision, whose deep involvement with the struggles of mankind reminds us of the perpetual validity of the human story.

2. ORIGINS: 1917 TO 1940

JACOB ARMSTEAD LAWRENCE'S PARENTS WERE PART OF THE GREAT "NEGRO Migration" which surged around 1910-16 and continued into the 1940s, drawing blacks from the southern states and the Caribbean islands to better employment and social opportunities in northern industrial cities. Lawrence's mother was from Virginia and his father came from South Carolina. They met and first settled briefly in Atlantic City, New Jersey, where Jacob Lawrence was born on September 7, 1917. They then moved to Easton, Pennsylvania, which Lawrence dimly remembers as a coal mining town with very steep hills. Lawrence's father was a cook on the railroad and was often away from home; soon after Lawrence's sister Geraldine and brother William were born, his parents separated. His mother then moved the family to Philadelphia, where they lived in settlement houses while she attempted to keep the family going on her own (figs. 2 and 3). In about 1927, she went to New York City seeking better job opportunities; she left the children in foster homes, returning to visit them as often as possible. As soon as she could, his mother brought the children to New York; they settled in Harlem around 1930, in the upper 130s and 140s between Lenox and Seventh avenues near Striver's Row. Lawrence recalls:

> We came to New York, and of course this was a completely new visual experience seeing the big apartments. When I say "big," I mean something six stories high, because I wasn't used to apartments. In Philadelphia, they had brownstone . . . houses. . . . What I did miss . . . was the . . . open lots . . . where we used to play marbles and things like that and you didn't have to worry about vehicular traffic. . . . I can remember to this day seeing kids playing marbles in the gutter. . . something I had never experienced before.[1]

New York City games took on the character of the environment. Stick ball played in the

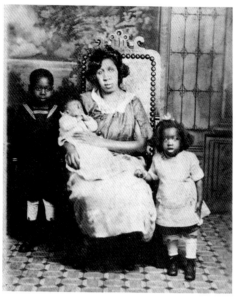

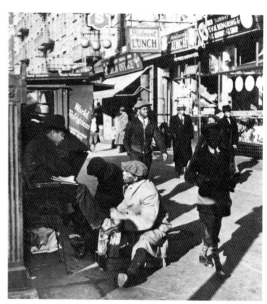

FIG. 2. Rose Lee Armstead Lawrence, c. 1920s.

FIG. 3. Jacob Lawrence (age 6) with his mother (29), sister Geraldine (2½), and brother William (3 months), 1923.

FIG. 4. Harlem Street Scene, Lenox Avenue, 1930s.

narrow side streets, with parked cars and manhole covers for bases, was strange and foreign to me. So I withdrew from much of that kind of activity. I was thirteen, and children entering adolescence find it more difficult to adjust than when they are younger.[2]

The Harlem community to which Jacob Lawrence and his family moved had just experienced the rich decade of the 1920s known as the Harlem Renaissance.[3] With the onset of the Depression the renaissance waned, but the social fabric of Harlem continued to foster new attitudes and cultural growth. Harlem of the early 1930s was a unique black urban community. The largest of its kind in the world, it was crowded, multifaceted, and sophisticated. Black intellectuals from all over the world had gravitated there in the twenties; many were still present and their ideas continued to have resounding impact.

Harlem first began to grow rapidly during the period of the Negro Migration. Being part of the largest city in the country, Harlem attracted a good portion of the migrants (fig. 4). The problems and needs arising from this massive transplantation resulted in the establishment of reform groups such as the National Association for the Advancement of Colored People in 1909 and the National Urban League in 1910. Vocal progressive periodicals such as *The Crisis, Opportunity,* and *The New York Age* were published by these and other Harlem organizations and were edited by such articulate intellectuals as William E. B. DuBois (fig. 5) and James Weldon Johnson. These widely read periodicals stressed black achievement and self-realization, and supported and promoted Harlem authors and artists, providing a showcase for their work. Out of this concentration of people and the formation of these two active organizations came an accumulation of talent that turned Harlem into a national hub of cultural renewal.

By the 1920s, leaders such as DuBois and Johnson were drawing young blacks to New York because they represented this spirit of renewal. Marcus Garvey arrived there in 1916 from Jamaica. He started the Universal Negro Improvement Association in Harlem, with the hope of realizing his dream that blacks would re-establish themselves as a nation in Africa. Frequently, Garvey appeared in parades, wearing an elaborate uniform of purple and gold and a helmet of feathers. He inspired thousands of followers throughout the country with his cries of "Up, you mighty race!" Although his back-to-Africa movement failed and he was eventually convicted of mail fraud, he was responsible for creating a fervent black nationalism movement in America in the twenties.

With the sudden population increase, business and professional opportunities that did not exist in New York at large arose in Harlem for black shopkeepers, lawyers, and doctors. The community produced its own shops, churches, theaters, social and civic centers, and clubs (such as the legendary Cotton Club), becoming a cos-

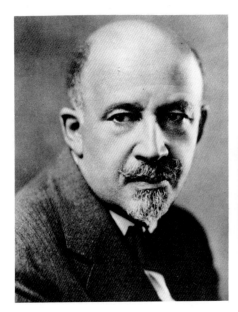
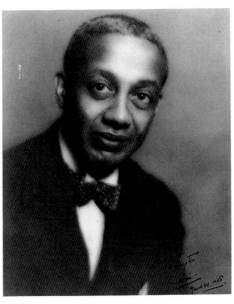

Fig. 5. William E. B. DuBois, 1930s.

Fig. 6. Alain Locke, 1928.

mopolitan subsection of Manhattan. As the decade of the 1920s began, Harlem was the recognized "international capital for the black race."[4] Another leading figure of this era was Alain Locke, a philosophy professor and critic who became a major chronicler of the Harlem Renaissance (fig. 6). In his lectures and essays, Locke encouraged blacks to turn to their heritage in a search for cultural identity, guiding them to recognize black contributions to the folk traditions of America, and to explore them artistically. Locke introduced the African art legacy directly into this country through his writings and exhibitions of a large collection of African art he brought from Europe. He lectured widely on the influence of African art forms on such modernists as Picasso and Matisse. He worked steadily to make Americans aware of the aesthetic achievements of blacks, from African sculpture to American novels and poetry. Locke published *The New Negro* in 1925, a collection of writings by and about young black artists, which was a major stimulus to the Harlem Renaissance. From Harlem emanated the sense that there was a "new Negro," transformed by an amended sense of personal and cultural worth.

From this historical awareness and pride, the arts and cultural and creative activities in general gained impetus in the Harlem community. Literature, music, theater, vaudeville, and the visual arts flourished. In 1921, the first all black-created musical, *Shuffle Along,* was produced; it played on Broadway for two years. In 1927, the well-known *Porgy* opened and had a long run in New York and London. During the 1920s, such diverse and significant figures rose to fame as the poets Langston Hughes (fig. 7), Claude McKay (fig. 8), and Countee Cullen, novelists Nella Larsen and Zora Neale Hurston, singers Marian Anderson and Paul Robeson, dancer Bill "Bojangles" Robinson, pianists "Jelly Roll" Morton and Fats Waller, and artists James Porter, Hale Woodruff, Augusta Savage, and Richmond Barthé.

This cultural energy notwithstanding, the Harlem that Lawrence entered toward the close of the twenties was not an economically thriving community. Harlem's magnetism had also created many unfortunate conditions that the Depression exacerbated: the community was overcrowded, people were poor (at least half were on relief), general living conditions were deplorable, and food was extremely scarce. By the 1930s, about a half million people were packed into Harlem's approximately three square miles.[5] Evictions for nonpayment of rent were frequent, and dilapidated tenements were filled. The community rallied by setting up soup kitchens and free clothing and shelter programs, and by throwing rent parties in private homes, with admission charged to collect money for rent payment.[6] Over 160 Harlem churches also exerted strong influences. The energies of the charismatic Father Divine and Adam Clayton Powell, Sr., provided the community with both voice and guidance.

Despite the poverty of the Depression, elements of the Harlem Renaissance persisted in the 1930s, and cultural activities continued to produce great figures. The

FIG. 7. Langston Hughes, 1930s.

decade of the thirties in Harlem was a great period for music. The greatest jazz bands of all time came out of that era, including Lionel Hampton, Count Basie, and Benny Goodman, who played regularly to the packed 200 by 50 foot dance hall floor of the popular Savoy Ballroom in Harlem. Vaudeville and stage entertainment continued to be major attractions. The Apollo Music Hall presented extravagant vaudeville shows, most of the major jazz bands, and black dancers, comedians, and singers, among them Billie Holiday, Ella Fitzgerald, Josh White, Leadbelly, and Louis Armstrong.

Dramatic theater continued to flourish. Many writers remained active in Harlem during the Depression, including Hughes, McKay, and Cullen, while new young writers such as Richard Wright and Ralph Ellison were gaining recognition. Many artists were active, especially the sculptor Augusta Savage and painters Aaron Douglas and Charles Alston. One artist reminisced of the thirties, "You'd want to be either in Harlem then or in Paris. These were the two places where things were happening."[7]

Representative of this cultural force in Harlem in the 1930s was the role that the local public library assumed within the community. The 135th Street Public Library was not just a library; it was a civic focus. The words of Ernestine Rose, the librarian at that time, illustrate this attitude: "If the first function of a library is to quicken mental life and expression, the second is to preserve the records of this life."[8] Ms. Rose, a white woman, believed in promoting the "Negro genius" by attempting to make all members of the community aware of their history and cultural heritage. Exhibitions of the library's comprehensive art collection beginning in 1920 helped promote awareness of black art forms from Africa and the United States. Performances and lectures were presented in the library's auditorium. The library also housed the largest accumulation of black studies materials in the world, partly through the efforts of Ms. Rose, but primarily through funding from the Carnegie Foundation to acquire the Arthur Schomburg collection (books, original manuscripts, pamphlets, etchings, and portraits) in 1926. Schomburg, born in Puerto Rico, had spent years collecting material on the history of his people, and was curator of the collection from 1932 until his death in 1938. Over the years, the Schomburg Collection has been augmented with more volumes and documents (the library itself is now called the Schomburg Center for Research in Black Culture) and, as part of the New York City public library system, remains the most extensive center of its kind in existence.

The persistence of the cultural floodtide in Harlem in the 1930s was made possible in part by the continuing support of such philanthropic agencies as the Harmon Foundation, a white organization "with missionary overtones" which had been very active in the period of the Harlem Renaissance.[9] This foundation was interested in "encouraging the artistic development of the Negro race." The Harmon Foundation offered grants to artists and writers and sponsored annual art exhibitions with large cash prizes. It held its first exhibition in 1928 at the Art Center in midtown Manhattan; these shows were held annually well into the 1930s. The Rosenwald Foundation, established by Julius Rosenwald the Sears-Roebuck magnate, offered fellowships to blacks and southern whites in the various arts.

Jacob Lawrence recalls the Depression years:

> The thirties was actually a wonderful period in Harlem although we didn't know this at the time. Of course, it wasn't wonderful for our parents. For them, it was a struggle, but for the younger people coming along like myself, there was a real vitality in the community.[10]

Upon arriving in Harlem, Jacob Lawrence attended the last year of grammar school and then Frederick Douglass Junior High School with the other neighborhood children. His mother took the family to the Abyssinian Baptist Church, pastored by Adam Clayton Powell, Sr., and the largest Protestant church in the country at the time:

> I can remember going to church regularly and being in Sunday school and participating in church plays. Powell, Sr., was a very big name then. I can remember some of his sermons. One of his famous ones was the dry bones sermon. I heard him do that several times and he was very dramatic with it.[11]

Lawrence recalls that one of his earliest works was a map illustrating the travels of St. Peter, for which he won a church prize at age sixteen.

To keep her children safe and busy while she was working, Lawrence's mother enrolled them in a day-care program at Utopia House, a settlement house offering children hot lunches and after-school arts and crafts activities at nominal cost. The arts program was run by painter Charles Alston, who was then working on his master's degree at Columbia University and was becoming a leading black artist. During the many hours he spent at Utopia House, the young Lawrence worked first with crayons, then poster paints, showing a preference for composing in repeated brightly colored patterns like those he saw in the furnishings at home:

> Our homes were very decorative, full of a lot of pattern, like inexpensive throw rugs, all around the house. It must have had some influence, all this color and everything. Because we were so poor, the people used this as a means of brightening their life. I used to do bright patterns after these throw rugs; I got ideas from them, the arabesque movements and so on.[12]

Lawrence now describes these earliest art projects as being "nonfigurative geometric designs, dealing with primary and secondary colors and black and white on paper. . . . I was playing with color; I always liked it."[13] He also made painted masks from papier mâché, creating many from his imagination, "fantastic gargoyles, animals, and birds, realistic faces with decorative headdresses, and caricatures that were more like Halloween masks."[14] He has said of these early activities:

> It was only later that I began working out of my own experience. I built street scenes inside corrugated boxes [he cut the boxes so that only three panels remained, like a stage-set or a triptych], taking them to familiar spots in the street and painting houses and scenes on them, recreating as best I could a three-dimensional image of those spots. And then I began to gradually work freely on paper with poster color.[15]

A quiet and serious boy, Lawrence impressed his teacher Charles Alston with his concentration. Alston later said, "It would [have been] a mistake to try to teach Jake. He was teaching himself, finding his own way. All he needed was encouragement and technical information."[16] Alston's recognition of Lawrence's gifts and his fostering of Lawrence's pursuit of his own natural inclinations were as unusual as they were fortunate.

With the 1933 inauguration of Franklin Roosevelt, a series of federally sponsored social programs was put into effect. The new president's administration had vowed to provide work for the unemployed; some of the new programs had an immediate impact on artists in the Harlem community. Several programs were directed to supporting the arts and indigent artists, with the aim of deploying the artistic potential of the country in the decoration of public buildings and sites. Roosevelt formed the Public Works of Art Program (PWAP) to assist artists through the first winter of his administration by employing them on public works at a weekly salary. Over 3,500 artists in several states earned $32 a week, the minimum unskilled labor wage at the Ford factory at that time. Their jobs were assured for only two months. In 1934, the Treasury Relief Art Project was established to commission artists for specific tasks in connection with embellishment of federal buildings. In 1935, the Works Progress Administration was founded to relieve general unemployment with construction work, and the WPA Federal Art Project (FPA) was set up later that year specifically to create jobs in the areas of art, writing, and theater.[17] Holger Cahill, a collector of American folk art, was the national director of the Project. A major exhibition program of WPA art was launched to show the public that its money was not being wasted; catalogs from these shows reveal that "social concern was very strongly in the air."[18] When the project was terminated in 1943, over 5,000 artists had received public aid and thousands of works had been produced. The nationwide WPA program affected the young Jacob Lawrence directly, because it funded community cultural centers and art workshops in Harlem, where free classes were taught by professional artists.

Lawrence first studied at the Harlem Art Workshop between 1932 and 1934, where he again was instructed by Charles Alston, its director. The workshop, sponsored by the College Art Association, had facilities in the 135th Street Public Library (fig. 9). Lawrence then continued to study with Alston and also with Henry Bannarn, a painter and sculptor, at a WPA Harlem Art Workshop established in Alston's studio at 306 West 141st Street, a building that also housed the studios of many well-known artists. Alston's studio, in particular, became a gathering place for those in

FIG. 8. Claude McKay, 1930s.

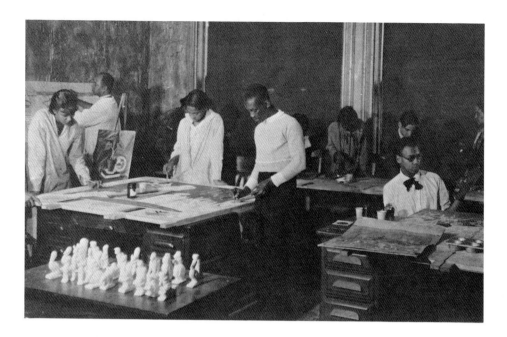

FIG. 9. A Harlem Art Workshop, 1935.

the arts in Harlem. For a few dollars a week Lawrence was permitted to maintain space in an area of Alston's studio, and this was where he worked until 1940.[19] Alston was the Harlem director of the WPA Mural Project, and artists assigned to it would come regularly to "306" to sign in with him (fig. 10). Lawrence recalls meeting many notable people there:

> At 306 I came in contact with so many older people in other fields of art . . . like Claude McKay, Countee Cullen, dancers, . . . musicians. Although I was much younger than they, they would talk about . . . what they thought about their art. . . . It was like a school. . . . Socially, that was my whole life at that time, the "306" studio.[20]

At Alston's studio Lawrence also met Alain Locke, Langston Hughes, Aaron Douglas, Richard Wright, and Ralph Ellison.

The most influential mature artist in Harlem in the thirties was Augusta Savage, whose storefront studio near where Lawrence lived was open to all who wanted to drop in (fig. 11). Artist Romare Bearden, also a community member, remembers that "this talented woman artist who had studied in Europe and come back to Harlem poured out warmth and enthusiasm and was freely available to the young people."[21] Savage was a community leader and a dynamic teacher who literally pulled young people off the streets to join her classes. Once when she observed a sculpture student having trouble modeling the female breast, she unbuttoned her blouse and bared her breasts to him in a matter-of-fact manner, saying, "If you want to see a breast close up, here!"[22] Among her students were the developing Harlem artists Norman Lewis, William Artis, Ernest Crichlow, and Gwendolyn Knight, a young painter originally from Barbados in the West Indies (fig. 12). Although Lawrence did not attend Savage's workshop, he met Knight there in his early teens; their long friendship culminated in marriage in 1941.

During this period, Lawrence attended the High School of Commerce on West 65th Street but dropped out after two years because he received little encouragement in art. He also felt he was needed to help support the family because his mother had lost her job and gone on relief:[23]

> I did hold odd jobs in those days. And I had a good paper route which brought in half as much each week as most men were earning. Then there were jobs in a laundry and a printer's shop. After that I spent all of my evenings in the art studios.[24]

Although Lawrence's parents had lost contact, his younger brother had discovered that their father was now running a small corner store in Harlem. Lawrence resumed a tenuous relationship with him:

> I used to go to see him. He bought me a violin because I told him I was interested in music. I had a few lessons on it. In fact, I can remember taking lessons from Joshua Lee,

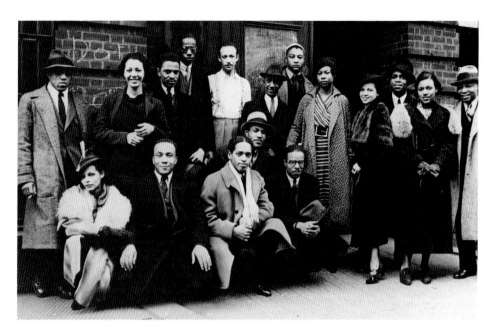

FIG. 10. The "306" Group in front of 306 West 141st Street, mid-1930s. Gwendolyn Knight is left front, Charles Alston is standing, center, in white shirt.

who taught at one of the WPA centers where you could get free lessons. . . . My father used to come by every week and give me a couple of dollars.

He also remembers his relationship with his mother: "We always had problems and frictions. We couldn't communicate, and because of that we weren't very close." When asked where he believes he got his early self-confidence about his work, Lawrence replied:

> I had acceptance at a very early age from the community, and that does a lot. The people that accepted me didn't necessarily know about art, but they encouraged me. My mother had no experience in the visual arts; the creative process was not part of her experience. She encouraged me to go into the civil service because of the security it offered; she didn't see art as affording that type of security.
> I got most of my encouragement from Charles Alston and Augusta Savage. And, you just have to believe that what you're doing has value and that's it.[25]

Lawrence's relationships with the community were crucial to his development as an artist. Because of his lack of strong family ties, the neighborhood became like a family to him and the 306 group a nurturing force. Ronald Joseph, an eccentric but extremely literate and well-informed painter who was on the WPA Mural Project, was of particular influence. Joseph, Gwen Knight, and Lawrence became close friends, attending museums and galleries and sharing and arguing about ideas. Gwen, a student at Howard University in Washington, D.C., had dropped out because of financial hardship during the Depression and was on the Harlem WPA Mural Project. Gwen and Ronald Joseph hired Lawrence to pose as their model several times, giving him a generous two dollars for a few hours' work. Lawrence speaks of how he looked up to both of them; they were several years older and better educated than he. A fourth friend in their group, Bob Blackburn, was a young graphics artist whose ideas Lawrence also respected. Lawrence was the only one of the four not from the West Indies; the immigrant status of the others, which set them apart even in Harlem, enhanced their closeness.

In the mid-1930s, Jacob Lawrence also came to know Romare Bearden, a painter closely associated with the 306 group. Four years older than Lawrence, Bearden had been a mathematics major at Columbia University. When they met, Bearden was studying at the Art Students League with the German Expressionist George Grosz. Although never close friends, they have kept in touch through the years.[26]

When he was about seventeen, Lawrence joined the Civilian Conservation Corps (CCC) and spent approximately six months near Middletown, New York, building a dam:

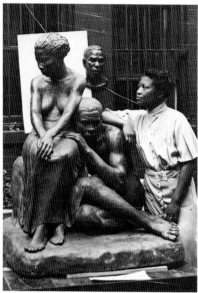

FIG. 11. Augusta Savage and one of her works, 1936.

It was a good experience, physically hard, but I'm glad I went through it. I learned the feel of lots of things—of a shovel, of how it feels to throw dirt up above your shoulders, for instance. Like any experience, it had things in it you never forget for painting.[27]

In 1937, Lawrence received a two-year tuition scholarship to the American Artists School at 131 West 14th Street, New York, where he studied with Anton Refregier, Sol Wilson, Philip Reisman, and Eugene Moreley.[28] He also earned money for his school expenses by posing as a model for the school's classes. In the evenings, he continued to visit the art workshops in his community and to work at Alston's studio. It was during this period that Lawrence began to produce significant work: paintings of Harlem everyday life.

JACOB LAWRENCE'S EARLIEST SURVIVING WORKS DATE FROM AROUND 1936, when he was eighteen. Typical paintings from this initial period (c. 1936–38) were either outdoor street views or interior scenes, presenting groups of the people of Harlem involved in their daily pursuits (pls. 1–4). In these works, he has said that it was his intention to simply "record my environment . . . the activity, the movement . . . what was around me."[29] Four representative works, *Street Scene—Restaurant* (c. 1936–38), *Street Orator* (1936), *Interior* (1937), and *Interior Scene* (1937), are genre images full of wit and compassion. *Street Scene—Restaurant* (pl. 1) offers a characteristic Harlem sight, people relaxing on the front stoop watching the street activity. In this case, the three women are prostitutes observing with amusement a man uncomfortably approaching the door of a brothel. Presented as a frontal tableau, the architectural facade assumes the character of a stage backdrop, a reflection of Lawrence's youthful experiences painting small stage-set scenes in cardboard boxes. The figures are reduced to flat planes of color with much use of outline, and the space is shallow, with depth achieved by overlap of forms. The scene is rendered with no visible horizon, as a dweller of the crowded inner city would view his surroundings. *Street Orator* (pl. 2), from the same year, Lawrence remembers as "one of the first works in which I explore the elements of form through the use of color and value in the faces of the listeners":

> In walking the streets of Harlem, among many other experiences was hearing and seeing the various street corner speakers standing on ladders and lecturing to those who would listen on "the evils of capitalism . . . the benefits of moving back to Africa . . . religion . . . and/or the exploitation of the black community in general."[30]

In the family image, *Interior* (pl. 3), the mother's red dress draws attention to her task, as she bends to gather more laundry to place in the huge pot boiling on the woodstove. Behind her are the icebox, laundry tubs, and sink of the crowded quarters; illumination is provided by an exposed suspended electric bulb. Unobtrusively, the rest of the family attends to its meal. Somber tones convey an oppressive environment.

Lawrence's early paintings have a simple, some say "primitive" look. This quality is effected because the figure/ground relationship is characteristically unresolved, the forms are flat and simplified, and objects appear to float in space. Yet close examination reveals his firm grasp of structure and form. The figures are frontal or profile shapes that have a cartoon or caricature quality. In these basic shapes, however, he has captured the quintessence of body language: pose and movement are reduced to essentials and gestures are quickly read. Faces are masklike, disclosing his early experiences in making painted papier mâché masks as well as his exposure to African masks (discussed further below), yet expression is present in the eyes and the mouth and personality is conveyed particularly through the hands and feet. The focal figures are supplemented by the placement of carefully chosen props around the periphery. The variety of figural poses enlivens the otherwise static backdrop. The apparent simplicity of the work is countered by Lawrence's sure sense of design; his early interest in boldly colored geometric pattern is still present.

Lawrence's method of dividing the background of the picture into strategically placed enframed areas is reminiscent of the Dutch interiors Lawrence recalls viewing in his frequent trips to the Metropolitan Museum of Art as early as age thirteen or fourteen. In analyzing his early works, Lawrence says that he was working in a "geometric manner, using economy and selectivity":[31]

[After my early painted street scenes in corrugated boxes] . . . almost like stage sets . . . my later work was the same kind of thinking only two dimensional. . . . I was very much aware of the plastic elements.

 I always appreciated . . . certain technical things in painting. I guess it's almost like a magic of the picture plane. If you'd asked me forty years ago, I couldn't have explained it in this way. But in reprospect, I admired the Early Renaissance painters for this reason—the magic they could achieve, the moving back and forth within the picture plane—it's still flat, two dimensional. I remember [at] the Met—I was about sixteen . . . some feet away I noticed this room, and as I approached it, it wasn't three dimensional, it was flat. It was all done in *trompe l'oeil* inlaid wood. It was a kitchen done during the Renaissance. . . . Closet doors were open, there was a table. I always liked that kind of thing. I liked the technique; it fascinated me. One of the challenges in studios at that time was to paint a white egg, on a white tablecloth, on white marble . . . although all white, you get the feeling of an egg, the feeling of the cloth, the feeling of a table. One of the fascinating things about two-dimensional art is that it has a magic.[32]

Lawrence here reveals his awareness of aesthetic choices at the time when he did the paintings and refutes the "naive" or "primitive" categorizations that some writers have assigned his work. Although Lawrence was clearly intrigued by the naturalism of the Old Masters, in his own work he has chosen instead to concentrate on emotional expression.

 The forms in Lawrence's art are basically inspired by nature but are pruned and altered in a way that becomes increasingly expressionistic and cubist as his work continues. Opaque, flat color areas are created with water-base medium (at this early point, usually poster color, the inexpensive premixed tempera in jars, on brown wrapping paper, often coated with a preservative shellac). The absence of concern with effects of natural light (minimal light and shade differentiations, no atmospheric perspective) is a feature that will remain almost unchanged for decades. The works of this period are relatively small, generally no more than 20 by 30 inches.

 In *Interior Scene* (pl. 4), Lawrence's composition assumes a new tension; the stage-set look is still present but the background planes are askew, the perspective steep. The forms seem about to slide off the picture plane. This brothel scene is sprinkled with humorous and intriguing details: the woman asleep in the chair with her head back and her mouth open, the curious animals and flying creatures that inhabit the room (flies and rats being symbolic of the squalor in Harlem), and the wide-eyed children peeking in the window. A potentially chaotic composition, the vertical axis of forms provides stability. The prominent central table is so secure, in fact, that the man leans fully against it without slipping.

 The Funeral (pl. 5) portrays a frequent occurrence in Harlem during the Depression, and Lawrence's often sober hues of this period are especially appropriate for the theme.[33] Here, the artist changes his position as onlooker: rather than the frontal stage setting, he rotates the view, using a strong diagonal sweeping from the upper right corner to the lower left corner, dividing the picture plane almost in half and implying spatial recession. He then balances the energy of this diagonal with the rhythm of reiterated vertical forms, in a bold artistic manipulation of space. This is a compositional device that Lawrence will choose frequently throughout his career. In this work of 1938, outline of forms is beginning to disappear, leaving crisp silhouettes. The general cartoon quality is still present, however, in such features as the dumpy, rounded figures, the wide, staring eyes, and the toylike treatment of the vehicles of the era.

 Several aspects of Lawrence's early work suggest the possible influence of comic strips, especially the simplified, easily legible imagery and the genre subject matter reflecting popular culture. But when asked whether he read comics as a youngster, he recalled nothing beyond ordinary experiences:

I read Dick Tracy, Katzenjammer Kids, Maggie and Jiggs, Little Orphan Annie, things like that. I remember Mutt and Jeff [flip books] in school, and they were pretty pornographic. During recess, the kids would turn the pages; it was like a movie, and you'd see things happening.[34]

 In his early paintings, Lawrence displays a persistent preference for the primary colors red, yellow, and blue, secondary colors orange and green, and black and white. Lawrence reflects on his early use of color:

FIG. 13. Charles Alston, *Magic in Medicine: Primitive Medicine,* 1937. Oil on canvas. Mural panel in Harlem Hospital, New York.

FIG. 14. Henry Bannarn, *Woman Scrubbing,* 1939. Limestone.

> I never learned color in an academic way. . . . So this may have something to do with [my] expressing myself in a very limited palette . . . not knowing in my earlier days how to manipulate mixed color and . . . get greys.[35]

Lawrence's early narrow palette later became the basis for his academic restriction of color, one of the foundations of his style:

> Limiting yourself to these colors gives an experience you wouldn't get otherwise . . . in mixing colors . . . green, orange, purple. . . . It forces you to be more inventive . . . working with so few elements that you have to be innovative. A teacher I once had said, "Why use three colors when you can use two? Why use five colors when you can use three?" The idea is, it forces you to work with less, to work with a degree of economy, and out of that you could get a stronger work than you might get otherwise.[36]

At this point in his work, Lawrence used poster tempera because it was cheaper and dried quickly; he enjoyed the "fast" quality of the water-base media so much that he has never given them up.[37] The genre scenes of this early period became a hallmark for Lawrence. With these paintings he established his style: expressionism rooted in Social Realism.[38]

IN APRIL 1937, LAWRENCE'S WORK WAS EXHIBITED FOR THE FIRST TIME. SIX PENCIL drawings were hung at a Harlem Artists Guild group show at the 115th Street Library. Another Harlem Artists Guild show was held the next month at the American Artists School. This group show of twenty-two participants presented several Lawrence paintings. In both exhibitions Lawrence's work was shown along with that of his teachers, Alston and Bannarn.[39]

The influences that contributed to Lawrence's art are often subtle and in many cases difficult to fix. Lawrence attributes the strongest initial influences on his art to his immediate community, particularly Alston, Bannarn, and Augusta Savage. For example, while Lawrence was working in the 306 studio, Alston created a large pair of WPA murals entitled *Magic and Medicine,* which were hung in the Harlem Hospital (on 135th Street across from the library) in 1937; these murals contrasted African and American lifestyles in the context of the history of medical practices (see fig. 13). Bannarn's sculptured stone figures characteristically were forceful renderings of heroic historical personages (see fig. 14), and Augusta Savage's work dealt with figural black themes. Lawrence's work is concerned with similar content. It is Lawrence's feeling that the major influences of the local artists on him, however, were not stylistic but experiential:

> I must attribute my motivation and my desire to be an artist to . . . the black community . . . and certain people within it, like Augusta Savage and Claude McKay, whom I knew

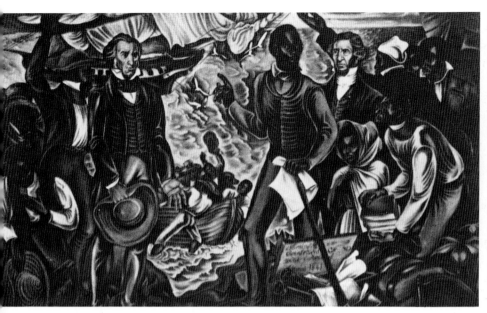

as a young man. Of course, he wasn't a visual artist but he was a writer who had a very strong sense of the human condition. I talked with him and knew him. It was quite an experience for me.[40]

Lawrence came to feel even more acutely the impact of McKay's aggressive humanism a few years afterward when they worked in neighboring studios.

Lawrence has also spoken of being aware of the work of other prominent contemporary black artists in the mid-thirties, such as painters Hale Woodruff and Norman Lewis and sculptor Richmond Barthé, and he may have assimilated some effect from their conceptualizations: for example, Woodruff's interest in epic narrative about black heroes, as demonstrated in one of his *Amistad* murals (fig. 15); Lewis's simplified, geometric closely cropped figures and his concern with Harlem genre (fig. 16); and the sculptures of Barthé, which were figural works of specifically ethnic subjects (fig. 17).

In Harlem in the 1930s, interest in Africanism and African art was strong and was encouraged. Alain Locke exhibited his collection of African art widely, and the 135th Street Public Library continuously displayed pieces from their impressive collection of African sculpture (see fig. 18 for pieces Lawrence would have seen). An experience that increased Lawrence's awareness of African art forms was described in a recent book by Romare Bearden and Harry Henderson:

> One day, leaving the YMCA where he liked to shoot pool, Jake stopped at the door of a crowded meeting room. The speaker, a slender erect man, said Black people were never going to get anywhere until they knew their own history and took pride in it. Jake edged into the room. The speaker described the achievements of Black men in Africa, the golden city of Timbuktu, African use of iron when most of Europe was ignorant of it, the elegant bronze casting required to create the superb art treasures of Benin in Nigeria.[41]

The speaker was "Professor" Seyfert, a carpenter turned teacher, who conducted such meetings regularly. He and other educators in Harlem conducted a black studies program for the eager young people of the community. Professor Seyfert was especially encouraging to the developing artists in Harlem: "He believed that through their pictures they could show black people their history and inspire them." Lawrence further recalls Seyfert:

> [He was] a black nationalist who gave lectures in black history to any interested groups. . . . One of his projects (besides the collecting of books pertaining to black history) was to get black artists and young people such as myself who were interested in art . . . to select as our content black history. . . . For me, and for a few others, Seyfert was a most inspiring and exciting man, in that he helped to give us something that we needed at the time.[42]

FIG. 17. Richmond Barthé, *Blackberry Woman*, 1932. Bronze, 24 × 11½ × 14. The Whitney Museum of American Art, New York.

Seyfert also arranged for the Harlem artists to see the 1935 show of West African sculpture at the Museum of Modern Art, which Lawrence attended. He was struck by the African approaches to form, and after returning home he carved two small wooden sculptures. "I didn't have regular carving tools, so I whittled more than I carved," he recalled. "The show made a great impression on me."[43]

It is interesting to speculate about the powerful influence of the Africanism movement and the effect of the ideas of people like Locke on Lawrence's art. In the mid-1930s, Locke believed adamantly that American black artists would show an inherited African artistic heritage in their work. In his writings, he listed what he considered to be general characteristics of the numerous African styles: skill of surface ornamentation and mastery of design patterns; a sculptural approach in which the object is reduced to basic planes and masses, with vigor, vitality, and forceful abstraction or simplification; and free distortion of natural forms. Locke explained how the work of the African artist must be considered:

> [Not as a] crude copy of natural forms, but as a purposeful creation of mass design, with free distortion of natural shapes into arbitrary stylized forms expressing abstract designs. African art is based not on the imitation of nature but on free creative improvising on themes taken from nature and used to convey forcefully a selected mood, an intended idea, or a human situation.[44]

Later (1940) Locke conceded that it was difficult to identify racially distinctive characteristics in the work of America's black artists:

> Perhaps we shall see eventually a decided and novel development in those subtler elements of rhythm, color, and atmosphere which are the less direct but more significant way of revealing what we call race.[45]

Intriguingly, all of Locke's statements seem to describe Lawrence's work as it was in the 1930s and as it remains today. Although Lawrence disavows an awareness of transmittance of African art characteristics in himself, his art could be considered a supporting example of Locke's theories.

Lawrence has also spoken of the influence of a 1937 exhibition of the work of William Edmonson, the stonecutter and sculptor whose direct, simplified forms call to mind Brancusi's early work (see fig. 19):

> I remember a great deal of talk about Edmonson, a Negro sculptor. He was given a big show. I think in content it meant a lot to me. . . . He had this big show at the Museum of Modern Art. I was just a kid at the time. . . . But I remember this had great influence on me. . . . I don't know how this was translated into my painting, if it was at all. But I remember it had a great impact.[46]

From the beginning, Lawrence's work shared the basic features of these two models, especially the masklike faces of African sculpture and an inclination toward the elemental forms Edmonson preferred.

Lawrence acquired his general knowledge of art from numerous sources. Trips to the Metropolitan Museum at an early age gave him a general exposure to art history. He would walk the sixty-odd blocks to the museum and spend hours admiring the works, especially those by the great masters; he particularly recalls a *Pietà* by the Italian Early Renaissance panel painter Crivelli, as well as a work by Botticelli.[47] Early Renaissance painting, with its qualities of didactic clarity and figural beauty, as well as its use of water-base media, provided eloquent lessons for Lawrence. He also speaks of having read numerous art books at the Harlem Art Workshops he attended:

> There were many books there. I saw Goya's *Disasters of War;* they did have that. I think most of what they had were figurative things. There was a great interest in Pieter Breughel [the Elder], like *The Wedding Dance* [fig. 20]. There was a whole book about Breughel, and I was very impressed with that—the color, the movement. The artists around used to talk about his composition, his picture structure, in looking at the works. I do remember a discussion once, which I didn't participate in because these people were older than myself; they spoke of one painting, the one with the snow and a string of birds moving across in a straight line [*Hunters in the Snow,* 1565]. They used to talk of these other things and respond to my composition and picture structure because they thought I had a feel for it, and my work was hard-edge and rather flat.
>
> The other people who were mentioned there at that time were the Mexican muralists (Orozco, Rivera, and Siqueiros), the Chinese woodcut artists, Käthe Kollwitz, William Gropper, and George Grosz. We were interested in these artists because of their social commentary.[48]

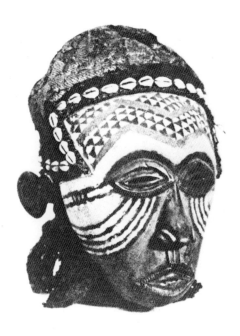

FIG. 18. African sculpture, (a) Kota reliquary figure, Gabon, Locke Collection; (b) Kuba mask, Zaire, Collection of the Schomburg Center for Research in Black Culture, New York.

Lawrence recalls being particularly aware of the work of artists discussed in *Modern Art: The Men, the Movements, the Meaning,* by Thomas Craven, a book from the mid-1930s.[49] This art history text, which Lawrence refers to as being very conservative, discussed the modernism of Cézanne, Picasso, and others, but turned quickly to the work of Grosz, Thomas Hart Benton, Charles Burchfield, and the Mexican muralists, with this proclamation:

> Modernism . . . has destroyed itself. It was a concentration on method to the exclusion of content. The next move of art is a swift and fearless plunge into the realities of life.
>
> Grosz, Benton, Rivera, and Orozco . . . may be held accountable for the changing direction of art—a new movement which, winning allegiance of the young, is leading art into the communication of experiences and ideas with social content.[50]

Lawrence, one of these young artists, has said, "I liked the Mexican school of painting [figs. 21 and 22] . . . the pure, bold color, the big forms . . . the content—dealing with people.[51]

Two primary style influences on American art of the 1930s were the Social Realism of the Mexican muralists and American Scene painting (along with the affiliated Regionalism). The new forms of abstract art that had been introduced to the American public in 1913 at the Armory Show were rejected by many in favor of a representational art with a strong social message. A propensity toward naturalism, with American scenes and events as subject matter, had been a constant trait in American art, from Washington Allston to Thomas Cole to the Ashcan School. Emerging in all the arts of America in the twenties was a search for cultural roots, as well as a new emphasis on locally realized experience.[52]

After World War I, there were many efforts throughout the world to develop art forms that would be useful to and expressive of expanding industrial societies. The Expressionists and Constructivists in Germany and Russia, for example, tried to encompass these ideals. Social Realism was staunchly promoted by Marxist activists and critics. In 1922, the artists in post-revolutionary Mexico issued a manifesto explaining their "new monumental art of social purpose."[53] Through the national program of public monumental wall paintings, in which they emphasized Indian heritage and the overthrow of oppression, the Mexican muralists sought to effect social change through an art that "stirs to struggle."[54] It is greatly significant that these artists painted several large murals in New York City and other U.S. cities in the early thirties. In fact, the raw power of contemporary Mexican art made a sudden impact on the United States, giving added force and bite to American painting of social protest during the Depression years.[55] Lawrence was swept up by the movement of Social Realism in American art in the 1930s:

> This was the way that all artists in every area were thinking: the writers, the artists, the people in the theater. . . . It wasn't a selection on my part. It was just that this was the

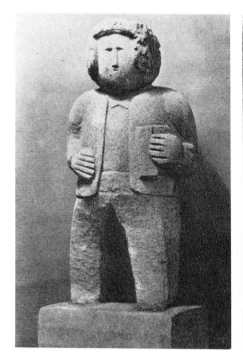

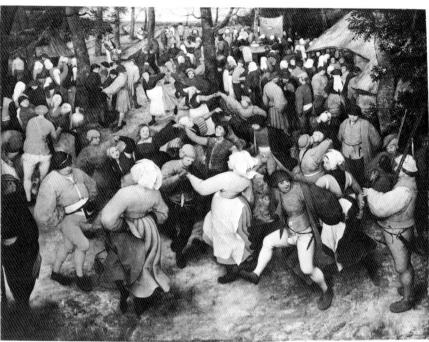

FIG. 19. William Edmonson, *Lawyer*, 1938. Limestone.

FIG. 20. Pieter Breughel, the Elder, *The Wedding Dance*, c. 1566. Oil on canvas, 47 × 62. Detroit Institute of Arts, City of Detroit Purchase.

trend, this was it. . . . And therefore any youngster involved in that period of art, this was all he would get. Because his teachers were oriented in this way.[56]

It is also apparent that beneath the concern of many American artists with various aspects of realism lay an increasing attentiveness to the aesthetics of abstraction and pure form. Many painters in the 1930s remained committed to modernism, among them Joseph Stella, Max Weber, Stuart Davis, and Arthur Dove. Abstraction as an international artistic movement was gaining substantial ground in New York. By the late 1930s, European artists had begun gravitating to the United States to escape repression and the threat of an engulfing war in their homelands. Most of them settled in New York and exerted overwhelming artistic influences. Hans Hofmann started his own school in New York in 1934 and became a major figure in the development of American Abstract Expressionism in the forties. Fernand Léger, following his highly successful retrospective of mechanistic Cubism at the Museum of Modern Art (1935), had arrived in New York by 1940, as had Piet Mondrian and Max Ernst. Émigrés Arshile Gorky and Willem de Kooning found work in New York on WPA projects; Gorky's controversial abstract mural for the Newark Airport (1935–37) was one of the first abstract public art works in the country. Nationally, Josef Albers and Laszlo Moholy-Nagy introduced Bauhaus modern design concepts to American artists through their teaching.

In that decade, watershed exhibitions of abstract art were mounted in New York by the major museums and galleries. Cubism, German Expressionism, Neoplasticism, Russian Suprematism, Surrealism, and Dada appeared upon the American art scene for the first time in a coherent manner, and numerous significant catalogs were written by curators such as Alfred Barr.[57]

Many artists of the thirties produced a Social Realism flavored by other more abstract styles. This is exactly what Jacob Lawrence also began to do. Lawrence has spoken of being aware of artists exploring abstraction in the 1930s. He recalls that the work of painter John Marin was discussed at the 306 studio: "He was just coming to the fore. An American Place [the Alfred Stieglitz gallery in New York that showed the work of Marin and other modernists] was a place that was always talked about." Lawrence has mentioned his early appreciation of the work of Arthur Dove (fig. 23), Charles Sheeler (fig. 24), and Giorgio de Chirico (fig. 25);[58] the collective influences the expressionism, cubism, and surrealism of these three artists, respectively, often appear to operate in Lawrence's work in subtle ways throughout his career.

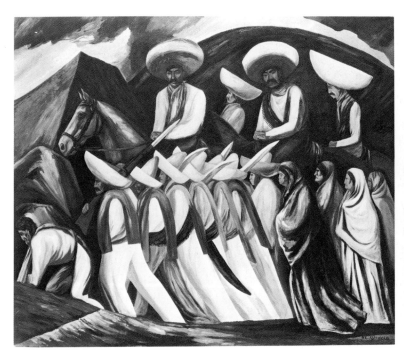

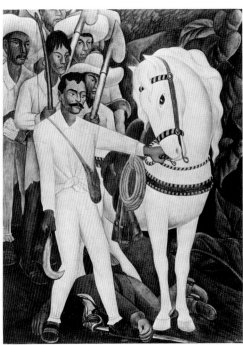

From the beginning, Lawrence's painting displayed an original manner that was not derivative. This unusual circumstance was the result of several interrelationships. Lawrence's early work was a product of his closed sphere of existence: as a youth, he seldom left Harlem except to go to school or to visit the Met. He has said, "My first contact was with the Negro painter and teacher and the people from the neighborhood,"[59] and they encouraged him to retain his originality. Moreover, because blacks were not generally welcome at private art galleries, he was not directly exposed to important new art that might have stimulated formal changes. Finally, although he was a shy observer, Lawrence confidently followed his own unique style because, as he has remarked, "I have an assuredness of myself."[60]

Stimulated by what he learned about early black leaders from the local history club instructors, Lawrence began reading avidly about the struggles and deep convictions of these legendary figures. He became particularly fascinated with the life of Toussaint L'Ouverture, a Haitian slave who, in the late eighteenth and early nineteenth centuries, led his country to freedom from French rule and founded the Republic of Haiti, the first black Western republic. Lawrence also saw *Haiti*, a W. E. B. DuBois play on Toussaint's life, at the Lafayette Theater.[61] Inspired by Toussaint's heroic achievements, Lawrence decided to do a painting on the subject. To thoroughly understand Toussaint's life, he spent many hours at the local library studying material in the Schomburg Collection.

Feeling that a single painting could not do justice to the saga he wished to portray, he chose the series format. The forty-one paintings of the *Toussaint L'Ouverture* series (1937–38) form a narrative, each depicting an important episode in Haiti's fight for independence. The works are in tempera on white paper, in a relatively small size (pls. 6–8) like much of his early work. Describing the *Toussaint* project a few years after completing it, Lawrence revealed both his method and his motivation to interpret black history:

> I've always been interested in history, but they never taught Negro history in the public schools. . . . It was never studied seriously like regular subjects. My first real introduction to Negro history was when I was very young—thirteen, I imagine—when a Mr. Allen spoke on it at Utopia House. He spoke about Toussaint L'Ouverture. . . .
>
> I do my research first; read the books and take notes. I may find it necessary to go through my notes three times to eliminate unimportant points. . . . Most of my information came from Charles Beard's book *Toussaint L'Ouverture*. I read other books—there were more novels than anything else. One book—I don't even remember its name—told me of the conditions on the island, and its resources. It gave a short sketch of the history

FIG. 21. José Clemente Orozco, *Zapatistas*, 1931. Oil on canvas, 45 × 55. The Museum of Modern Art, New York, given anonymously.

FIG. 22. Diego Rivera, *Agrarian Leader Zapata*, 1931. Fresco, 7'9¾" × 6'2". The Museum of Modern Art, New York.

FIG. 23. Arthur G. Dove, *Ferry Boat Wreck*, 1931. Oil on canvas, 18 × 30. The Whitney Museum of American Art, New York, gift of Mr. and Mrs. Roy R. Neuberger.

of the Haitian revolution. From that, I got mostly the appearance of the island. We know little of these people's achievements. Having no Negro history makes the Negro people feel inferior to the rest of the world. I don't see how a history of the United States can be written honestly without including the Negro. I didn't do it just as a historical thing, but because I believe these things tie up with the Negro today. We don't have a physical slavery, but an economic slavery. If these people, who were so much worse off than the people today, could conquer their slavery, we certainly can do the same thing. They had to liberate themselves without any education. Today we can't go about it in the same way. Any leadership would have to be the type of Frederick Douglass. . . . How will it come about? I don't know. I'm not a politician. I'm an artist, just trying to do my part to bring this thing about. I had several reasons for doing this work, and these are some of them. Someone had to do it. Another reason is that I have great admiration for the life of such a man as Toussaint L'Ouverture. It's the same thing Douglass meant when he said, "Judge me not by the heights to which I have risen but by the depths from which I have come." There's so much to do, there's never any trouble to find subjects.[62]

In painting his series, Lawrence adopted an unusual system. He completed pencil drawings and laid them all out in sequence. Instead of completing separate paintings, he mixed a color and filled the areas in each work where that color was to appear, using darker colors first. He repeated this procedure for each color. By working on all paintings at once, he obtained a consistency of color throughout the entire series. Bearden and Henderson note that this approach "demonstrates an unusual organizing and aesthetic ability. It derives from his pattern-making as a youngster, when he would put in all of one color in his design, then follow with the other colors, one by one."[63]

The *Toussaint* series focuses on the mistreatment of the Haitian natives by the colonial farmers and military leaders and on Toussaint's heroic struggle to educate himself, fight the military occupational forces, and achieve independence for Haiti. The works were not titled but numbered, and each was given a short narrative description. Number 10 of the series (pl. 6) is typical: "The cruelty of the planters toward the slaves drove the slaves to revolt, 1776. These revolts kept cropping up from time to time—finally came to a head in the rebellion." This scene shows a planter whipping a bound slave while other chained and fearful slaves huddle nearby. We sense keenly the fierce determination of the planter through his broad stance, raised arm, and clenched jaw. The expressive diagonal of the prone slave, supplemented by the extended arm of the planter, creates a potent X-shaped central focus. The gold cross on the planter's chest is ironically reiterated in the bloody slashes on the slave's back. A white man in a position of exploitation or ruthless dominance will become a familiar symbol in Lawrence's early series.

These paintings with subjects in a rural setting are among the first to show dramatic open spans of sky, with pointed cloud and vegetation forms that contribute to the emotional expressionism. The sharp, undulating forms silhouetted against

broadly handled expanses are reminiscent of the work of Arthur Dove, and Lawrence has indicated his early interest in Dove's work (fig. 23):

> Perhaps I can explain best [what influences I have experienced] by telling who I like. Orozco, Daumier. Goya. They're forceful. Simple. Human. In your own work, the human subject is the most important thing. Then I like Arthur Dove. I like to study the design, to see how the artist solves his problem, how he brings his subject to the public.[64]

Lawrence's work can be compared with Dove's in the use of abstracted natural forms and interest in the language of color. In the *Toussaint* series, colors are bold, pure, and limited, and black and white are frequently used symbolically and for dramatic contrast.

In Number 17 of this series (pl. 7), Toussaint and his forces ride on the settlement of Marmelade. Writhing flamelike forms render the violence of the event. The neckless heads of the figures are bent forward in their exertion. The prelude to a dramatic battle scene is powerfully presented; the soldiers almost ride out at the viewer, pressing their horses forward toward encounter. In Number 36 (pl. 8), earth tones render a subdued Toussaint, taken prisoner by Napoleon's troops. Again, overlaid diagonals create focus and balance. These works also reveal the influence of José Clemente Orozco and Diego Rivera (figs. 21 and 22). Lawrence acknowledges the early influence of Orozco:

> My first ambition was to design masks. Then I wanted to do stage sets, and I did build a few. I was always interested in the theater. Then I wanted to do murals. It was about this time [before 1936] I learned about Orozco and began to take note of outside well-known artists. He was the first.[65]

The initial appeal to Lawrence was Orozco's content: his interest in the drama of man's striving to achieve his ideals and his visually "succinct call for the restitution of individual integrity."[66] In his work, Orozco universalizes the sorrows he observes to be characteristic of his time. Generally, Orozco's art is free of conscious propaganda, presented with no projected meaning except the one that the spectator draws from it. His plastic forms convey feelings of power and might. Similar to Orozco's, Lawrence's artistic stance is that of a humanist with a moral vision, not a political position. Lawrence may have considered Orozco's 1923 statement as advice worth following:

> A painting should not be a commentary, but the fact itself; not a reflection but light itself. Not an interpretation but the thing to be interpreted.[67]

The unmistakable Orozco style includes diagonal lines and oblique slashes, angularly outstretched arms, strong but sensitive hands, bodies like the stylized designs of medieval wood carvings, heads often hairless with a spectral look, intensity of feeling yet stillness, and color patterns of black and white, grey, and brown. Lawrence's expressionism reveals the impact of Orozco in the manifestation of many of these features, especially the use of diagonal stresses and the rhythmic device of reiterated vertical forms with simplified contours. The main difference in their work, however, is that Orozco's sometimes horrific imagery tends to express his cynicism and fatalism, whereas Lawrence's emphasizes mankind's transcendence of the horrible, demonstrating his innate optimism.

The influence of Rivera's style is visible in Lawrence's stacked figures that press forward toward the spectator in shallow space and his frequent use of, for example, horses and fleshy green vegetation in the early series. Rivera's exotic flora and precise, ample figures often recall the work of Henri Rousseau, which had impressed Rivera while in Paris; Lawrence has also expressed a respect for Rousseau's art, similarly demonstrated in his vegetal and figural forms.

A UNIQUE ASPECT OF LAWRENCE'S OEUVRE HAS BEEN HIS CONSISTENT USE OF THE series as a format to render narrative content. The *Toussaint* series was only the first of many. Features of his early life and environment suggest why he has continued to choose this unusual format. Because Lawrence arrived in Harlem just after the peak of the Harlem Renaissance, he fell heir to a singular cultural climate. His choice of the series resulted from three cumulative external and internal influences in that milieu.

First, the young Lawrence was influenced by and responded to the spirit of black consciousness among the older artists and thinkers of the Harlem community. His strong awareness of heritage, gained from these cultural leaders, moved him to develop narrative and thematic modes in his art to communicate the black experience clearly and effectively. His teachers, Alston and Bannarn, pointedly addressed issues of ethnic origin and social injustice in their work. Augusta Savage was his first contact with black nationalism. The work of the painter Aaron Douglas was familiar in the Harlem community, and Lawrence knew it well. He often saw Douglas's mural cycle in the 135th Street Public Library, *Aspects of Negro Life* (1934), which concerned the spiritual identity of the black people (fig. 26). In addition, literary figures in the community highly influenced Lawrence's artistic development, particularly Alain Locke. "Locke was a mentor to many people my age," Lawrence has remarked. "He would talk with us informally, and was very encouraging."[68] Lawrence's relationships with writers such as Langston Hughes and Claude McKay, whose moving poetry and fiction were among the first major literary works concerning the lives of common black people, were also significant. Lawrence has reflected on the inspiration Hughes received from the Harlem community:

> I can well understand what Langston Hughes said . . . that he would never live outside the Negro community. Because this was his life . . . his sustenance. This sustained his motivation and spirit.[69]

Second, Lawrence became fascinated with black history and its heroic figures—an interest that pervaded Harlem. Lawrence recalls, "People would speak of these things on the street. I was encouraged by the community to do [narrative] works of this kind; they were interested in them."[70] Through history, Lawrence was able to take his art beyond local genre and the confines of his community. Exploring the topic of Toussaint L'Ouverture, Lawrence's library research led him toward a literary approach to his subject: "I was really inspired by what I found in those books and I wanted to try to record this tremendous story with brush and paints."[71]

Finally, although difficult to document, through his training and his own studies Lawrence had become aware of the serial tradition in the history of art—from Egyptian wall painting to Renaissance panels to more contemporary developments. Lawrence's early attraction to the work of the Mexican muralists is particularly significant, for their work is characteristically in sequential narrative sections. And three artists of major impact on Lawrence—Giotto, Daumier, and Goya—were masters of serial art. About his choice of the series format, Lawrence said, "I wanted to tell a lot of things. This was the only way I could work and tell the complete story."[72]

Since Lawrence's use of the series format has sometimes been attributed to his being inspired by the series of Ben Shahn (e.g., fig. 27), it is important to mention that Lawrence does not recall being aware of Shahn's work until the early 1940s.[73] Certainly his work shares several features with Shahn's, in addition to the serial format: the use of tempera, the social content, and the flat personalized figural forms. But Lawrence's work also differs from Shahn's in numerous ways. Shahn was trained as a graphic artist and photographer, and his paintings display a luminous, realistic precision for which Lawrence does not strive. Although draftsmanship is at the heart of both of their styles, Lawrence's prodigious, straightforward shapes contrast markedly with Shahn's linear, weightless, often surrealistic forms. Like the documentary photographs he took for the WPA, Shahn's series were generally concerned with specific social topics of contemporary urgency, whereas Lawrence's themes were characteristically historical or (later) of an epic breadth. Most significantly, Lawrence's work always portrays the story of his own people, whereas Shahn, a Russian immigrant, assumed the causes of many aspiring minority groups. Lawrence has mentioned that he greatly admired Shahn's work after meeting him in the early 1940s, for in fact then they both exhibited at the same gallery, but it is apparent that Lawrence's style and approach were set earlier.

IN FEBRUARY 1938, AT THE AGE OF TWENTY, LAWRENCE HAD HIS FIRST ONE-MAN exhibition, sponsored by the James Weldon Johnson Literary Guild, at the Harlem YMCA. The show presented paintings of Harlem genre scenes from 1936–37. This statement by Charles Alston introduced the show:

The place of Jacob Lawrence among younger painters is unique. Having thus far miraculously escaped the imprint of academic ideas and current vogues in art, to which young artists are most susceptible, he has followed a course of development dictated entirely by his own inner motivations.

Any evaluation of his work to date is most difficult, a comparison impossible. Working in the very limited medium of flat tempera he achieved a richness and brilliance of color harmonies both remarkable and exciting.

He is particularly sensitive to the life about him; the joy, the suffering, the weakness, the strength of the people he sees every day. This for the most part forms the subject matter of his interesting compositions.

Still a very young painter, Lawrence symbolizes more than any one I know, the vitality, the seriousness and promise of a new socially conscious generation of Negro artists.[74]

Lawrence's next show, in February 1939, was held at the American Artists School (fig. 28), where he was a student between 1937–39. Sol Wilson, one of Lawrence's teachers, remarked in the catalog:

Jacob Lawrence's paintings are the work of a talented artist . . . [who] is a product of the intense cultural upsurge now taking place in Harlem, a section which has been, and still is, suffering from neglect and discrimination. But he is one whose spirit and urge to create will overcome all obstacles. . . . His style is direct and spontaneous, a quality that springs from and is related to his subject matter and ideas. There is honesty and feeling in Jacob Lawrence's work which places it on a high level.[75]

In what was probably the first critical response to Lawrence's art, a writer in *Art News* recognized the originality and power of Lawrence's work, while reflecting the socially conscious attitudes of the era and the prevalent theories about inherited personality traits among blacks:

A fresh, vivid view of Negro life in New York may be seen in the tempera paintings of Jacob Lawrence, a graduate of the American Artists School where an exhibition of his work is now being held. . . . The bright colors in flat areas and the literal view of the world turn out to be his manner of expressing his very sensitive reactions to a kaleidoscopic, animated world, in which his spirit is not be downed by the oppression and neglect of his own people which he sees on all sides. They have little of the mournfulness of spirituals. Rather are they testimony of the unquenchable joie de vivre of the Negro, his inestimable gift to repressed, gloomy Nordics.[76]

That same year, Lawrence's completed *Toussaint L'Ouverture* series was shown at the De Porres Interracial Council headquarters on Vesey Street, his first one-man show outside Harlem.

In 1939, the Baltimore Museum, together with the Harmon Foundation, held an exhibition of the work of the country's black artists. Lawrence's *Toussaint* series was hung in entirety in a special room, as he remembers:

As far as I can recall this marked the first time a major museum gave over its facilities to an all-black show. And this was in the 1930s when there was little or no talk about "the black thing" and the pressing need for it to be seen and appreciated. . . . I didn't at the time realize how big a show that was. Why, my participation in it with an entire series . . . was the biggest thing that had happened to me up to that time.[77]

The originality of treatment in the series aroused much interest. The March 1939 issue of *Survey Graphic* contained reproductions of a few of the series, and a review in the *Baltimore Sun* was full of praise:

These small sketches, with their economy of flat, sharply defined forms and their . . . variations in a consistent color pattern, are charged with feeling and movement. The designs are full of swift, racing vigor, and the notable mingling of realistic and symbolic elements of simplified abstract form with the quality of illustration give them a powerful impact. The theme, moreover, is well developed and the mood finely sustained and, both individually and as a series, they constitute a striking and original work.[78]

When the *Toussaint* series was exhibited in Baltimore, the Haitian ambassador to the United States expressed interest in the work. It was his hope that either his government would purchase the series for display at the Haitian Pavilion of the 1939 World's Fair or that the museum at Port au Prince would acquire the series. Alain Locke, then professor of philosophy at Howard University in Washington, D.C., did as much as he could to promote the sale from his vantage point. A letter from Locke to Jacob Lawrence regarding the matter reveals their mentor-protégé relationship:

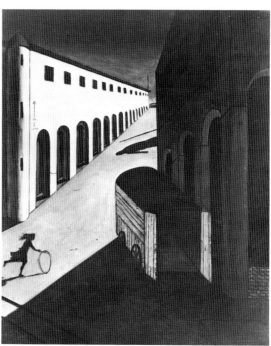

Fig. 24. Charles Sheeler, *Church Street "El,"* 1920. Oil on canvas, 16⅛ × 19⅛. The Cleveland Museum of Art, Mr. and Mrs. William H. Martlatt Fund.

Fig. 25. Giorgio de Chirico, *The Melancholy and Mystery of a Street,* 1914. Oil on canvas, 34½ × 28⅛. Private collection.

Of course there would be some difficulty in case of a sale and your relief status. However . . . the Harmon Foundation and I have an idea as to how that could be managed without in any way curtailing your eventual use of the funds. But you must not hope too much as I take it the Haitian government is not on easy street just now.

I heard . . . that you were considering a donation of the work. I think you should not do this, as you deserve the eventual returns for your own advancement, more materials, etc. I am sure that they will be bought by some agency or other and then given to some collection or museum. . . .

However, sound things progress slowly; don't be impatient. You have already accomplished much for a youngster.[79]

The *Toussaint* series was again shown in 1940 at the American Negro Exposition in Chicago, and Lawrence won second prize. This exhibition encompassed black art between 1851 and 1940, and newspapers quoted Locke's opinion that it was "the most comprehensive and representative collection of the Negro's art that has ever been presented to public view."[80]

While continuing to paint during these years, Lawrence also worked at other jobs to contribute money to the family. Augusta Savage worried that he was turning aside from painting through economic necessity. In 1937, she took him down to WPA headquarters and tried to get him a job on the Federal Art Project, but he was too young to be considered because he was not yet twenty-one. A year later she took him back again and he was hired. Lawrence's appreciation for her attention has been great: "Her interest was a peak experience in my life because, you know, she didn't forget."[81] He feels that if Augusta Savage had not insisted on getting him on the Project, he would never have become an artist. "It was a real turning point for me," he has observed.[82]

Lawrence's participation in the WPA Federal Art Project had monumental impact on his development as an artist. He joined it late in 1938 and remained for eighteen months. He was assigned to the Easel Project, was provided with all of his materials, and painted at his own studio at the 306 building. He was required to deliver two paintings every six weeks, for which he was paid $23.86 per week with no tax deductions. During that period, he was able to work on technique and establish himself as a professional artist. Each week he would collect his check at WPA headquarters, where he met many other WPA employees—artists, writers, and theater people. Lawrence has reflected:

It was my education. I had no college education. But I met people like Saroyan before he got famous. They all used to talk about what was going on in the world. Oh, not only about art, but everything.

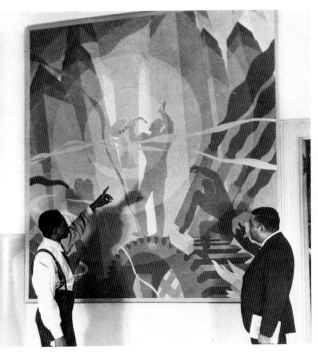

FIG. 26. Aaron Douglas and Arthur Schomburg in front of one panel of Douglas's mural cycle, *Aspects of Negro Life: Song of the Towers* (one of four panels), 1934. Oil on canvas, 6′ × 6′. Collection of the New York Public Library, Countee Cullen Branch.

FIG. 27. Ben Shahn, *The Passion of Sacco and Vanzetti*, 1931–32 (one of twenty-three panels). Tempera on canvas, 84½ × 48. The Whitney Museum of American Art, New York, gift of Edith and Milton Lowenthal in memory of Juliana Force.

The artists were all working together. We'd go down together to King Street to sign in. We saw each other's work. We talked about art.[83]

He later noted:

[What I was paid] is nothing in these days. Yet at that time it was. It would be equivalent to $100 today. I was on relief, which you had to qualify for before getting on the Project, so it gave you dignity because you could work and get paid for it. . . . It gave you more than just money.[84]

The WPA programs possibly can be credited with preserving a whole generation of American artists, among them Philip Evergood, William Gropper, Ben Shahn, Louise Nevelson, Mark Rothko, Stuart Davis, and Jackson Pollock. According to art historian Herschel Chipp, "The WPA had drawn together in a comradeship of necessity most of the leading artists of an entire generation." And these artists came out of the Depression "with an increased awareness of themselves as artists—American artists."[85]

While employed on the Project, Lawrence also painted two more historical sequences, the *Frederick Douglass* series (1938–39) and the *Harriet Tubman* series (1939–40). These works present the dramatic biographies of two American abolitionists who lived around the time of the Civil War. The *Frederick Douglass* series presents the life of Douglass, a Maryland slave, who became a famous lecturer and writer and held several public offices in his later years (pls. 9–11). The first panel (of thirty-two)[86] is a Maryland landscape, with a provocative caption: "In Talbot County, Eastern Shore, State of Maryland, in a thinly populated worn out district, inhabited by a white population of the lowest order, among slaves who in point of ignorance were fully in accord with their surroundings—it was here that Frederick Douglass was born and spent the first years of his childhood—February 1817." In the widely varied works of this series, bold color schemes and simple compositions are used to enhance narrative force.

Panel 22 (pl. 9) presents Douglass after he has gained freedom and achieved notoriety as an antislavery speaker both in America and in England. In this interior scene, the tipped space and dynamic opposed diagonals characteristic of much of Lawrence's work are present. The perspective is dramatically steep in this example, a persistent visual reference to the work of such modernists as De Chirico and Sheeler (see figs. 25 and 24). Against an umber background, bright, pure colors punctuate the composition in angular patches. The tones of brown and green that Lawrence frequently uses in these two series become symbolic allusions to the soil to which these former slaves were inextricably tied. The subordinate forms are selected by the

Fig. 28. Jacob Lawrence at American Artists School exhibition opening February 12, 1939.

artist to emphasize the writing and reading materials used by Douglass, who was editor of the first black newspaper, *The North Star*.

Panel 30 (pl. 10) is an outdoor tableau, depicting the newly freed slaves heading into an unknown world. To capture movement, Lawrence, like Orozco, presents repeated, simplified striding figures that lean forward, moving from right to left, a compositional device Lawrence frequently favors. The forest is a canopy of sharply pointed trees towering ominously over the throng. An epic grandeur is achieved by the distance assumed by the artist. The final work of the series (pl. 11), presents a solitary flag billowing gracefully, its staff plunged into the soil, symbolic of the contribution of Douglass and many others to the nation. Promise and hope are insinuated by the broad streaming cloud and the single flower vigorously sprouting from the barren landscape. Lawrence said of his style at that time: "When the subjects are strong, I believe simplicity is the best way of treating them."[87]

In these works, Lawrence turns to a new water-base medium: casein tempera. He had learned about the new medium from his friend Romare Bearden: "He saw that I was interested in the water medium and he said, 'Why don't you try gouache and casein?' which I knew nothing about. This was about 1937."[88] Lawrence experimented with casein tempera, mixing his own paint out of ground pigment, a milk protein solution, and ammonia as a preservative. He applied the paint to hardboard panels layered with gesso, which creates a hard, chalky white ground resembling fresco: its absorbent surface sucks the paint from the soft brush and causes the medium to dry quickly. The artist cannot redo an area but must paint over it if he wishes to make changes, thus building up color.

Much of the appeal of the *Frederick Douglass* panels lies in the textural freshness of the application of the paint, a new feature in this series: the viewer can discern exactly how the artist created each area. Still evident are the unrefined brushstrokes following form and creating line and movement within forms. Lawrence recently observed: "Around this period, I explore the idea of texture (my shapes are very flat; they're flat today)—probably because of the nature of the tempera paint itself (dry pigment on gesso panel).[89]

The "brutality," or rawness, of this technique is particularly appropriate in these works, for it enhances Lawrence's expressionist style, helping him render the emotional impact he wishes to capture about an incident or idea portrayed. In this trait, Lawrence's painting again recalls that of the Mexican muralists. Lawrence has described Orozco's characteristic feathered brushwork in physical terms: "He wasn't

imitating something, but he actually felt the form. He was moving around the form almost like a sculptor."[90] Although the works in these two series are small (12 by 18 inches), they have the formal impact of monumental wall paintings. In addition, their small size impels the intimate experience of close scrutiny, causing the viewer to become aware of the intriguing visual qualities of Lawrence's use of the medium. Lawrence's technique shows a sureness of approach and a knowledge of one's medium unusual in so young an artist.

The *Harriet Tubman* series (pls. 12–15) contains thirty-one narrative panels done in the same size and medium as the *Frederick Douglass* sequence. Harriet Tubman, also born a slave in Maryland, around 1821, escaped from her owners at age twenty-one. Through her belief in God and with help from the underground railroad, she gained freedom in the North. She then worked there and dedicated her life to liberating slaves from plantations in the South, helping them to escape at night through the refuge network of the underground railroad. In this way she led over 300 slaves to freedom. Her efforts become so troublesome to plantation owners that at the peak of her activity they offered a reward of $40,000 (in 1855) for her head. Tubman even acted as a spy, a scout, and a nurse for the Union Army in the Civil War. When she died, services were held in her honor and a bronze memorial tablet was placed on the outside of the city courthouse in Auburn, New York. Lawrence explained his interest in this subject for a series:

> This is one of the great American sagas. . . . Exploring the American experience is a beautiful thing, . . . the building of America, the contribution all of us have made, which is part of that experience.[91]

> We hear about Molly Pitcher, . . . about Betsy Ross. . . . The Negro woman has never been included in American history.[92]

The first panel of the series (pl. 12) portrays a group of slaves working on the plantation. The graceful, elongated black silhouettes of profile figures with long slender bare feet evoke Egyptian wall paintings, an early influence on Lawrence (e.g., the Egyptian collection at the Metropolitan), and also recall the Aaron Douglas murals (fig. 26). Against a background of bare earth, areas of brilliant color sparkle like inlaid jewels. Depth is achieved by the simple method of overlapping the figures and stacking them to indicate recession, a traditional approach employed in Renaissance paintings and Mexican murals familiar to Lawrence. Panel 2 (pl. 14) powerfully addresses the cruel experience of slavery. The truncated figure being whipped fills the spare visual field.

Panel 7 (pl. 13) focuses on Harriet herself, cutting wood on the plantation. Strength is conveyed in her massive crouching form, her arms and hands looming forward with emphatic presence. The kerchiefed head is bowed, the features indistinct, with subtle outline delineating the nose and an eye. Her foot peeks out elegantly from her skirt hem as her knee braces the log. In this epitome of Lawrence's simple but forceful composition, the figure boldly fills the picture planes with its hulking shape, an interplay of oblique angles. Relief from the blocky, overwhelming solidity of the central form is created by the feathered brushstrokes. Figural distortions such as these also appear in the work of Henry Bannarn and the Mexican muralists. Emphasis on muscularity and powerful hands and arms to symbolize courage was seen frequently in art of social content of the period. Large hands were also a formal device in Picasso's Cubism and Neoclassicism. Lawrence often uses big hands to clarify points and bulk or thinness of figures to reinforce emotional tone, in a manner similar to conventions of medieval art. Artistic license notwithstanding, photographs of Frederick Douglass and Harriet Tubman reveal that they both were unusually robust-looking people, their experiences matching their exploits.

In Panel 29 (pl. 15), Harriet, as a nurse during the Civil War, feels the pulse of an ailing Union soldier. The two figures are assembled like a Renaissance *Pietà* grouping, with compelling focus created by the pyramidal pairing of dark and light silhouettes. Although very early, the *Frederick Douglass* and *Harriet Tubman* series remain among the artist's strongest work.

Lawrence's art is not an attempt at naturalism: his work is always stylized, with a dominant sense of abstraction enhanced by a sureness of line. As he has explained:

> If at times my productions do not express the conventionally beautiful, there is always an effort to express the universal beauty of man's continuous struggle to lift his social position and to add dimension to his spiritual being.[93]

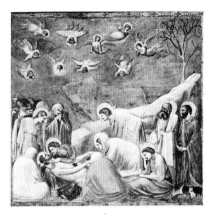

Fig. 29. Giotto, *The Lamentation*, 1305–06. Fresco. Arena Chapel, Padua.

Some of Lawrence's serial works particularly recall Early Renaissance altarpiece paintings (e.g., Duccio's *Maestà*, c. 1309–11), with their often episodic nature, characteristic arid emblematic landscapes, flat cutout trees, vivid contrasting colors, and emphasized significant gestures of figures. Markedly comparable is Giotto's work, which Lawrence had studied not only for its instructive aspects, but also as a source for Orozco's style. In designing his early series, Lawrence may well have drawn inspiration from works such as Giotto's *Lamentation,* a panel from his Arena Chapel frescoes (c. 1305), with its impassioned imagery, shallow stage-set appearance, compelling focus, localized modeling, and absence of cast shadows (fig. 29). Like Giotto, Lawrence cuts content to its essential core and seeks the most fundamental compositional solutions to presenting dramatic narrative.

The narrative and stylistic dynamics of Lawrence's series were established with these early examples. Suggesting descent from the black oral tradition, each painting is illustrative of and illuminated by its narrative caption. Each series tells a whole story, whether historical (such as these early productions) or thematic (as in later series)—the number of tableaux being determined by the needs of the narrative. Imagery is designed with a deliberate continuity of style and color. A familiar cast of characters is repeated or scattered throughout the panels of a series. If there is a protagonist, he or she is present in most panels, identified by physiognomy, costume, and gestures even when not the primary focus. Although the separate panels are contained artistic statements, the strength of the series resides in their connective nature—the way the panels reinforce and enhance each other visually and dramatically. The uniqueness of Lawrence's series lies not only in the sequential format being a special aesthetic means but also in the artist's distinctive narrative conceptualization.

In this first phase of his career, Jacob Lawrence fixed the artistic patterns that have served him for the ensuing fifty years. Genre and narrative/serial modes proved assertive vehicles for what he wished to communicate. The water-base media, the small format of paper or panels easily moved about on his worktable, the colorful patterns of forms flattened into vibrant geometries—all were elements of his work even as a child and they became his trademarks. And he had found his theme—man's struggles—which would become the essence of his life's work.

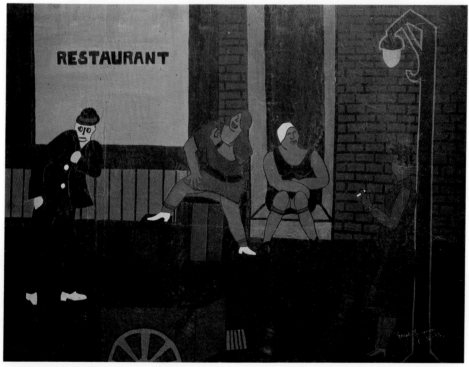

BELOW
PL. 1. *Street Scene—Restaurant*, c. 1936–38.
Tempera on paper, 26¼ × 35.
Collection of Mr. and Mrs. Philip J. Schiller.

ABOVE
PL. 2. *Street Orator*, 1936.
Tempera on paper, 23¼ × 18.
Collection of Gwendolyn and Jacob Lawrence.

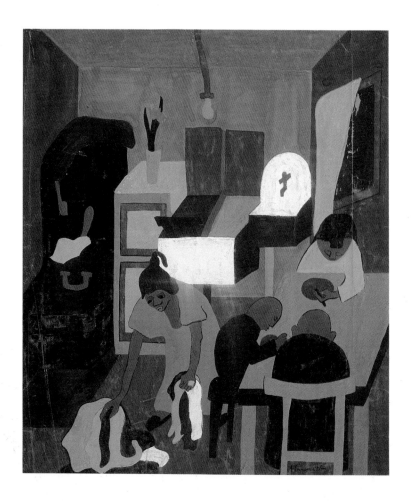

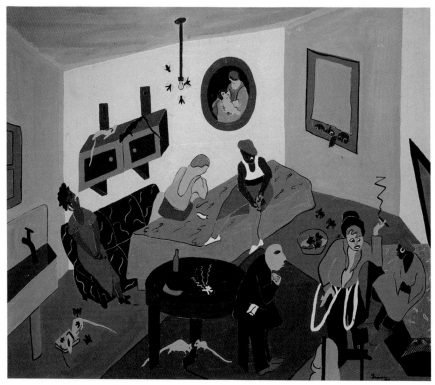

ABOVE
PL. 3. *Interior*, 1937.
Tempera on paper, 30 × 25½.
Collection of Gwendolyn and Jacob Lawrence.

BELOW
PL. 4. *Interior Scene*, 1937.
Tempera on paper, 28½ × 33¾.
Collection of Mr. and Mrs. Philip J. Schiller.

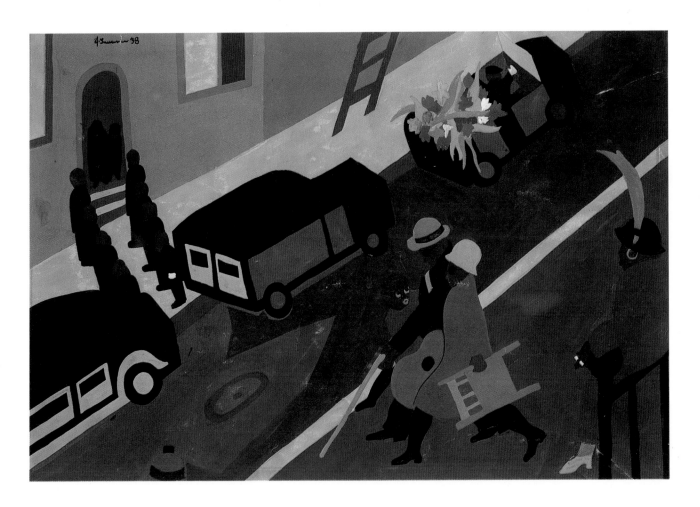

Pl. 5. *The Funeral*, 1938.
Tempera on paper, 14 × 18.
Collection of Gwendolyn and Jacob Lawrence.

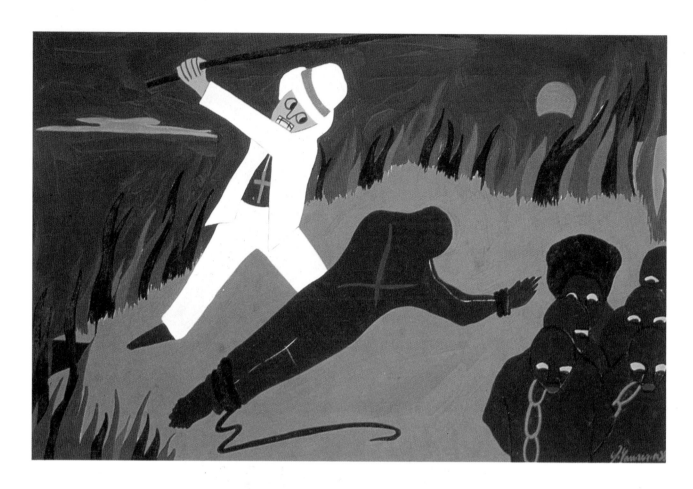

PL. 6. *Toussaint L'Ouverture* Series, 1937–38.
No. 10: *The cruelty of the planters led the slaves to revolt, 1776. These revolts kept
cropping up from time to time—finally came to a head in the rebellion.*
Tempera on paper, 11 × 19.
The Amistad Research Center's Aaron Douglas Collection, New Orleans.

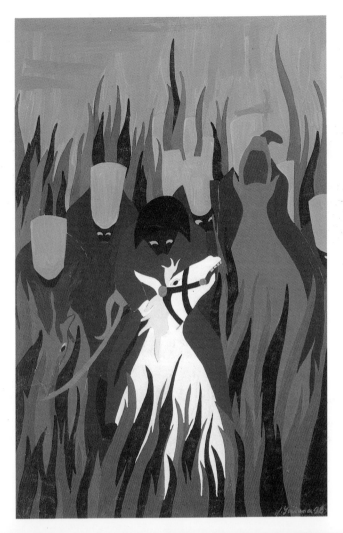

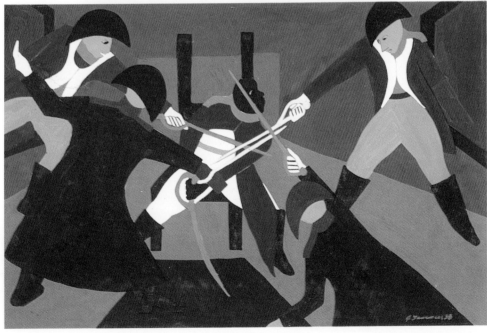

BELOW
PL. 8. *Toussaint L'Ouverture* Series, 1937–38.
No. 36: *During the truce Toussaint is deceived and arrested by LeClerc.*
LeClerc led Toussaint to believe that he was sincere, believing that when
Toussaint was out of the way, the Blacks would surrender.
Tempera on paper, 11 × 19.
The Amistad Research Center's Aaron Douglas Collection, New Orleans.

ABOVE
PL. 7. *Toussaint L'Ouverture* Series, 1937–38.
No. 17: *Toussaint captured Marmelade, held by Vernet, a mulatto, 1795.*
Tempera on paper, 19 × 11.
The Amistad Research Center's Aaron Douglas Collection, New Orleans.

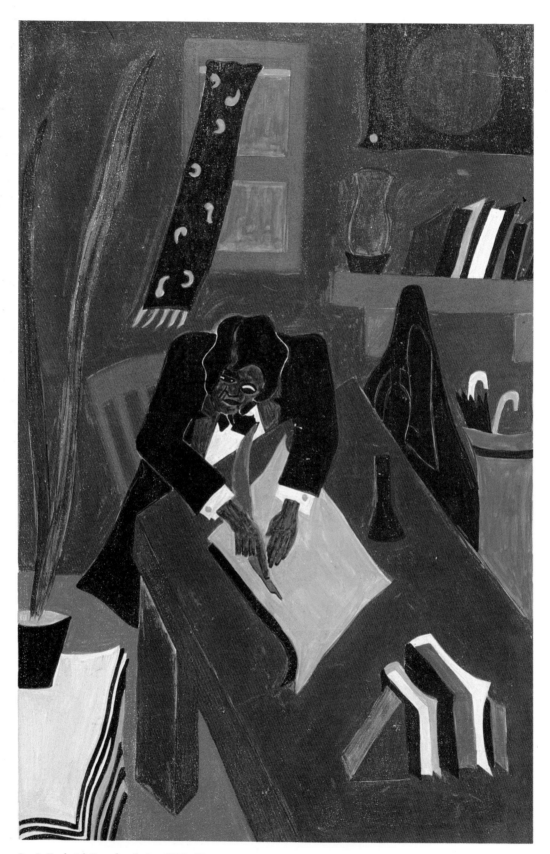

PL. 9. *Frederick Douglass Series, 1938–39.*
No. 22: *Leaving England in the Spring of 1847 with a large sum of money given him by sympathisers of the Antislavery movement, he arrived in Rochester, New York and edited the first Negro paper, "The North Star." As editor of the "North Star," he wrote of the many current topics affecting the Negro such as the Free Soil Convention at Buffalo, the nomination of Martin van Buren, the Fugitive Slave Law, and the Dred Scott Decision.*
Tempera on hardboard, 17⅞ × 12.
Hampton University Museum, Hampton, Virginia.

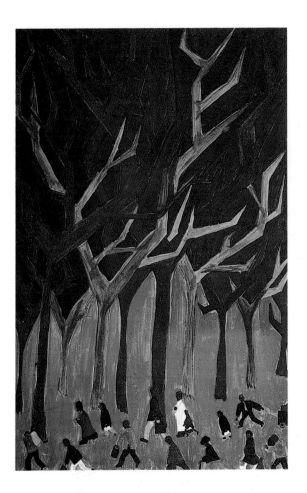

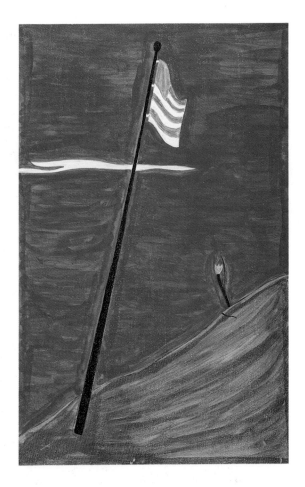

PL. 10. *Frederick Douglass* Series, 1938–39.
No. 30: *The war was over. The slave was literally turned out by their masters into a world unknown to them. Here they had ceased to be the slaves of nature.*
Tempera on hardboard, 17⅞ × 12.
Hampton University Museum, Hampton, Virginia.

PL. 11. *Frederick Douglass* Series, 1938–39.
No. 33: *Frederick Douglass revisited the Eastern Shore of Maryland—here he was born a slave—now he returned a free man. He left unknown to the outside world, and returned well known. He left on a freight boat, and returned on the United States. He was a citizen of the United States of America.*
Tempera on hardboard, 17⅞ × 12.
Hampton University Museum, Hampton, Virginia.

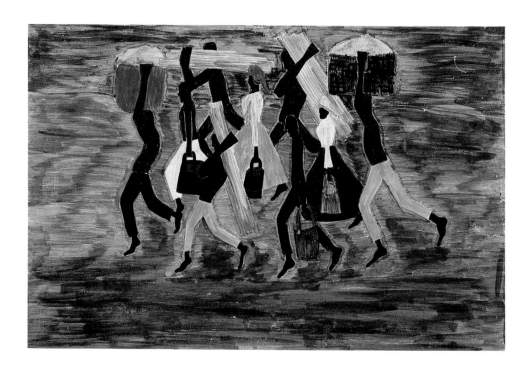

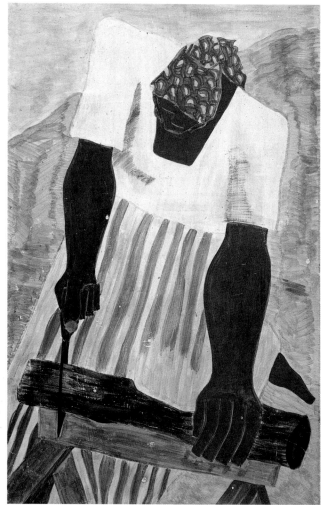

ABOVE
PL. 12. *Harriet Tubman* Series, 1939–40.
No. 1: *"With sweat and toil and ignorance he consumes his life, to pour the earnings into channels from which he does not drink"* (*Henry Ward Beecher*).
Tempera on hardboard, 12 × 17⅞.
Hampton University Museum, Hampton, Virginia.

BELOW
PL. 13. *Harriet Tubman* Series, 1939–40.
No. 7: *Harriet Tubman worked as a water girl to cotton pickers; she also worked at plowing, carting and hauling logs.*
Tempera on hardboard, 17⅞ × 12.
Hampton University Museum, Hampton, Virginia.

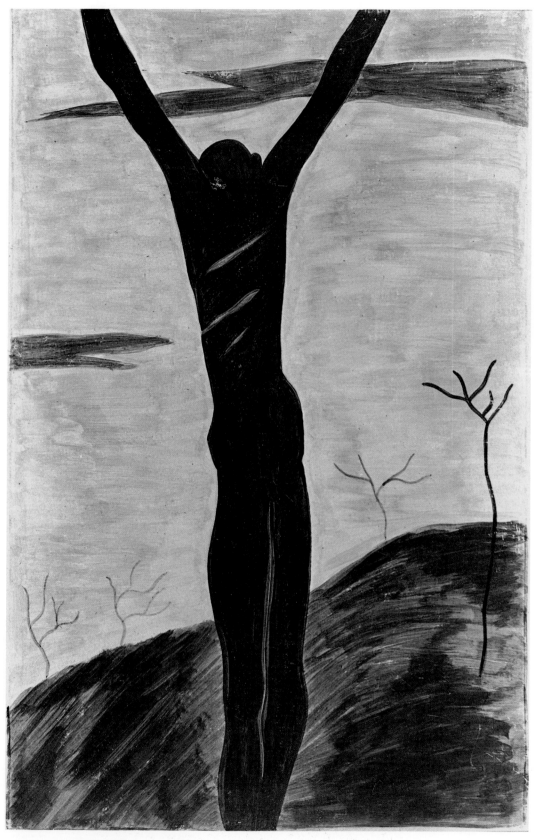

PL. 14. *Harriet Tubman* Series, 1939–40.
No. 2: *"I am no friend to slavery, but I prefer the liberty of my own people to that of another people, and the liberty of my own race to that of another race. The liberty of the descendants of Africa in the United States is incompatible with the safety and liberty of the European descendants. Their slavery forms an exception (resulting from a stern and inexorable necessity) to the general liberty in the United States."*
—*Henry Clay.*
Tempera on hardboard, 17⅞ × 12.
Hampton University Museum, Hampton, Virginia.

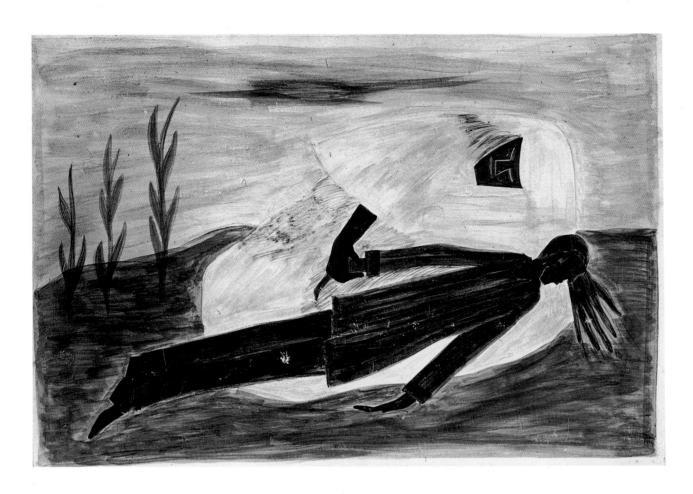

PL. 15. *Harriet Tubman* Series, 1939–40.
No. 29: *She nursed the Union soldiers and knew how, when they were dying by large
numbers of some malignant disease, with cunning skill to extract from roots and
herbs which grew near the source of the disease, the healing drought, which allayed
the fever and restored numbers to health.*
Tempera on hardboard, 12 × 17⅞.
Hampton University Museum, Hampton, Virginia.

3. Early Maturity: 1940 to 1949

In 1940, Jacob Lawrence received the first of three consecutive annual Rosenwald Foundation Fellowships.[1] He had applied for Rosenwald funding to create a series of paintings on the Negro Migration in the early decades of this century. The fellowship allowed him to move into his own studio in a loft building on 125th Street, where he lived and worked for about a year and a half.

Other well-known artists and writers had studios in the same building. Lawrence recalls: "People would move in and out. Romare Bearden was upstairs. Claude McKay, Ronald Joseph, William Attaway, and Robert Blackburn were there. The *Negro Digest* was started there. I paid $8 a month rent, because I was on the back. If you were on the front, I think it was $10."[2] Lawrence is particularly inclined to speak of his interactions with Claude McKay during this period:

> Claude McKay was a mentor. He was an older man, and I always appreciate him because he spoke to me like a peer. I have a book of his that he inscribed for me, *A Long Way Home.* I think he appreciated me because he was a nationalist, from Jamaica, and I was dealing with this kind of content. He was an intellectual and very close to the Garvey movement. . . . He would wander into my studio, and I'd go to his place and talk. He was a very tough fellow, and very critical of our whole social environment, critical of whites, critical of blacks; . . . he was very analytical. He was kind too; he was very kind to me. You know who he'd be close to? Malcom X; that type of personality. He had very high expectations of the people around him.[3]

It was Claude McKay who, at the 306 studio, had introduced Lawrence to George Grosz's work, *Ecce Homo,* a 1923 collection of drawings.[4] These explicit renderings

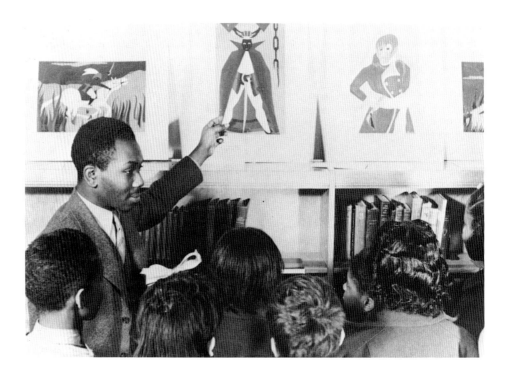

FIG. 30. Jacob Lawrence speaking to students about his *Toussaint L'Ouverture* Series (1937–38), Lincoln School, New York, February 28, 1941.

from around the time of World War I are Grosz's responses to a German society abandoned to its most ignoble instincts. Grosz had been teaching in New York at the Art Students League since 1932 and artists were aware of his pungent political and social satire. Lawrence was impressed by Grosz's skills as an observer, although his own imagery never resorted to the demeaning extremes of Grosz's depictions.

The large studio made it easier to work on the new series, *The Migration of the Negro* (1940–41), also based on research he conducted in the Schomburg Library:

> When I received [the Rosenwald Fellowship], my research was almost done. Then it took me about a year to paint the series. . . . I did plenty of research in books and pamphlets written during the migration, and afterward. . . . I took notes. Sometimes I would make ten or twenty sketches for one incident. [This series is the last for which he did preparatory studies.] By the time I started work on the *Migration* series, I was more conscious of what I wanted to do. I was looking consciously at things and for things.[5]

Unlike the preceding series, the *Migration* theme combines the remoteness of historical fact with the immediacy of personal experience. Lawrence had a vital sense of his own connection with this epoch of black history. At that time, most Harlem blacks or their parents had been part of that migration. Lawrence remembers hearing discussions about it in his youth:

> When I was about three or four years old . . . there were a lot of racial problems, particularly in the South. My folks used to talk about the lynchings. The National Association for the Advancement of Colored People had become involved, and they used to keep a record of how many blacks were killed.
> I was aware of these things, but not in an intellectual way. As a youngster, you just hear stories. This was really the time of the migration. I didn't know the term "migration," but I remember people used to tell us when a new family would arrive. The people in the neighborhood would collect clothes for these newcomers and pick out coals that hadn't completely burned in the furnace to get them started. I didn't see the migration as an historical event, but people were talking about it. That was prior to our moving to Harlem.[6]

The sequence of sixty panels graphically documents the exodus of the American blacks from the South seeking better opportunities in the urban centers of the North, as well as the situations they encountered when they arrived (see pls. 16–19).

Making and laying out all the sixty gesso panels was involved and time-consuming. As for previous series, Lawrence made his own gesso from rabbit-skin glue and whiting, which he then applied in layers to each hardboard panel. Each

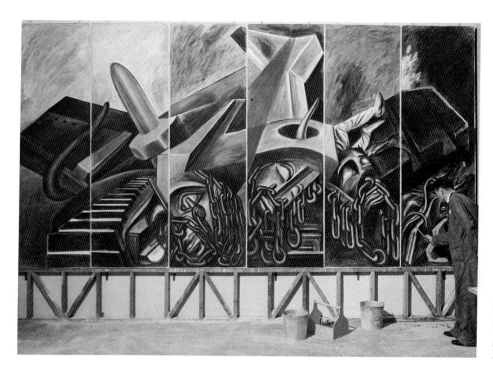

FIG. 31. José Clemente Orozco working on *Dive Bomber and Tank*, 1940. Fresco, 9' × 18' (six panels, 9' × 3' each). Commissioned by the Abby Aldrich Rockefeller Fund. Museum of Modern Art, New York.

gesso layer was brushed perpendicular to the last and the final layer (of three or four) was sanded down after it dried. Gwendolyn Knight, who was now Lawrence's constant companion and frequently worked in his studio, helped him lay out the panels and compose the prose captions.[7]

During this period, Lawrence's career gained momentum rapidly (fig. 30). While producing the *Migration* series, he also participated in several exhibitions. Early in 1940, he had been included in an exhibition of the work of twenty-one artists at the Harlem Community Art Center.[8] In the fall of 1940, Lawrence's paintings were shown at Columbia University.[9] And the *Harriet Tubman* series was shown in December 1940 in an exhibition at the Library of Congress in commemoration of the Thirteenth Amendment.[10]

While working on the *Migration* series, Lawrence had the opportunity to meet Orozco, who was painting his mural *Dive Bomber and Tank* (1940) at the Museum of Modern Art (fig. 31). Jay Leyda, film historian, who was then working in the film library of the museum, arranged the encounter. Lawrence recalls, "Although my contact with Orozco was brief, it was most encouraging and it had great meaning to me":[11]

> He was a very quiet man. I went to see him; it was around lunch time. I don't know if he had seen any of my work or not. No one was there when I was there. He worked in an enclosure. I remember it very well because there wasn't much said. You know, at that time, when you did a mural on a project you had to have three stages, I think: the sketch of the entire mural, and then you had to present a part of that, the detail [and the actual mural]. So I asked him, "Where's your sketch, where's your detail?," and so on. He said he didn't need one. You know these cardboards that come in men's shirts from the laundry? Well, he had one with just a few scratches on it. In other words, he was working very spontaneously, very direct. I was very impressed by that. Then I asked him if he wanted anything for lunch, because I could go out and get him something. He said a bag of cherries, and I went out and got him a bag of cherries and gave it to him. And that was it. You know, he had one arm. He was just the opposite of what I've heard of Siqueiros, who was very bumptious, and Rivera, the same way. Orozco was very impressive because his work has a certain power, and being a young fellow, I expected a different personality altogether. He was very, very quiet, but very friendly.[12]

The *Migration* series begins with a depiction of the migrants flocking to the railroad station to go north (pl. 17). The surging crowd of featureless figures, distinguished by a variety of hats, becomes a sea of hopeful humanity. Panel 52 (pl. 18) captures the tensions that resulted in riots as the northern cities experienced the great

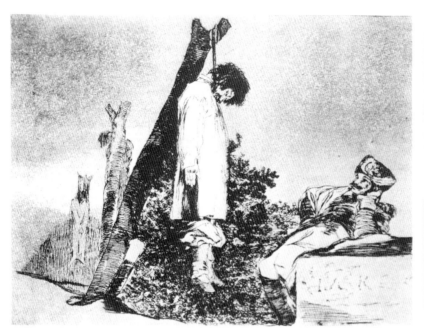

FIG. 32. Francisco Goya, *The Disasters of War*, No. 36: *Tampoco*, c. 1811. Etching.

FIG. 33. José Clemente Orozco, *El Ahorcado*, c. 1926–28. Ink and wash. Collection Delphic Studios.

influx of migrants. Form is contorted: limbs are stretched and become a jigsaw puzzle of pointed pieces. Panel 54 (pl. 16) portrays the importance of the church in the lives of the migrants, reinforced by the liturgical fresco that looms behind them.

Panel 15 (pl. 19) of the *Migration* series is a simple but powerful image of lynching. A heavy noose hangs in isolated menace near a hunched, grieving figure. Instead of depicting the violent act itself, Lawrence provides a thought-provoking statement on the despair and emptiness created by criminal treatment of blacks in our country. The painting's somber message recalls Goya's work. Goya's etching *Tampoco* (fig. 32) is of similar content but without Lawrence's restraint. It is a part of Goya's series *The Disasters of War* (1810–13) that so impressed Lawrence as a young student; the series records atrocities committed during Napoleon's occupation of Spain. Like Goya, Lawrence often uses figures verging on the grotesque as a means of social commentary, yet as art educator Edmund B. Feldman has pointed out, "compared to the revolutionary artists of the nineteenth century, Lawrence relies more on the power of abstract patterning. There is less blood and gore, more emphasis on position and silhouette."[13] Another work that contains many engaging visual similarities with Lawrence's Panel 15 (pl. 19) is Orozco's *El Ahorcado*, 1913–17 (fig. 33). The strongly reduced compositions of both works are based on an oblique dark ground plane, a lumped figural foreground group, and an emphatic gallows against empty space. This drawing was contained in a widely read collection of Orozco's works published in New York in 1932; although Lawrence cannot remember, this volume might well have been one of the books on Orozco that he saw at the art workshops and which contributed to the acknowledged influence of Orozco's art on his own.

The *Migration* series represents several subtle changes in Lawrence's work. In addition to integrating history and personal reflection, this series combines both rural and urban genre. The imagery is generally treated in a sober manner; wry humor conveyed in earlier paintings is disappearing. Many kinds of violence are rendered; there was violence in the *Toussaint* series, but here it is presented with more vigor and variety (e.g., bombing of houses, police brutality, judicial inequities). And to render social content forcefully, Lawrence's style is becoming more abstract, with more purposeful distortion and increased cubist angularity (e.g., pl. 18). Lawrence has explained this stylistic move:

> My work had always been flat, geometric. I didn't think in terms of Cubism, but later in my development I became more aware of it. Most people at that time worked cubistically without thinking about it. The 306 group was aware of it. Ronald Joseph's work was cubist looking, and he liked the cubist work of Walt Kuhn and talked about it a lot.[14]

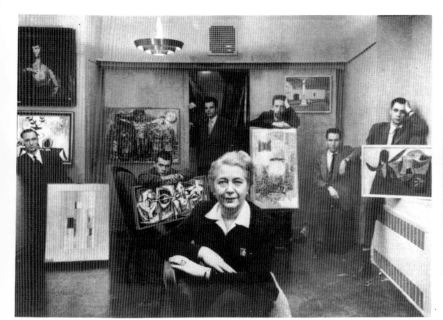

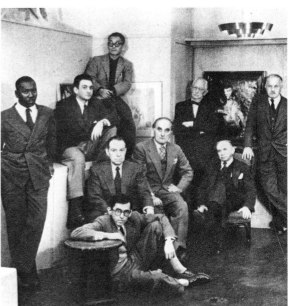

FIG. 34. Edith Halpert and Downtown Gallery artists, 1952.

Behind Mrs. Halpert and with their work are, from left: Charles Oscar, Robert Knipschild, Jonah Kinigsten, Wallace Reiss, Carroll Cloar, and Herbert Katzman.

Seated, from left, are: Jack Levine (on floor), Stuart Davis (behind Levine), William Zorach, Bernard Karfoil. Behind them are Jacob Lawrence, David Fredenthal, Yasuo Kuniyoshi, Charles Sheeler, and Ben Shahn.

The panels of the *Migration* series indicate with compelling clarity that Lawrence's brand of Social Realism has much in common with the goals shared by the great nineteenth century Realists. Lawrence's concerns correspond with Gustave Courbet's innovative reflection of everyday reality and the celebration of the commonplace through his interest in the worker, with Honoré Daumier's social satire and feeling for the dignity of the poor, and with Jean François Millet's presentation of the noble labors of the peasant. In addition, some of the panels imply the influence of Grosz's biting exposure of society's weaknesses.

Because of his interest in the lives of people in particular geographic areas (such as Harlem and the deep South), Lawrence's paintings often have Regionalist or American Scene overtones, although his work would not fit securely in either style category. About his interest in the American scene, Lawrence has said:

> I've always had the idea that the artists of America haven't exploited America sufficiently, both currently and historically. . . . There doesn't seem to be enough rapport between the artist and the country. There seems to be more passion in the people than in their art. . . . You do find this expression in the other arts. I don't mean regionalism in a petty, small way. . . . I'm thinking of William Faulkner, in literature, for example.[15]

On July 24, 1941, Jacob Lawrence and Gwendolyn Knight were married. The following month, they went to New Orleans for their honeymoon, where Lawrence began a planned *John Brown* series with the support of a second Rosenwald Fellowship. While he was in New Orleans, Lawrence's career took a significant turn in New York. Alain Locke had brought the *Migration* series to the attention of Edith Halpert, owner of the Downtown Gallery. Halpert was a clever and innovative dealer.[16] Inspired by Alfred Stieglitz's crusade to advance modern art, she perpetuated his original program of finding and encouraging young American artists. The wife of painter Samuel Halpert, she opened her first gallery in 1926 and rapidly became known for her judgment as an entrepreneur with a discerning eye. She championed the painters she represented by giving them one-man shows and frequent visibility, loaning works willingly to museum shows all over the country, and keeping prices low. Impressed with Lawrence's *Migration* series, Halpert developed the idea of a multiple-gallery black artists' show, with each dealer subsequently retaining one artist. The show was organized with the assistance of the Harmon Foundation. Lawrence agreed to his participation long-distance. The show opened on December 9, 1941. Because of what happened at Pearl Harbor the preceding Sunday, "all of the dealers except Edith Halpert scrapped their plans. She stood by her pledge and she took me on," he recalled. "Her letter inviting me to join her gallery came and I accepted, little knowing the true meaning of it."[17]

Fig. 35. Stuart Davis, *House and Street*, 1931. Oil. 26 × 42¼. Whitney Museum of American Art, New York.

Halpert's exhibition, "American Negro Art: 19th and 20th Centuries," included artists such as Henry O. Tanner, Charles Alston, William H. Johnson, Horace Pippin, and Romare Bearden, in addition to Lawrence, whose work proved a tremendous success. The Museum of Modern Art and the Phillips Memorial Gallery (now The Phillips Collection) in Washington, D.C., vied for purchase of the *Migration* series, finally agreeing to divide the paintings.[18]

In the November 1941 issue of *Fortune* magazine, twenty-six of the series were reproduced in color, along with a stirring article by Locke that manifested the social sensibility of the era. Locke's essay is candid about "the great American minority," pointing out that in the South that the migrants left behind "an average of fifty-six Negroes were being lynched every year," and that America's treatment of the Negro is something that "Hitler has used . . . as prime propaganda to convince people that U.S. democracy is a mockery." Decrying the "humble counsel of Booker T. Washington, who urged his followers 'to know their place' and to crawl into the white man's kingdom through the back door," the article concludes with an inflammatory cry: "But even in the segregation and discrimination he endures, the Negro is finding strength. . . . He would be ready now to rally around a leader he could understand— a Negro Huey Long—and if he gets kicked around much longer he will probably find one."[19]

With the *Migration* series, Lawrence achieved widespread recognition. Representation by Edith Halpert and national coverage in *Fortune* quickly brought this young painter to the attention of the American public. The critical response to the series was laudatory:

> Jacob Lawrence [is] a young Negro artist whose work promises to earn for him the same high recognition accorded to Paul Robeson, Marian Anderson, W. C. Handy, and other talented members of his race. His use of harsh primary colors and his extreme simplicity of artistic statement have extraordinary force.[20]

The racial categorization in this review is typical of the times. The American public had begun to realize, especially in the 1920s, that whites did not have exclusive rights to artistic creativity. But because of the establishment's general reluctance to allow art to transcend race, as well as black nationalism's vested interest in having art observe a racial framework, for several decades Lawrence's work would be considered representative of "Negro art," not simply American art.

Lawrence evaluates his early success:

> The American art world was becoming very conscious of the young American artists . . . the young Negro artist was one of the young American artists too . . . and I had done the *Migration* series. So all of these factors coming together was a very happy event for me entirely. . . .

I must give credit to . . . Alain Locke . . . who I think was very, very important in bringing us to the stage where we could be recognized by the establishment.[21]

Lawrence and his bride missed the exhibition in New York because they were still in New Orleans. This was the Lawrences' first trip to the South and their first experience with Jim Crowism as a constant reality. They learned not to go into restaurants or stores, and to remain wary and uninvolved. Because of the color bar in public accommodations, they found rooms to rent in a private home through the Urban League.[22] Lawrence completed the *John Brown* series while there, and also did a few scenes of New Orleans (e.g., *Bus,* 1941, pl. 20, which depicts segregated public transportation). Every month or so he would send Edith Halpert two or three paintings; she would write back with encouraging news of her appreciation of the works and how well they were selling.[23]

The Lawrences had wanted to stay in New Orleans for Mardi Gras, but because of Pearl Harbor the celebration was canceled, so they moved on to Lenexa, Virginia, where his mother had lived, to stay with distant relatives. Lawrence reflected: "I'd never been south before. I put on my application to the Rosenwald Foundation that I wanted to visit an urban southern community and a rural southern community. I remember my mother used to tell me about when she was a child, her mother took her to this farm in Virginia."[24] While in Lenexa, Lawrence produced several rural scenes (e.g., *Drawing Water,* 1942). Lawrence's early life had consisted "mostly of tenements, life in and out of tenements, purely that,"[25] and so for him to depict figures in a landscape, from first-hand experience, was new and something he would seldom repeat. Gwen Lawrence looks back on their stay in Virginia: "That was the most beautiful part of Virginia. It was so beautiful that spring, the dogwood, and the pine underfoot—just walking in a sea of dogwood, and the scent of the honeysuckle was all over the place."[26]

The Lawrences returned to New York in July 1942, and from that point Lawrence's success gained impetus. Through his gallery association, Lawrence met numerous museum directors, curators, and collectors as well as well-known artists on Halpert's roster (see fig. 34), among them Ben Shahn, Charles Sheeler, and Stuart Davis. Other Downtown Gallery artists in the 1940s and 1950s included Mark Tobey, Max Weber, Joseph Stella, Georgia O'Keeffe, John Marin, Jack Levine, Yasuo Kuniyoshi, Horace Pippin, Arthur Dove, Ralston Crawford, and Julian Levi, whose works were representative of many forms of realism and abstraction.[27] Lawrence saw their paintings frequently and many of these artists became life-long friends. Lawrence has often mentioned how fortunate it was that Halpert invited him to join her gallery: "Sometimes we look back and wonder what would have happened to me if it had not been for Augusta Savage and Edith Halpert."[28]

Lawrence's *John Brown* series consists of twenty-two panels, gouache on paper; since he was working away from his studio, this medium and support were easier to manage. This series takes a step Lawrence never repeated: its protagonist is a white man (pls. 21–23). This particular man, however, is part of one of the most poignant stories in the history of American blacks. John Brown, the great abolitionist, fought to his death with the conviction that he had a divine mission to overthrow black slavery in America. Lawrence brought his notes from his Schomburg research to New Orleans; his primary sources were Franklin B. Sanborn's factual *Life and Letters of John Brown* (1891) and the interpretive *God's Angry Man* (1932) by Leonard Ehrlich.[29] Almost every scene of the series focuses on the figure of the emaciated, fanatical John Brown. Old photographs indicate that Lawrence's treatment of John Brown is relatively accurate because Brown was haggard, with unkempt white hair, looking much like a vision of an Old Testament prophet.

Panel 6 (pl. 23) shows John Brown gathering his followers in New York State and arming them. Familiar compositional features are the reciprocation of bold diagonals, the precipitous space, and the angular treatment of figures. Lawrence makes particularly striking use of black and white pattern in these paintings, as in Panel 21 (pl. 21). The *John Brown* series represents the apogee of Lawrence's dramatic narrative abilities: through economy of means—large flat forms, pure colors, and extreme reduction of details—expression is heightened. Lawrence's concern here is the universality of the theme in which a man lays down his life in a struggle for freedom and justice.

This series contains some of the most disturbing imagery Lawrence will ever present: blood flowing from the crucified Christ (in Panel 1) and an analogous hanging body of John Brown (in the final panel, pl. 22). Many painters had dealt with the John Brown theme (e.g., John Steuart Curry, 1939) and many would again, but this was the first time it had been undertaken from the black viewpoint.[30]

John Brown was exhibited at the Downtown Gallery with excellent critical reception. A reviewer in *Art Digest* commented:

> The artist has made of this saga a powerful and compelling series. . . . Collector Milton Lowenthal purchased the entire collection . . . on the opening day of the show. This reviewer hopes that the new owner can be prevailed upon by an alert publisher to issue the series in book form. It would be an authentic contribution to the aesthetic folklore of America.[31]

In what was one of the few published negative responses to Lawrence's work, an *Art News* critic wrote:

> Jacob Lawrence's John Brown series . . . only occasionally reaches the heights of his earlier work. One of the artist's great traits—his gift for dispassionate statement—seems to have waned in the face of a theme removed from real life. Though visually pleasing thanks to an infallible compositional sense, the emotion tends toward the strained, propagandizing type while a more drastic stylization frequently detracts from the simplicity of the message.[32]

When the Lawrences returned to New York after their sojourn in the South, they lived and worked in their own apartment on the outskirts of Harlem. Lawrence returned to the familiar aesthetic territory of Harlem community imagery. *Tombstones* (1942), one of the first examples of this period, is possibly Lawrence's best known painting (pl. 24). Owned by the Whitney, it was first shown at a major museum exhibition (the Whitney Annual) in 1943.[33] It depicts a seemingly straightforward street scene: occupants of the tombstone seller's building relax in front of the house as people do in crowded city blocks on a warm day. Yet close examination reveals elements that suggest symbolic religious and life/death implications in the work: a little white doll lies askew on the sidewalk, a dramatic white cross looms out of the tombstones assuming focal significance, and nearby a woman and baby are posed remarkably like a Renaissance madonna and child grouping. A pronounced two-dimensional quality is achieved by a careful integration of an upward dynamism of the angular and twisting forms and the dominance of bold red and black pattern—a favorite choice of Lawrence in the 1940s. A brilliant blue is seen through the windows like a sky beyond, making a pierced paper backdrop out of the architecture. An aesthetic complement to the solid flat forms of the figures is offered by the delicate linear pattern on the carved tombstones.

The painting retains a remarkably fresh appearance; the gouache looks fuzzy and pooled on the paper, as if the work had just been painted that morning. The paint has been applied in thin washes, allowing the texture of the paper to show through. From the time he worked in the South, gouache on paper continued to be Lawrence's usual choice. In this period, when he was experimenting with gouache, he initially made his own mixture from ground pigment, rabbit-skin glue, and water, dripping the mixture through cheesecloth into a jar. He soon began to use tubed gouache, however, which he applies with a soft tapered sable brush.[34]

Another significant work from this period is *Pool Parlor* (1942), which won a $500 purchase prize at the 1942 "Artists for Victory" show at the Metropolitan Museum of Art (pl. 25).[35] This painting also has a steep compositional structure upon which the artist hangs flat forms. Lawrence assumes an elevated viewpoint, as if looking down from a balcony. Somber colors render a dark, smoky interior, and the white dots of both the pool balls and the players' intensely concentrating eyes punctuate the picture plane. An unusual effect is achieved by the cigarettes that have been set down, burning ends out, on the table edges while the players set up shots: the smoke zigzags its way up into space rather than curling up, indicating the artist's formal preference here for linear angularities.

Supported by a third Rosenwald Fellowship, Lawrence's work of this year culminated in a *Harlem* series (1942–43), thirty genre scenes of Harlem life (pls. 26–29). In this most personal sequence, Lawrence reworks childhood memories and impressions. Panel 1, "This is Harlem," presents a rooftop view of the city, approached very much like the stage sets Lawrence had constructed as a young teen-

FIG. 36. Jacob Lawrence, 1944.

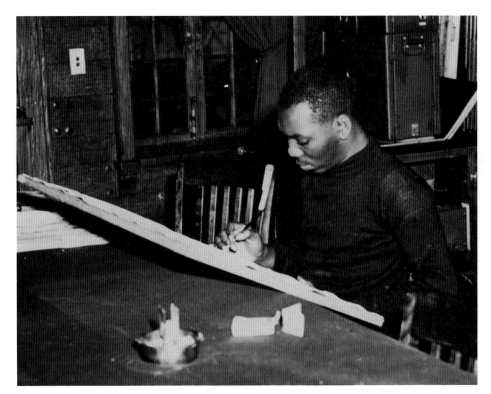

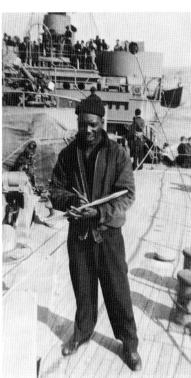

FIG. 37. Jacob Lawrence at work painting aboard the *Sea Cloud*, 1944. (a) In the ward room. (b) On deck.

ager. Lawrence has said: "The Harlem series was the same kind of thinking . . . only two dimensional."[36] The teeming view of the city's buildings, billboards, and inhabitants is an upbeat, syncopated composition of primary colors. The shapes become a geometric puzzle; they are cubist yet recognizable, and evoke Stuart Davis's work (e.g., fig. 35).

Another piece from the series, Panel 2 (pl. 27), is a simple interior. Much of Lawrence's imagery has demonstrated an affinity with the Social Realist photography of the early decades of our century, and this scene is especially reminiscent: the force of the empty space bears down on the woman's shoulders, revealing the despair of the poor. The figure is rendered in simple frontality, her masklike face inclined toward the money on the table. Euclidean space and form prevail; the figure becomes rectangle, square, truncated cone. In Number 15 of the series (pl. 28), Lawrence expresses a Harlem tenement scene familiar to him:

> During the years of Prohibition, some made a living by distilling spirits in vats which were secretly located in tenements. Since I was in my teens and would not be arrested, I was paid (about twenty-five cents) to pick up and deliver a gallon can of whiskey from and to buyers throughout the community.[37]

Number 19 of the series (pl. 29) offers a lighter side of the story: Harlem's nightlife is described with active line and rich color.

The Regionalist tendencies of Lawrence's work are particularly present in the *Harlem* series. Although a unique community, Harlem's situations are representative of urban ghetto life everywhere. As in the *Migration* series, there is a vital sense of patrimony, linking Lawrence with his forebears, and an implied coherence among those who share a struggle for an improved existence. This was remarked upon by art historian Oliver Larkin in 1960:

> Few mural artists could have built such nervous and powerful commentaries as Lawrence did on small panels in the *Harlem* series and the *Migration of the Negro* series. [His work represents a] fresh consciousness of the American environment.[38]

The *Harlem* works are propaganda paintings in the best sense, telling a story of cold water flats and hot night clubs with gravity and ebullience. More vibrant in color and more mature in design, this series embodies the progress made by Lawrence in his art by the early 1940s.

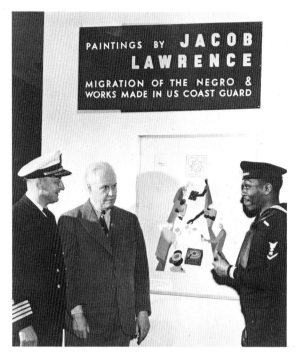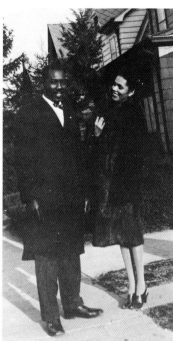

FIG. 38. Captain Rosenthal, writer and photographer Carl van Vechten, and Jacob Lawrence at the Museum of Modern Art opening, 1944. Lawrence gestures toward a *Coast Guard* painting.

FIG. 39. Jacob and Gwen Lawrence, February 17, 1946.

A retrospective consideration of Lawrence's oeuvre reveals that he frequently concentrates aesthetically on women, portraying them as central, often heroic, images. Three selected works from the period directly following the *Harlem* series demonstrate his treatment of women (pls. 30, 31, and 35). *Woman with Grocery Bags* is a magnified close-up of large cubic forms. The now familiar oversized hands dominate: they have become symbolic of labor, tenacity, and strength in Lawrence's designs. Extremely abstract in initial impression, the forms of this decorative composition soon become recognizable: the red and white striped bag and the centrifugally placed banana, red gloves, white purse, and blue belt. The characteristic bend of the figure in motion is accented by an elegant blue outline on the coat and hair, the use of outline returning here from early work. *The Apartment* (pl. 31) is a riotous, Matisse-like red room in a bold red and black pattern. Like the previous painting, the composition is divided into quarters, the daring spiral design in one corner countered by the vertical accents in the others. A weary woman returns home from her workday, oblivious to the atmosphere of precarious objects and mis-scaled proportions surrounding her dark silhouette.[39] *The Seamstress* (pl. 35) presents a favorite theme of the painter: the powerful and efficient spiderlike hands of the seamstress become the center of attention.

One easily concludes that Lawrence's characterization of women stems from his observation of the perseverance of the average woman in the Harlem community, who is often poor, works very hard, and also raises a family. Lawrence's own mother had been one of these women. In addition to Lawrence's awareness through his research of the many courageous black women in American history, female family leaders as active visible figures in the community have been inspiring personages for his art.

Lawrence's particular appreciation for women as compositional subjects may also stem from perceptions gained through his relationship with Gwen, who is a vivacious and perspicacious person. The Lawrence marriage is an uncommon partnership. They have known each other since childhood, and Lawrence's respect for Gwen is apparent to all who know them. She has provided steady strength and critical guidance, for which Lawrence often notes his appreciation. While Gwen has allowed her artistic career to become second to her husband's, she has continuously pursued her work in painting and sculpture, and she has remained active in the art world at large. The two are excellent counterpoints for each other: whereas he is

easygoing and reserved, she is emotive and gregarious. Their lives are focused on art and they have many friends in art, but their work and closeness eliminate most external activities. There is no doubt that Gwen has been a decided influence in Lawrence's life and in the development of his attitudes and the content of his art.

THE UNITED STATES ENTERED WORLD WAR II ON THE EUROPEAN FRONT WITHIN A week of the Japanese attack on Pearl Harbor. On October 20, 1943, Jacob Lawrence was drafted into the U.S. Coast Guard, at that time part of the Navy. He was given a steward's mate rating, the assignment then commonly given to blacks entering the Navy. After basic training at Curtis Bay, Maryland, he was stationed in St. Augustine, Florida, where he was assigned to servicing the dining and living quarters of the officers. While in the service, he initially underwent unpleasant experiences of discrimination:

> I remember being annoyed at the induction center . . . when a sergeant told me I'd like being a steward's mate because the food was so good and I could eat all the food I wanted. . . .[40]

> St. Augustine is a tight little town. You see and feel the prejudice everywhere. In the Hotel Ponce de Leon, where we were first stationed, the steward's mates were stuck way up in the attic.[41]

At the Christmas dinner held for servicemen and their wives, the Lawrences were snubbed, and a woman refused to sit next to Gwen.[42] Fortunately, Lawrence's commanding officer, Captain J. S. Rosenthal, was sensitive to the situation; he encouraged Lawrence to continue painting, even offering the artist space to do so in his quarters.[43]

Lawrence was first assigned to the USS *Sea Cloud,* the yacht of Joseph E. Davies, former U.S. Ambassador to the Soviet Union, now converted to a weather patrol ship in the Atlantic. He was stationed out of Boston, and the couple could commute back and forth to New York (fig. 36). In her husband's absence, Gwen had moved to Brooklyn to be closer to her mother. During this period, Gwen continued to paint. She also studied dance with the New Dance Group under Jane Dudley and Sophie Maslow, who were two star members of Martha Graham's troupe.[44]

In his first ship assignment, Lawrence again was fortunate: the captain of the vessel, Lieutenant Commander Carlton Skinner, was conducting what the press called an "experiment to combat racial discrimination at sea." Commander Skinner was very proud of having initiated integration in the Navy. He had become acutely aware of racial discrimination in the service when he had found it impossible to promote one of his black crew because of race. This led him to write to his admiral requesting the experiment. He received permission to take a racially mixed crew "on a tour of duty to determine whether abandonment of the segregation policy would work out in actual operation. . . . At the end of a year, his ship got a grade AA rating on every operation." As a result of Skinner's program, the Coast Guard concluded that "the experiment was a success and that the team work was first rate." This was the first integrated ship in the U.S. Navy or Coast Guard.[45]

In the atmosphere created by Carlton Skinner and his officers, Lawrence experienced what he called "the best democracy I've ever known."[46] Skinner helped Lawrence obtain a public relations rating so that in addition to his regular duties, he could purchase materials and paint documentary works of Coast Guard life (fig. 37). Skinner remarked, "There were several other shipboard artists by 1944. The Service was getting used to it."[47] In addition to his official work (see pls. 32 and 33, discussed below), Lawrence painted a portrait of Skinner while serving on the *Sea Cloud* (pl. 34). Skinner's face is surrounded by Coast Guard symbols floating in an all-encompassing blue oceanic expanse. The work exemplifies Lawrence's characteristic tendency to capture likeness through caricature—to reinforce recognition through distilled overstated representation.

After about eight months, Lawrence was assigned to a troop transport ship, the USS *General Wilds P. Richardson.* Captain Rosenthal, his commanding officer at boot camp and captain of this ship, had requested Lawrence as his combat artist.[48]

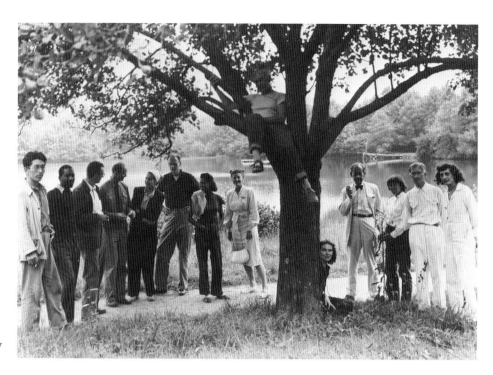

FIG. 40. Black Mountain College Summer Institute, 1946. Left to right: Leo Amino, Jacob Lawrence, Leo Lionni, Ted Dreier, Bobbie Dreier, Beaumont Newhall, Gwendolyn Lawrence, Mrs. Gropius, Varda (in tree), Nan Newhall, Walter Gropius, Molly Gregory, Josef Albers, Anni Albers.

On the *General Richardson,* Lawrence had full-time duties as official Coast Guard painter. The ship made repeated trips to England, Italy, Egypt, and India in 1945.

During his twenty-six months in the service, Lawrence produced numerous *Coast Guard* works (possibly over forty-eight), but most were lost after being placed in the Coast Guard archives (see pls. 32 and 33 for two photographed examples).[49] Some were exhibited at the Museum of Modern Art in October 1944 (fig. 38). In reflecting on the content of these works, Lawrence said at that time:

> It's the little things that are big. A man may never see combat, but he can be a very important person. The man at the guns, there's glamour there. Men dying, men being shot, they're the heroes. But the man bringing up supplies is important too. Take the cook. He just cooks, day in and day out. He never hears a gun fired except in practice. He's way down below, cooking. Now the coxswain, or the gunner's mate, the man at the wheel, people admire what they do. But the cook—the cooks may not like my style of painting. But they appreciate the fact I'm painting a *cook.*[50]

Lawrence's paintings of the discipline of daily routine aboard ship and the activities in port preserve a record of a particular segment of this wartime experience. They also represent for Lawrence an opportunity to be part of a way of life that was relatively free of discrimination. This fact is reflected in his pictorial statements being quiet, even-tempered, noninflammatory. Both races work together and mingle in recreational activities. They are faced with the same fundamental issue—the war. In his accommodation of new content in a strange environment, Lawrence's compositions become more formally intricate. Forced to experience the confinement and intimacy of shipboard life, he has closely scrutinized his surroundings; pictorial detail is more calculated, space is compressed. The dominating color in these works is the blue of the sea. Significantly, in the *Coast Guard* works Lawrence begins to investigate the possibility of breaking up figures into arbitrary shadowlike segments, in contrast to his former taste for large areas of unmodulated color; he comes to explore this problem increasingly in subsequent work.

In 1945, critic Elizabeth McCausland in *Magazine of Art* assessed the effects of Lawrence's Coast Guard experience:

> Lawrence's latest phase as an artist is most encouraging. His . . . *Coast Guard* paintings [mark] a great advance over the brilliant promises of his youth. . . .
>
> Jacob Lawrence's continued growth is gratifying; for racial discrimination has not bred positive social attitudes toward the war in all Negro intellectuals. That Lawrence

Fig. 41. Gwen and Jacob Lawrence, Black Mountain College, North Carolina, 1946.

paints hopefully is hopeful, and that the United States Coast Guard gave him a chance to make his visual record is hopeful.[51]

Lawrence was discharged from the Coast Guard in December 1945. A month later, he was saluted by *New Masses* magazine at an award dinner "honoring Negro and white Americans whose achievements in the arts, sciences, and public life are major contributions toward greater racial understanding." Those being honored included Mary McLeod Bethune (education), Pearl Primus (dance), W. E. B. DuBois (history), Paul Robeson (singing), Alain Locke (literary criticism), and Duke Ellington (music). Revealing the tenor of the times, the dinner program set forth the magazine's ideals:

> The roster of distinguished figures at this gathering alone is a repudiation of those who by word or act defend the Hitler slogan of white supremacy. Only by the full recognition in every corner of our land of the contributions of all of America's people can we achieve the rich and abundant life within our reach.[52]

To welcome back its war veteran artists, in May 1946 the Downtown Gallery held an exhibition, "Six Out of Uniform," of the work of Lawrence, Ralston Crawford, Louis Guglielmi, Jack Levine, Mitchell Siporin, and Edmund Lewandowski.[53]

Home from the service (fig. 39), Lawrence eagerly resumed painting and during this productive period again returned to familiar subject matter (pls. 36–40). *Shoemaker*, possibly the first work he did upon returning, is a neighborhood shop scene. It has a theatrical quality, with the cobbler's forceful, angular figure set off among delicate red shoes. His continuing choice of fundamental color (blue, red, yellow) is remarkable.

The painting *Barber Shop* (pl. 37) contains the essence of much of Lawrence's aesthetic motivations:

> The painting . . . is one of the many works . . . executed out of my experience . . . my everyday visual encounters . . . as was the ice man . . . the barefoot prophet, the shell-shocked veteran of World War I, the woman with the shopping bag, the street orator, children at play, and the many tenements that reached from 110th Street on the south to 155th Street on the north, and from Lenox Avenue on the east to St. Nicholas Avenue on the west. It was inevitable that the barber shop with its daily gathering of Harlemites, its clippers, mirror, razors, the overall pattern and the many conversations that took place

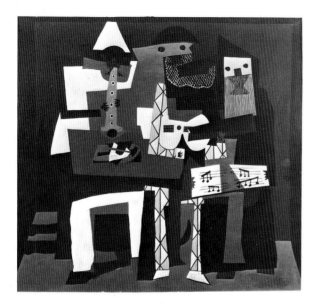

FIG. 42. Pablo Picasso, *Three Musicians*, 1921. Oil on canvas, 6′7″ × 7′3¾″. Museum of Modern Art, New York, Mrs. Simon Guggenheim Fund.

FIG. 43. José Clemente Orozco, *The Requiem*, 1928. Lithograph.

there . . . was to become the subject of many of my paintings. Even now, in my imagination, whenever I relive my early years in the Harlem community, the barber shop, in both form and content . . . is one of the scenes that I still see and remember.[54]

Barber Shop is a repeated diamond pattern of three figural groups. The thin line of the masklike facial features is repeated in the clothes, chair bases, and footrests. The stiff legs and pointed shoes are a Lawrence convention and are reminiscent of similar features in the work of German Expressionist painter Ernst Ludwig Kirchner, with whose art Lawrence is familiar.

The Lovers (pl. 39) represents what must have been one of the most typical postwar scenes worldwide. Forms appear to slip off the picture plane to the left, and the composition is stabilized by the central axis of the figural pyramid and the round table in the foreground, a device recalling *Interior Scene* of 1937 (pl. 3). Unusual for Lawrence is the mood of the work, created by the half-empty bottle, the cigarettes, the record player, and the sexually suggestive plants that flank the scene.[55] A painting in a similar vein from the same year is *Jukebox* (pl. 40). The female figure in this composition is not portrayed eulogistically but is leaning against the jukebox in a swoon: Lawrence seldom depicts women in seductive attitudes. Also distinctive is the deep ultramarine blue pervading the sultry interior. Lawrence's early interest in pattern clearly survives, as evidenced in the arabesques of the jukebox exterior and the geometric parquet floor. *Funeral Sermon* (pl. 36) from 1946 is a painting done after Lawrence's sister's death. She had died while he was still in the service, in 1944.[56]

These paintings immediately following Lawrence's experience as a combat artist build upon the advances made in his Coast Guard work. Within sophisticated compositions of increasingly concentrated circumstance controlled by elaborate designs, forms are more elegant, often insistently angular. Cobalt and aquamarine blues dominate four of these paintings, demonstrating a taste for blue the artist acquired while at sea.

SHORTLY AFTER LAWRENCE'S RETURN FROM THE WAR, HE WAS INVITED TO TEACH AT Black Mountain College, the small avant garde school in North Carolina, during the summer of 1946. Many of the great innovators in American arts studied and worked at Black Mountain during the late 1940s and 1950s, including Robert Rauschenberg, John Cage, and Merce Cunningham. This was the first of Lawrence's many teaching posts. At Black Mountain, he met Josef Albers, the former Bauhaus master, who was head of the art department and director of the Summer Art Institute. Lawrence was greatly influenced by Albers's propagation of Bauhaus design principles. Before coming to Black Mountain, Lawrence was asked by Albers to send a statement entitled "My Ideas on Art (Painting) and the Artist." His comments are revealing:

During my apprentice days (about seven years) I was not grounded so much in the technical side of painting as I was in the philosophy and subject I was attempting to approach. As a professional artist this philosophy has always taken precedence over technique. For I believe the technique will come if the subject the artist is painting is important to him. My belief is that it is most important for an artist to develop an approach and philosophy about life—if he has developed this philosophy he does not put paint on canvas, he puts himself on canvas. When I paint a picture it is the last thought process concerning my subject. I think the most important part of a painting is the feeling toward the subject and what the artist wishes to say about it.[57]

At the eight-week summer session, Lawrence taught one painting class two mornings a week (figs. 40 and 41). The rest of the time he was free to attend lectures by Albers and other instructors:

Albers was a fascinating man. He was a tough man but very good. When I was at Black Mountain, his command of English was very limited, but his demonstrations were so visual that it made up for that. He had a very dynamic personality, and I really got a lot from that association.[58]

FIG. 44. Jacob and Gwen Lawrence, 1947.

Lawrence has evaluated the significance of his experience teaching at Black Mountain:

This was a milestone for me, as it initiated me into the ranks of teacher. It was an experience also for all of us concerned, for it was the South. Most of all, through Albers, I came to know something of the Bauhaus concept of art, which, simply put, stresses design—the theory and dynamics of the picture plane. Regardless of what you're doing, form, shape, color, space, and texture become the important things with which you deal.[59]

[Albers] had a great influence on me in a plastic, aesthetic sense. . . . I would say that much of my teaching is based on the teaching of the Bauhaus and Josef Albers. . . . I try to point out to [students] there's less chance of your becoming just illustrative when you become involved with the plastic elements of painting.[60]

Thus, Lawrence arrived at Black Mountain with an aesthetic philosophy based on compelling social content tempered by need for personal expression. After exposure to Albers's teaching, he translated an enhanced intellectual awareness of the formal qualities of painting into an increased emphasis on the elements of design, not only in his work but also in his pedagogy. Although Black Mountain was a very progressive school, Lawrence was the first black artist to be invited to teach there. Because of its location in the deep South and attendant racial tensions, particularly in rural areas, the Lawrences never left the college campus to go in to the nearby town of Asheville. The school was a self-contained entity, with students and teachers spending much time together. Gwen Lawrence participated in this arts community by teaching dance during the summer session.[61]

Once home in New York City, Lawrence, funded by a Guggenheim Fellowship that he had received just before his discharge from the service, began work on a series based on his war experiences. The fourteen panels of the *War* series (1946–47) are done in egg tempera on gessoed hardboard (see pls. 41–43). In the late 1930s, Lawrence had begun to experiment with egg tempera, an archaic form of water-base paint in which ground pigment is combined with water and egg yolk; when it dries it leaves a sheen. The use of this medium lent a new luminosity and transparency to his art. Lawrence described his use of the medium in these works:

There's very little color here. That's the beauty of the egg tempera. It's a glazing medium. You get your color by just glazing over, and it becomes darker and darker. Every medium has its own beauty. . . .
 In the early Renaissance paintings (like Crivelli), there's a lot of drawing, and the medium is a glazing medium—a lot of the white of the board comes through; texture . . . is drawing more than paint. It's a beautiful thing to exploit.[62]

Later he explained further:

In the egg tempera, you're working so thin that it's hard to get an even surface. Casein tempera is more opaque; egg tempera is more translucent and waxy. That's why I work on small panels, because you can't make big strokes with it . . . and you get streaks . . . unless you're going to use that as part of your form.[63]

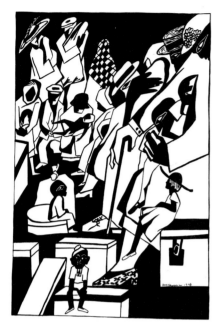

In painting the *War* series, Lawrence concentrated on the effect of war on individuals:

> In approaching this subject, I tried to capture the essence of war. To do this I attempted to portray the feeling and emotions that are felt by the individual, both fighter and civilian. A wife or mother receiving a letter from overseas; the next of kin receiving a notice of a casualty; the futility men feel when at sea or down in a foxhole just waiting, not knowing what part they are playing in a much broader and gigantic plan. . . .[64]

Employing close harmonies of somber color, he created a work that is profoundly poetic in its deeply felt personal emotion and sense of universalized human tragedy. There is great variety among the compositions: some are filled with active pattern, where others are dominated by single, blocky forms, the latter often presenting the more sober themes.

Shipping Out (pl. 41) is a complex figural grouping, rendering with great success the overwhelming claustrophobia of crowded stacked bunks below decks on a troop ship. This work again invites comparison with Egyptian wall painting, in the rhythm of the repeated figural silhouettes and the use of a frontal eye in a profile.[65] The subdivision of forms is now a special concern of the artist; he creates schematic patterns that do not model but suggest the swelling of form. The relatively long brush strokes across the forms collectively effect dynamic sweeps of movement. This feature, in its emphasis of the brushwork traces and the added energy they contribute, may reveal the influence of the gestural brushwork of Abstract Expressionism that was becoming a dominant trend in New York at this time.

Lawrence's experience at Black Mountain and his exposure to Albers's emphasis on one's "personal sense of looking"[66] apparently triggered an important transition in his style. For from that point on, Lawrence embraced a broader approach. His paintings are often more active visually, abstraction is heightened, and formal treatment of the overall composition becomes more complex as well as more consciously decorative. The paintings since the mid-1940s also display an increased use of a Synthetic Cubism derived from Picasso's work in the 1920s, with overlapped forms pressed toward the center (compare Picasso's *Three Musicians,* 1921, fig. 42). But like Picasso, no matter how abstract and stylized his forms become, Lawrence's source is always nature.

Casualty—The Secretary of War Regrets (pl. 42) is moving in its understatement. In the use of the expressive back view of the figure, this work recalls a favorite device of both Giotto and Orozco (figs. 29 and 43). *Going Home,* Panel 12 of the *War* series, is included here as Plate 43. Forty years later Lawrence reflected on his shipboard experiences with a sense of immediacy:

> I was on a troop transport ship which was a very sad experience, something that will remain with me for the rest of my life. We would go overseas carrying 5,000 troops and we would come back a hospital ship. I'm sure that many of those cases are in the hospital today—basket cases. I'll always remember the physical and psychological damage.[67]

The *War* series was shown at the Downtown Gallery in December 1947.[68] *Time* magazine called the paintings "by far his best work yet."[69] This series clarifies one of Lawrence's artistic strengths: he uses distilled form and color to capture the essence of a concept or incident, leading the viewer to sense the emotional issues behind the symbols and to experience the impact of allusion without feeling manipulated by the artist.

While Lawrence was developing the *War* series, twenty of his paintings were included in a significant exhibition, "Three Negro Artists" (Lawrence, Horace Pippin, and Richmond Barthé), at the Phillips Memorial Gallery (December 1946 to January 1947). The following month, he also participated in New York's A.C.A. Gallery's group show, "Social Art Today," which included Robert Gwathmey, Jack Levine, David Smith, Joseph Hirsch, Philip Evergood, Ben Shahn, and William Gropper. A reviewer in the *New York Telegram* considered the exhibition " 'in the nature of a roll call' to contemporary artists to use their art as an instrument for social reform"[70] (fig. 44).

An opportunity for Lawrence to travel again to the deep South and to explore old subjects arose in 1947 when he was commissioned by *Fortune* magazine to do ten paintings of postwar social conditions in the southern states. *Red Earth* (1947) is one of these works (pl. 44). In this image, the rich red Georgia soil upon which the farm-

ers depend creates a lush foreground expanse. Several of these paintings were published in color by *Fortune* in August 1948, accompanied by a short essay written by Social Realist photographer Walker Evans, who was on the magazine's staff. Evans remarked on the "strong tempera paintings—a little milder, a bit more objective than before"; his bias may stem from his appreciation for the camera's "objective" eye.[71]

That same summer (1947), Jackie Robinson precipitated the integration of baseball's major leagues, and Lawrence later created a work, *Strike*, to commemorate this event (pl. 45). The presence of the black catcher (not a portrait of Robinson) is discretely conveyed. Attention to the spiked shoes of the player indicates Lawrence's love of expressive, pointed shapes. When recently asked by a student whether he does sketches on site for a work such as this, Lawrence's response may reveal lessons learned from Orozco many years earlier:

> I've always worked in an expressionist manner. I get a feeling about a thing and go back to the studio. I don't do preparations. I work direct, on the paper—it suits my temperament. The degree of our success depends on how we discover our own temperament and how we [best] perform.[72]

Strike demonstrates two new interests of the artist: his response to an isolated topical event and the subject of athletes in arrested motion. This work is tied to earlier work by his "freeze-frame" approach to figural composition. The work represents a move forward in his evolving style, as it captures the active, noisy atmosphere of the crowded ball park through compressed incident. Lawrence's work from the late 1940s demonstrates general development: figures are larger, forms are subdivided into smaller and smaller areas, and works become busy pattern. About *The Wedding* (pl. 46), another representative work from this period, Lawrence said:

> For me, the most important function of art is observation. My long term approach is an effort to develop the insight and personal philosophy I bring to my observation. I tried to do this in *The Wedding*. I conceived the idea on the spot and in my handling of the problem established the atmosphere of tradition by a formal handling of the design. The pageantry is suggested by emphasizing and enriching the color, and by exaggerating the elements present at the wedding which was my original take-off point.[73]

In 1948, Lawrence participated in the Art Institute of Chicago's Eighth Annual Exhibition of the Society for Contemporary Art. For his entry, *Migration* (1948), he received the Norman Wait Harris Silver Medal and prize. The exhibition of water colors and drawings included work by such artists as Milton Avery, Lyonel Feininger, Morris Graves, Ben Shahn, Stuart Davis, Matta, and Mark Tobey.[74] Lawrence's work was also included in a multi-gallery exhibition of the work of Artists Equity members in New York in March 1948. Art historian and critic Sam Hunter highlighted the work of Lawrence in his review in *The New York Times*:

> Both as an earnest [indication] of the contemporary mood and vitality of American art and as an achievement in intelligent selection, the fourteen group shows . . . are cause for jubilation. . . . If the emphasis is . . . on content and dramatization of contemporary situations, it is precisely by thus limiting itself that this art is convincing in its honesty. Most responsive to social content without sacrificing emotional vitality or intensity . . . are the paintings of Ben Shahn, Jacob Lawrence, Fletcher Martin, Jack Levine, and Aaron Bohrod.
>
> [In Lawrence's work] there is a laconic handling of explosive subject matter, direct as a broadside. . . .[75]

The opportunity to execute his first book illustrations came to Lawrence in 1948, when he was asked to contribute six illustrations for Langston Hughes's poetry volume, *One-Way Ticket* (fig. 45). Hughes's poetry about the oppression of the blacks in America is emotionally charged; the drawings are among Lawrence's most strident work. These black and white gouaches have the appearance of woodcuts. Like Käthe Kollwitz, an artist long of interest to Lawrence, he uses the stark black and white pattern to convey his social subject matter. His approach to these drawings also may have been influenced by woodcuts by Chinese artists of the 1930s, as well as those of social scenes by the Belgian Frans Masereel (Lawrence has a 1928 volume of Masereel's graphics in his library).[76] Stimulated by other commissions around this time, Lawrence did several drawings for the *New Republic* and for *Masses and Mainstream* (1948 and 1949) in a highly surrealistic imagery that reveals an incisive

ONE-WAY TICKET

I pick up my life
And take it with me
And I put it down in
Chicago, Detroit,
Buffalo, Scranton,
Any place that is
North and East—
And not Dixie.

I pick up my life
And take it on the train
To Los Angeles, Bakersfield,
Seattle, Oakland, Salt Lake,
Any place that is
North and West—
And not South.

I am fed up
With Jim Crow laws,
People who are cruel
And afraid,

Who lynch and run,
Who are scared of me
And me of them.

I pick up my life
And take it away
On a one-way ticket—
Gone up North,
Gone out West,
Gone!

FIG. 45. Illustration and poem, poetry volume, *One-Way Ticket* by Langston Hughes, 1948. (a) Illustration, *One-Way Ticket*, gouache on paper, 25 × 16½. (b) Poem, "One-Way Ticket," from Hughes, 1948.

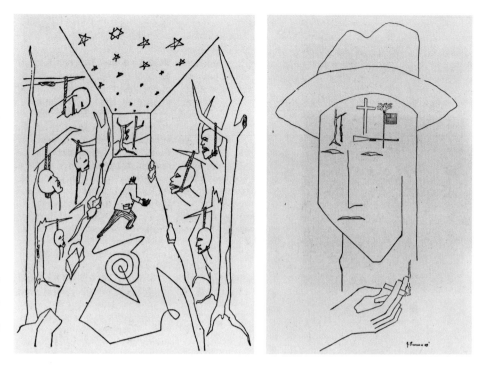

FIG. 46. Illustrations for *New Republic* articles, 1947 and 1948. (a) "Violence and Hope in the South" by Henry Wallace, *New Republic*, 117:23 (December 8, 1947). (b) "Books in Review: A Liberal View of the South" by Richard Watts, Jr., *New Republic*, 118:3 (January 19, 1948), p. 27.

journalistic treatment of texts with controversial social and political content (fig. 46). These drawings show a new concern with line, an interest Lawrence came to exhibit more fully in subsequent years.

THE 1940S WERE A TIME OF GROWTH AND EXPANSION FOR JACOB LAWRENCE. THE wide recognition he received for his series and his Downtown Gallery association put him in touch with all segments of the art world. Travel abroad and in the American South carried him beyond the familiar life of Harlem, bringing greater exposure to the human condition. At Black Mountain, Lawrence discovered the energies and rewards of teaching, and contact with Josef Albers and other artists augmented his aesthetic outlook. His art acquired breadth and greater stylistic complexity and sophistication, reflected in over 250 works he produced in this decade.

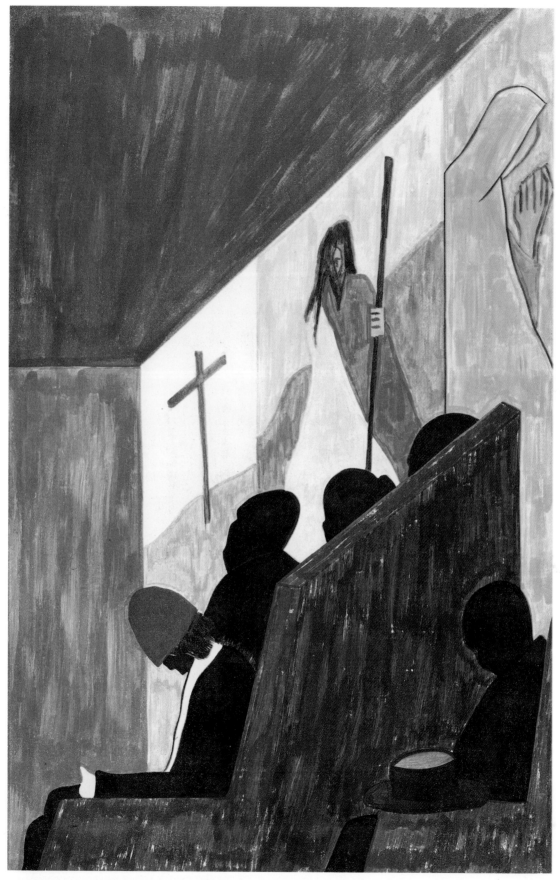

PL. 16. *The Migration of the Negro Series*, 1940–41.
No. 54: *In the church the migrants found one of their main sources of recreation and social activity.*
Tempera on hardboard, 18 × 12.
Museum of Modern Art, New York, gift of Mrs. David M. Levy.

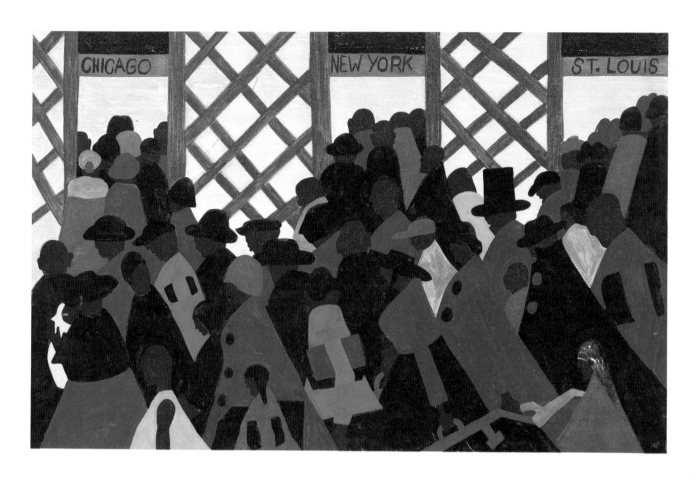

PL. 17. *The Migration of the Negro* Series, 1940–41.
No. 1: *During the World War there was a great migration North by Southern
Negroes.*
Tempera on hardboard, 12 × 18.
The Phillips Collection, Washington, D.C.

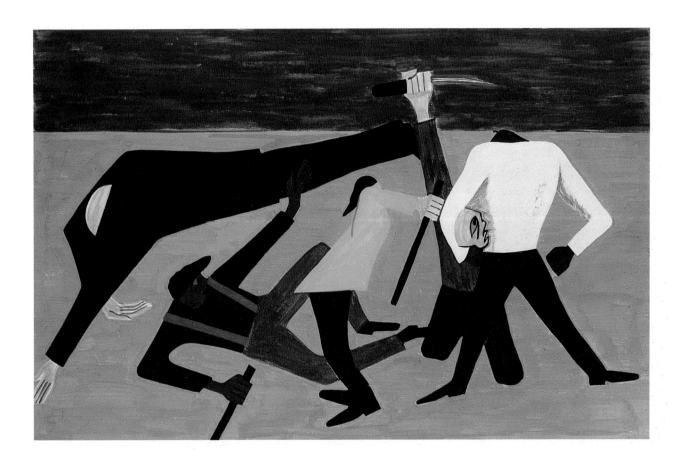

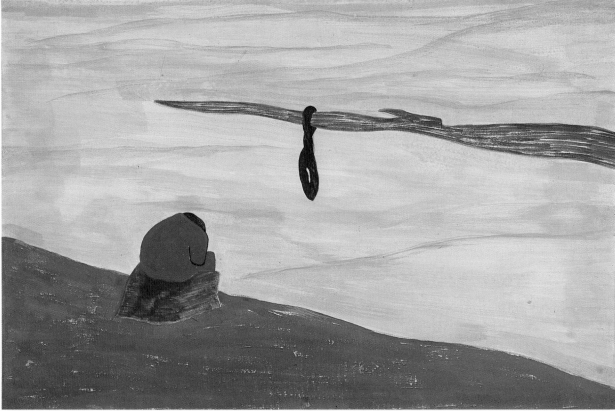

ABOVE
PL. 18. *The Migration of the Negro* Series, 1940–41.
No. 52: *One of the largest race riots occurred in East St. Louis.*
Tempera on hardboard, 12 × 18.
Museum of Modern Art, New York, gift of Mrs. David M. Levy.

BELOW
PL. 19. *The Migration of the Negro* Series, 1940–41.
No. 15: *Another cause was lynching. It was found that where there had been a lynching, the people who were reluctant to leave at first left immediately after this.*
Tempera on hardboard, 12 × 18.
The Phillips Collection, Washington, D.C.

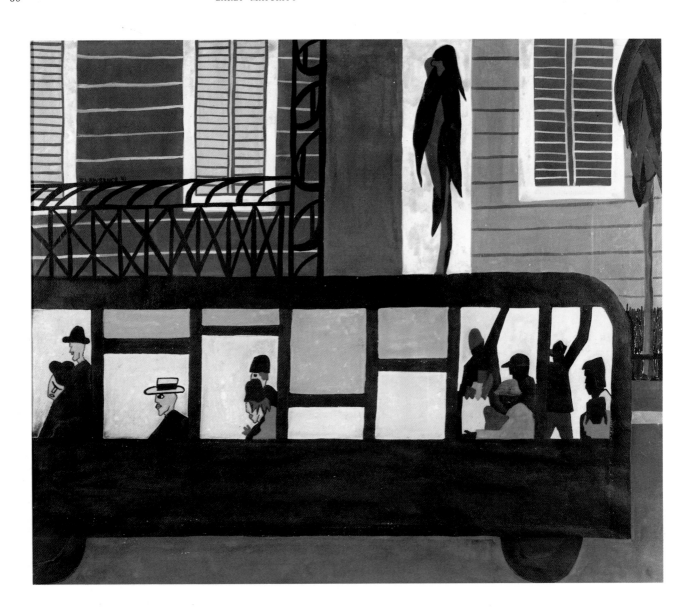

PL. 20. *Bus*, 1941.
Gouache on paper, 17 × 22.

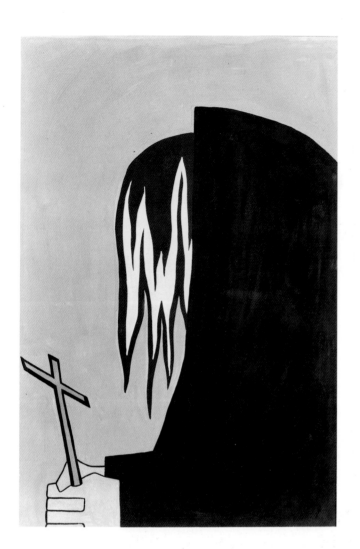

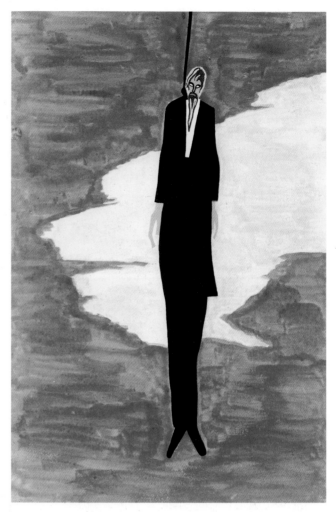

PL. 21. *John Brown* Series, 1941.
No. 21: *After John Brown's capture, he was put to trial for his life in Charles Town, Virginia (now West Virginia).*
Gouache on paper, 19¾ × 13⅝.
Detroit Institute of Arts, gift of Mr. and Mrs. Milton Lowenthal.

PL. 22. *John Brown* Series, 1941.
No. 22: *John Brown was found "Guilty of treason and murder in the 1st degree" and was hanged in Charles Town, Virginia, on December 2, 1859.*
Gouache on paper, 19¾ × 13⅝.
Detroit Institute of Arts, gift of Mr. and Mrs. Milton Lowenthal.

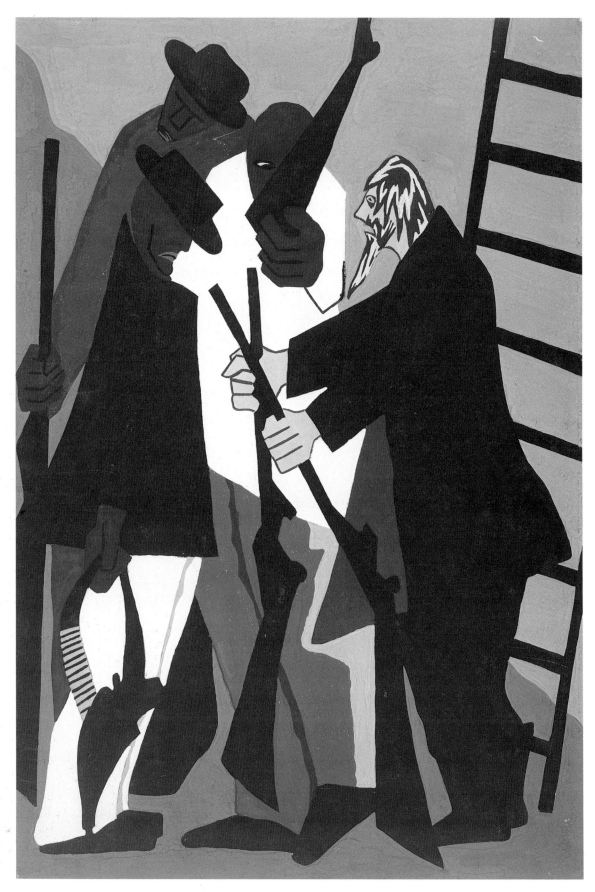

PL. 23. *John Brown* Series, 1941
No. 6: *John Brown formed an organization among the colored people of the
Adirondack Woods to resist the capture of any fugitive slave.*
Gouache on paper, 19¾ × 13⅝.
Detroit Institute of Arts, gift of Mr. and Mrs. Milton Lowenthal.

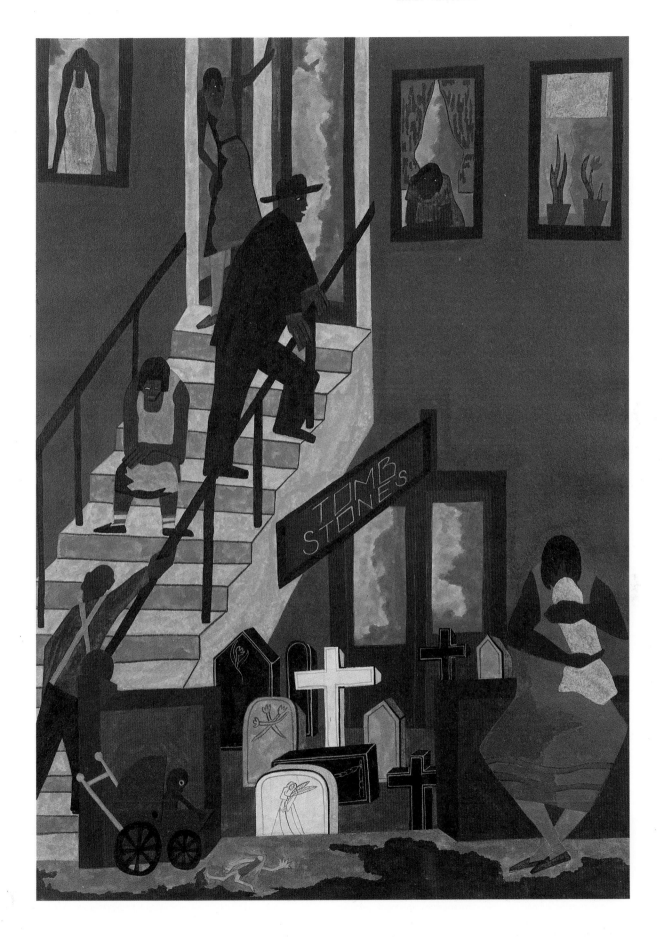

PL. 24. *Tombstones*, 1942.
Gouache on paper, 30 × 22.
Whitney Museum of American Art, New York.

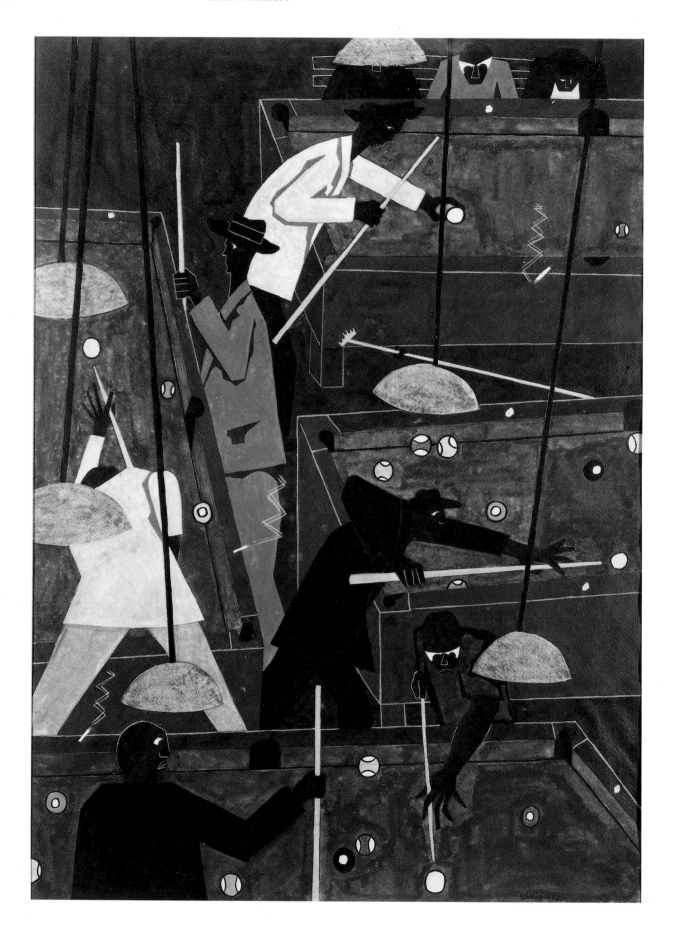

PL. 25. *Pool Parlor*, 1942.
Gouache on paper, 30 × 22¼.
The Metropolitan Museum of Art, New York, Arthur H. Hearn Fund.

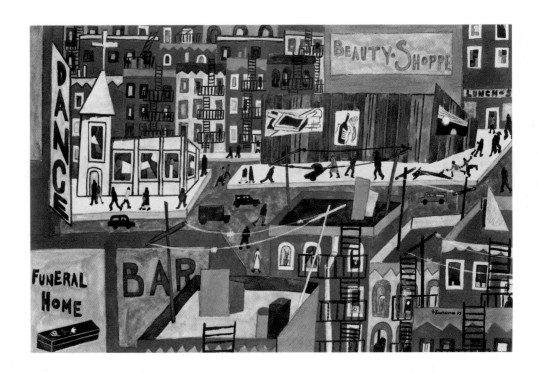

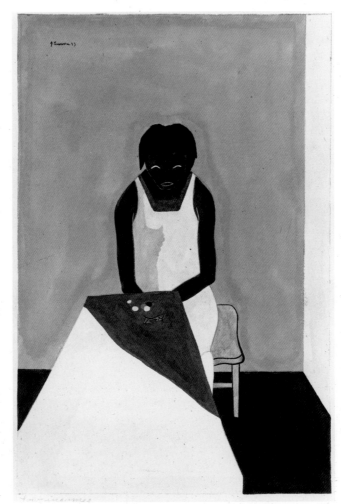

ABOVE
PL. 26. *Harlem* Series, 1942–43.
No. 1: *This is Harlem.*
Gouache on paper, 14⅜ × 21⅞.
Hirshhorn Museum and Sculpture Garden,
Smithsonian Institution, Washington, D.C.

BELOW
PL. 27. *Harlem* Series, 1942–43.
No. 2: *Most of the people are very poor. Rent is high.*
Food is high.
Gouache on paper, 21 × 14.
Collection of Pietro Belluschi.

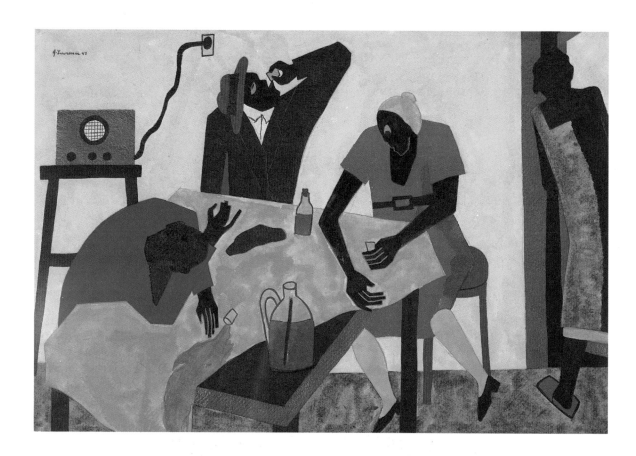

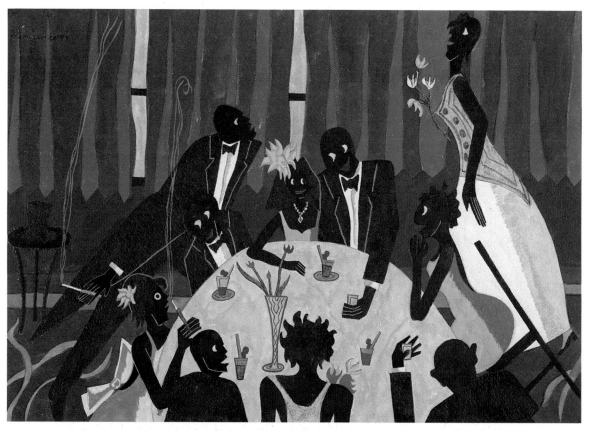

ABOVE
PL. 28. *Harlem* Series, 1942–43.
No. 15: *You can buy bootleg whiskey for twenty-five cents a quart.*
Gouache on paper, 14¼ × 21¼.
Portland Art Museum, Oregon, purchase from the
Helen Thurston Ayer Fund.

BELOW
PL. 29. *Harlem* Series, 1942–43.
No. 19: *And Harlem society looks on.*
Gouache on paper, 14 × 21.
Portland Art Museum, Oregon, purchase from the
Helen Thurston Ayer Fund.

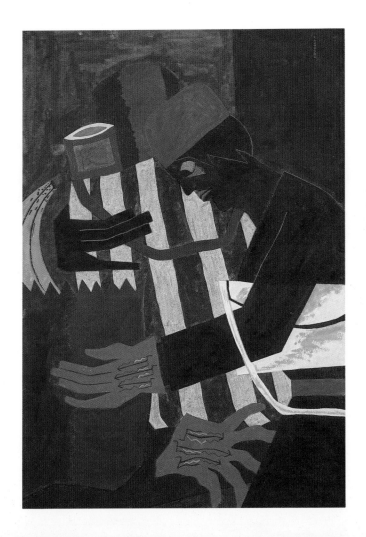

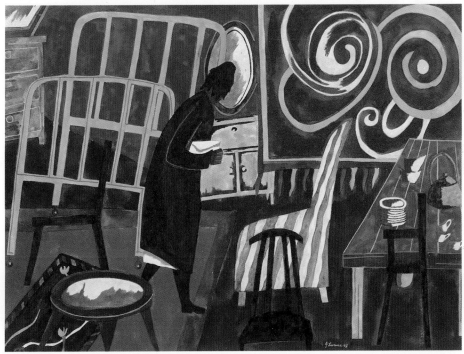

ABOVE
PL. 30. *Woman with Grocery Bags*, 1943.
Gouache on paper, 29¾ × 21.
Collection of Mr. and Mrs. Charles Gwathmey.

BELOW
PL. 31. *The Apartment*, 1943.
Gouache on paper, 21¼ × 29¼.
Hunter Museum of Art, Chattanooga, Tennessee, purchase from
the Benwood Foundation and the 1982 Collectors' Group Funds.

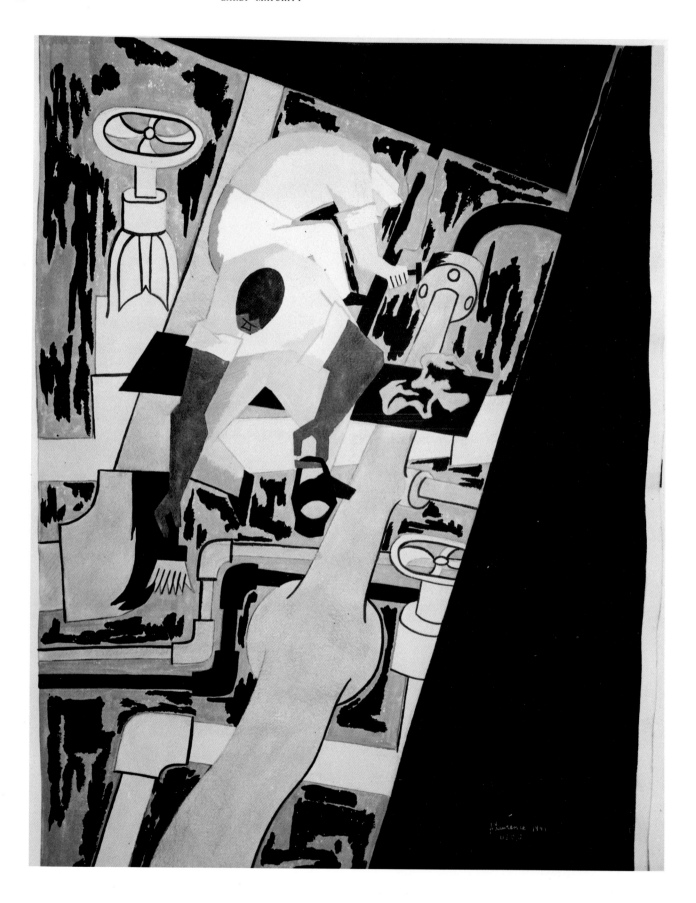

PL. 32. *Painting the Bilges*, 1944.
Gouache on paper, 29 × 20.
U.S. Coast Guard Archives.

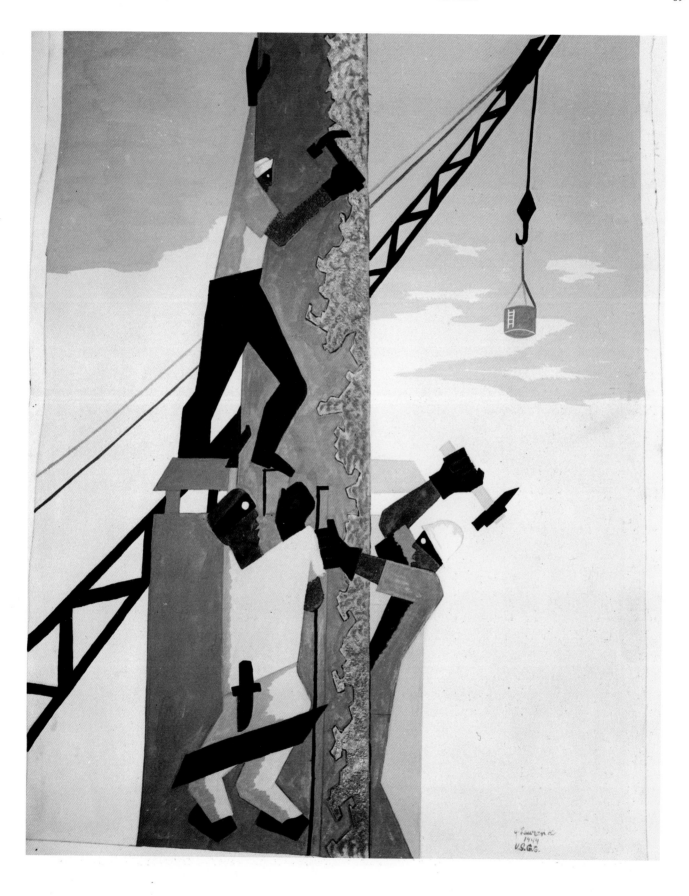

PL. 33. *Chipping the Mast*, 1944.
Gouache on paper, 29 × 20.
U.S. Coast Guard Archives.

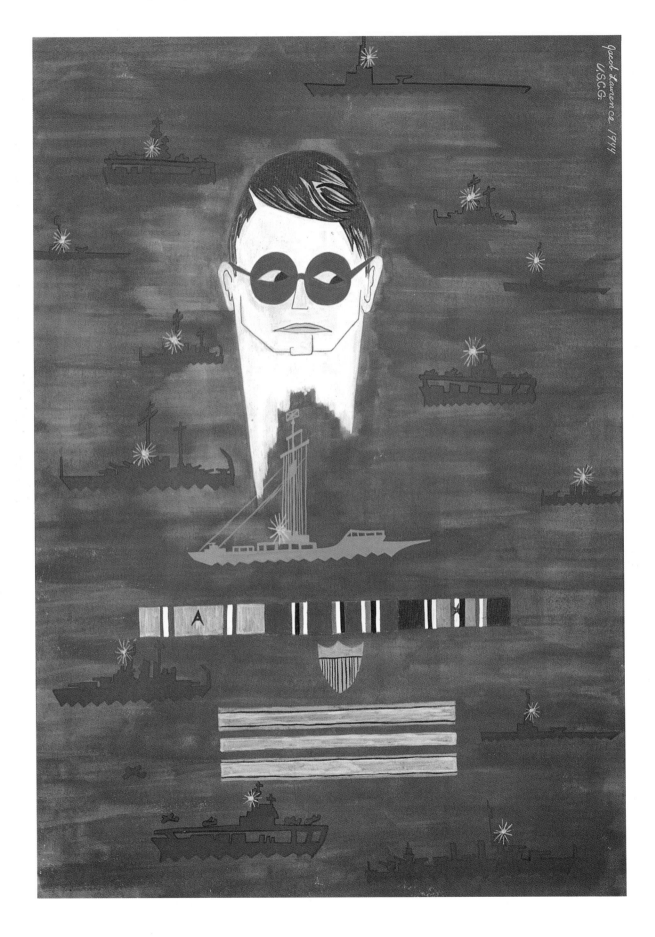

PL. 34. *Captain Skinner*, 1944.
Gouache on paper, 29 × 20.
Collection of Carlton Skinner.

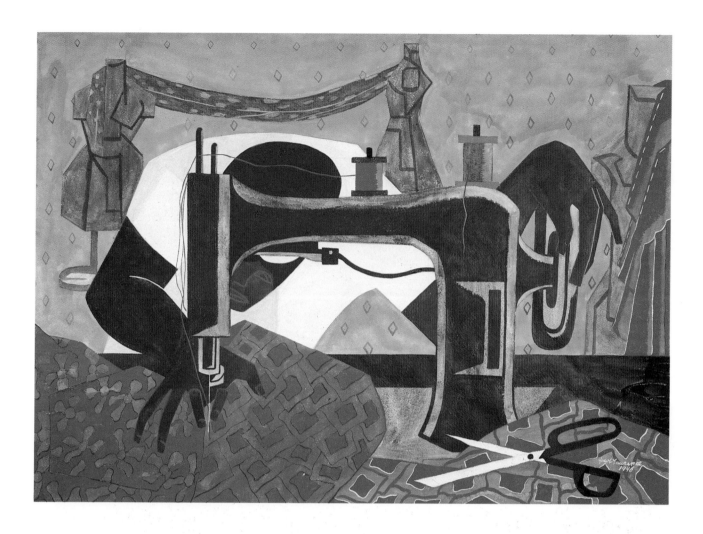

PL. 35. *The Seamstress*, 1946.
Gouache on paper, 21⅝ × 29⅞.
Southern Illinois University Museum, Carbondale, gift of the National
Academy of Art.

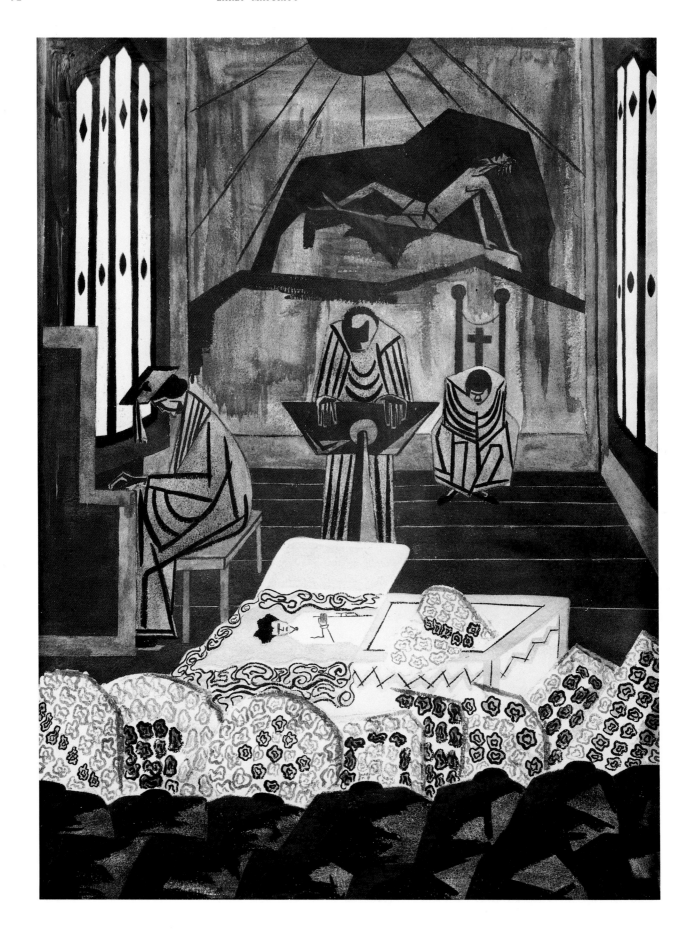

PL. 36. *Funeral Sermon*, 1946.
Gouache on paper, 30 × 22.
Brooklyn Museum, New York.

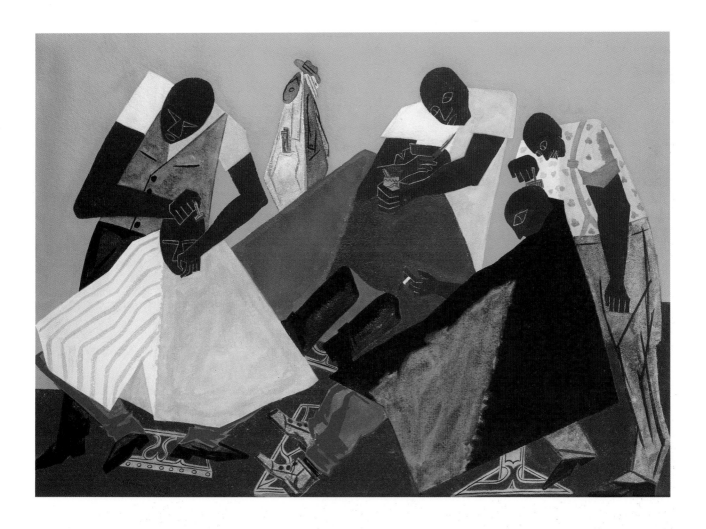

PL. 37. *Barber Shop*, 1946.
Gouache on paper, 21⅛ × 29⅜.
Toledo Museum of Art, Ohio, gift of Edward Drummond Libbey.

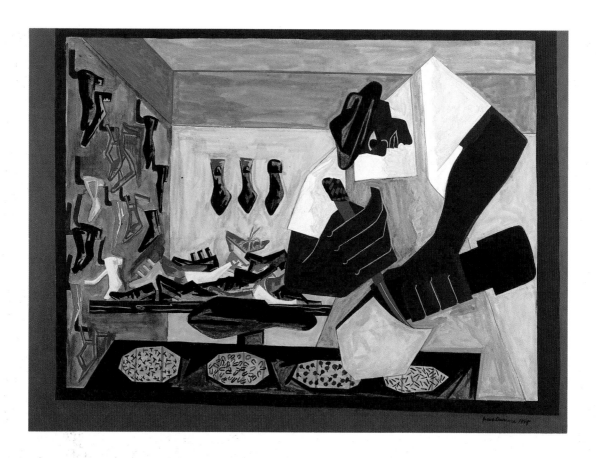

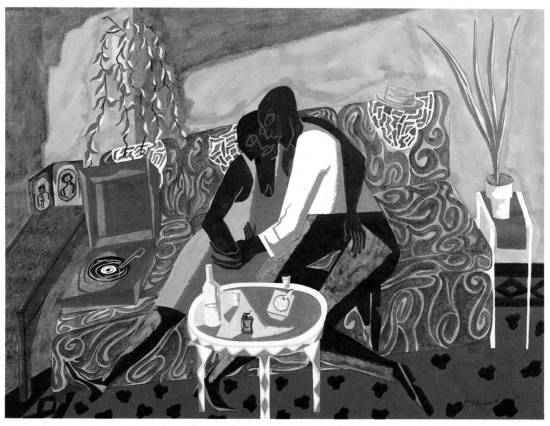

ABOVE
PL. 38. *Shoemaker*, 1945.
Tempera on hardboard, 30 × 40.
Metropolitan Museum of Art, New York, George A. Hearn Fund.

BELOW
PL. 39. *The Lovers*, 1946.
Gouache on paper, 21½ × 30.
Collection of Mrs. Harpo Marx.

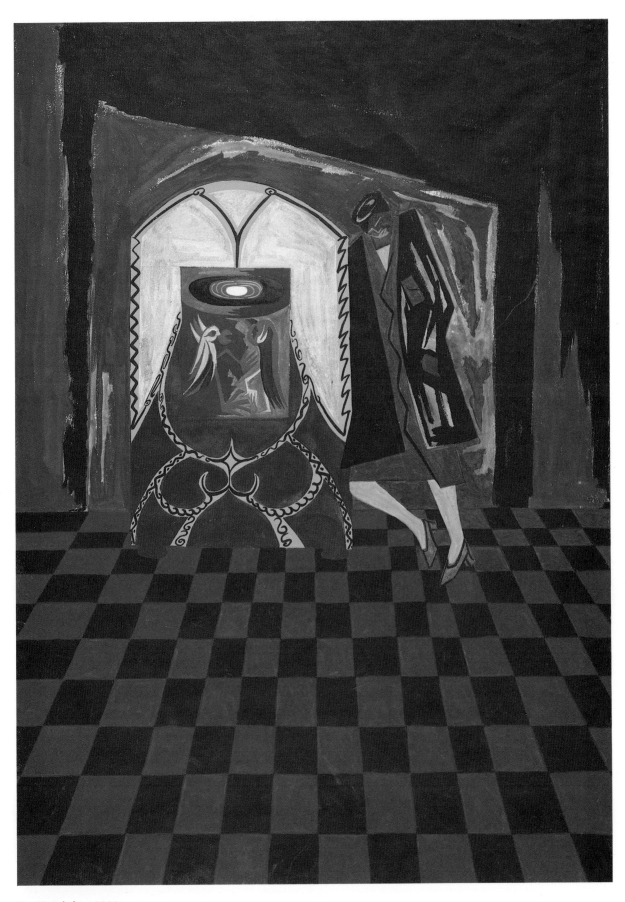

PL. 40. *Jukebox*, 1946.
Gouache on paper, 30 × 22.
Detroit Institute of Arts.
Gift of Dr. D. T. Burton, Dr. M. E. Fowler,
Dr. J. E. Greene, and Mr. J. J. White

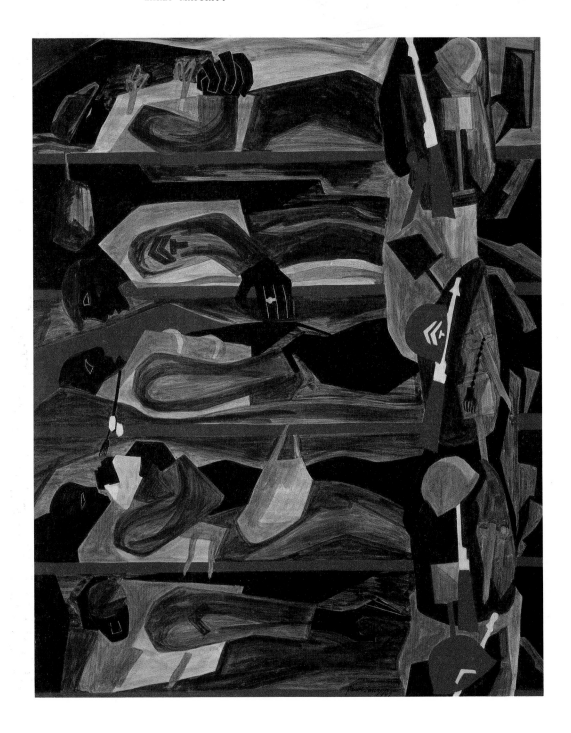

PL. 41. *War* Series, 1946–47.
No. 2: *Shipping Out.*
Egg tempera on hardboard, 20 × 16.
Whitney Museum of American Art, New York, gift of Mr. and
Mrs. Roy R. Neuberger.

PL. 42. *War* Series, 1946–47.
No. 11: *Casualty—The Secretary of War Regrets.*
Egg tempera on hardboard, 20 × 16.
Whitney Museum of American Art, New York, gift of
Mr. and Mrs. Roy R. Neuberger.

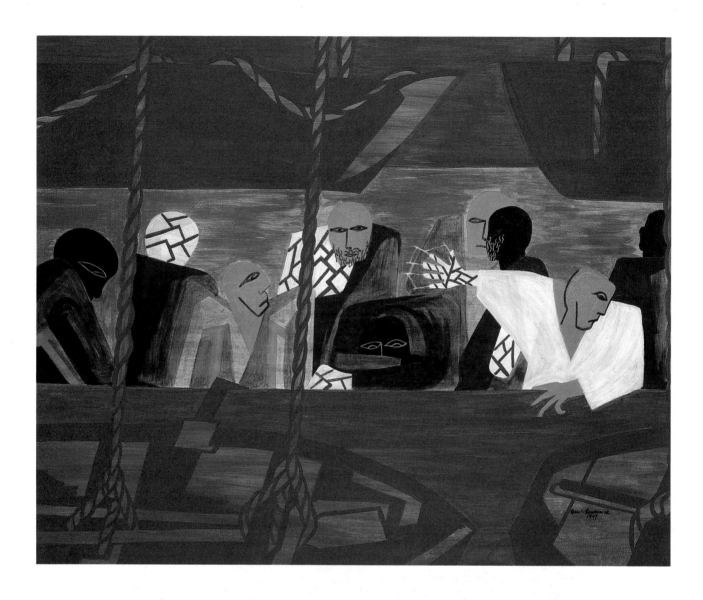

PL. 43. *War* Series, 1946–47.
No. 12: *Going Home.*
Egg tempera on hardboard, 16 × 20.
Whitney Museum of American Art, New York, gift of
Mr. and Mrs. Roy R. Neuberger.

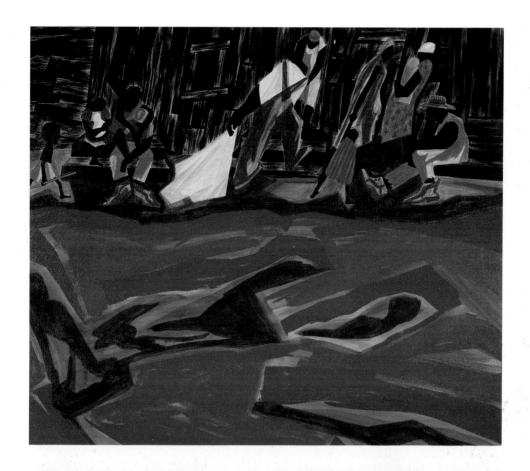

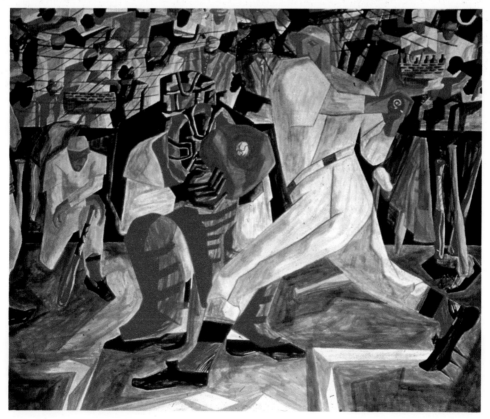

ABOVE
PL. 44. *Red Earth*, 1947.
Tempera on hardboard, 20 × 24.
Collection of Mr. and Mrs. James Banks.

BELOW
PL. 45. *Strike*, 1949.
Tempera on hardboard.
Howard University, Washington, D.C.

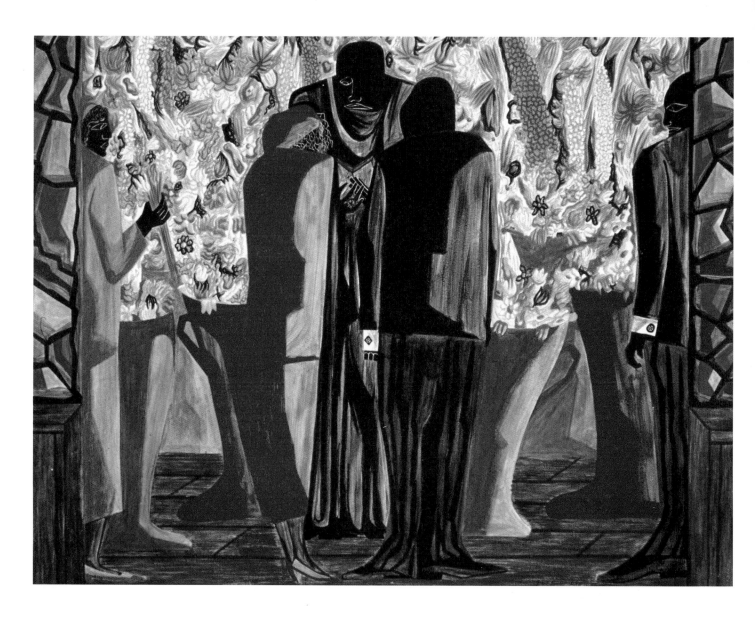

PL. 46. *The Wedding*, 1948.
Tempera on hardboard, 19¼ × 23½.

4. Mid-Career in New York: 1949 to 1968

At the end of the 1940s, Lawrence at thirty-two was extremely successful and had enjoyed wide recognition for almost a decade. Succumbing to the pressures created by this success, in October 1949 Lawrence entered Hillside Hospital, a psychiatric hospital in Queens, as a patient. Bearden and Henderson attribute his distress to career-related tensions:

> More successful than he had ever dreamed, Lawrence now began to realize how difficult were the problems he was tackling. Like many other artists, he was extremely sensitive and filled with self-doubt about his own abilities. He had been, he felt, only lucky. His successes seemed unreal when so many of his friends were less well off. And this made him nervous and depressed.[1]

Lawrence spent nine months at Hillside, returning home in July 1950. Throughout his treatment and voluntary confinement, Lawrence remained actively creative, producing several drawings and eleven strong paintings of the patients, their moods, and routines (fig. 47). The *Hospital* works were shown at the Downtown Gallery soon after his discharge from Hillside; a lengthy article in *The New York Times Magazine* came out at the same time, offering clarification of his crisis.[2]

In the two paintings included here (pls. 47 and 48), it is evident that Lawrence for the first time deals in his art with an environment peopled entirely by whites, and moreover by the psychically disordered. In *Depression,* men pace the halls, their shoulders slumped and heads bowed with the weight of their despair. The pea green walls faithfully convey institutional stillness and boredom. One man ambulates with hands clasped behind his back in concentrated pointlessness. Characteristic of their disordered world are the puffy eyes and messy hair; one man still wears pajamas and

FIG. 47. Jacob Lawrence at work on the *Hospital* paintings, at Hillside Hospital, 1950.

slippers, displaying a typical patient's habit of not bothering to dress in the morning. Through a doorway, a Jewish man reads his sacred book, a drooping but spritely flower on the dresser offering a note of hope. Cheerful insistence is also found in unexpected touches of vibrant color: bright blue slippers, red suspenders, the bright red bedspread. *In the Garden* (pl. 48) presents a contrasting, frantic tone through a new approach to composition: pictorial massing of vegetation and insects becomes arclike facets and diamond-shaped pattern. The unsettled minds of patients who garden for occupational therapy are reflected in the shifting prismatic broken forms and surfaces that render the frenzied energy expended. Lawrence remembers this scene as one of exuberant activity: "It was exciting for me to do gardening. It was the first time I'd lived in the country. I didn't make any sketches. I remember the feeling of it, and I tried to get that feeling in here."[3] He later reflected that the *Hospital* series was close in content to his other series "because it still says struggle, doesn't it?"[4]

The *Hospital* paintings are a unique serial document in art history, presenting the life of psychiatric patients in a private sanitarium. Lawrence's technique has altered to make drawing more obvious: line predominates, a treatment following no doubt from his recent experiences in the late 1940s with drawings as finished works (see fig. 46). This feature is most clearly evident in the pencil drawing that shows through the thinly applied wash of color in the *Hospital* paintings. Color is lighter in tone, perhaps owing to his use here of casein on paper, a medium that gives a chalky watercolor effect. Building upon his emotional explorations of the *War* series, Lawrence's subject matter has become more introspective. In this series, the mental state of the individual is his concern: imagery makes a shift in focus to faces and facial expression. Even though the artist is one of the patients, he assumes the objectivity of an onlooker, empathetically reflecting on the condition of his fellow patients. Dr. Emmanuel Klein, who was Lawrence's doctor and had "long studied the relation between art and neurosis," explained:

> Unlike Van Gogh, Lawrence simply had nervous difficulties neither particularly complicated nor unique, which became so much of a burden that he voluntarily sought help. These paintings do not come from his temporary illness. As they always have—and is true for most real artists—the paintings express the healthiest part of his personality, the part that is in close touch both with the inner depths of his own feeling and with the outer world.[5]

Lawrence evaluated the significance of his hospital stay:

> I gained a lot: The most important thing was that I was able to delve into my personality and nature. You have people to guide you, and I think it was one of the most important periods of my life. It opened up a whole new avenue for me; it was . . . a very deep experience. . . .[6]

Lawrence's rapid recovery is greatly attributable, he is quick to point out, to his wife's unwavering support during this difficult time.

When Lawrence left the hospital he returned artistically to genre subjects, taking a fresh and intense look at old, familiar things; the new intricacy explored in the *War* and *Hospital* series is extended. *Slums,* 1950 (fig. 48), depicts a Harlem tenement window like those in the background of many earlier examples, but this time he magnifies it, concentrating on the decay and infestation prevalent in many Harlem dwellings: the empty tin can, the trap containing the bloody, drooping, dead mouse, the attracted flies, and cockroaches swarming over the window frame. The window shade is askew, and outside all seems awry: clothes hang in disarray from the fire escape through which we look; details of facades and repeated rooftops become a confusing cubic pattern. Beyond, gables peek up like giant's eyes. In contrast to the lighter spirited Harlem cityscape of eight years before, Lawrence focuses on the squalid minutiae of the inner city: the uneasy reality of the slums is revealed. His *Photographer's Shop* (pl. 49) of this period is similar to many earlier shop-front scenes, but this one lacks actual human figures.[7] Instead, he offers the images of people, like traces: the displaced phases of their lives. The flowers become a starlike pattern or a sparkle, and the sparkle becomes a characteristic of his work in the 1950s. These two paintings represent an iconographic departure for Lawrence, for rather than direct depiction of people involved in their daily existences, he offers instead the objects that represent their presences. This penchant for overt symbolism,

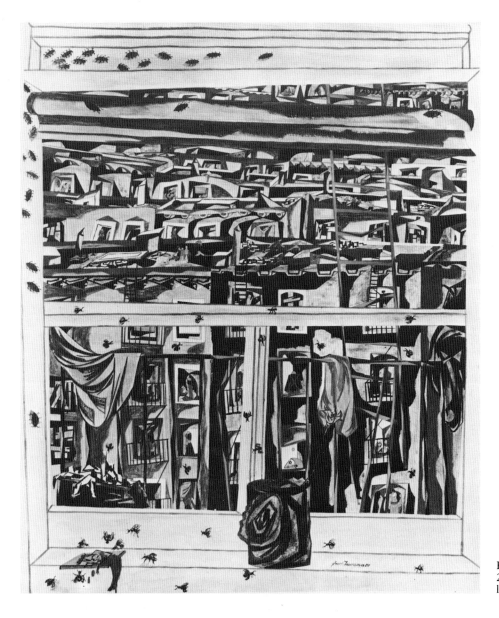

FIG. 48. *Slums*, 1950. Gouache on paper, 25 × 21½. Collection of Mr. and Mrs. William Marsteller.

evident in much of his work in the early 1950s, suggests that because of his psychiatric treatment, Lawrence became more interpretive and evolved a more penetrating approach to content.

Chess on Broadway (pl. 50) is one of the artist's many views of chess players. Lawrence explained: "I was always curious about chess. So while we were in New Orleans we got a game and we bought Capablanca's book, the great Cuban chess master, and we learned how to play through the book."[8] In the forties and fifties he frequented the chess parlors in New York on 42nd Street. Also, the Harlem YMCA had chess, and he had gone there to play and watch the players.[9]

Following genre works of this kind, Lawrence began a series he called *Theater,* based on his longstanding interest in Harlem theater life. These twelve panels, of which *Tragedy and Comedy* (pl. 51) and *Vaudeville* (pl. 52) are elegant representatives, are drawn from Lawrence's youthful memories of the Apollo Theater in Harlem:

> Going to the Apollo Theater was a ritual of ours . . . to see the comedians—vaudeville. I grew up with this. The actors made the circuit of the East Coast and came back every four weeks. We got to know the performers. With television, now, there's not the kind of rapport as in a large theater. The smells, the makeup, the magic comes through.[10]

FIG. 49. Jacob Lawrence working, mid 1950s.

In describing the decorated panel behind the actors, Lawrence explained, "I wanted a staccato-type thing—raw, sharp, rough—that's what I tried to get."[11]

The *Theater* paintings are among his most abstract compositions, presenting the artificial quality of drama. The decorative character of his work, particularly evident beginning in the mid-1940s, is most pronounced in this phase. Stylistic experimentation is evident in the incorporation of the elongated diamonds and facets he first used to break up surfaces in the *Hospital* paintings. This sequence of works, with its macabre imagery, was reported by *The New York Times* to have "shrill color and line that cuts like a hot, sharp knife," exposing "the whole nerve of the theater and entertainment world."[12] The series was shown at the Downtown Gallery in February 1953 and the critical reception was most approving.

This new decorative mode is continued in *Village Quartet* (pl. 57) and *Masks* (pl. 53) from the mid-1950s. In *Village Quartet* (1954), Lawrence expresses the rhythm, color, and staccato pattern of his visual and auditory reactions when visiting one of the bars or small nightclubs in Greenwich Village.[13] *Masks* is mysterious: areas of the artist's studio appear to be invaded with cracks or meandering vines. The faceted, stylized modeling has entered the faces that the masks create about the room; eyes are no longer shown in sharp contrast but are lost in the design of highlights and shadows. In other works of this period, this tendency causes human expression to be underplayed and impact to be created by body language and gesture.

Almost as if these works from the first half of the 1950s were a temporary foray into fantasy for Lawrence, he turned to producing a new, ambitious historical series, *Struggle: From the History of the American People,* an effort supported by a Chapelbrook Foundation Fellowship and based on research at the Schomburg Library. Lawrence had also become associated with the Alan Gallery in 1953. Charles Alan had worked with Edith Halpert at the Downtown Gallery ever since the war, with the understanding that he take over when she retired. But when the time came, Halpert found herself emotionally unable to give up the gallery, so she divided the roster, giving Charles Alan the artists that had been with her less than thirty years. "She was very unhappy about giving Jake up," Gwen Lawrence recalls. "She was going through a hard time because she was bitterly against Abstract Expressionism—she was very figurative [in preferences]."[14] Lawrence enjoyed his relationship with the Alan Gallery, which in the late 1950s represented artists such as Bruce Connor, Paul Burlin, David Fredenthal, Suzi Gablik, William King, Louis Guglielmi, and Herbert Katzman (fig. 49).[15]

During this period, Lawrence had also been invited to enter a mural competition for the United Nations Building in New York. After completing the mural study in the fall of 1955, he accepted a residency fellowship offered by the Yaddo Foundation in Saratoga Springs, New York—an organization established to aid creative work in arts and letters. In a letter to Charles Alan he indicated how much the UN competiton meant to him:

> I am settled now and working—you know that always takes a little time. I think it was a very good idea for me to come to Yaddo at this time, as I was just about exhausted from the mural. . . . I think that I have prepared myself for the decision of the jury—whatever it may be. There is the satisfaction of knowing, however, that I put everything I could into this assignment, therefore giving myself every possible chance. It is a job that I am not ashamed of. . . . So along with yourself and Gwen, I am keeping my fingers crossed.[16]

The ten competition finalists (mural studies and sculpture models) were exhibited at the Whitney Museum. The winning design was announced November 5; Lawrence shared first prize with Stuart Davis. Unfortunately, the mural was never done because of lack of funding. The subject of his study was "the five races—black, brown, yellow, red, and white."[17]

Lawrence spent two months at Yaddo, where he had his own studio, working on the *Struggle* series (1955–56). The series carries the observer from the Revolutionary War through the early decades of American history with dramatic assertion (see pls. 54–56). These paintings, of egg tempera on small gessoed panels and with descriptive titles, are in the same format as the early series. The episodic narrative begins with Patrick Henry (1775) and ends in 1817 with the first movement westward in covered wagons. Thirty panels were completed of the projected sixty that would end with the sailing of the American fleet around the world in 1908. Lawrence realized that his approach to American history was broadening:

 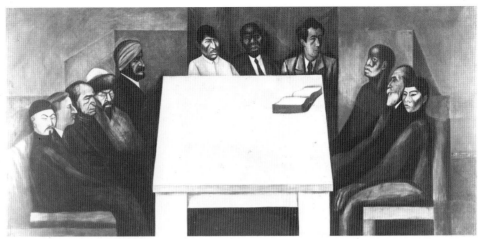

FIG. 50. José Clemente Orozco, *The Trench*, 1926. Fresco. Panel from the National Preparatory School Murals (1923–26), Mexico City.

FIG. 51. José Clemente Orozco, *The Table of Brotherhood*, 1930–31. Fresco, 6'4" × 16'9". Panel from the murals at The New School for Social Research, New York.

> Years ago, I was just interested in expressing the Negro in American life, but a larger concern, an expression of humanity and of America, developed. My History series grew out of that concern.[18]
>
> Hope has broadened the scene. The statement is broader, even though it is the same statement.[19]
>
> I wanted to show in doing it how the Negro had participated in American history. . . . There were Negroes with Washington when crossing the Delaware. . . .[20]
>
> The Negro struggle is a symbol of man's struggle, from my point of view. . . .[21]
>
> Man's struggle is a very beautiful thing . . . the struggle that we go through as human beings enables us to develop, to take on further dimension.[22]

In style, this series combines the monumental forms of previous historical series with his more recent manner of breaking up the entire composition into slender sherds. Most of the panels are viewed at close range, often so near the subject matter that it becomes almost unreadable pattern, extending the tendency first seen in Lawrence's *Coast Guard* and *War* pieces. Number 11 of the *Struggle* series, often called *Espionage* (pl. 55), illustrates a coded message sent by Benedict Arnold to British Major John Andre, which said: "General Washington will be at King's Ferry Sunday evening next." The two conspirators are shown in a dramatic closeup rendering the furtiveness of espionage.[23]

Many of the works (e.g., pl. 56) imply the influence of Orozco (see fig. 50) in his forceful use of the active human figure, interlocking diagonals, and expressive light and dark contrasts. When asked whether he had actually seen any of Orozco's work besides *Dive Bomber and Tank* (the fresco Orozco was completing at the Museum of Modern Art when they met), Lawrence responded that he had seen the murals at the New School for Social Research:

> I especially remember the one of the people seated around the table [fig. 51]. And I remember when he died. He died in 1950. I remember because I was at Hillside Hospital, and somebody told me that Orozco died.
>
> I show this work [*The Trench*, 1926] to my beginning drawing classes because the composition is so strong. It's a very structured composition; it's so strong, the diagonals. I relate Orozco to Giotto. I was first told that Orozco had studied Giotto when I was at the Harlem Art Workshop. You can see the relationship there, to Giotto. It's a very architectonic kind of structure.[24]

The *Struggle* series was exhibited at the Alan Gallery in late 1956. Emily Genauer, of the *New York Herald Tribune*, reviewed the show in an article that expressed her relief from the prevalent frustration of dealing critically with Abstract Expressionism.[25]

During the late 1940s and 1950s, when Abstract Expressionism was the dominant trend in New York painting and was influencing art worldwide, Lawrence's work remained consistently figural. He has been asked by interviewers many times to explain his resistance to abstract art, and at one point he revealed:

> I do not receive complete personal satisfaction from abstract or nonobjective paintings.

FIG. 52. Jacob Lawrence, Ibadan, Nigeria,
1964.

> I have seen many beautiful works using nonobjective shapes, but the more representa-
> tional forms give me another dimension. It's just too fragmentary and not a complete
> expression.
> Composing is most important. I seem to gravitate to geometric forms. It is like
> opening a book of geometry; I may not understand the formula but I love the beauty of
> line. . . . Action painting does not hold me because of its lack of structure.
> I do find myself attracted to some painters of the nonobjective school. I have great
> admiration for de Kooning's series on women. I admire the strength in Kline's work, and
> I find myself looking at Motherwell because of the structure.[26]

And yet Lawrence disclosed just how strongly he feels about his stylistic stance when
he extended these thoughts in a speech delivered in the early 1950s to a gathering of
artists and art students. He cautioned them to never abandon an awareness of the
significance of humanity in art:

> Maybe . . . humanity to you has been reduced to the sterility of the line, the cube, the
> circle, and the square; devoid of all feeling, cold and highly esoteric. If this is so, I can
> well understand why you cannot portray the true America. It is because you have lost all
> feeling for man. And the art of those that are devoid of feeling themselves cannot reflect
> the vital, strong, and pulsating beat that has always been humanity. And your work shall
> remain without depth for as long as you can only see and respect the beauty of the cube,
> and not see and respect the beauty of man—every man.[27]

Lawrence began teaching at Pratt Institute in 1955, as an instructor in design
and figure drawing. From Yaddo he wrote to Charles Alan:

> This week (Friday) I will be coming in for my first class at Pratt. It is an experience that I
> shall be looking forward to. This one class, however, I feel will be enough for me, as I do
> not wish to become bogged down on the teaching side of art—I do not feel that this is
> where my talents lie. Besides, I think it would drain me too much. I have too much to
> paint about, and I wish to concentrate on just that—*Painting*.[28]

He found, however, that he enjoyed teaching tremendously, and for the next fifteen
years Lawrence taught at Pratt regularly, as well as at other schools including Five
Towns Music and Art Foundation on Long Island, Brandeis University, the New
School for Social Research, and the Art Students League. In 1970, Pratt appointed
him Full Professor, Coordinator of the Arts, and Assistant to the Dean of the Art
School. During these years, Gwen Lawrence continued to pursue her painting, study-
ing for about ten years at the Art Students League and at the New School for Social
Research under Anthony Toney. She became particularly interested in sculpting while
Lawrence was a visiting professor at Brandeis University in spring 1965, and she has
continued to take sculpture instruction through the years.[29]

During these years of teaching, Lawrence's painting activities and growth did not abate. His work of the late fifties takes a mellow turn in mood and exhibits regained poise. He produced several lyrical urban scenes, of which *The Street* is typical (pl. 59). His colors have become more tonal, partially because of the chalky look of the casein he is using. The gathering of a family's generations in *The Street* is grouped around a central object, the focus pulling away from the corners and edges, a characteristic of his work in this period. The soft pale blue and rose composition of the family group is wrapped with enveloping arcs. The familiar sparkle is reiterated in the pram wheels' spokes and the shadows on the ground. The use of cast shadows is new in Lawrence's work of the fifties, no doubt an extension of his desire to explore spatial dimensions and to break up surface in an all-over way. Elements of whimsy abound in the clouds, the fish balloons, the spidery hands.

Two other works from this period, *Fulton and Nostrand* (pl. 60) and *Parade* (pl. 61), exemplify an interest in deeper exterior space, broader scope, and exploration of linear perspective. Conversely, the interior works of this period often use a piled-up space scrutinized so closely that there are no walls. Plate 58 compares two renditions of library scenes, a theme Lawrence has repeated throughout his career. The two versions are separated by forty years and illustrate Lawrence's different approaches to interior space. Many of the street scenes from this period reflect the surroundings of Lawrence's home in the Bedford-Stuyvesant area of Brooklyn (Fulton and Nostrand was a nearby street intersection). The influence of George Grosz may be evident in the bold red vertical lamp post, which echoes a device Grosz often used to great effect, as in *Metropolis,* 1911–17.

In 1960, the Brooklyn Museum held Lawrence's first major retrospective exhibition. It was circulated nationally by the American Federation of the Arts. The monograph that accompanied the show reproduced all of the exhibited paintings and contained the first comprehensive essay about his life and accomplishments.[30]

This period in Lawrence's development (1949–62) represented both his lowest personal phase as well as some of his most satisfying professional achievements. His work continued to open up stylistically and philosophically. He began to experiment with thought, form, space, and symbol, creating an art replete with fancy and surrealism. Most significantly, he had become deeply involved with teaching, which he found to be a stimulating contribution to his artistic growth.

IN RESPONSE TO AN INVITATION FROM THE AMERICAN SOCIETY OF AFRICAN CULture (AMSAC) and the Mbari Club of Artists and Writers of Ibadan, Nigeria, in

FIG. 53. *Nigerian* Theme, *Market Woman,* 1964. Gouache on paper, 30¾ × 22¼. Collection of Gwendolyn and Jacob Lawrence.

FIG. 54. José Guadalupe Posada, *Calavera "El Morrongo,"* c. 1910–12. Engraving.

FIG. 55. Jacob and Gwen Lawrence with Terry Dintenfass, late 1960s.

1962 Lawrence journeyed to Africa to exhibit his work. He was asked to travel with the show for ten days in Lagos and Ibadan. He found the trip so "stimulating, both visually and emotionally," that he returned to Nigeria in April 1964 with his wife to live and work for eight months.[31] In remarks printed in a 1964 Mbari Club publication, Lawrence reflected:

> I became so excited then by all the new visual forms I found in Nigeria—unusual color combinations—textures, shapes, and the dramatic effect of light—that I felt an overwhelming desire to come back as soon as possible to steep myself in Nigerian culture so that my paintings, if I'm fortunate, might show the influence of the great African artistic tradition.[32]

During his second visit, he became involved in delivering lectures, moderating symposiums, and running a series of workshops in drawing, painting, and art appreciation (fig. 52). In a speech to the Society of Nigerian Artists, he commented:

> An element which any work of art must contain if it is to endure . . . is mystery. . . . We all know that traditional African art has mystery. . . . I hope by this experience to better understand and become more aware of the universal concept of the abstract.[33]

In Africa, Lawrence produced eight paintings and several drawings (pls. 62 and 63, fig. 53). His treatment of this new material is unusual. Two representative works, *Street to Mbari* and *Meat Market*, show a fresh gaiety, rendering impressions of the vital atmosphere, the bright light and hot sun, and the riotous pattern of vibrant colors of the Nigerian marketplace. The number of figures and forms has increased dramatically to accurately depict the crowds in the West African markets. Several new elements are present: a preponderance of women (who run the markets) and babies, animals, and birds, and, once again, touches of humor. Rather than reflecting one central event, these compositions offer a wealth of visual data, creating a tapestry of figures, garments, stalls, awnings, and parcels. The human figure receives new treatment in the African works. Stimulated by the bare feet and functional hands he observed, Lawrence pays elaborate attention to them: they become broader, more quickly tapered. Articulation of general anatomical details is emphasized, stressing the plastic qualities of the human figure. Facial expressions capture the stereotyped frown caused by working in the bright sun. Figures diminish in size as they recede, and in *Street to Mbari* the typically steep perspective becomes a spatial tunnel. In *Meat Market*, bloody quarters of meat and bone swarming with flies make an emphatic motif throughout the scene. People move about busily in the heat, carrying and cutting slabs of meat.

Market Woman (fig. 53) is a gouache drawing. At first glance the imagery appears surreal, but it is actually a commonplace sight at a Nigerian market: a woman selling skulls and dead birds. Here, Lawrence may reveal the influence of José Guadalupe Posada, a Mexican graphic artist whose work he especially enjoys, who became famous for his journalistic prints in the late nineteenth and early twentieth centuries. Posada is particularly well known for his *calavera* (skull) prints, which he used for political and social satire (fig. 54).[34] The droll use of death-associated images is characteristic of some Mexican art.

The Nigerian works were exhibited at the Terry Dintenfass Gallery in January 1965. Lawrence explained why he left Charles Alan in 1962:

> I went with Terry Dintenfass because of Bob Gwathmey and Philip Evergood. We were friends and had the same philosophy. They kept working on me so I finally went with them. Also Charles Alan was buying and selling [the dealer pays the artist for the painting, then retains the entire eventual selling price] and I didn't want that.[35]

RESUMING LIFE IN NEW YORK, LAWRENCE CONTINUED WORKING ON A THEME HE had taken up in the early sixties: the civil rights activities in the South. Responding to this era of turmoil and upheaval in America, between approximately 1961 and 1969 Lawrence produced his most overt protest work—both paintings and drawings (pls. 64–66). These angry portrayals of racial injustice were based on incidents occurring between 1954 and 1964. In 1963, several of the powerful paintings were shown at the Dintenfass Gallery in a group show devoted to the subject. Lawrence received a note from his friend Jack Levine, a painter, about the show: "I had a chance to see the

paintings today. I thought they were wonderful. They have a profound drama which no one else can touch. An amazing epic style."[36]

The Ordeal of Alice, 1963 (pl. 66), presents a young black girl integrating an all-white Southern school, her pure white dress and stockings pierced by arrows of bigotry. She is taunted by red, green, and blue ghoulish children and adults who dance around, frightening her; one dangles a dead mouse. A hideous crone behind the suffering girl kicks up her heels in antagonistic glee. Flowers spring out of the ground, ironic assertions of the world's beauty. The young martyr bears the attacks stoically, strong dark and light contrast enhancing the drama of her situation. The motif recalls familiar Renaissance renditions of St. Sebastian, whose pale body was similarly depicted frontally and pierced with numerous arrows.

Other paintings from this same phase include *Invisible Man Among the Scholars* (1963), which questions a black person's chances in the white educational establishment of our country; *Taboo* (1963), an exploration of our society's attitudes toward interracial marriage; and *Praying Ministers* (pl. 64), representing the many times clergymen of all faiths came together to pray for peace during this period of unrest. Lawrence also made several strident civil rights drawings, some dealing with the clashes between rioters and police. *Struggle No. 2* (pl. 65) is a vehement statement about police brutality: selected lines forcefully carry the energy of the horse, the thrust of the tensed rider's leg, and the grasping hands of the rioters. The black gouache is brushed on with calligraphic economy, complemented with stunning splashes of red. In the 1960s, Lawrence was also called upon to illustrate numerous journals including *Freedomways* (fig. 56), a quarterly review of the Freedom Movement, and *Motive,* a monthly magazine of the Methodist Student Movement.[37] *Wounded Man,* 1968 (pl. 67), is the painting from which the *Freedomways* drawing derives.

In the civil rights works, Lawrence produced some of the few examples of wounded persons in his body of work (the *Struggle* series also offers a few instances). In the past, Lawrence had shown reluctance to depict the injured or dead, choosing instead a moment before or after the action when repellent elements were at minimum. He appeared especially to shun depiction of injured or ravaged black people: generally in his work, it is the whites who are most brutalized. In the *John Brown* series, the reality of the hanged John Brown is starkly presented. By contrast, lynching in the *Migration* series is symbolized by an empty noose. The *War* series depicts badly wounded soldiers, and psychologically deranged patients appear in the *Hospital* series. This selection could simply reflect the preponderance of whites in the circumstances, but also invites interpretation as a comment on "reaping as you sow." Lawrence's art conveys intensely personal views, and he resists explaining his work after it is finished. When asked to discuss a painting, he will simply reply that it was "a reflection," or an "observation," implying that the visual statement is his last comment on the subject.

The influence of the activist movement on Lawrence's art during this period is exciting to witness. However decorative many of his civil rights examples appear, they contain unusually violent imagery and bizarre, macabre symbolism. Lawrence has acknowledged that the creations of these years represent a "more or less surreal period."[38] More than that, for Lawrence, these pieces are harsh and aggressive, carrying the successful violent impact of Orozco's outcries. In this epoch of protest, Lawrence's work became uncharacteristically bitter. This outwardly reserved man was compelled to use his art as a forum for unprecedented revelations of resentment and rage. As intimate expressions of what it means to be black in our country, these works are the authoritative epitome of what has been called American black art.

ARISING FROM ISSUES OF THE CIVIL RIGHTS STRUGGLE, IN THE 1950S THE BLACK ART movement began to gain momentum in this country. American black artists were seeking a larger forum for recognition, and exhibitions of their work became events of great interest. For many decades, Jacob Lawrence has been referred to widely as "the best known black artist in America."[39] It is readily apparent that Lawrence's ethnic alliance is what gives his work its content and imbues it with its unique power. Milton Brown has observed:

FIG. 56. Cover illustration for *Freedomways,* a quarterly review of the Freedom Movement (Winter 1969). From drawing, *Wounded Man,* 1969. Gouache on paper, c. 24 × 18.

> There is something monolithic about Jacob Lawrence and his work, a hard core of un-deviating seriousness and commitment to both social and black consciousness. He has projected the black experience in America more consistently and effectively than any other black artist of his generation.[40]

It is appropriate, therefore, to briefly probe the designations "black artist" and "black art" to gain some understanding of the significance of these distinctions in relation to Jacob Lawrence's work.[41]

The people who were brought to the American colonies to be slaves originally had a rich cultural heritage that was obscured in the transition to North America. Ever since that time, many American blacks have striven to restore an identity that assimilates both their ancestral heritage and their American past. According to Alain Locke, pioneering black artists in this country succeeded "only as exceptional individuals, detached from the group, and as a result they eschewed the Negro subject."[42] In most instances, these artists' only chance for training or recognition was to go abroad. Art for and about black people continued "to be eclipsed" in this country well through the nineteenth century. In 1936 Locke stated:

> One might have expected the moral sympathies of Abolitionism and Emancipation to have worked some profound change in the public mind with regard to the Negro. However, the attention drawn to his plight only accentuated this status in the public mind, which forgot the types and considerable groups of Negroes whose position was far from the common lot. Reconstruction literature and art prolonged the values of slavery and the slave status unduly.[43]

In the post–Civil War decades, the "Uncle Remus" and other peasant stereotype images of the plantation tradition that had been popularized in the work of artists such as William Sydney Mount (1807–1868) (e.g., *Music Hath Charms*, 1844) still prevailed. This romantic attitude changed slowly, as new approaches to visual material began to interest the American artist. More serious studies of character and the local scene began to be creative concerns. A similar change also occurred in the portrayal of the American Indian, and Locke credits the mid-nineteenth century Realism movement in art with the obvious advance and gain.[44]

Locke considers that Winslow Homer (1838–1910) was "in many respects the father of [the black art] movement without intending to be."[45] Homer sketched black natives in the Caribbean and painted them as blacks had never before been depicted by American artists. His work, *The Gulf Stream* (c. 1899), for example, "had a great deal to do with breaking artistic stereotypes about the Negro." By portraying black persons "with something of their own atmosphere and dignity," he rendered them in situations of common human appeal. The painter Eastman Johnson (1824–1906) also made works of similar thrust (e.g., *Ride for Liberty*, c. 1863). The work of these white artists did much to overturn what Locke called "the cotton-patch and cabin-quarters formula." Just after the beginning of the twentieth century, Robert Henri and George Bellows, among The Eight, included blacks in their studies of urban life as part of an increasing concern with imagery that was picturesque as well as characteristically American.

After the turn of the century, European artists discovered African art via the enormous eclectic collections of nineteenth century travelers and colonial plunderers.[46] This precipitated a second major change in attitude. Connoisseurs realized that these objects were of extraordinary workmanship—that the bronze pieces of Benin, for instance, represented some of the finest examples of lost-wax casting in the world. At about the same time, a group of young painters and art critics in Paris, coming into contact with fine African carvings, became fascinated with the way human and animal forms were represented in simplified abstractions and deliberately emphasized symbolisms. The influence of this unconventional approach to imagery had direct impact on the developing Cubism of Picasso and Braque and greatly affected the work of Matisse and Modigliani. Public interest in the work of black American artists was "heightened directly and indirectly by European recognition of the beauty of African art."[47] And American black artists also gained knowledge of an artistic heritage they could claim with pride and self-assurance. For the first time, many such artists felt free to indulge in a "natural interest in depicting the life of [their] own group."[48] Artists of black heritage first became known in the U.S. in large numbers in the 1920s, as part of the Harlem Renaissance. W. E. B. DuBois, as editor of *The Crisis*, encouraged a "school of Negro art" in his writings; he said (in 1926), "'Truth

in Art' be damned. I do not care for any art that is not used as propaganda."[49] The Harmon Foundation's promotion of the artistic achievements of black Americans, especially in the late 1920s and 1930s, focused "considerable public and professional attention on the accomplishments and needs of Negro artists."[50] Marcus Garvey's back-to-Africa movement during the twenties and thirties laid the foundation for the black pride and black-is-beautiful philosophies that flourish today. In addition, Alain Locke encouraged young artists to turn to their cultural heritage for inspiration and visual material. In his *Negro Art, Past and Present* (1936), the first art history text on American black art, he stated that "African Negro art . . . is the source of the Negro's distinctive art tradition."[51] His voice and DuBois's strongly influenced the direction of black art.

Although black life seldom had been the content of earlier American art, Locke observed that the 1931 Harmon Foundation exhibition indicated a new trend:

> By 1931, there had been a decided change of attitude on the part of younger Negro artists, if the Harmon show that year was typical. Negro subjects and native materials predominated . . . [and] the quality and vitality of the work had improved as these artists came to closer grips with familiar and well-understood subject matter.

In his promotion of ethnocentricity, Locke said:

> A real and vital racialism in art is a sign of artistic objectivity and independence and gives evidence of a double emancipation from apologetic and academic imitativeness.[52]

Thus, a developing freedom from cultural stigma fostered a healthier attitude of race pride in the 1920s, and as a result, more culturally expressive work was produced. By the 1930s, the WPA Federal Art Project employed numerous black artists, many of whom credit their artistic careers to this opportunity.

Around 1940, the museum and gallery world "showed its earliest retreats from the freeze-out against black artists."[53] Several large group shows for black artists were organized in Baltimore, Atlanta, New York, and Chicago. Jacob Lawrence and Horace Pippin received gallery sponsorship in New York and Philadelphia respectively, the first black artists to be so recognized.[54] Locke's *The Negro in Art*, published in 1940, made a valuable contribution through its comprehensive presentation of reproductions of existing art by and about blacks as well as its concise historical summary of American black art and the ancestral African arts. In 1943, James Porter, pioneer black art historian, published *Modern Negro Art*, which contained some of the first critical analysis of works by black artists.

About the decade of the 1950s, critic and curator Carroll Greene has stated:

> "The winds of change" which had been felt in Africa's new nation states began to be felt here, and by the mid-1950s the Black Revolution had its painful birth. . . . The Black Revolution [had] its effect on the works of black artists. Social commentary became more prevalent; . . . works were often bitter, ironical, or sarcastic as they attacked the various hangups of our times.[55]

Following the advice of Locke thirty years before, to "look to the art of the ancestors," many artists journeyed to Africa to experience African life and to attempt to understand its aesthetic. African themes and conscious Africanisms began to appear in the work of many of these artists.[56] Acceptance of black art forms gained a powerful impetus in the turbulent decade of the 1960s, when social unrest and the dynamics of black political identity received national attention. Edmund Barry Gaither, director of Boston's Museum of the National Center of Afro-American Artists, described the impact of the 1960s: "After Birmingham, Harlem, Watts and the others, cultural institutions re-discovered the black man and his world, and the groundwork for black studies programs and the new 'black shows' was laid."[57]

The black art exhibitions of the 1960s differed in many cases from earlier ones in that they were sponsored by major institutions (such as the Whitney and the Metropolitan). Roger Mandle stated that the all-black exhibition of the late 1960s and early 1970s fulfilled three aims:

> It challenged the viewer to judge and enjoy works of art on their own merit, not measuring his response by sympathy with the artist.
> It challenged the establishment, by recognizing the achievement of these artists, to acknowledge the potential and desire for quality urgently developing in our community.
> It encouraged the Black youth of America.[58]

The exhibition activity in the sixties and seventies generated numerous major catalogs and textbooks which found their way into libraries everywhere; these contribute much to the understanding of the history of American black art and artists. In the late 1960s, Jacob Lawrence expressed strong feelings about the significance of black art exhibitions and critics:

> We have Dr. Locke, we have Porter . . . I think this is where the power is. Hell, you can give a show and it's forgotten when it comes down. . . . Your power lies in the analytical and critical approach to art. I think we need both.[59]

Out of the era of black militancy arose a concept of an art by and for black Americans. The term "black art" was used first by the militant black artist. Artists would argue among themselves about its meaning, each defining it differently and each believing that the creative expression of the black American derives from and can stand for different ideas. In 1970, Gaither clarified some of the confusion:

> Not every artist who is black can be called a "black artist" if the term is to be meaningful. . . . At its broadest, "black artist" may mean simply an artist whose formative experience was in the black community.

He went on to define black art:

> Black art is a didactic art form arising from a strong nationalistic base and characterized by its commitment to (a) use the past and its heroes to inspire heroic and revolutionary ideas, (b) use recent political and social events to teach recognition, control, and extermination of the "enemy," and (c) to project the future which the nation can anticipate after the struggle is won.
>
> In his visual language the black artist is basically a realist. Black art is a social art and it must be communicative.

At the same time, Gaither recognized two other factions of the black art movement: "(1) 'Afro-American' art, done in several styles and tendencies, and (2) 'Neo-Africanism,' a direction rooted in the study of traditional African art, its formal organization and its palette."[60]

As early as 1940, Locke had acknowledged the problematic nature of establishing an art unique to the American black people:

> In our cultural situation in America, race at best can only be some subtle difference in the overtones of that other imponderable we know and treasure as nationality. We must not expect the work of the Negro artist to be too different from that of his fellow artists. Product of the same social and cultural soil, our art has an equal right and obligation to be typically American at the same time that it strives to be typical and representative of the Negro. . . .[61]

When critic and curator Jan van der Marck was asked in 1970 to define "black art" for the journal *The Art Gallery,* his reply was instructive:

> A misnomer, but who cares. Ten years ago it might have been applied to Ad Reinhardt or considered the pictorial counterpart to black humor and black comedy. Today it is more than art made by black people—it is a battle cry. Black art stands outside of and is, in fact, scornful of the arena of international art with its carefully controlled codes of rules and conventions—an art that admittedly serves art rather than people. Ignoring rather than flouting international tradition, young black artists develop their own style from scratch. Their art serves the black liberation, it denotes black pride, it is a weapon of propaganda and it is an art of the streets, not of museums. Black art is epic, popular and for mass consumption. It is an important means for young and militant talents to link heritage and background with the furthering of the black cause and the destiny of the black race. For whites to demand that black art comply with current international aesthetics is unreasonable and short-sighted. The revolution will have to be fought before art by black people becomes another strand in the fabric of international art and the term "black art" is recognized as a misnomer. Until then, the art world has to accept black art on its own terms—or turn away from it, at a loss![62]

In many stylistic and thematic ways, Lawrence's work complies with almost all available notions of black art. Lawrence's early historical series about epics (the *Migration* series) and heroes *(Toussaint L'Ouverture)* are uniquely black in theme; Lawrence is clearly a chronicler of the American black experience.

While many developing black artists have looked to Jacob Lawrence as an example of rare promise in a racist society, some of the more militant artists in the

Fig. 57. Left to right: Romare Bearden, Charles Alston, and Jacob Lawrence, mid 1970s.

sixties and seventies criticized his acceptance in the white-dominated art world as "Uncle Tom-ism."[63] His response to this kind of accusation exhibited a characteristic aplomb:

> I don't regard it as personal—it's never said to me directly. But it's a healthy thing—the young ones should think this way. They push us into being more aggressive. It makes you think—if someone calls you an Uncle Tom, maybe you ask yourself, "Am I?"[64]

At a 1968 symposium sponsored by the Metropolitan Museum on "The Black Artist in America," one young black artist reacted to Lawrence's over thirty years of professional acceptance with an emotional retort: "I'm talking about unity, I'm not talking about one artist going that way and doing his thing. I think we should be marching. . . ."[65]

In a recent interview, Lawrence was asked whether during the sixties, when black consciousness was so vociferous, he felt pressure to be more political in his art:

> No. The only problem I had was the problem many artists had who had been attached to schools and were dealing with students. You were always in a "damned if you do and damned if you don't" position. I was teaching at Pratt Institute, and that was the time when all the black students would sit together in the cafeteria. If you didn't sit with these students, you were criticized, and if you did sit with the students, the attitude was "What are you doing here?" I had those kinds of problems, but they didn't bother me too much.
>
> Of course, I was a black but I was also in a position of authority, and those students were striking out in all directions. If you were seen as part of the Establishment, they didn't realize that your struggle had been as great as theirs. What I found is that you could accept the health of this rebellion intellectually, but emotionally you couldn't. You'd want to tell these people, "Look, I've been through some things, too, and so have the people before my generation, and they're the ones who made it possible for you to have this kind of protest."[66]

Lawrence was never actively caught up in the black art movement, although he recognized the multifold value of the struggle. Regarding the categorization of "black art," he expressed his early reluctance to accept the term at the Metropolitan symposium: "You know, there's something I can't understand here . . . [the] term . . . 'Black art.' . . . I think it would be more correct for us to say 'art by Black people,' but not 'Black art.' "[67] Lawrence was not alone in his opinion. The 1968 symposium was most illuminating in its nonclarification of the issues, because it revealed that the black artists on the panel (including Romare Bearden, moderator, Sam Gilliam, Tom Lloyd, Richard Hunt, Hale Woodruff, William Williams, and Lawrence) disagreed

FIG. 58. Jacob Lawrence teaching at Brandeis University, 1965.

about the then relatively new term, how it should be applied, or whether the concept even existed.

In the same year, Charles Alston said at the peak of the black art movement:

> There is no such thing as "black art," but rather a "black experience." I've lived it. But it's also an American experience. I think black artists want to be in the mainstream of American life and I believe in their insistence on it.[68]

Since the 1960s, Lawrence has modified his stance on black art as an entity. He explained his current position:

> I used to question this, but now I'm beginning to see two sources where I would say yes. I used to say the only black art is that art from Africa. And the criterion I used is when you look at it, you can tell, just like you can Asian art, if it's traditional. Now I also add art from the black experience of figural content. The black art movement of the sixties was a good thing. Just like the idea of "black is beautiful." I never did like that, but there was a need for it, you see.[69]

And when asked whether he feels that the black art movement of the sixties accomplished its goals, he has said:

> Yes, I think so. I think it gave a certain respect, a certain worthiness which I think many black people needed. It was very good in that way.
> To me, [the "black art" label] doesn't matter, in my work. I work out of my experience, and if somebody wants to call that black art, that's all right.[70]

Lawrence himself is not militant. He has pointed out that his work is not an art of protest. In 1980, Jacob Lawrence was invited to the White House by President Carter to be honored, along with nine other artists, for showing in his art a protest against racial discrimination. Lawrence declined the invitation and disagreed with the President's evaluation of the thrust of his work: "I never use the term "protest" in connection with my paintings. They just deal with the social scene. . . . They're how I feel about things."[71]

Lawrence's art, while closely depicting black community life and history, characteristically maintains the position of simple genre. Clearly, however, his work periodically is overtly inflammatory (pieces of the early series, for example, and especially the civil rights imagery). It may be Lawrence's intention to inform the viewer by simply revealing situations honestly, but his content and style are often undeniably and appropriately incitive.

Lawrence has most recently referred to himself as a "Western" artist, broadly considering himself to be part of the complex panorama of Western civilization. He also describes himself as a humanist, and like Goya, Orozco, and Daumier, in his work he shows a commitment to exploring the human dilemma. Bearden and Henderson assert that Jacob Lawrence is a "black master of American art."[72] He is regarded by both the black art community as well as by mainstream historians as a senior distinguished artist, although Elsa Honig Fine, in her book *The Afro-American Artist* (1973), accused him of having dropped the banner in the 1950s by letting his work become illustrative: "Lawrence, like Shahn, became an illustrator of the first order, but he thereby failed to fulfill his early promise as a leader of a school of Afro-American artists."[73] Fine's confusing opinion derives no doubt from the widespread and understandable difficulty in defining black art. She turned instead to Romare Bearden as one of the leading figures in the black art revolution of the 1960s (fig. 57).

There have been many parallels in the careers of Bearden and Lawrence, culminating in their becoming the two major influences in American black art. Although both Lawrence's and Bearden's early art shared similar concerns and visual approaches (e.g., the use of a personalized cubist idiom to render ethnic genre, the adoption of a serial format to convey historical or literary themes), Bearden's work became increasingly nonrepresentational, turning to collage in 1963. His later photo-collages approach documentation in appearance. Bearden, unlike Lawrence, was actively involved in the black art movement in the 1960s in New York, organizing art exhibits and cofounding both the Cinque Gallery for young minority artists and the Spiral Group, which was concerned with problems of black identity in art.

In 1984, Barry Gaither evaluated black art's contemporary position:

> No longer does there exist a widely felt sense of being part of a movement, for though

common problems are acknowledged, the great majority of artists are more consumed with strictly artistic problems than were their predecessors. For many, the "mainstream" is obtainable, or at least it is perceived to be. Every option—in form and content—is under exploration without the strong discipline of an ideological framework. We are experiencing a moment at once exhilarating for the existential freedom that it offers while, at the same time, perilous in that it threatens to sever the rich twentieth century link between black cultural expression and the general social condition of the black majority.[74]

FIG. 59. *Self-Portrait*, 1965. Gouache on paper, 18 × 16. Collection of Gwendolyn and Jacob Lawrence.

Clearly, the need to proclaim a separate black art arose from historical imperative and political necessity. Lawrence himself observed:

> There are people who hold onto the [concept of black art] for other reasons; they feel that it's important for sociological reasons, for heritage. There are those who feel that if this philosophy were held onto that somehow their art would be more vital—it would bring an energy to it.[75]

Particularly in recent decades, we have witnessed the struggles of numerous American minority groups with the problems of acculturation and ethnicity—profound issues that affect every phase of their lives. The art of blacks, Chicanos, Alaskan Eskimos, Native Americans, and others reflect their quandary: how to live as Americans in the modern world and yet maintain ties with heritage. When there is no longer a need to make social protest statements of art, the basis for a black art will no doubt subside. But will that represent progress for the arts? As social conditions that stifle cultural traditions, cause economic and educational deprivation, and create the psychological effects of the system of segregation are corrected,[76] the more the creative potential of all American artists will develop and flourish. But this hopeful process also includes the fearsome eventuality that we will lose those distinguishing cultural links, that "sense of a relationship to a central core,"[77] as Gaither defines it, that infuses black art with such idiomatic fire.

BY THE EARLY 1960s, LAWRENCE'S ACCOMPLISHMENTS WERE WIDELY acknowledged throughout the arts community. In 1965, he was elected to membership in the National Institute of Arts and Letters. A letter from painter Philip Evergood reflected the respect friends and peers held for Lawrence:

> The Institute needs more painters with some guts and imagination like you. Shahn wrote a beautiful tribute to you, I thought, when he proposed you. The only way I could help was by *voting* for you. I'd have been honored if they'd asked me to second you.[78]

The civil rights works (c. 1961–69) Lawrence had continued to do when he returned from Africa were among his most stylistically and iconographically experimental, and the stimulation he received from the series of teaching jobs after 1956 may have contributed to his willingness to probe fresh aesthetic attitudes (fig. 58). An unusual work from 1965 is *Self-Portrait* (fig. 59), a gouache and brush drawing, one of only a few self-portraits.[79]

Generations of 1967 (pl. 68) depicts a grouping that in its frontal stiffness is reminiscent of photographic family portraits. Behind the family hangs an antislavery struggle scene, once again underscoring Lawrence's concern with politics, history, and heritage. Lawrence's dedication to the concepts of family and continuity may derive from his own hard earlier life. He was not close to either of his parents, and his younger brother and sister died from causes symptomatic of the ghetto—his sister from tuberculosis in her early twenties, and his brother from a drug overdose. Both his parents died of cancer.[80] Today, he seldom discusses his family, and one senses that these memories are painful. Lawrence and his wife have developed a close bond over the forty-five years of their marriage. With no children of their own, their sense of family is vested in each other.

In 1967, Lawrence was approached by a publisher (Windmill Books, Simon. and Schuster) to do a children's book, his first attempt at this kind of material. He was allowed to choose his own subject matter and selected the story of Harriet Tubman. He felt it would be particularly appropriate for children because "it is a dramatic tale of flight and fugitives."[81] The book, entitled *Harriet and the Promised Land* (1968), included seventeen paintings (gouache on paper) presented in full-page color reproductions and accompanied by the story in verse.[82] The style of these

works (pls. 69 and 70) shows a continuation of many of the interests newly exhibited in his African paintings: the steeper, deeper perspective; the profusion of forms, including many creatures; women carrying babies; and the exaggerated anatomy of the figures, especially the knotty hands and feet. He repeats some of the iconography of the *Harriet Tubman* series painted in the 1930s, such as the North Star, which was the fleeing slaves' guiding light, and the snake, which represented the danger that stalked them in their journey.

Because this book was for children, many restrictions were placed on presentation of content. For example, in *Canada Bound,* No. 15 of the series (pl. 70), the symbol of blood was in the original but was taken out on the advice of the publisher.[83] With censorship still rankling, after the book was completed Lawrence did a few works on the Harriet Tubman theme for himself without restrictions; *Forward* and *Daybreak—A Time to Rest* are two (pls. 71 and 72). Harriet Tubman had actually carried a gun, but Lawrence was not permitted to have it in the book renditions, so he included it prominently in these two works. In their simplified monumental forms and in their medium (egg tempera on gesso panel), they revive the epic style of Lawrence's early series. For Lawrence, there seems to be a connection between choice of medium/support and significance of work. Lawrence has often chosen tempera with gesso panel for themes that are particularly meaningful to him (e.g., most of the series, the civil rights works) and paper for single paintings. A water-base medium on paper creates a work of limited durability, whereas the combination of tempera (particularly egg tempera) on gesso panel produces an extremely hard surface of greater longevity.

Some reviewers considered the content of *Harriet and the Promised Land* too visually disturbing for children. A New England librarian complained that the book made Harriet look grotesque and ugly, and Lawrence replied in a letter:

> If you had walked in the fields, stopping for short periods to be replenished by underground stations; if you couldn't feel secure until you reached the Canadian border, you, too, madam, would look grotesque and ugly. Isn't it sad that the oppressed often find themselves grotesque and ugly and find the oppressor refined and beautiful?[84]

In 1973 the Brooklyn Museum and the Brooklyn Public Library awarded Lawrence the Books for Children Citation for the volume.

Other work from this period in the late 1960s is represented by *Brooklyn Stoop* (pl. 73). This painting is an unusual composition centered on children; Lawrence often includes children in groups but seldom makes them the focus. Lawrence had turned to this content at this time because he had been asked to contribute a piece to the Unicef Calendar for 1969 (*Boys at Play,* 1966). In these two works, the artist presents a racial mix, the beginning of a trend that becomes more and more assertive in his work in the following decades.

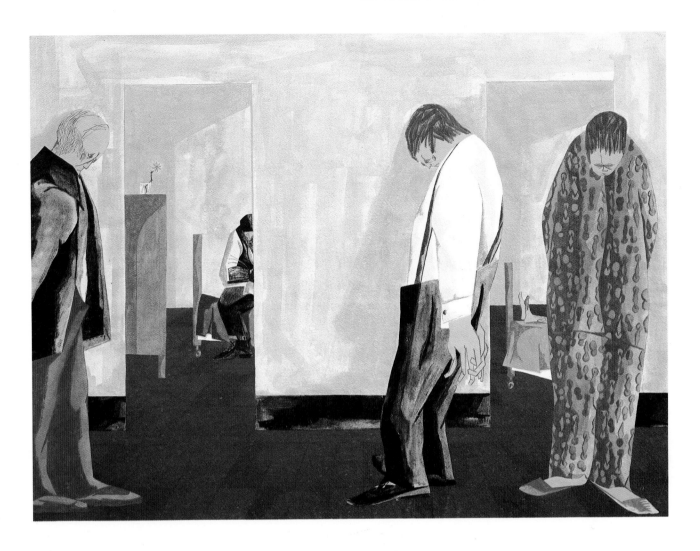

PL. 48. *Hospital* Series, *In the Garden*, 1950.
Casein on paper, 22 × 30.
Collection of Abram and Frances Kanof.

PL. 49. *Photographer's Shop*, 1951.
Watercolor and gouache on paper, 23 × 32.
Milwaukee Art Center, Minnesota.

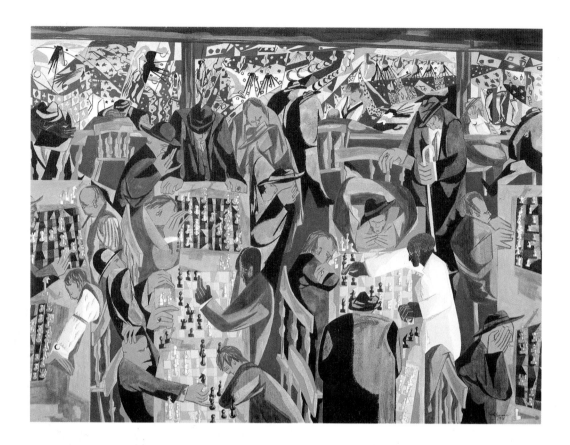

PL. 50. *Chess on Broadway*, 1951.
Gouache and watercolor on paper, 21½ × 29½.
Collection of William A. Riesenfeld.

PL. 51. *Theater* Series, 1951–52.
No. 2: *Tragedy and Comedy*.
Egg tempera on hardboard, 23⅜ × 29⅜.
Collection of Mr. and Mrs. Alan Brandt.

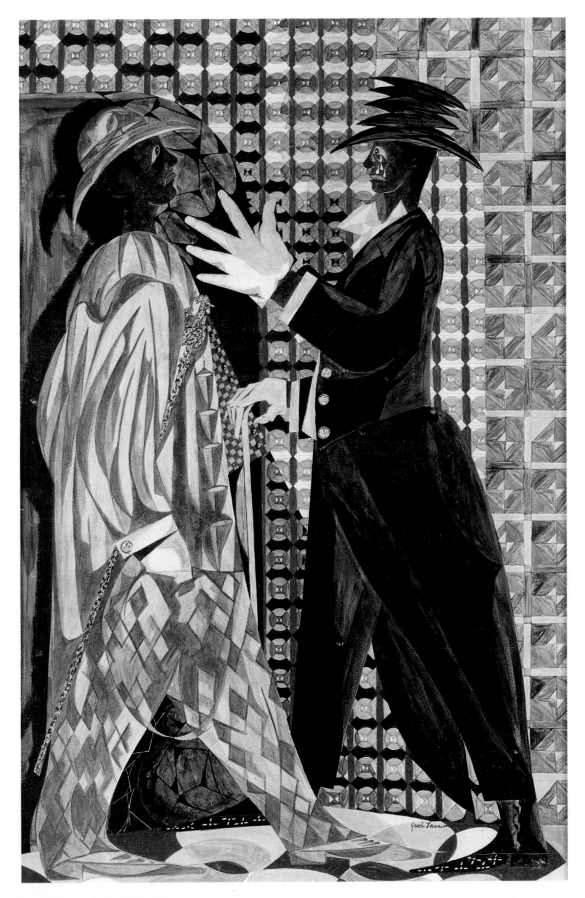

PL. 52. *Theater* Series, 1951–52.
No. 8: *Vaudeville*.
Egg tempera on hardboard, 29⅞ × 20.
Hirshhorn Museum and Sculpture Garden, Smithsonian Institution,
Washington, D.C.

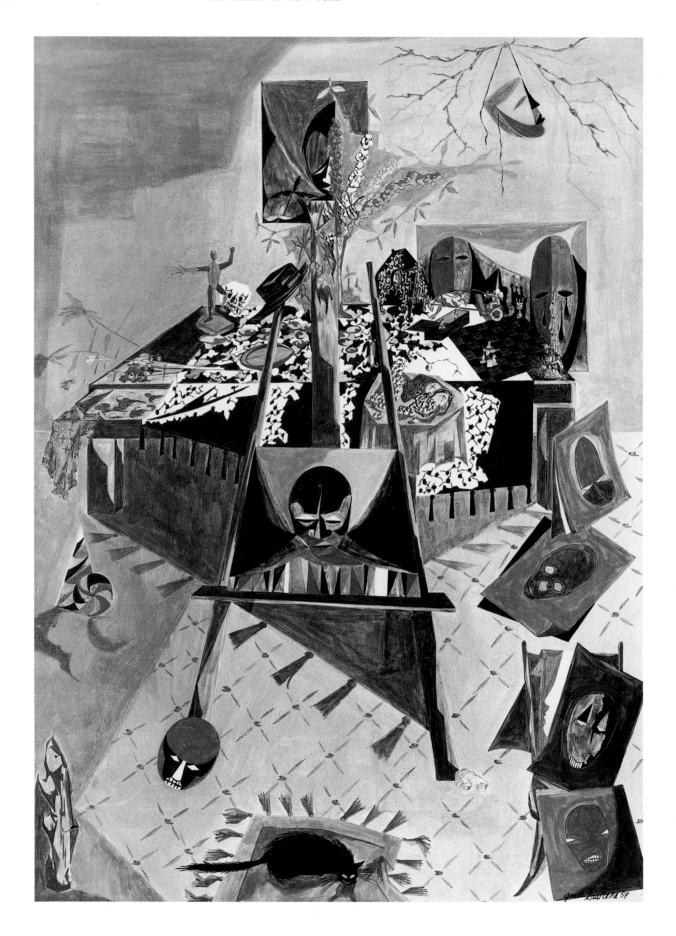

PL. 53. *Masks*, 1954.
Egg tempera on hardboard, 24 × 17¾.
Collection of Mr. and Mrs. William Marsteller.

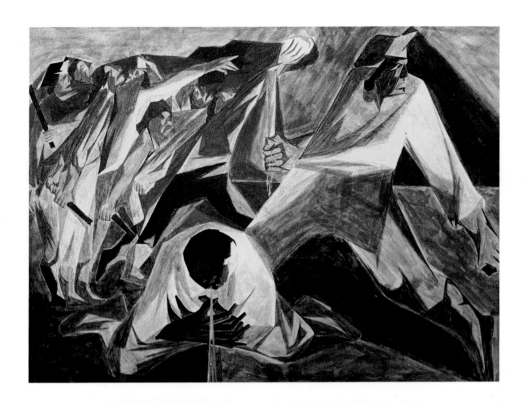

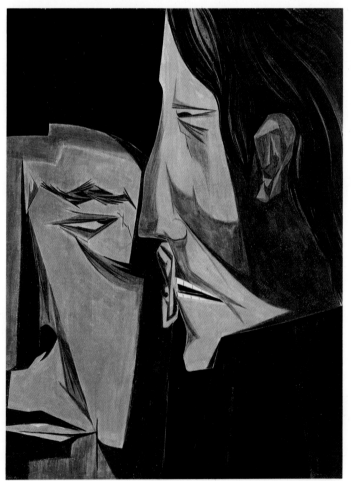

ABOVE
PL. 54. *Struggle: From the History of the American People* Series, 1955–56.
No. 2: *Massacre in Boston.*
Egg tempera on hardboard, 18½ × 22½.
Collection of Janet Lehr.

BELOW
PL. 55. *Struggle: From the History of the American People* Series, 1955–56.
No. 11: *120.9.14.286.9.33 -ton 290.9.27 be at 153.9.28.110.8.17.255.9.29 evening 178.9.8 . . .—An informer's coded message.*
Tempera on hardboard, 16 × 12.
Collection of Gabrielle and Herbert Kayden.

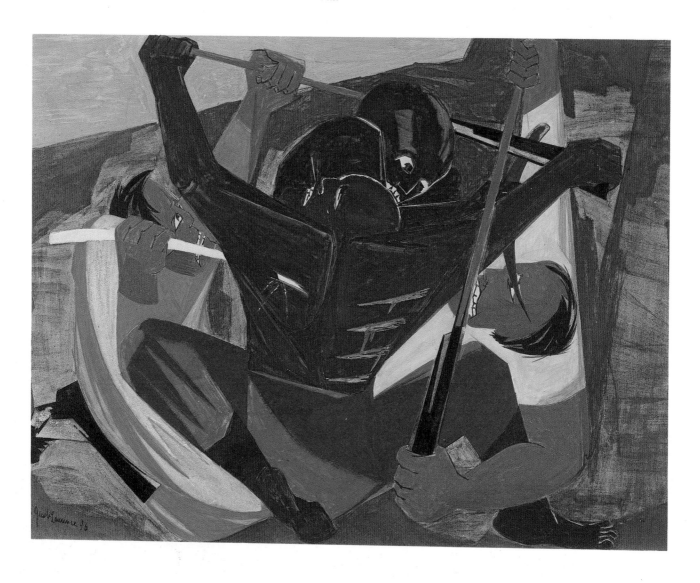

PL. 56. *Struggle: From the History of the American People* Series, 1955–56.
No. 27: . . . *for freedom we want and will have, for we have served this cruel land
long enuff. . . .—A Georgia Slave, 1810.*
Egg tempera on hardboard, 12 × 16.
Collection of Gwendolyn and Jacob Lawrence.

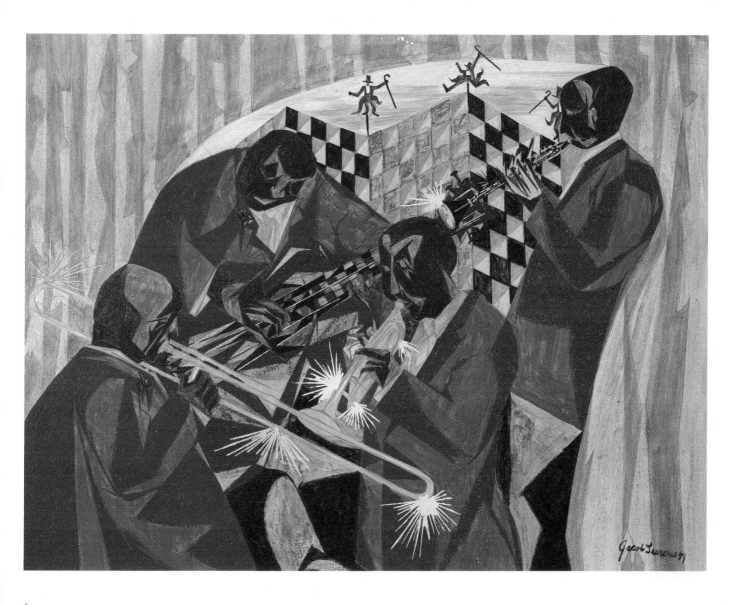

PL. 57. *Village Quartet*, 1954.
Egg tempera on hardboard, 9 × 12.
Private collection.

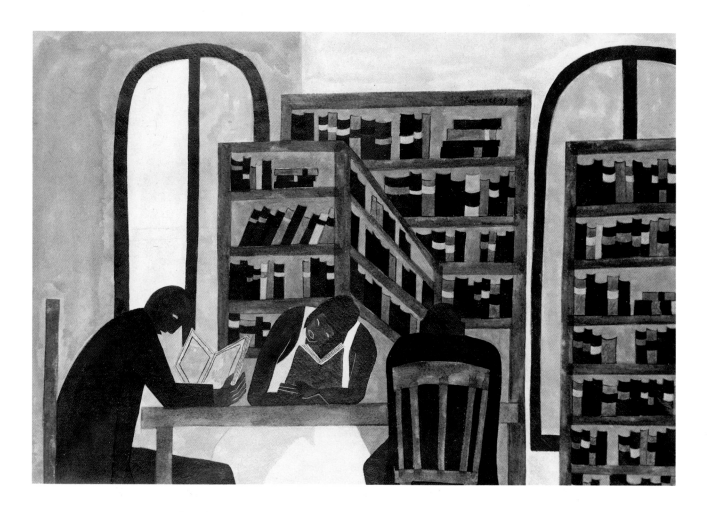

PL. 58. Two paintings on the *Library* theme.
(a) *Harlem* Series, No. 28: *The libraries are appreciated*, 1943.
Gouache on paper, 14¼ × 21¼.
Philadelphia Museum of Art, The Louis E. Stern Collection.

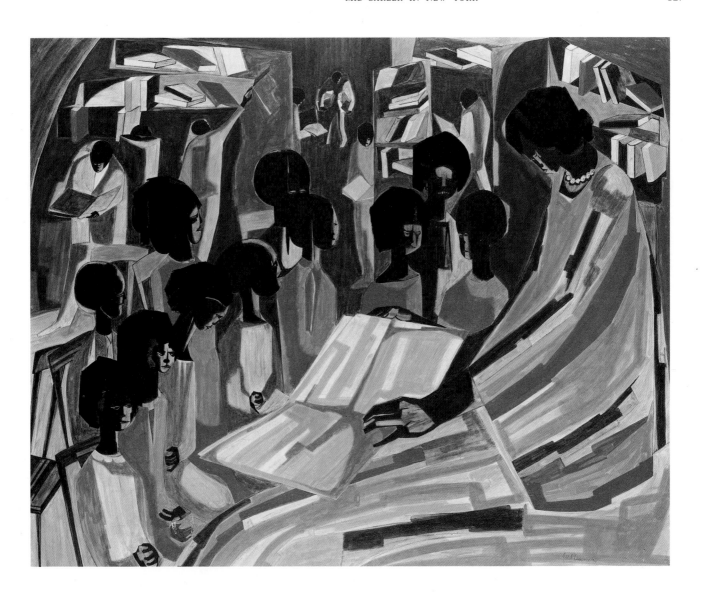

(b) *Library II*, 1960.
Egg tempera on hardboard, 23½ × 29½.
Collection of Martin and Sarah Cherkasky.

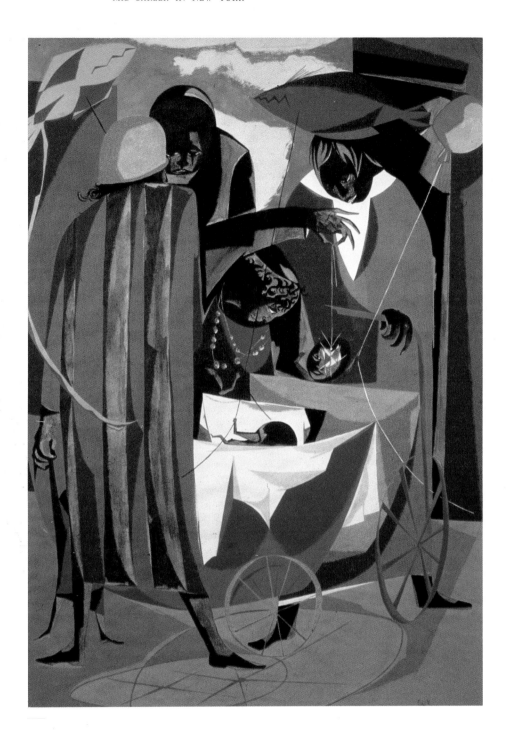

PL. 59. *The Street*, 1957.
Casein on paper, 32½ × 24.

PL. 60. *Fulton and Nostrand*, 1958.
Tempera on hardboard, 24 × 30.
Collection of George and Joyce Wein.

PL. 61. *Parade*, 1960.
Egg tempera on hardboard, 23⅞ × 30⅛.
Hirshhorn Museum and Sculpture Garden, Smithsonian Institution,
Washington, D.C.

PL. 62. *Nigerian* Series, 1964. *Meat Market,*
Gouache on paper, 30¾ × 22¼.
Collection of Judith Golden

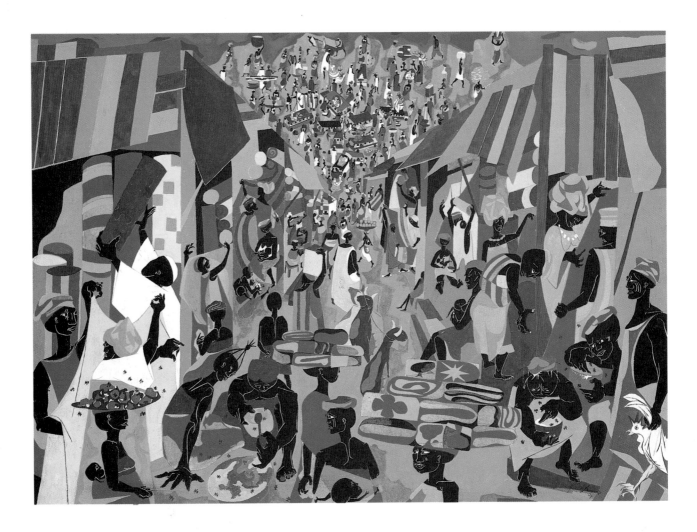

PL. 63. *Nigerian* Series, 1964. *Street to Mbari.*
Gouache on paper, 22¼ × 30⅜.
Courtesy of Terry Dintenfass Gallery, New York.

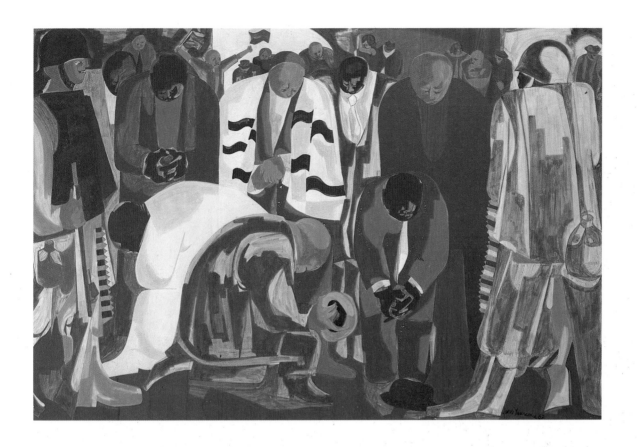

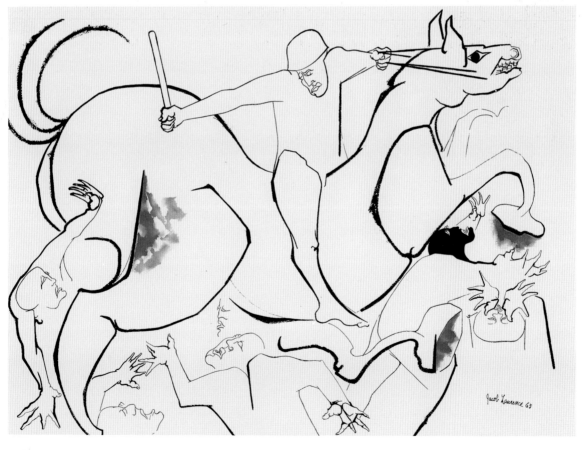

ABOVE
PL. 64. *Praying Ministers*, 1962.
Egg tempera on hardboard, 23 × 38.
Spelman University, Atlanta, Georgia.

BELOW
PL. 65. *Struggle No. 2*, 1965.
Ink and gouache on paper, 22¼ × 30¾.
Seattle Art Museum, gift of anonymous donors in honor of the museum's 50th year.

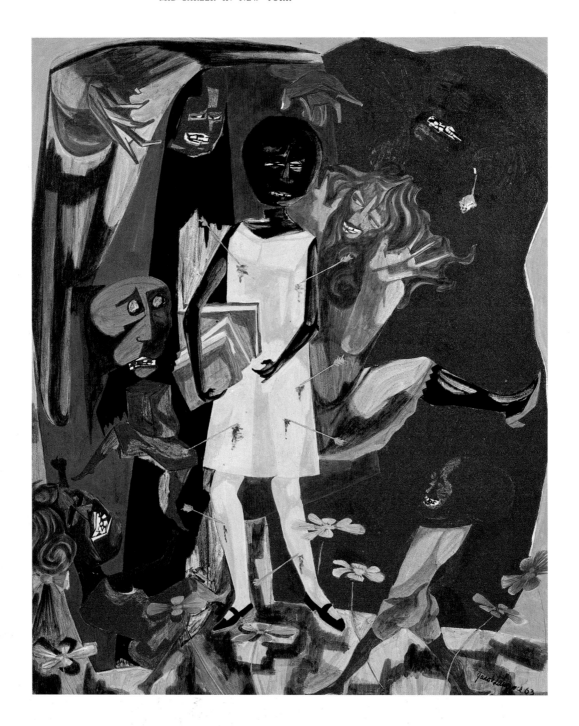

PL. 66. *The Ordeal of Alice*, 1963.
Egg tempera on hardboard, 19⅞ × 23⅞.
Collection of Gabrielle and Herbert Kayden.

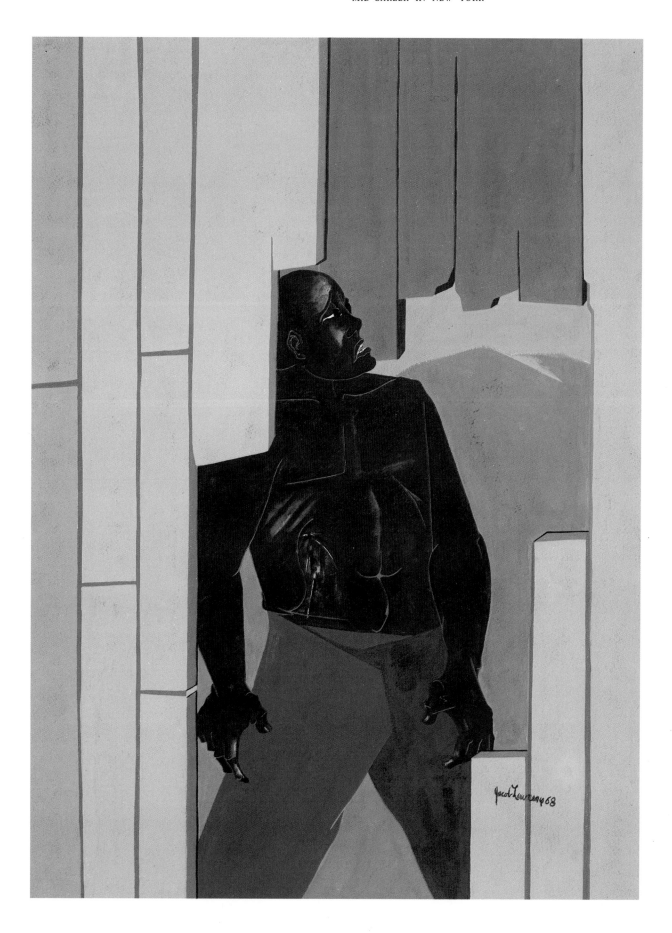

PL. 67. *Wounded Man*, 1968.
Gouache on paper, 29½ × 22.
Collection of Gwendolyn and Jacob Lawrence.

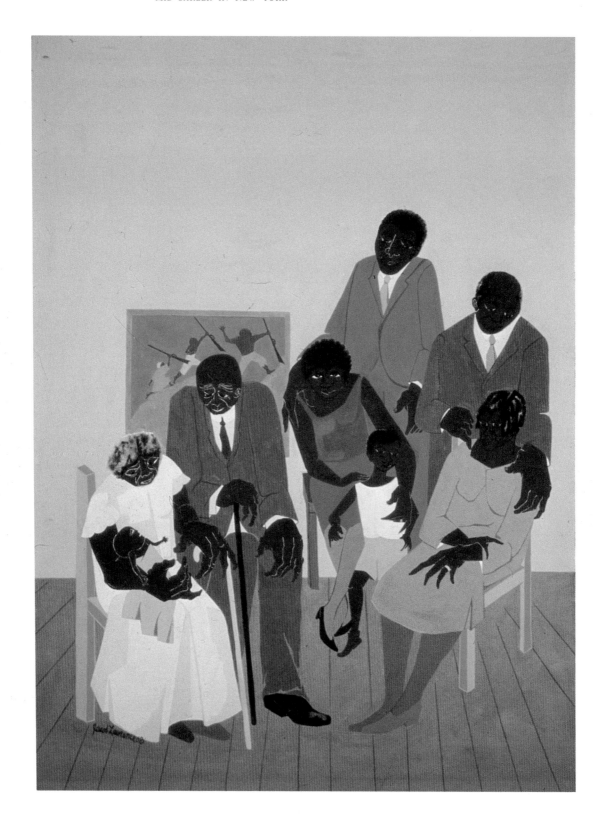

PL. 68. *Generations*, 1967.
Gouache on paper.

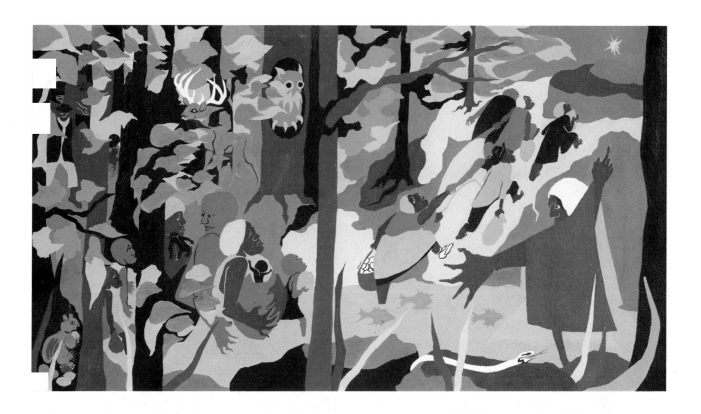

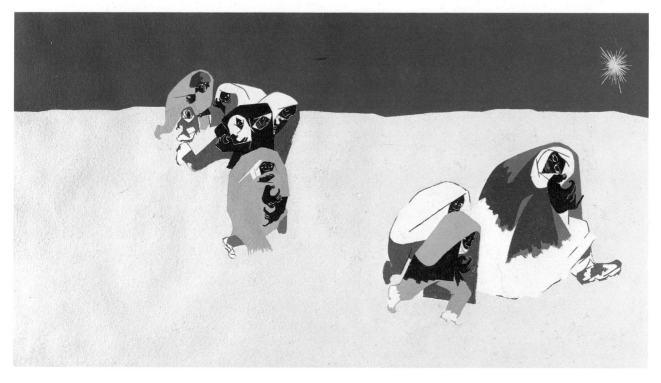

ABOVE
PL. 69. Illustration for *Harriet and the Promised Land*, 1967.
No. 10: *Forward*.
Gouache on paper.

BELOW
PL. 70. Illustration for *Harriet and the Promised Land*, 1967.
No. 15: *Canada Bound*.
Gouache on paper, 14 × 25.
Collection of Dr. and Mrs. James L. Curtis.

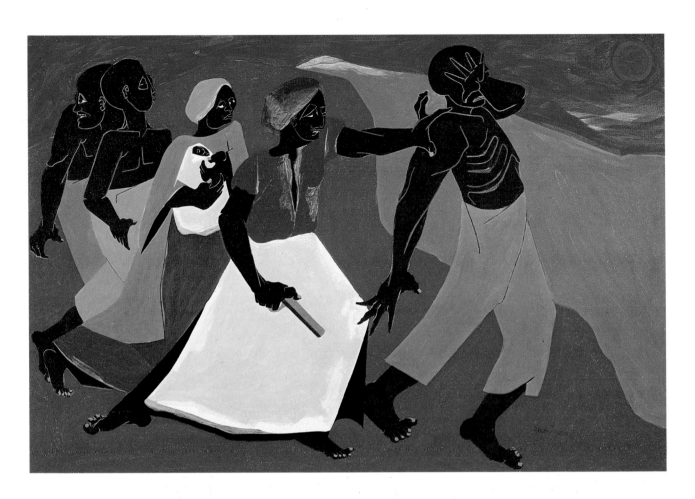

PL. 71. *Harriet Tubman* theme, 1967. *Forward.*
Egg tempera on hardboard, 24 × 35¾.
North Carolina Museum of Art, Raleigh, Museum Purchase Fund.

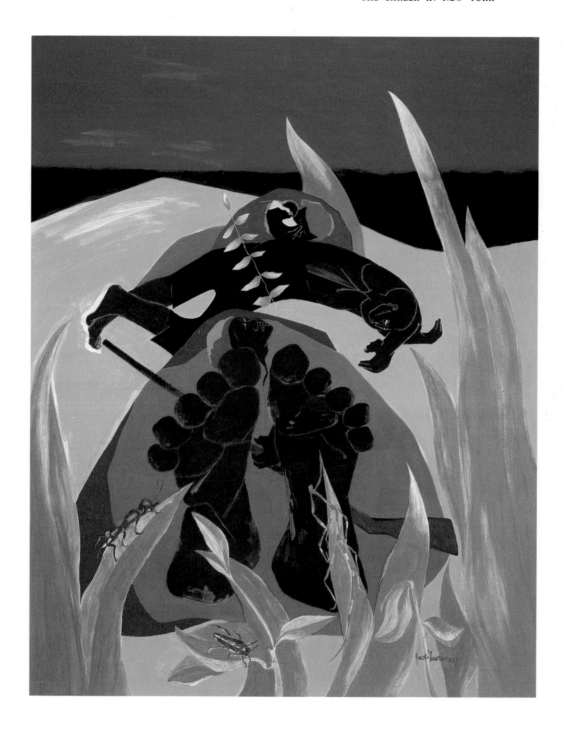

PL. 72. *Harriet Tubman* theme, 1967, *Daybreak—A Time to Rest.*
Egg tempera on hardboard, 30 × 24.
The National Gallery of Art, Washington, D.C., gift of an anonymous donor.

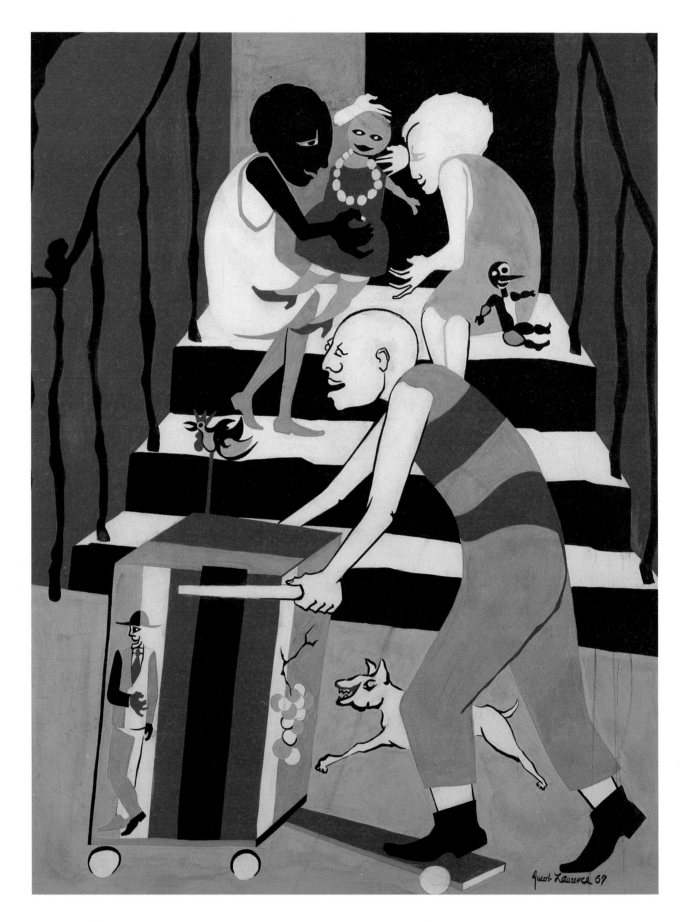

PL. 73. *Brooklyn Stoop*, 1967.
Poster design for Goddard Art Center, New York.
Casein on paper, 21 × 16.
Collection of Gwendolyn and Jacob Lawrence.

5. At Home in the West: 1968 to Present

In the late 1960s, Jacob Lawrence's subject matter began to reflect the greater diversity of both his travel experiences and intensified teaching. He retained his preference for water-base media but also made prints, many drawings, and enamel murals. In this period of personal expansion, Lawrence also did more book and magazine illustrations.

He was commissioned by *Time* magazine to do cover portraits of black leaders: Lieutenant Ojukwu of Biafra (August 23, 1968, issue on the war in Africa), the Reverend Jesse Jackson (April 6, 1970, issue focusing on black America; fig. 60), and activist Stokely Carmichael (an issue that never materialized). These portraits, rare in his work, were done from photographs; Lawrence had not met the subjects.

Lawrence also illustrated *Aesop's Fables* (1970) for Windmill Books/Simon and Schuster, the publisher of *Harriet and the Promised Land*. Figure 61 portrays the story of the greedy dog who barks at his reflection in the water and drops his bone. The black gouache drawings of the animal protagonists are overtly humorous. The artist's general reserve is deceptive because his personality is rich in sensibility and wit. Humor always lurks beneath the surface: in daily social contacts he seldom initiates it but is quickly receptive to it. Those who know him realize that he is acutely aware of the human comedy that surrounds him; he simply withholds verbal comment.

Lawrence made his first trip west of Chicago to teach at California State College in Hayward in September 1969, where he remained for eight months (fig. 62). He was then appointed Visiting Artist, University of Washington, in Seattle (April through June 1970). He had also taught at Skowhegan School of Painting and Sculp-

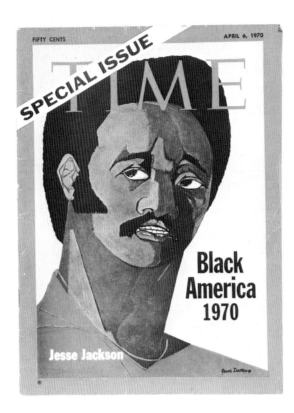

FIG. 60. *Time* Magazine cover portrait, April 6, 1970, from painting of *Jesse Jackson*, 1970. Gouache on paper. Collection of *Time* Magazine.

FIG. 61. Illustration for *Aesop's Fables*, 1970. *Dog and Bone*. Gouache on paper, 18¼ × 9½. Collection of Gwendolyn and Jacob Lawrence.

ture in Maine during the summer sessions of 1968–70; in 1970 Lawrence received the first of several honorary doctorates (see Chronology), and was appointed to Skowhegan's Board of Governors, joining such artists as Louise Nevelson, Robert Indiana, Mark di Suvero, and Ronald Bladen.

That same year, he also received the highest honor of the National Association for the Advancement of Colored People, the Spingarn Medal, awarded for the first time to an artist. His acceptance speech reflects his deep convictions:

> If I have achieved a degree of success as a creative artist, it is mainly due to the black experience which is our heritage—an experience which gives inspiration, motivation, and stimulation. I was inspired by the black aesthetic by which we are surrounded, motivated to manipulate form, color, space, line and texture to depict our life, and stimulated by the beauty and poignancy of our environment.
>
> We do not forget . . . that encouragement which came from the black community. . . .[1]

Throughout his career, Lawrence has reflected on his memories of the Harlem community for imagery. A painting from this period, *The Pool Game* (pl. 74c), portrays a theme inspired by the many pool halls in Harlem. Two earlier examples of the same theme are reproduced here for stylistic comparison (pl. 74a, b). "The pattern, color, movement, shapes, textures, and light always fascinated me," he revealed. "It was a scene most magical to view."[2] And he acknowledged, "The content of my work repeats itself over and over again."[3]

A year after his visiting appointment, in 1971 Lawrence was invited to take a permanent position as Full Professor at the University of Washington. Although accepting it required a major change for the Lawrences, confirmed New Yorkers, they felt ready for it. Never expecting to stay very long, he has remained in Seattle teaching painting, drawing, and design. The Lawrences live in a small house in a quiet residential neighborhood near the university, where they both have studios.

In Seattle, Lawrence began to concentrate on a sequence of works on the *Builders* theme, a subject that has preoccupied him since about 1968 and which he had in fact dealt with several times before in a very similar way (see, for example, *Cabinetmakers*, 1946, pl. 75). It is instructive to compare Orozco's *Science, Work, and Art* from the frescoes at the New School for Social Research (1930–31), which Lawrence had seen, and compare it with Lawrence's *Cabinetmakers* of 1957 (see pl.

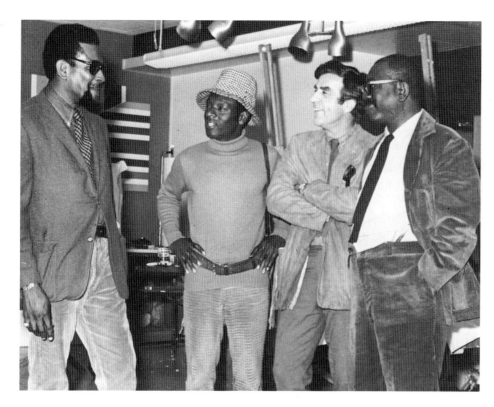

Fig. 62. Jacob Lawrence, while a visiting artist at California State University at Hayward (September 1969–March 1970). Left to right: William Majors (visiting artist), Ray Saunders (faculty), Roger Barr (Director of the Art School), and Lawrence.

76 and fig. 63); the structural similarities of the two works are readily apparent, indicating once again the profound and continuing influence of Orozco's art on Lawrence.

Lawrence grew up around carpenters and cabinetmakers, and he recently discussed his interest in the *Builders* theme:

> In Harlem there were some cabinetmakers named the Bates brothers, who were close to the arts. We all worked together at the center. . . . They worked with tools that were aesthetically beautiful, like sculpture. I wasn't conscious of how impressive it was to me. . . .[4]

Lawrence has a collection of tools in his studio: "Many hand tools haven't changed for centuries: they have such balance and are so functional. The human body is like a tool. Any living thing has this kind of structure." Lawrence has distinguished that the *Builders* "is really not a series. . . . It's like a theme. . . . The *Builders* came from my own observations of the human condition. If you look at a work closely, you see that it incorporates things other than the buildings, like a street scene, or a family. . . ." He also said, "I like the symbolism. . . . I think of it as man's aspiration, as a constructive tool—man building."[5]

Most of the *Builders* works are gouache on paper and of similar dimensions (about 30 by 20 inches). Several typical works are included here from the period 1969–77 (pls. 77–83). For over seventeen years Lawrence has concentrated almost without interruption on this theme and approach, a singularly consistent commitment. A classical serenity is detectable in his recent work, possibly attributable to the isolation and relatively slower pace of Seattle. Lawrence acknowledges that the *Builders*, done for the most part in Seattle, show some influences of his new surroundings:

> I would say not so much in content but in the art form. I've found myself exploring tonal color more. In the East, most of us for the most part work with more prismatic color. But here, I've found myself working with greyed, tonal colors. One of the things out here that I've become very conscious of is this kind of tonal atmosphere. I think the grey atmosphere [of the Northwest] is very beautiful.[6]

Besides working with tonality, Lawrence has explored illusions of long-range Northwest vistas in these works. In *Builders No. 2,* 1973 (pl. 80), a mountain is depicted

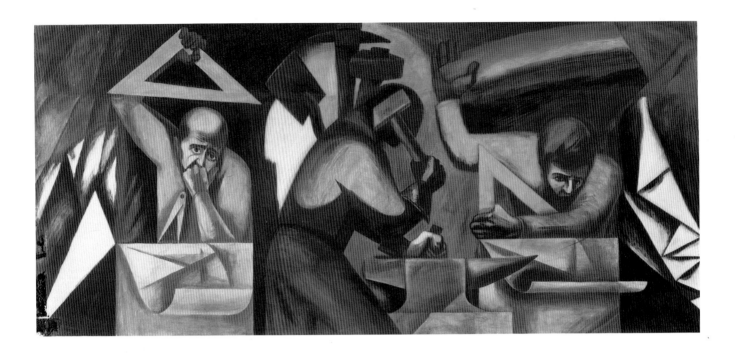

FIG. 63. José Clemente Orozco, *Science, Work, and Art*, 1930–31. Fresco, 6′3″ × 16′2″. Panel from the murals at the New School for Social Research, New York.

beyond the window—Mount Rainier, about sixty miles from Seattle, whose hovering presence fills the view from many windows in the city.

The *Builders* works include other new stylistic features. Lawrence's perspective is even more precariously tipped, presenting a bird's eye and often worm's eye view, and forms are often accumulated in tall, vertical compositions. Boards that the builders work with enhance spatial depth, becoming foreshortened directionals of linear perspective; the elongated pyramidal arrangement of forms also contributes to this effect. Horizon is often almost eliminated in favor of a close-up view, and the top edge of the work tends to compress the adjacent smaller, more distant forms. A tension is rendered: forms appear as if about to spill out at the viewer. Large, blocky objects (figures, tables) are played off against small intricate ones (tools, equipment). Heads and hands gain more significance as they achieve focus next to broadly handled forms. And all of these elements interlock like a Cubist collage. Robert Pincus-Witten wrote in *Artforum* in 1974:

> Striking is Lawrence's pragmatic acceptance of a once standard Cubist-Expressionist mode. Lawrence is sublimely unconcerned with the Kantian doubt that underlies the evolution of Modernist art history—of which the central paradigm is Analytical Cubism's transformation into Synthetic Cubism. Instead, Lawrence views Cubist-Expressionist representationalism in terms of a fundamental exploitation harnessed to straight narrative needs. In this, Lawrence demonstrates the vitality of a style which was long thought to be purely decorative. In Lawrence's hands that conceptual complex is transformed into Carpenter Cubism, as serviceable and as malleable as the situation warrants.[7]

The influence of graphics also appears generally in his painting of these years because of the many serigraphs and lithographs Lawrence had begun to do: shapes are flatter, often solid and unmodulated, and details of facial features are almost eliminated. And finally, it is highly significant that in these works different ethnic groups are depicted working together toward mutual goals.

With the recent *Builders,* Lawrence's work assumes a major shift in tone: it is more philosophical and objective, more symbolic, less regionally specific and emotive. The emphasis on manual labor in these works stresses the positive aspects of

FIG. 64. Jacob and Gwen Lawrence at opening of the Whitney Retrospective Exhibition, New Orleans Museum of Art, February 1975.

man's struggle and aspirations. Grace Glueck, critic for *The New York Times,* who has followed Lawrence's career, quoted him about this change:

> For him, the newer paintings represent a "broadening of imagery, an expansion of my humanist concept. I had to do the black thing first—but like most artists, I'm expanding, probing, constantly seeking new symbols—always within the humanist context."[8]

Lawrence has remained active on both the east and west coasts and internationally during the last fifteen years. Starting in 1971 he served two consecutive three-year terms on the Washington State Arts Commission; also in that year the sixty *Migration* paintings were united for a group show at the Museum of Modern Art in New York. In 1972, he was commissioned to do a poster for the Olympic Games in Munich, one of many posters done in recent years (pl. 84). As part of the commission, Lawrence and his wife were invited to attend the games in Germany. Lawrence explained:

> There were about twenty-eight artists from around the world who were asked to do Olympics posters. They asked me to do it because they were thinking in terms of a black to show the contribution which blacks have made to the Olympics. They asked me to consider that, and they knew what content I worked with.[9]

He has also created several posters for Seattle events in the past decade. The *Bumbershoot* poster, 1976 (pl. 85), for the Seattle annual arts festival is a work of the *Builders* style. Emphasis is on the carnival atmosphere of the urban celebration; implied activity extends beyond the frame. Both this and the Olympic Games poster use broad expanses of green lawn, a characteristic feature of the Seattle area which Lawrence has noticed in contrast to New York.

In 1981, Lawrence was commissioned by the Pacific Northwest Arts and Crafts Association to design a poster for the annual Arts and Crafts Fair in Bellevue, Washington (pl. 87). This work is unusual, for it is predominantly peopled by the whites mainly in evidence at the Bellevue fair. Caricature becomes most evident when Lawrence is dealing with the white person's physiognomy; this imagery becomes an opportunity for him to indulge in wry social observation.

An opportunity to return to the historical narrative format came in 1973, when

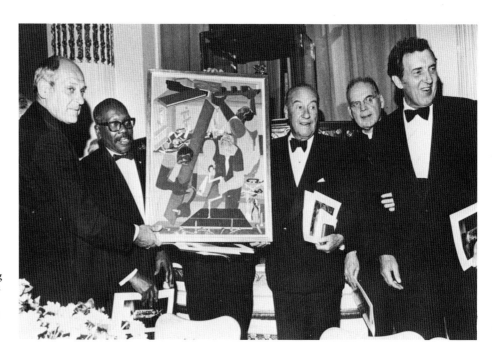

FIG. 65. Lawrence's *Builders*, 1974, being presented by Skowhegan School of Painting and Sculpture to Bishop Paul C. Marcinkus (left), emissary of Pope Paul VI, at presentation banquet, Plaza Hotel, New York, April 1974. Senator Muskie (right) also present.

Lawrence was commissioned by the state of Washington to paint a series on George Washington Bush, a black explorer and pioneer. The *George Washington Bush* sequence was exhibited at the State Capital Museum in Olympia, and remains there on permanent display. The five panels read from right to left, as Bush leads his band over the Oregon Trail to the West Coast; narrative captions describe the journey. Lawrence created the series based on information obtained from the Washington State Historical Society, the Oregon Pioneer Association, and from old Oregon and Washington newspapers.[10] His methodical approach to painting a series, which he developed in the beginning of his career, has been documented photographically; Plate 86 demonstrates the five working stages for one of the panels.

The Whitney Museum of American Art in New York invited Lawrence to have a major one-man retrospective exhibition in 1974. The show traveled to five U.S. cities and presented over 160 paintings selected from more than forty years of work (fig. 64). *Builders—Family* (pl. 88) was chosen for the show's poster and the cover illustration for the catalog. Lawrence explained: "I designed it for that purpose, for the poster, so I kept it very simple and flat."[11] The catalog essay by Milton Brown offered the most cogent summary of Lawrence's life and work to date. Many reviewers praised the exhibition, including Hilton Kramer, *New York Times* critic, who said that the Whitney show presented "a large body of work that is exceptional both in thematic coherence and in sheer expressive force. . . . The exhibition . . . is . . . extremely moving."[12] Spencer Moseley, a Seattle artist present at the opening, was struck with viewers' reaction:

> It was the only exhibition I've ever attended where the works brought tears to the eyes of those who viewed the paintings. There are probably few parallels in Art History, but the unveiling of Giotto's frescoes in the Arena Chapel may well have evoked a similar response from an equally involved audience.[13]

In April 1974, one of Lawrence's *Builders* works (*Builders,* 1974, pl. 82) was presented by the Skowhegan School of Painting and Sculpture to Pope Paul VI for inclusion in the Vatican Museum's collection. Skowhegan expressed a desire to donate a work of art to the Vatican Collection and had inquired which artist's work the Pope might wish to acquire; he asked for a painting by Jacob Lawrence.[14] The presentation was made at a banquet held at New York's Plaza Hotel, and the work was accepted by a papal emissary (fig. 65).

An opportunity to create his first portfolio of prints arose in 1975 when the Founders Society of the Detroit Institute of Arts commissioned Lawrence to do his 1941 *John Brown* series as serigraphs. Lawrence had become involved in printmaking in the late sixties but this was to be a major suite of twenty-two

FIG. 66. Jacob Lawrence signing the *John Brown* prints of the 1977 serigraph portfolio. Left: Mr. Sillman of Ives-Sillman, Print Workshop, New Haven.

silkscreen prints (fig. 66). The idea to create a print version of the series evolved because the *John Brown* paintings were in poor condition and the Institute was reluctant to loan them. A catalog, *The Legend of John Brown*, accompanied the 1978 exhibition of these works and was published by the Institute with a poem, "John Brown," by Robert Hayden.[15]

During the 1976 U.S. Bicentennial celebration several of Lawrence's works were spotlighted. The Whitney *Builders—Family*, was included in the American Freedom Train Traveling Exhibition that toured the country and was reproduced in the program for that exhibit, which presented "the face of America, as envisioned by her artists."[16] Other painters included in the exhibition were Albert Bierstadt, Frederick Remington, Thomas Cole, Georgia O'Keeffe, Winslow Homer, and Morris Graves.

Lawrence received several Bicentennial commissions because his content lent itself so appropriately to the event. Transworld Art in New York City asked him to do a print on some aspect of American history since the Revolution. The resulting painting, *Confrontation at the Bridge* (pl. 89), is based on a 1963 incident in Birmingham, Alabama, during the nonviolent civil rights demonstrations led by Dr. Martin Luther King, Jr., and a group of ministers, who attempted to march into the heart of the city but were met and arrested by Commissioner "Bull" Connor and members of his police force.[17] This work presents a pointed example of how the artist selects his material: from the bloodshed, violence, death, and scenes of physical force exerted and experienced, he chooses to portray a moment before the peak of the conflict, thus enhancing dramatic power through viewer anticipation. Plate 90 reproduces another Bicentennial commission, *The Migrants Arrive and Cast Their Ballots*. This work was commissioned by the Lorillard Company to be part of a portfolio of silkscreen prints by twelve artists.[18] For this serigraph, he chose a theme he had first attempted in the *Migration* series, thirty-four years earlier.

During this past decade, Lawrence has produced numerous drawings that explore the human figure (fig. 67) in graphite on paper. "They are very close to my paintings," Lawrence has commented, "with the same kind of structure, with the figure itself incorporated with the picture plane. They have a certain factual quality about them."[19] Inspired by the woodcuts of Vesalius (fig. 68), Lawrence explained:

Vesalius was a sixteenth century doctor; I've studied his drawings, which come from a time when they first discovered the human figure for medical purposes: they went out on the battlefields to get cadavers. He was the first person to include the figure in the landscape, peeling away portions of the figure. They were not just like medical drawings, but were creative works of art.[20]

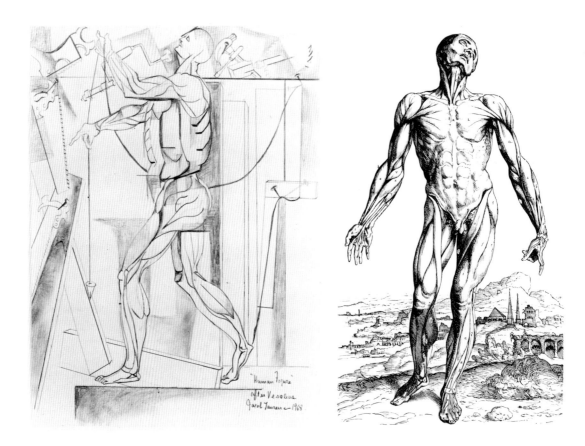

FIG. 67. *Human Figure After Vesalius,*
1968. Graphite on paper, 23¾ × 17½.
Collection of Gwendolyn and Jacob
Lawrence.

FIG. 68. Vesalius, *Figure Drawing.* Wood-
cut, c. 1547.

These nude figures by Lawrence represent a new emphasis on anatomical explora-
tion. They become a mixture of realistic physical details and stylized pattern. Shad-
ing that resembles chiaroscuro provides highlights to muscles and other structural
features; a curvilinear treatment appears which Lawrence does not usually employ, a
feature that may also convey the influence of life drawing that he had been teaching
and doing himself. A drawing (fig. 69) from about 1968 reveals, for Lawrence, an
exceptionally naturalistic approach to the human figure. This singular piece was
done when he was teaching at Skowhegan, where drawing from the model is em-
phasized in sculpture classes.

Another stylistic departure in this period appears in a painting entitled *The
Serengeti,* 1977 (pl. 91). This commission for the Champion Paper Company was
included in a publication they produced on Africa. Lawrence's versatility emerges in
the slender, rhythmic forms and lyrical colors that capture the flat heat of the
Serengeti plain teeming with a variety of wild herds.

The decade of the 1970s was a stable time for Lawrence, both personally and
artistically (fig. 70). Far from the Harlem community and its imagery, he took advan-
tage of opportunities to probe fresh content and develop new approaches. The paint-
ing *University* (1977), rendered during a period of immersion in the academic envi-
ronment (pl. 92), illustrates Lawrence's impression—an elegant ivory tower with its
many classrooms and activities.

At this time, Lawrence also did two untypical works with himself as the subject.
His *Self-Portrait,* 1977 (pl. 93), was painted for the National Academy of Design;
each new member is required to submit a self-portrait to the academy's collection.
Painted with the aid of a mirror, it shows Lawrence looking directly at the viewer and
seated in his studio, surrounded by his paintings, shelves with tools, and tubes and
jars of paint on a work table. In this work, the paintings (among them a *Harriet
Tubman* work and *Tombstones*) and objects serve as symbols of his life and career,
for many of them are not actually installed in his studio. His masklike face is divided
into broad planes, with white of the paper retained to create relief lines. Lawrence's
preference for dominant red, yellow, and blue primaries prevails. His glasses, which

FIG. 69. *Nude Study*, c. 1968–69. Litho crayon and pencil on paper, 18 × 24. Collection of Gwendolyn and Jacob Lawrence.

he does not use for close work, are absent, and he has painted his eyes with relative naturalism.

The Studio (pl. 94) also shows Lawrence in his workroom. In actuality, the back window of his studio looks out on the blank wall of the neighboring house. Lawrence decided to fill the view with a New York cityscape to bring in some of his early experiences.[21] Lawrence's studio reveals an organized and orderly nature: all papers and mementos are filed in numbered and indexed folios, and he maintains a meticulously neat work area. Lawrence believes that an artist's studio can be very revealing:

> When I was quite young, I was very fortunate. Coming out of the Service I met many older artists who befriended me; some were very famous. Charles Sheeler was one. He invited me to his studio. It's very interesting seeing people's studios and how they work. You can get a feeling for the artist's personality. Sheeler's studio was like a clinic—very, very neat, very precise, everything exactly where it should be, and this is the kind of person he was. Whenever graduate students come in, when they start their first year, I always want to see the studio—it tells me a lot about the person.[22]

During the Carter administration Lawrence received much attention from Washington, D.C., starting with the President's inauguration. Lawrence was invited by the Presidential Inauguration Committee, along with Andy Warhol, Robert Rauschenberg, Jamie Wyeth, and Roy Lichtenstein, to render impressions of the inauguration ceremonies in January 1977. The final works, silkscreen prints, were compiled into a portfolio and sold to defray inaugural expenses (fig. 71).[23] On returning from the inauguration, Lawrence shared his experience with a gathering of art students and faculty:

> The idea of involving artists is a very good thing. . . . It was a very beautiful experience: the excitement, the way the artists responded.
> I was very impressed by the simplicity of the artists. They are internationally known, but very simple, very secure people. Of all the artists present, we saw only Wyeth sketching. Andy Warhol wasn't there—he was in Kuwait. He had sent two assistants to take photographs, which he'll work from in his studio.

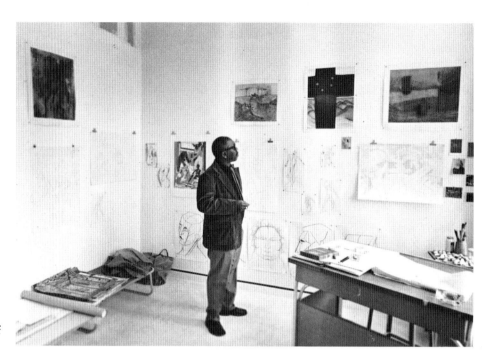

FIG. 70. Jacob Lawrence in his University of Washington studio, 1975.

The entire experience had a very abstract character. I don't know what I'm going to do to express my feelings. Just entering the White House, seeing the columns, you get a feeling of the country, a feeling of something very real, that has a great dimension. You think about the Civil War, the Revolution, about the founding of the country. You had a sense of history, of what man had achieved—it was all there: our intellectual capacity, and beyond that, our emotional sensibility. . . . This is the surreal thing that I'm trying to express.[24]

Lawrence did two impressions of the event, and he chose the one he felt was stronger (pl. 95).[25] The crisp, cold day is clearly suggested by stark trees silhouetted against an icy blue sky. The artist focuses on the onlookers, not the President:

When Carter said he wanted this to be a "people's inauguration," it was that. As we sat, when he was taking the oath of office, I looked behind me and way in the distance there were bare trees and people were up in these trees and they were applauding more than the people in the immediate area, who I imagined were the people with special privileges. The bare trees . . . and limbs—you could see the people up there, and then you could hear this muffled sound from a great distance. I see it as the most important ingredient of the election and the inauguration, and that's the people themselves.[26]

Lawrence's imagery here is different, even unexpected, because he depicts a mostly white crowd. The people look up toward the steps of the Capitol. Flat profile forms are dotted by facial features, little flags, and scooplike hands; details are distilled.

The elements of Egyptian mural art that appear in these paintings may connect with the fact that while in Washington, D.C., he and Gwen had attended the Tutankhamun exhibition and had revisited the permanent Egyptian collection at the Metropolitan a few weeks before; in his art school talk, Lawrence had mentioned his fascination with the mystery of Egyptian art.

In 1978, Lawrence was nominated by President Carter and confirmed by the U.S. Senate to serve a six-year term as a member of the National Council on the Arts. In 1980, Carter commissioned Lawrence to design a Labor Day poster on a *Builders* theme (pl. 96). Of its subject he noted: "For a number of years, women have been more and more evident in our labor force. It is for this reason that women are so evident in this work."[27] That same year, he was also commissioned to do a work for an "Images of Labor" exhibition that traveled throughout the country under the sponsorship of the Smithsonian Institution in 1981 (pl. 97). Thirty-two American artists were selected to create art inspired from a series of quotations about the working American. Lawrence chose a Mark Twain statement on the American Labor movement, which is included, in part, at the bottom of the poster.[28] This work reasserts Lawrence's early interests in Social Realism and the workers of society.

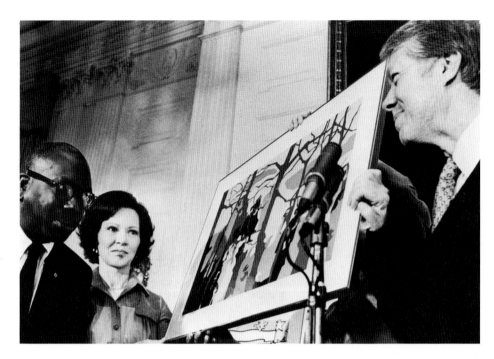

FIG. 71. Jacob Lawrence presenting *The Swearing In #1*, 1977, to President and Mrs. Carter. Serigraph, 18 × 28. (From the painting, *The Swearing In #1*, 1977, gouache on paper, 18 × 28. Collection of Gwendolyn and Jacob Lawrence.)

Lawrence's work has always been stylistically appropriate for monumental wall paintings, and in the period 1978–81, Lawrence undertook his first two mural commissions. The first, a *Games* mural for the Kingdome Stadium in Seattle, was commissioned in 1978 and installed in 1979 (fig. 72). This project presented a technical challenge: he had to use materials that would endure in a semi-protected setting subject to dampness. He decided upon porcelain enamel on steel, and was assisted in producing the final panels of the mural by David Berfield, a Seattle ceramic artist. The finished work comprises ten panels joined in an image of boldly foreshortened massive athletes backed by the onlooking crowd. The large mural is visible above or below the crowds that enter and exit the stadium. Just before the mural was hung, Lawrence discussed his conceptualization:

> I envisioned a piece that would change in value because of atmospheric light. It is a fortunate space in that there is a ramp to the right where spectators come down and another vantage point from below. . . . The mural will not be complete until you see it in its final setting. The environment becomes part of the work.[29]

Lawrence's second mural, a commission received in 1979 from Howard University, was installed in December 1980 on an interior brick wall in the Armour J. Blackburn University Center on the Howard campus. He again used enamel on steel (pl. 98). Entitled *Exploration*, the mural was funded by the Mildred Andrews Fund, a Cleveland-based foundation, and was dedicated to the memory of Mary Mcleod Bethune, a leading black educator. The academic disciplines of the university are each depicted in a separate panel. The twelve joined panels are united by a flow of forms, with shallow "rooms" presenting each discipline. In flat color, the composition depicts ethnically mixed crowds in their various pursuits. Critical reception in the Washington, D.C., area was extremely favorable:

> The new mural . . . shows him at his best. . . . It is enormously sophisticated yet wholly unpretentious, humorous yet serious. . . . The colors are completely flat, but . . . his mural has the look of a rich relief. . . . This is not art that one tires of, for it is not the sort of work one can read at once.[30]

And Benjamin Forgey described the mural in *The Washington Star* as a

> . . . good piece of art in the right place. . . . He solved disparate, difficult problems elegantly. A theme of educational "Exploration" is . . . potentially hackneyed. In the main, Lawrence managed to give it fresh expression, perhaps because of his long experience with narrative themes in visual sequences . . . perhaps because of his long experience, period.
>
> In any case his Howard mural is distinguished in conception and execution. Tied

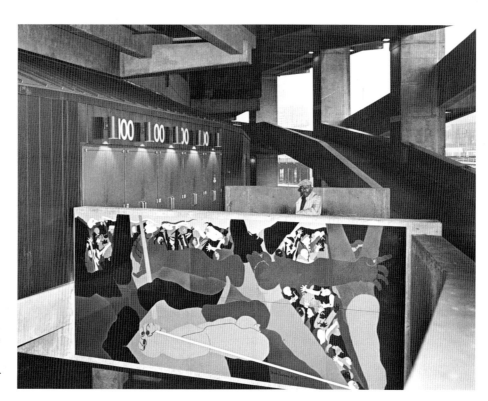

FIG. 72. Jacob Lawrence and *Games* mural in place, 1979. Kingdome Stadium, Seattle, Washington. Ten panels of porcelain enamel on steel, 4'8" × 3'6" each (9'4" × 17'6" × ⅞"). King County 1% for Art Collection, Washington.

together in a number of fairly subtle ways . . . it makes a rather sonorous dance across the long, low brick partition where it is hung. . . .[31]

In 1982, Lawrence was commissioned to do a second enamel mural for Howard University (pl. 99, fig. 73). This work, *Origins,* which deals with Harlem genre and history, was placed on a wall near the earlier mural in the Blackburn student union building in autumn 1984.

The artist received a fourth mural commission in April 1984 when the University of Washington asked him to create a work for both a campus site and a subject of his choice. Related thematically to his earlier *Theater* series, the mural, *Theater,* was mounted in the foyer of Meany Hall, the university's performance center, in June 1985 (pl. 100, fig. 74). Two themes are presented in the detail included here (pl. 100). In the tragedy and comedy portion (left), figures entwine with violent gestures; masks, daggers, and a tear flowing from an eye are evident—the latter a reference to Lawrence's *Vaudeville,* 1951 (pl. 52). Two musicians and a trumpet fill the jazz portion (right), a reminder of the artist's earlier cafe scenes (e.g., *Village Quartet,* pl. 57).

Many times in his work of the late seventies, Lawrence returned to familiar themes. The portrayal of library interiors, where he has spent much time, has interested the artist since his early years (see pl. 58); one of his first mature paintings is *The Curator,* 1937, a rendition of Arthur Schomburg surrounded by the shelves of books of the Schomburg Collection. *Library,* 1978, is a serigraph (pl. 101). The skin color of the figures, a stunning black with thin white outlines, creates an assertive dark pattern against pale institutional green and the colorful texture of the shelves of books. For Lawrence, there is a thread between the *Library* paintings and the *Builders* theme. A library and its contents symbolize man's continuous efforts to develop, to build.[32]

Lawrence has also continued to do works on the *Builders* theme. An example from 1979, *Builders—Green and Red Ball* (pl. 102), is a stylistic compilation of his recent poster compositions and *Builders* scenes, with athletes, playing children, and builders intertwined. He extended the *Builders* theme to numerous drawings in the early 1980s, many of which were exhibited as a unit in 1982 at several galleries in Los Angeles, Seattle, and the New York area (see, for example, figs. 76 and 77). These graphite-on-paper compositions of black and white pattern exhibit the artist's bias toward breaking all forms (figures and background spaces) into a patchwork of high-

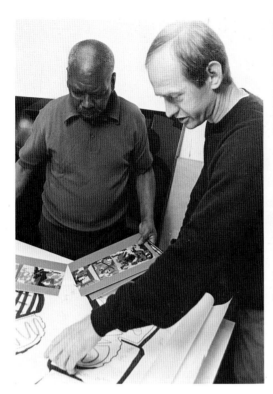
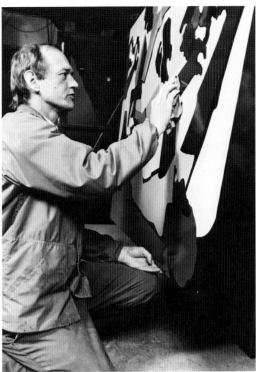

lights and subordinate shadows. The *Builder—Woman Sewing* is a particularly noble figure: with her huge hands, she recalls Lawrence's *Seamstress* of 1946 (pl. 35) and supporting figures in *Builders,* 1980 (pl. 96). The carpenter with a plumb line (fig. 76) confirms in a visual pun that Lawrence's space is tipped, out of plumb. In late 1985, Lawrence completed a sequence of eighteen *Builders* drawings (pl. 103). The inclusion of color and black ink is a logical progression in his graphic approach to the theme.

Subtle new directions in Lawrence's recent *Builders* paintings are evident in a painting from 1982, *Eight Builders* (pl. 104). The design is not of the common vertical thrust but is emphatically horizontal; forms are distributed across the picture plane. The space is less steep, with the trainlike windows in the back of the room establishing a sense of a horizon line and enhancing the lateral rhythm of the figures. Unusual attention is paid to texture: surfaces of forms are shaded softly in a variegated manner, and their contours are less angular. Some are even rounded and almost naturalistic, a quality that appeared in his art of the late seventies.

Lawrence's most recent major group of works and the first historical suite in a decade is the *Hiroshima* series (pls. 106 and 107), painted in 1982 on commission to Limited Editions Club of New York City.[33] The eight works illustrate a special edition of John Hersey's book *Hiroshima* as full-page silkscreen prints 12½ by 9½ inches. Before creating the paintings, Lawrence read Hersey's chillingly objective account of the atomic bomb explosion in Japan:

> I read and reread *Hiroshima* several times. And I began to see the extent of the devastation in the twisted and mutilated bodies of humans, birds, fishes, and all the other animals and living things that inherit our earth. The flora and fauna and the land that were at one time alive were now seared, mangled, deformed, and devoid of life. And I thought, what have we accomplished over these many centuries?[34]

A few months before the book was released, critic John Russell discussed the renewed widespread popularity of the illustrated book in *The New York Times*. He congratulated Limited Editions Club for choosing Lawrence and commented on the challenge presented by the commission:

> The problem is to make an image that will relate to the text without seeming to dictate our responses to it. Jacob Lawrence manages to portray a world split open and a population subjected to indignities for which there had been no precedent.[35]

FIG. 73. The production of the *Origins* mural, 1984.
(a) Jacob Lawrence and David Berfield confer, September 1984. On the table is the cartoon marked and cut as a stencil for glazing the enamel panels, and behind the artists are panels after an initial firing.
(b) Berfield readies a glazed panel for firing in the kiln.

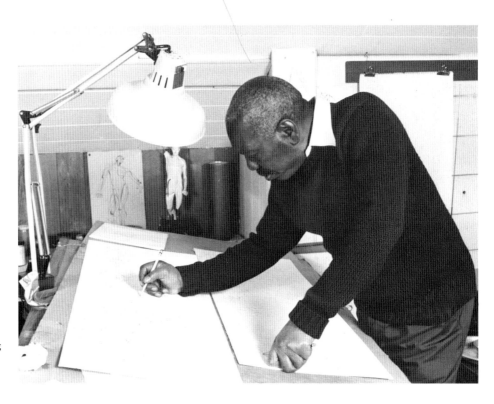

FIG. 74. Lawrence working on the *Theater* mural (1985), 1984. (a) The artist working in his studio on *Theater* mural study. Gouache on paperboard, 10¾ × 80. (b) Lawrence working on *Theater* mural cartoon, 1984.

The book also contains a poem written especially for the edition by Robert Penn Warren and signed by the poet.

In the *Hiroshima* works, Lawrence chooses an uncommon color scheme including much red, rose, yellow, and blue. With these primary yet oddly dissonant hues, he captures the horror of the catastrophe. He explains his approach to the material:

> I could have done one work; that was completely open. . . .
>
> I used my own experience. How people live, people at the table, in the park, in the marketplace. I didn't follow something out of the book. I don't think I could have executed the Japanese [physical features], and I didn't think it was important either. I didn't want it to be an illustration of that sort; I wanted it to be in terms of man's inhumanity to man—a universal kind of a statement.
>
> Although I didn't experience Hiroshima, I was trying to get the feeling of this tremendous tragedy in a very symbolic way. There are a lot of symbols in the works. I use a drooping flower and broken trees—things that are in the process of dying: moribund.[36]

The figures' heads are reduced to anonymous white skulls, a hot red rendering the blast. Lawrence's style of the early eighties, in which forms have quivering, articulated edges, is particularly appropriate here where agitated silhouettes echo the impact of the blast.

Lawrence's continued involvement in political issues through his art was revealed by his donation of a work to illustrate the *Artists' Call Poster,* January 1984 (pl. 105). His contribution, *Struggle—Assassination* (1965), one of his civil rights works, lent itself perfectly to this organization's series of events and exhibitions focused on protesting U.S. military policies in El Salvador.

One of Lawrence's most recent paintings, *Builder—Man on a Scaffold,* 1985 (pl. 108), is a richly colored pastiche of images that draws from the entire body of his work. As he has often done in the past decade (e.g., *Builders,* 1980, pl. 96), within the context of the *Builders* theme the artist brings Harlem vignettes into the present as a regenerative act, reasserting the continuity of his aesthetic commitment.

Bread, Fish, Fruit (pl. 109), completed in December 1985, was painted as a poster design for Lawrence's 1986 retrospective exhibition at the Seattle Art Museum. A family sits around the table, heads bowed and hands clasped in prayer. The man at the head of the table reads from the Bible. On the table, a simple meal is laid: pieces of fruit and a large basket of fish and bread loaves. The austere umber and ochre interior of rough-cut boards resembles rooms of the slaves' quarters in

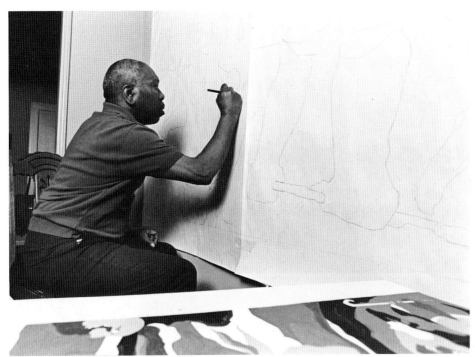 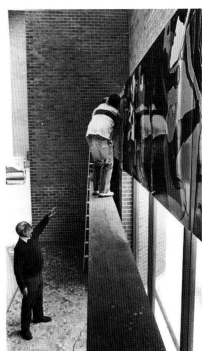

Lawrence's early series (e.g., *Frederick Douglass*). It is a carpenter's family, perhaps even emblematic of the family of Joseph: two of the men are dressed as workmen, tools are laid out on the far work table, and carpenter overalls hang on a nail. The combined elusive biblical and workers' themes appealed greatly to Lawrence.[37] He has increasingly expanded his *Builders* theme to include both religious and philosophical implications. The symbols of the biblical miracle of the loaves and fishes lends depth to this portrayal. His people here embody the ideals of work and faith.

FIG. 75. Lawrence supervising the hanging of the *Theater* mural, 1985, Meany Hall, University of Washington, Seattle.

IN DECEMBER 1983, JACOB LAWRENCE WAS ELECTED TO THE AMERICAN ACADEMY of Arts and Letters, an honor acknowledging the contribution of his art and teaching over many years.[38] Lawrence's sixteen years in Seattle comprise an extended period of stability for him. He has proved a successful transplant, although the New Yorker remains in evidence in the accents of his rich gravelly voice and the excitement with which he still speaks of his native city. When asked by an Easterner about his years in the West, he replied that it was "a 'retreat' not in the sense of defeat, but renewal. . . . Nothing is ever permanent and I may come back."[39] The Lawrences continue to think about returning to New York, now that semi-retirement offers opportunities for change.

In Seattle, Lawrence's commitment to teaching offered a sustaining base; artistically, he centered on the *Builders* theme. Within its development, his repertoire opened to other forms of expression. In his body of work the *Builders* are the thematic capstone: in their vision of people laboring to attain mutual goals, Lawrence's position as a humanist with a moral vision is underscored.

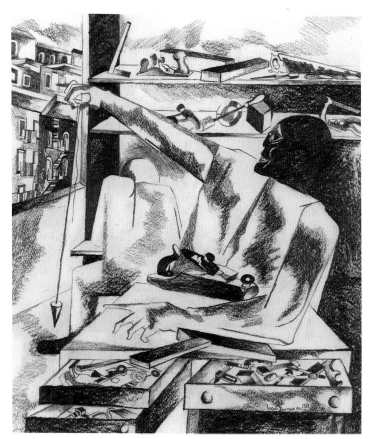

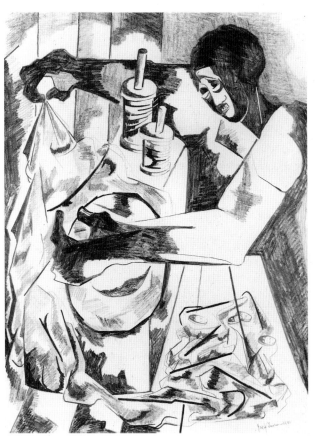

FIG. 76. *Carpenters* drawing No. 9, 1981.
Graphite on paper, 16 × 14. Collection of
Francine Seders.

FIG. 77. *Builder—Woman Sewing*, drawing,
1981. Graphite on paper, 22 × 18.

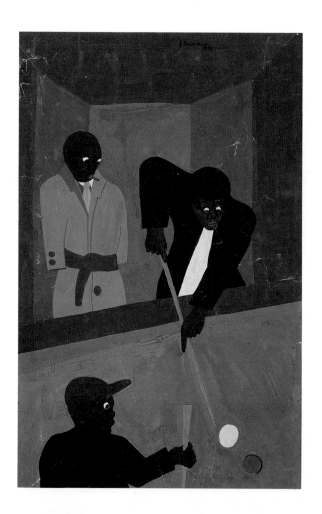

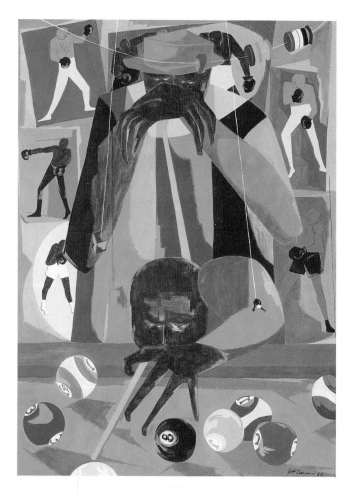

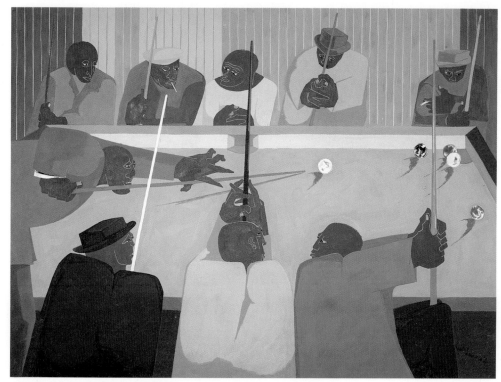

PL. 74. Three paintings on the *Pool Hall* theme.

ABOVE

(a) *Pool Hall*, 1938. Tempera on paper, 18 × 12. Collection of Gwendolyn and Jacob Lawrence.

RIGHT

(b) *The Cue and the Ball*, 1956. Gouache on paper, 30½ × 22½. Hirshhorn Museum and Sculpture Garden, Smithsonian Institution, Washington, D.C.

BELOW

(c) *The Pool Game*, 1970. Gouache on paper, 22 × 30. Museum of Fine Arts, Boston, Emily L. Ainsley Fund.

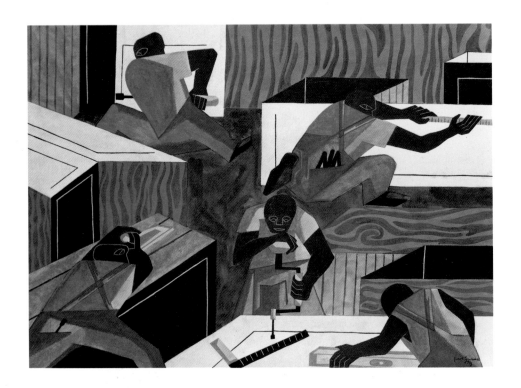

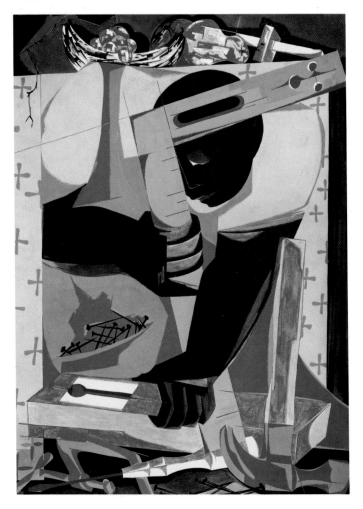

ABOVE
PL. 75. *Cabinetmakers*, 1946.
Gouache on paper, 22 × 30.
Hirshhorn Museum and Sculpture Garden,
Smithsonian Institution, Washington, D.C.

BELOW
PL. 76. *Cabinetmaker*, 1957.
Casein on paper, 30½ × 22½.
Hirshhorn Museum and Sculpture Garden,
Smithsonian Institution, Washington, D.C.

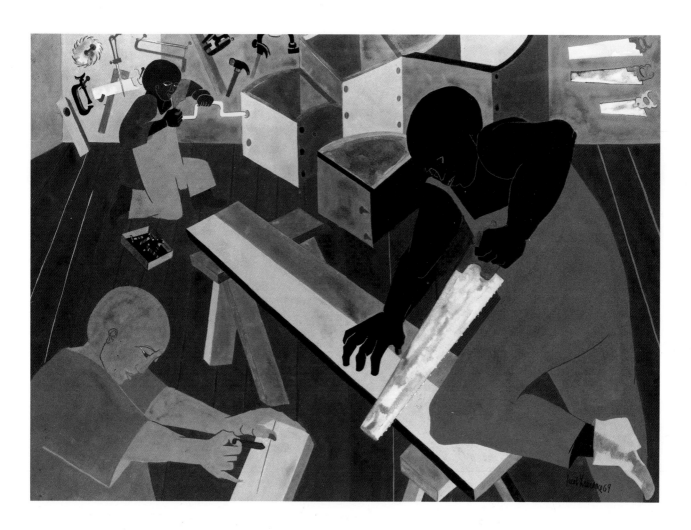

PL. 77. *Builders No. 1,* 1969.
Gouache on paper, 22 × 30.
Private collection

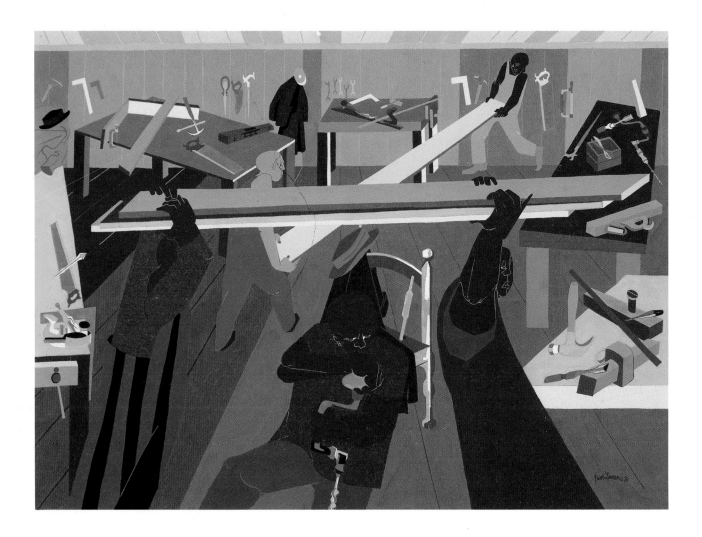

PL. 78. *Builders No. 1*, 1970.
Gouache on paper, 22 × 30.
Henry Art Gallery, University of Washington, Seattle.

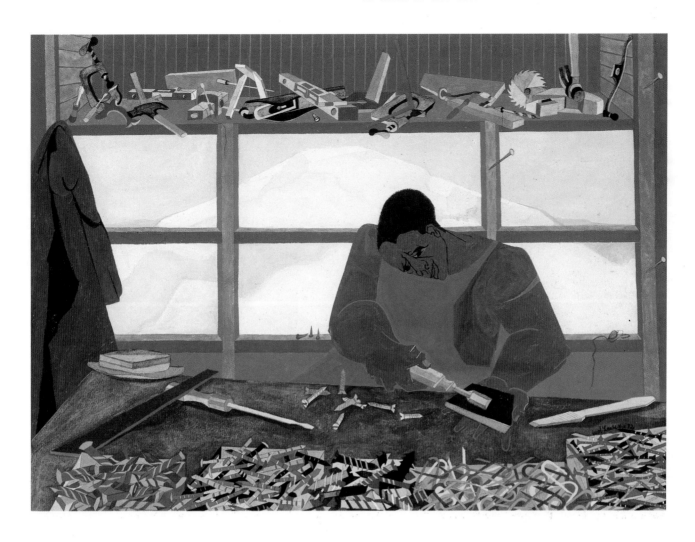

PL. 79. *Builders No. 1,* 1972.
Gouache on paper, 22¼ × 30½.
St. Louis Art Museum, Eliza McMillan Fund.

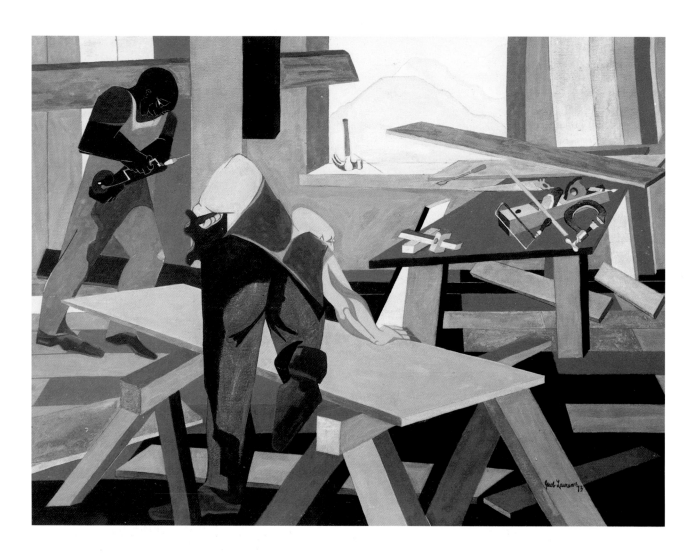

PL. 80. *Builders No. 2*, 1973.
Gouache on paper, 20 × 24.
Tougaloo College, Mississippi.

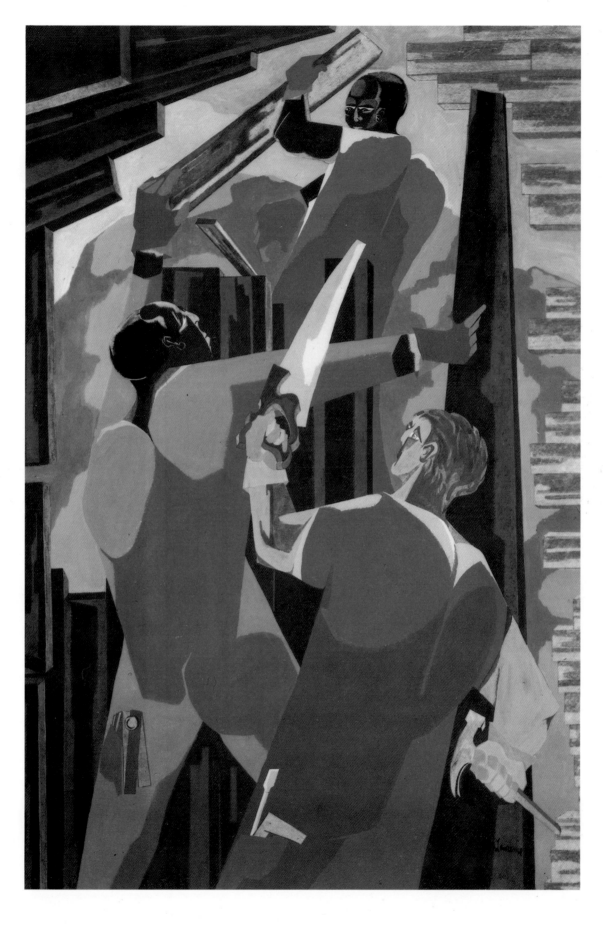

PL. 81. *Builders*, 1973.
Gouache on paper, 30 × 22.
Collection of Dr. Bernard Ronis.

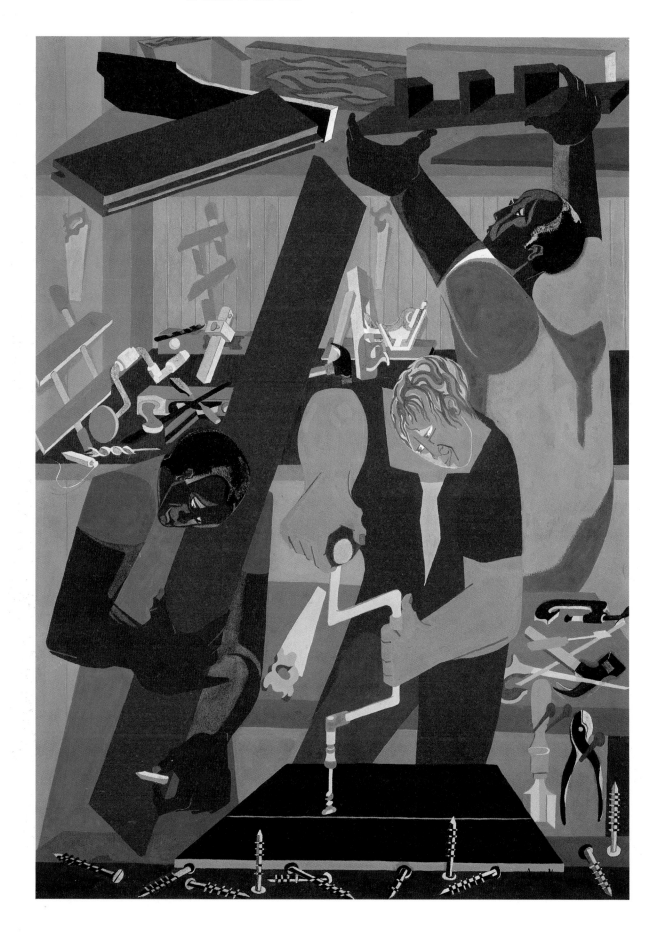

PL. 82. *Builders*, 1974.
Gouache on paper, 30 × 22.
Collection of the Vatican Museum, Rome, Italy.

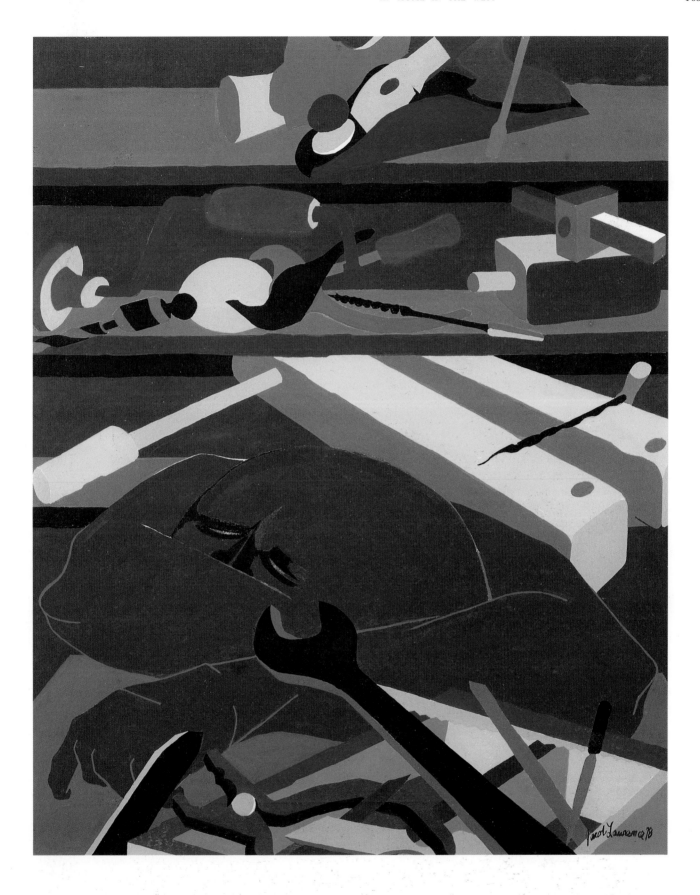

PL. 83. *Tools*, 1978.
Gouache on paper, 21¾ × 18½.
Collection of Gwendolyn and Jacob Lawrence.

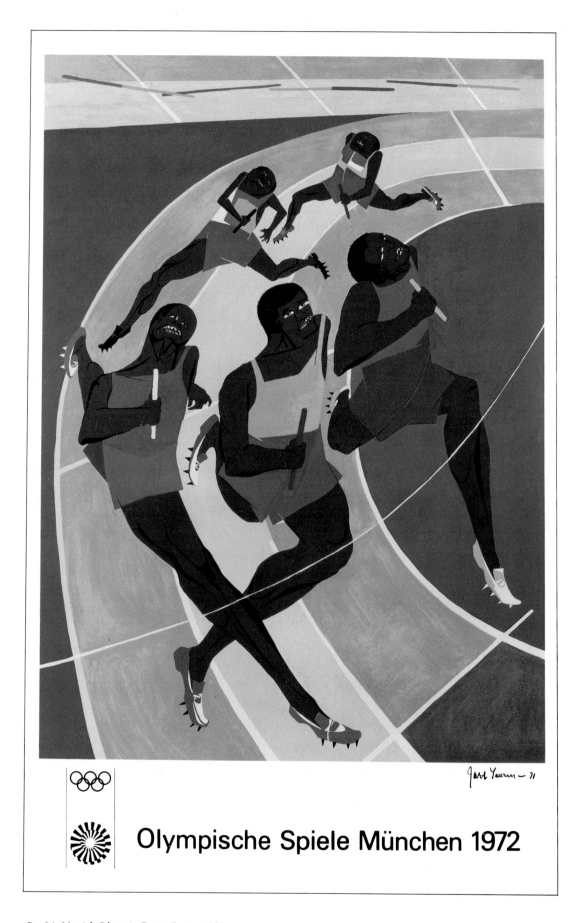

PL. 84. *Munich Olympic Games* Poster, 1972.
47 × 27.
Collection of Gwendolyn and Jacob Lawrence. (From study for *Munich Olympic Games*, 1971. Gouache on paper, 35½ × 27. Seattle Art Museum.)

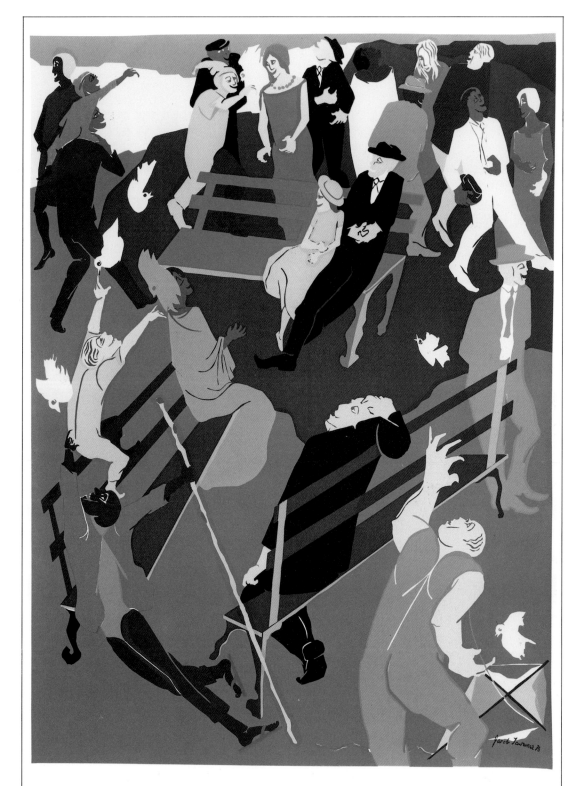

Pl. 85. *Bumbershoot '76* Poster, 1976.
37⅜ × 24.
Collection of Gwendolyn and Jacob Lawrence. (From study for *Bumbershoot '76*,
1976. Gouache on paper, 34¼ × 26¼. Seattle City Light 1% for Art Portable
Works Collection.)

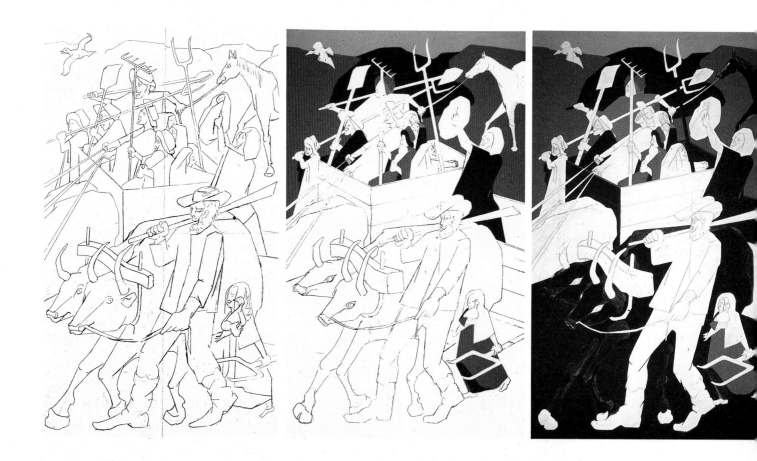

PL. 86. *George Washington Bush* Series, 1973.
Panel 2: *In the Iowa Territory, they rendez-voused with a wagon train headed for the Oregon Trail*. Five Stages: (a) drawing, graphite on gessoed paperboard, (b) stage 1, (c) stage 2, (d) stage 3, (e) final stage.
Casein-gouache on paperboard, 31½ × 19½.
Washington State Capital Museum, Olympia.

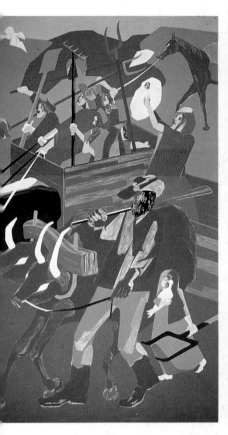

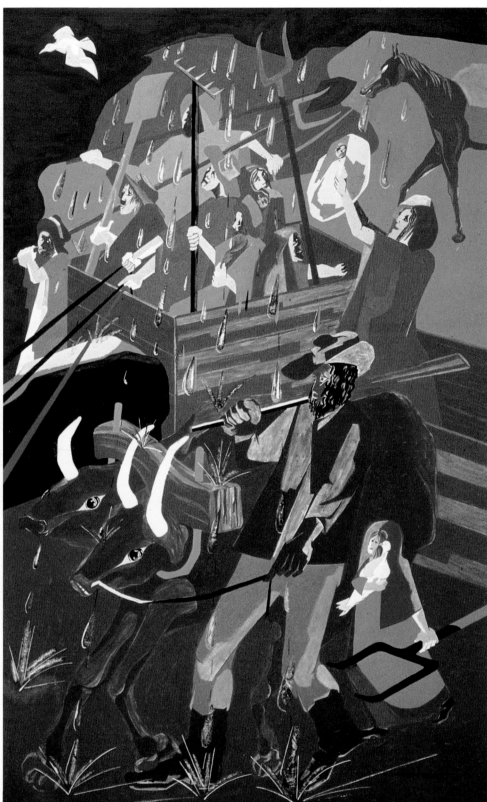

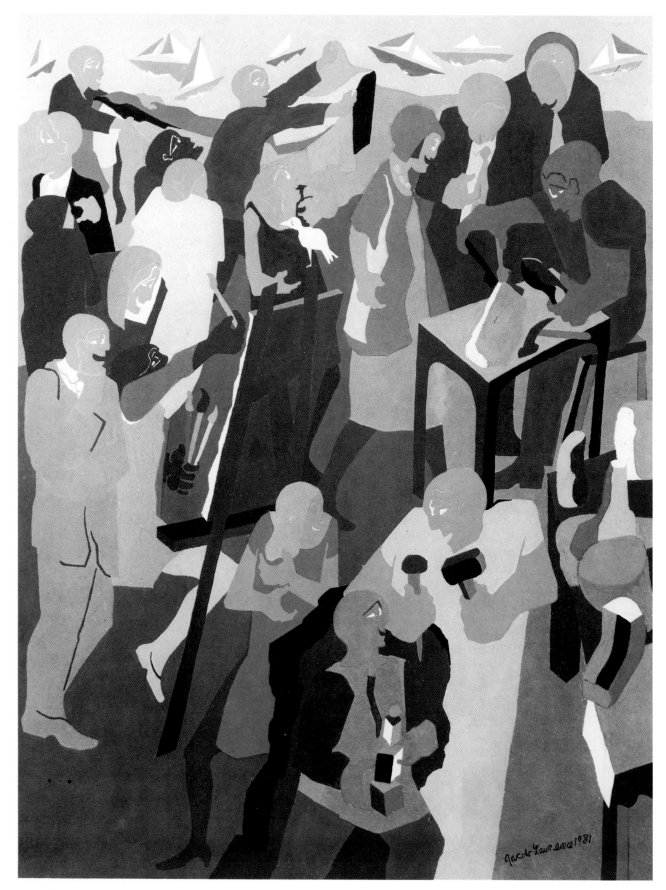

PL. 87. *Pacific Northwest Arts and Crafts Fair* poster design, 1981. Photolithograph,
18 × 14.
Courtesy of Francine Seders Gallery, Seattle. (From study for *Pacific Northwest Arts
and Crafts Fair*, 1981. Gouache on paper, 23 × 18½, Seattle Sheraton Hotel and
Towers Permanent Collection.)

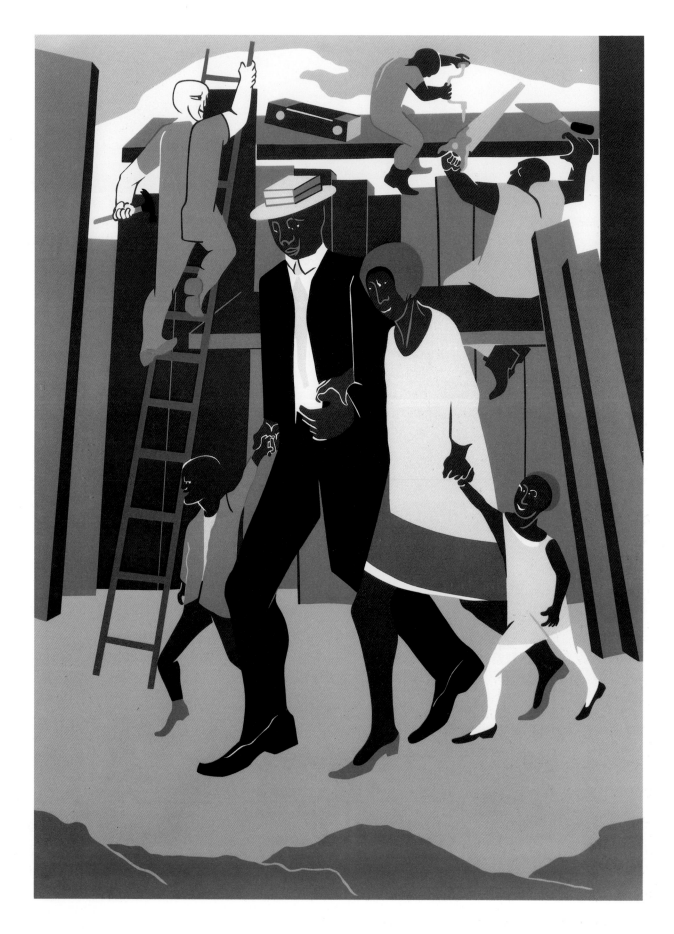

PL. 88. *Builders—Family*, 1974.
Poster design for the Whitney Retrospective, serigraph, 30 × 22.
Collection of Gwendolyn and Jacob Lawrence.

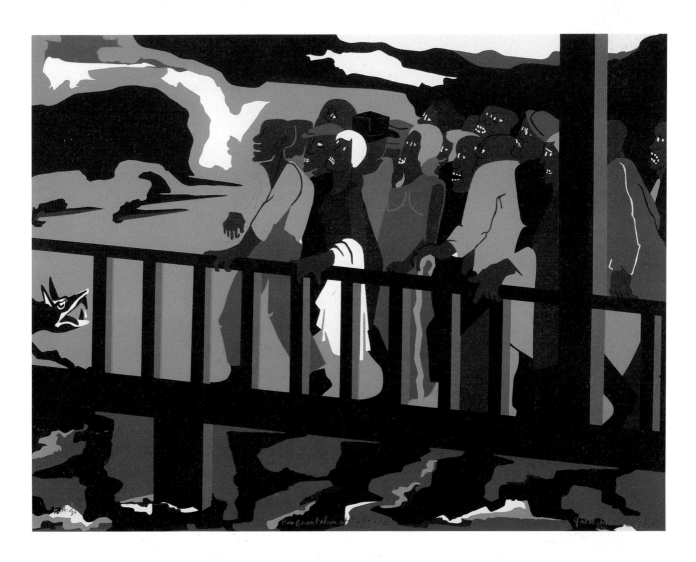

PL. 89. *Confrontation at the Bridge*, 1975.
Gouache on paper, 22½ × 30¼.
Private collection.

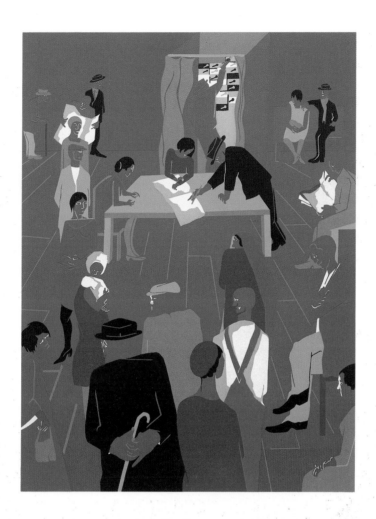

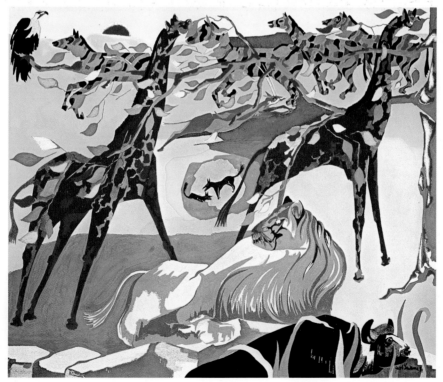

ABOVE
PL. 90. *The 1920s . . . The Migrants Arrive and Cast Their Ballots*, 1974.
Lithograph, 33 × 24½.
Collection of Gwendolyn and Jacob Lawrence.

BELOW
PL. 91. *The Serengeti*, 1975.
Gouache on paperboard. 17½ × 26.
Private collection.

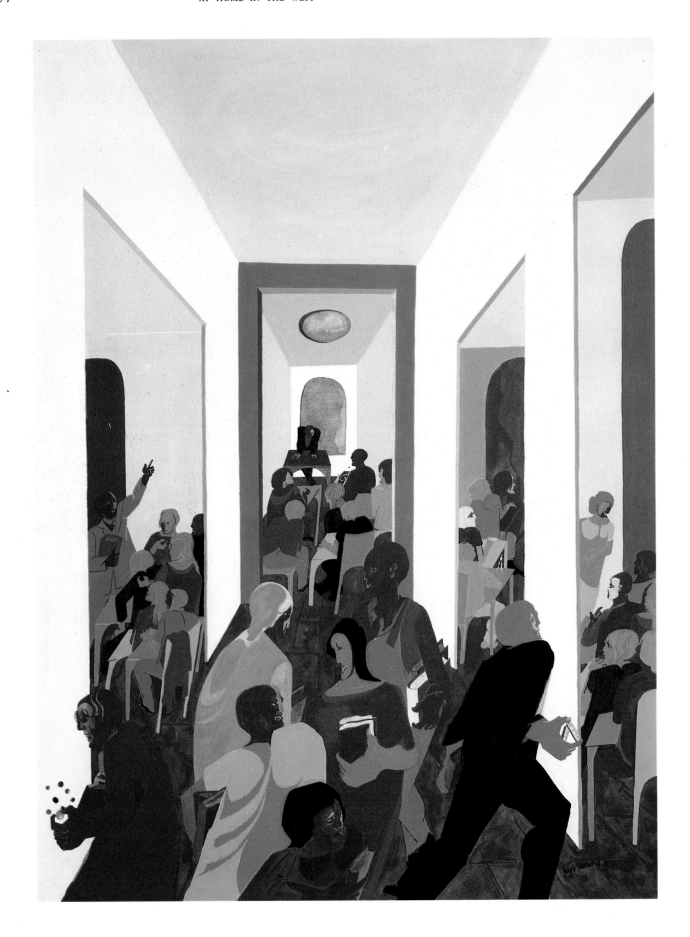

PL. 92. *University*, 1977.
Gouache on paper, 32 × 24.
Collection of Gabrielle and Herbert Kayden.

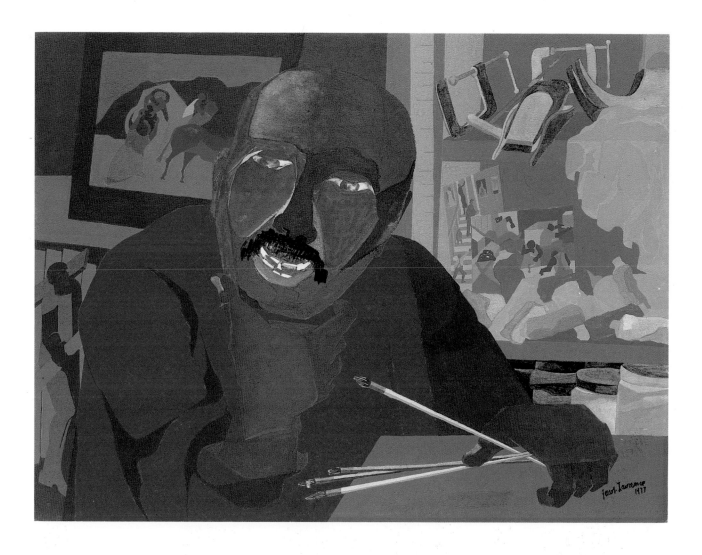

PL. 93. *Self-Portrait*, 1977.
Gouache on paper, 23 × 31.
Collection of the National Academy of Design, New York.

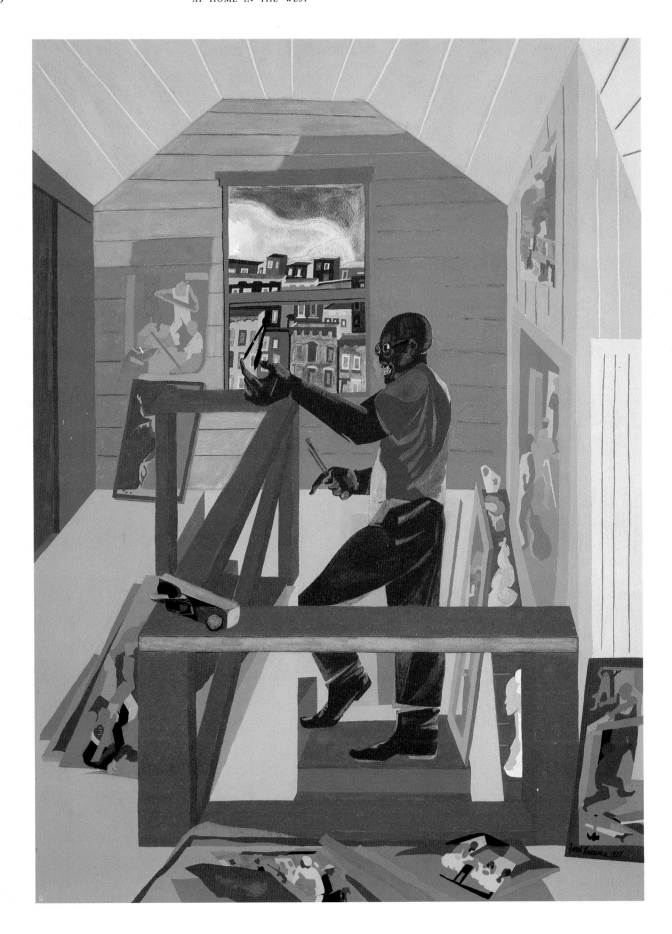

PL. 94. *The Studio*, 1977.
Gouache on paper, 30 × 22.
Collection of Gwendolyn and Jacob Lawrence.

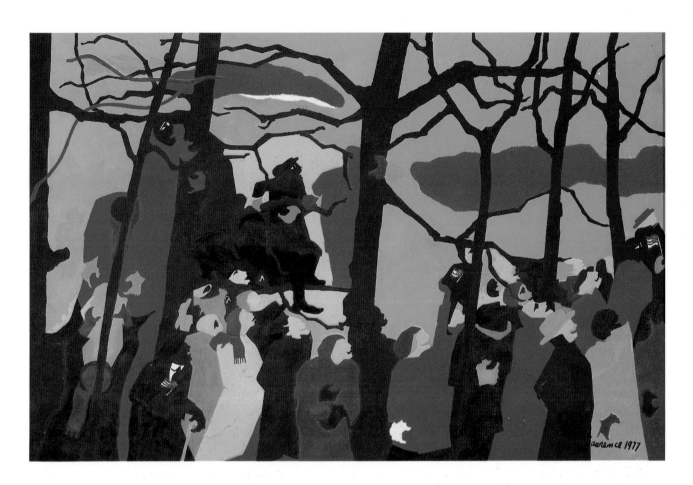

PL. 95. *The Swearing In #1*, 1977.
Gouache on paper, 18 × 28.
Collection of Gwendolyn and Jacob Lawrence.

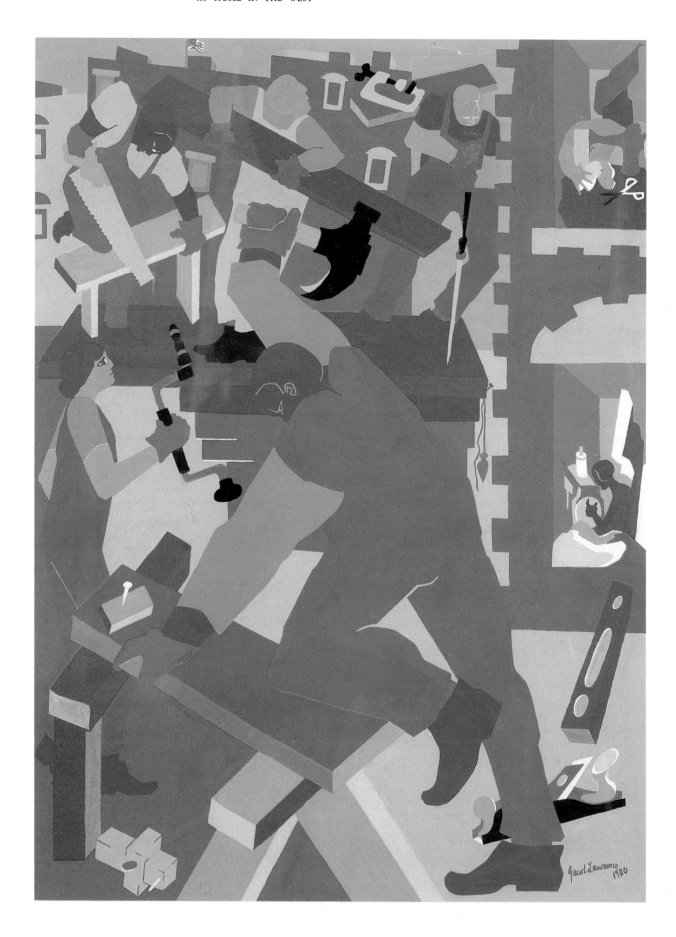

PL. 96. *Builders*, 1980.
Gouache on paper, 34¼ × 25⅜.
SAFECO Insurance Company, Seattle.

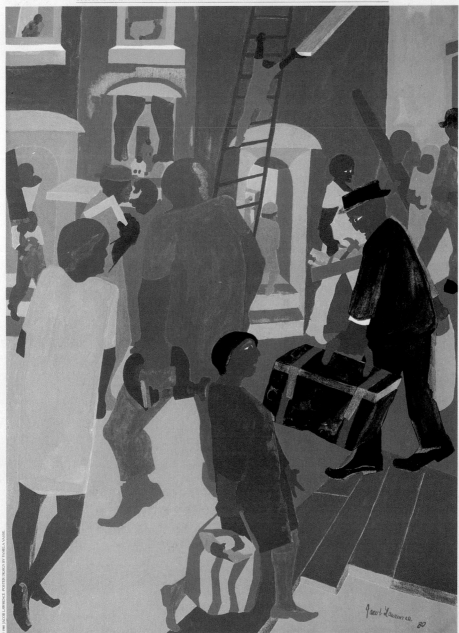

PL. 97. *Images of Labor* Poster, 1980.
36 × 24.
School of Art, University of Washington. (From the painting, *Images of Labor* 1980.
Gouache on paper, 25 × 18¼. Collection of Gwendolyn and Jacob Lawrence.)

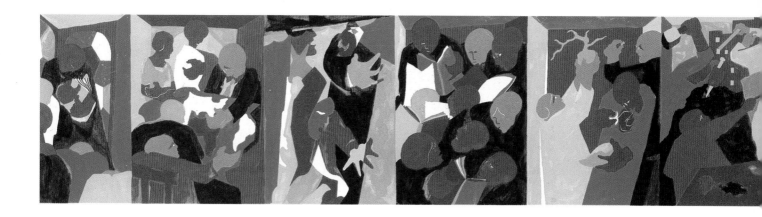

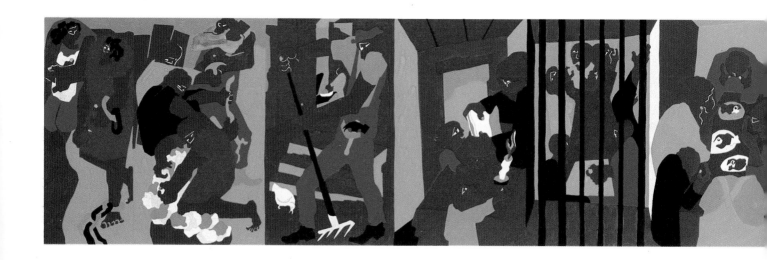

ABOVE
PL. 98. Study for *Exploration* mural, 1980, Howard University.
Twelve panels: religion, political science, theater, law, agriculture, fine arts,
philosophy, astronomy, music, medicine, mathematics, and history.
Gouache on paper, 19¾ × 78.
Mural: porcelain enamel on steel, 4'8" × 39'3" × 1".
Howard University, Washington, D.C.

BELOW
PL. 99. Study for *Origins* mural, 1984, Howard University.
Twelve panels: chains, labor, home, learning, bars, prayer,
death, beauty, family, music, religion, maternity.
Gouache on paper, 12 × 79¾.
Mural: porcelain enamel on steel, 4'8" × 39'3" × 1".
Howard University, Washington, D.C.

ABOVE
PL. 101. *Library*, 1978.
Serigraph, 10⅝ × 15.
Collection of Clyde and Jane van Cleve.

BELOW
PL. 100. Detail of *Theater* mural, 1985, University of Washington.
Mural: porcelain enamel on steel, 4′3″ × 41′6″ × 1½″.
University of Washington, Seattle.

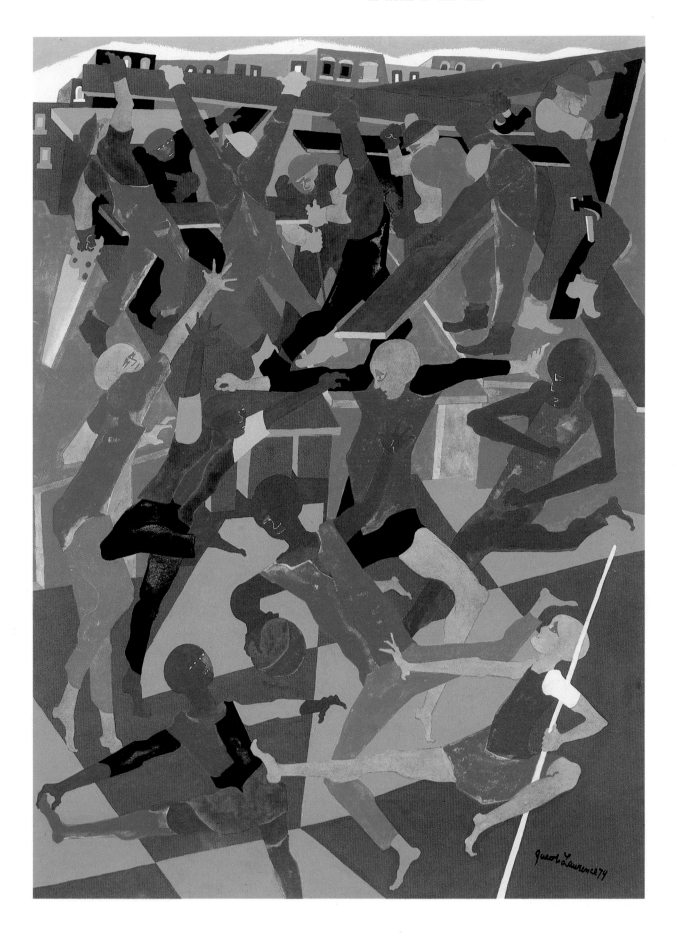

PL. 102. *Builders—Red and Green Ball*, 1979.
Gouache on paper, 30 × 22.
Courtesy of Francine Seders Gallery, Seattle.

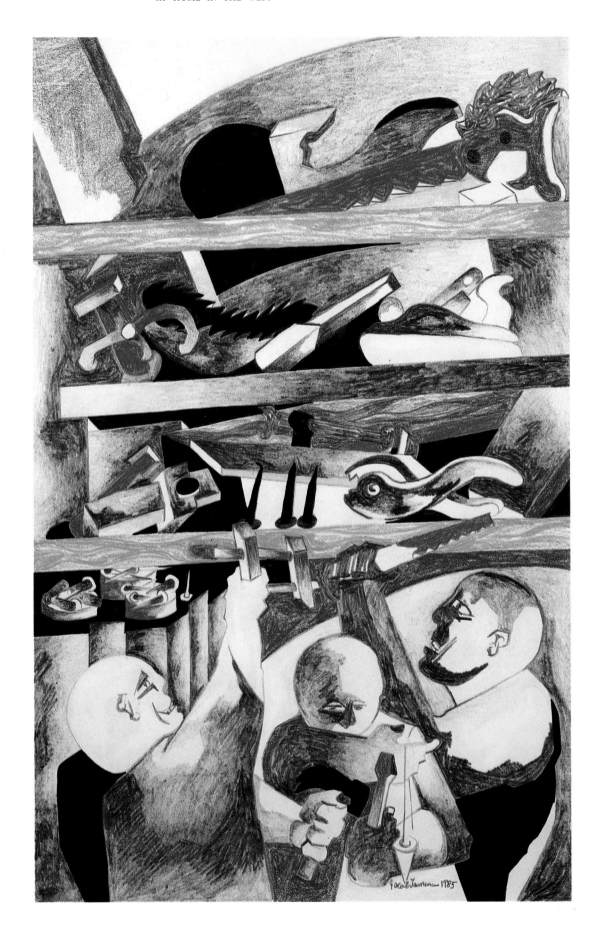

PL. 103. *Builders* color drawing 8, 1985.
Graphite, ink, and colored pencils on paper. 20 × 13.
Courtesy of Francine Seders Gallery, Seattle.

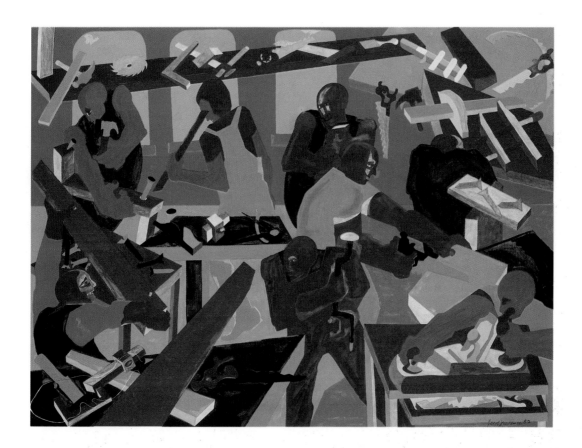

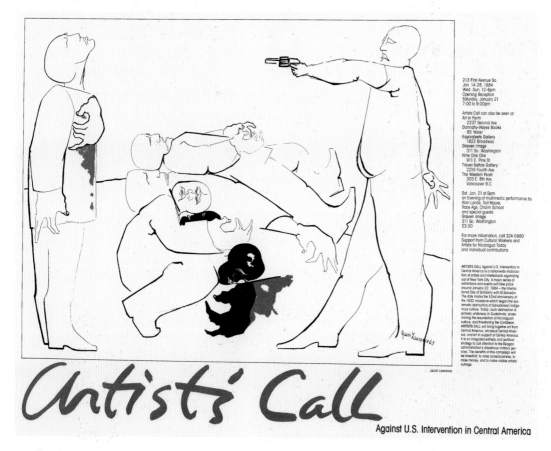

ABOVE
PL. 104. *Eight Builders*, 1982.
Gouache on paper, 33 × 44¾.
Collection of Seattle City Light 1% for Art Portable Works Collection.

PL. 105. *Artists' Call* Poster, 1984.
(From the drawing, *Struggle—Assassination*, 1965.
Gouache on paper, 22 × 30½. Collection of Gwendolyn and
Jacob Lawrence.)

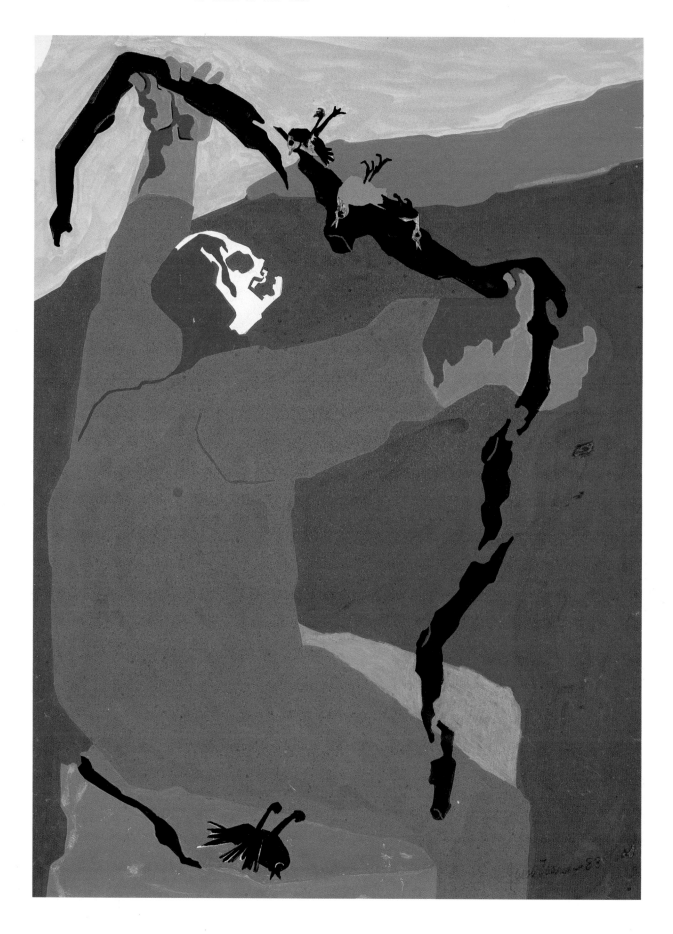

PL. 106. *Hiroshima* Series, 1983. No. 4: *Man with Birds.*
Gouache on paper, 23 × 17½.
Collection of Gwendolyn and Jacob Lawrence.

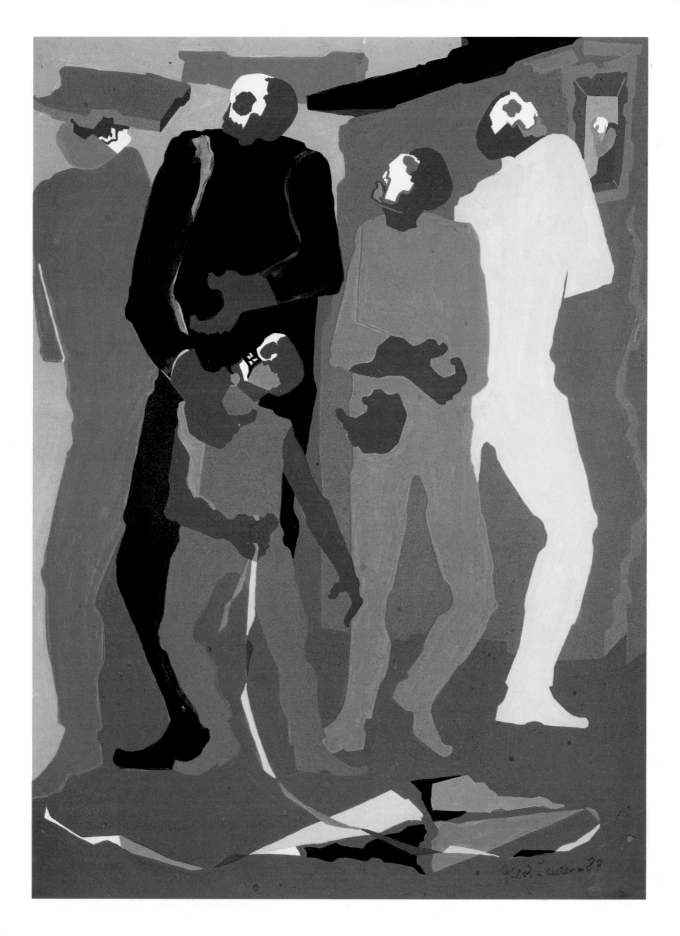

PL. 107. *Hiroshima* Series, 1983. No. 7: *Boy with Kite*.
Gouache on paper, 23 × 17½.
Collection of Gwendolyn and Jacob Lawrence.

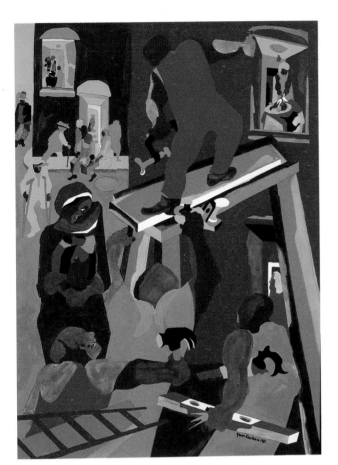

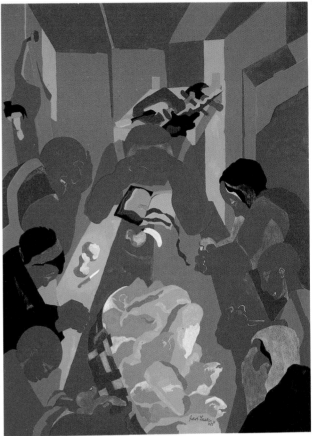

Pl. 108. *Builders—Man on a Scaffold*, 1985.
Gouache on paper, 29½ × 21¾.
Collection of PACCAR, Inc.

Pl. 109. *Bread, Fish, Fruit*, 1985.
Gouache on paper, 30 × 22.
Courtesy of the artist and Francine Seders Gallery, Seattle.

6. Conclusion

Over his long career, Jacob Lawrence has moved from a regionalist concern with East Coast urban-specific imagery to a general symbolism in his West Coast philosophical broadness. Always a social observer with a critical sensibility, Lawrence approaches his themes with a quiet didacticism: his paintings set forth an explicit social reality.

Lawrence's central themes are almost without exception human activity. Figures are magnified, bodies are simplified; focus is on the extremities, with heads projecting intellectual force and hands and feet the locus of physical activity. There is a particularized iconography of motion: arrested movement and gesture in his stilled figures read as decisive action. Often the works have a strong theatrical quality, with a stage-set look, a sense of drama, and illusory elements.

Lawrence's early work (1930s and 1940s) introduced his style: full of humor, compassion, and pictorial intensity, with many forays into the sober and gloomy. His middle work (1950s and 1960s) was dominated by stylistic experimentation (pattern, fragmentation, and facets) and was replete with bizarre, surreal imagism and overt violence. Around 1968 and afterward, he returned to a less intense, more straightforward approach, surpassing all previous work in objective optimism, in a symbolic emphasis on humanity's constructive potential. Wit is a common thread in Lawrence's work; it is seen most overtly in his children's books and more subtly in his Harlem street scenes which provided him special opportunities to consider the human comedy.

Lawrence's representations began with what some said was a naive or primitive manner but which others recognized as an original, intuitive sense of design. Law-

FIG. 78. Jacob Lawrence teaching, School of
Art, University of Washington, October
1984.

FIG. 79. Jacob and Gwen Lawrence, 1975.

rence admits to an early groping with form: "Since I did not have a formal art train-
ing, my work almost grew out of the way an unsophisticated person would work in a
flat kind of pattern, color, but not academically."[1] But even in its earliest phases,
Lawrence's work embodies a sophisticated sense of structure. Two paintings from his
first series (*Toussaint L'Ouverture*, 1937–38, pls. 7 and 8) demonstrate how he
makes striking use of dynamic compositional devices and complex figural
interrelationships.

In visual qualities of style and technique, some of his paintings bear uncanny
resemblances to Egyptian tomb murals; others exhibit many similarities to medieval
and early Renaissance manuscript paintings, frescoes, or panel paintings. Like artists
of those eras, Lawrence chooses simple water-soluble media in basic vibrant colors.
He explained his single-minded preference for these paints:

> I am just interested in putting paint on paper. . . . Since I have always been more inter-
> ested in what I wanted to say rather than the medium, I just stayed with it. I know this
> medium so well that my thinking is in terms of the tempera medium. It's like a lan-
> guage—the better you know the medium, the better you can think in it.[2]

Lawrence's work is also extremely modern, exhibiting awareness of contemporary
stylistic trends. In addition, Lawrence's content is always rooted in a sense of time
and place. His scenes and stories reflect the recognizable needs and dilemmas of our
epoch.

It is difficult to put a label on Lawrence's style, always original and personal.
When pressed, he will call himself an Expressionist. His work is Social Realist in
content and his means are variants of Expressionism and Cubism. He conveys his
messages through narrative and genre, with expressionistic hue and distortion and
often cubist treatment of form and space. Probably the most unusual aspect of his
work is that he picked a style, an approach to content, almost five decades ago and
has essentially maintained it throughout his whole career despite the prevailing force
of other artistic trends. Recently, Lawrence commented on the relationship of the
artist to the pressures of the art market:

> I tell students not to confuse the promotion and the marketplace with the creative pro-
> cess. . . . We all like headlines and that type of thing, but this shouldn't be confused with
> the real meaning of your work. In fact, I think an artist is most fortunate when he
> doesn't get too much attention. The so-called art movements usually come after the fact.
> If you're unfortunate enough to get swept up in a movement, then you'll find yourself
> following yourself.[3]

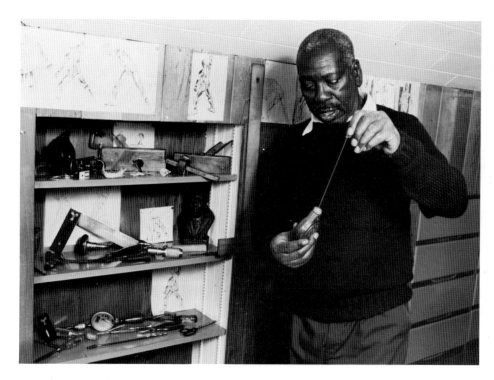

Fig. 80. Lawrence and his tool collection in his studio, 1984.

Lawrence's art carries the major significance of his being a black artist. His early years represented the epitome of the black experience. This Harlem teenager chose to pursue a vocation traditionally considered reserved for whites, a choice requiring an uncommon kind of perseverance. The increasing success that he has experienced also has meant increasing separation from peers and friends. Thus, Lawrence has had to sustain the burden of acceptance in the art world and the attendant loneliness. This alienation contributed to his nervous collapse in the late forties; while the causes of the malaise have not disappeared, Lawrence's abilities to cope with these tensions have strengthened.

It is precisely Lawrence's position of inclusion in the predominantly white art establishment that defines a major contribution of his art. Lawrence has made a special offering to the story of American art through his choice of subject: often-neglected episodes of black history and the contemporary black experience. Through his commitment to social themes and his illumination of many little-known realities, his art transcends pure aesthetics and goes on to raise consciousness.

On what being a black artist in our American society has given to his art, Lawrence says:

> It's been such a special kind of experience. I think it definitely has added a different kind of dimension than, say, another artist would have. And since we as a people have not been integrated (we may never be), . . . it cannot help but influence my thinking and then my work and my whole being.[4]

One of Lawrence's ultimate contributions to the art world is his teaching (fig. 78). His first experience with the teaching of art came when he was a student in WPA Federal Art Project programs in his community. To these early workshops can be attributed the birth of his commitment to painting. Over a period of more than thirty years, Lawrence has been an influential teacher, often the only black teacher in a white academic world. His active participation in the academic community has helped to build arts programs (he served six-year terms on both the Washington State Arts Council and the National Council of the Arts), efforts that might be seen as his desire to propagate the kinds of opportunities that served him so well from early in his career.

Although Lawrence's emotive and socially conscious style has not been popular at all times with more formally oriented colleagues and critics, he has continually enjoyed success and acceptance for his work. But teaching has been his mainstay,

often allowing him to keep producing and possibly inspiring him to do so—a kind of connective tissue between bodies of work.

In his form and content, Lawrence has been of his time, as well as both out of his time and ahead of it. His consistent preference for social and figurative subject matter was remarked upon by critic Emily Genauer in observations regarding the *Struggle* series at the height of Abstract Expressionism's reign (1955–56):

> Jacob Lawrence is one of the very few young American artists courageous enough to paint subject in a day when it is distinctly unfashionable; and much more than that, to make his subject a testament, an expression of his belief in man's continuing strength and will to achieve and preserve freedom.[5]

After many decades, a preference for subject and the figure has returned to favor in contemporary art. In 1974, Hilton Kramer acknowledged Lawrence's consistent position as a figurative, narrative painter:

> The fact is, by restoring painting's narrative function to a contemporary task, [Lawrence] has reopened a whole realm of possibilities that smart opinion long ago foreclosed. In terms of the art history of his time, this may turn out to be Mr. Lawrence's greatest distinction.[6]

It is possible to assert further that Lawrence's greatest strength lies in his series—in his ability to portray American historical narrative in vivid, authoritative compositional suites. In this strength, he offers a significant link in the traditions of American history painting, American Scene painting, and American figural art.

In a recent public interview at the Metropolitan Museum, Lawrence was asked what he considered to be the major influences in his life.[7] He cited Augusta Savage's guidance in the thirties, which led to his WPA employment; Edith Halpert, one of the top art dealers in the country; his marriage to Gwen (fig. 79), whose criticism has given him so much over the years; and his teaching. When asked what his biggest artistic struggle has been, he responded:

> Not being too facile. As a young artist develops, a certain kind of beauty or dimension can evolve because there is such a struggle going on. As we develop, we learn to do certain things and can become very facile. . . .[8]

Although Jacob Lawrence (fig. 80) resists analyzing his own art, his philosophy about the role and importance of art in human experience is evidenced in an eloquent statement:

> Painting is a way of expressing one's thoughts and feelings. I feel that I am more articulate in painting than in any other form of expression, therefore I am always striving to perfect this particular form of art so as to reach a greater degree of articulation.
>
> For me a painting should have three things: universality, clarity and strength. Universality so that it may be understood by all men. Clarity and strength so that it may be aesthetically good. It is necessary in creating a painting to find out as much as possible about one's subject, thereby freeing oneself of having to strive for a superficial depth.
>
> It is more important that an artist study life than study the technique of painting exclusively. Technique will come with the desire to make oneself understood. It is more important for the artist to develop a philosophy and clarity of thought.
>
> My pictures express my life and experience. I paint the things I know about and the things I have experienced. The things I have experienced extend into my national, racial and class group. So I paint the American scene.[9]

NOTES

The research for this book included numerous hours of taped interviews with Jacob Lawrence over the period 1982 to 1986. For detailed historical overviews and additional information, see also Ellen Harkins Wheat, "Jacob Lawrence, American Painter," master's thesis, University of Washington, 1983, and "Jacob Lawrence," Ph.D. dissertation, University of Washington, 1986.

1. INTRODUCTION

1. This judgment has been repeatedly stated in the literature: for example, Clifford Wright, "Jacob Lawrence," *Studio*, 161 (January 1961), pp. 26–28, and the *Time* magazine issues for December 22 1947, February 2, 1953, and February 24, 1961.

Valuable sources for biographical information on Jacob Lawrence were Romare Bearden and Harry Henderson, *Six Black Masters of American Art* (New York: Doubleday, 1972) and Elton Fax's *Seventeen Black Artists* (New York: Dodd, Mead, 1971); Milton Brown, exhibition catalog, *Jacob Lawrence* (New York: Whitney Museum of American Art, 1974), a cogent essay on Lawrence and his work; Carroll Greene, Jr., unpublished interview of Jacob Lawrence (Washington, D.C.: Archives of American Art, Smithsonian Institution, October 26, 1968); Elizabeth McCausland's early interview, "Jacob Lawrence," *Magazine of Art*, 38 (November 1945), pp. 250–54; and Aline B. Louchheim's article, "An Artist Reports on the Troubled Mind," *The New York Times Magazine*, October 15, 1950, pp. 15ff; and her catalog (written under her subsequent name, Aline L. Saarinen), *Jacob Lawrence* (New York: American Federation of Arts, 1960), also reprinted in David Shapiro, *Social Realism: Art as a Weapon* (New York: Frederick Ungar, 1973), pp. 236–42.

2. By this remark, Lawrence meant a commercial art gallery. Quoted in Greene, "Interview with Jacob Lawrence," p. 5.

3. Quoted in McCausland, "Jacob Lawrence," p. 251.

2. ORIGINS: 1917 TO 1940

1. Quoted in Greene, "Interview with Jacob Lawrence," p. 3.

2. Quoted in Fax, *Seventeen Black Artists*, p. 148.

3. On the Harlem Renaissance, see Margaret Just Butcher, *The Negro in American Culture*, 2d ed. (New York: Alfred A. Knopf, 1972), based on materials by Alain Locke; Alain Locke, *The New Negro: An Interpretation* (New York: Albert and Charles Boni, 1925); Nathan Irvin Huggins, *Harlem Renaissance* (New York: Oxford University Press, 1971); Jervis Anderson's essay about Harlem in *The New Yorker*, "IV: Harlem, Hard Times and Beyond," July 20, 1981, pp. 42–77 (one of a series of four essays); as well as the two encyclopedic volumes: Langston Hughes and Milton Meltzer, *A Pictorial History of the Negro in America* (New York: Crown, 1968), and Harry A. Ploski and Roscoe C. Brown, Jr., *The Negro Almanac* (New York: Bellwether, 1967).

4. Huggins, *Harlem Renaissance*, p. 18. The terms "Negro," "Afro-American," and "black" are used interchangeably in this book depending on the source quoted or the epoch addressed.

5. ". . . And the Migrants Kept Coming," *Fortune*, 24 (November 1941), p. 102. Both Fax and *Who's Who in America* (Jacob Lawrence section) say this article was written by Alain Locke, although there is no byline.

6. Anderson, "IV: Harlem," pp. 48–55, describes how the Harlem community survived during the Depression, including the role played by Harlem's churches.

7. Quoted in Anderson, "IV: Harlem," p. 47. He discusses the entertainers and writers in Harlem during the Depression and the tone of the era, pp. 44, 46–47, 64–65.

8. Harmon Foundation catalog, *Exhibition of the Work of Negro Artists* (New York: Harmon Foundation, 1931), pp. 13–15.

9. Lawrence quoted in Jane Van Cleve, "The Human Views of Jacob Lawrence," *Stepping Out Northwest*, 12 (Winter 1982), p. 35.

10. Van Cleve, "Human Views," p. 34.

11. Quoted in Greene, "Interview with Jacob Lawrence," p. 4.

12. Lawrence, in conversation with the author, February 15, 1983.

13. Jacob Lawrence, lecture, School of Art, University of Washington, Seattle, November 15, 1982.

14. Lawrence studied the work of the great maskmaker Benda at this time. Bearden and Henderson, *Six Black Masters*, p. 102.

15. Quoted in Fax, *Seventeen Black Artists*, p. 149.

16. Quoted in Bearden and Henderson, *Six Black Masters*, pp. 102–3.

17. In Harlem, poetry and fiction were hardest hit by the Depression. Many young writers were supported by the Federal Writers Project at crucial points in their careers (for example, Richard Wright and Ralph Ellison). Under the sponsorship of the Federal Theater Project, the first black theater program was established in Harlem in 1936 and was organized and run by John Houseman, then a young actor from Europe. Hundreds of black playwrights, actors, and theater personnel found employment at the old restored Lafayette Theater while the Project thrived. Productions included *Voodoo MacBeth*, a black adaptation of Shakespeare's play; *The Conjure Man Dies*, by Harlem Renaissance writer Rudolph Fisher; and William

E. B. DuBois's *Haiti*, a melodrama based on the lives of Toussaint L'Ouverture and Henri Christophe, the Haitian liberators (the production Lawrence saw that contributed to his fascination with the life of Toussaint; see discussion below, pp. 39 ff). Anderson, "IV: Harlem," pp. 63–64.

18. Discussions of the WPA Federal Art Project can be found in David Shapiro, *Social Realism;* Herschel B. Chipp, *Theories of Modern Art* (Berkeley: University of California Press, 1968); Francis V. O'Connor, *Art for the Millions: Essay from the 1930s by Artists and Administrators of the WPA Federal Art Project* (Greenwich, Conn.: New York Graphic Society, 1973), and also O'Connor, *The New Deal Art Project: An Anthology of Memoirs* (Washington, D.C.: Smithsonian, 1972); and Holger Cahill, *New Horizons in American Art* (New York: Museum of Modern Art, 1936). The quoted WPA observation is from a panel discussion transcribed in O'Connor, *The New Deal Art Project*, pp. 314–20.

19. Lawrence, in conversation with the author, February 15, 1983.

20. Quoted in Jacqueline Rocker Brown, "The Works Progress Administration and the Development of an Afro-American Artist, Jacob Lawrence, Jr.," master's thesis (Washington, D.C.: Howard University, July 1974), p. 109.

21. Anderson, "IV: Harlem," pp. 60–61.

22. Avis Berman, "Jacob Lawrence and the Making of Americans," *Artnews*, 83 (February 1984), pp. 82–83. Lawrence first met Augusta Savage in about 1933 or 1934. Her studio was on West 144th Street, and he lived at 142 West 143d Street at the time.

23. Bearden and Henderson, *Six Black Masters*, p. 103.

24. Quoted in Fax, *Seventeen Black Artists*, p. 151.

25. Lawrence discussed his relationship with his father and mother in conversation with the author, February 24, April 7, and April 21, 1983, and July 24, 1984.

26. Jacob and Gwen Lawrence, in conversation with the author, May 3, 1985.

27. Quoted in Louchheim, "An Artist Reports," p. 36.

28. The faculty of the American Artists School also included Isaac and Raphael Soyer, with whom Lawrence did not study but who later became his friends. The Advisory Board included Stuart Davis, William Gropper, Rockwell Kent, Max Weber, Meyer Schapiro, and Lewis Mumford, but Lawrence did not meet these people there.

29. Lawrence, lecture, November 15, 1982.

30. Jacob Lawrence, written statement to the author, September 20, 1984.

31. Lawrence, lecture, November 15, 1982.

32. Lawrence, in conversation with the author, February 4, 1983.

33. In the early exhibition catalogs, *The Funeral* (1938) was called *Dust to Dust*, Lawrence's original title for the work.

34. Lawrence, in conversation with the author, June 7, 1984. Lawrence's series (discussed below) also resemble comic strip art in the use of image with caption as text and narrative sequence employing a continuing cast of characters, which David Deitcher points out are the salient features of the comic strip in "Comic Connoisseurs," *Art in America*, 72:2 (February 1984), pp. 101–107. For some discussion of the relation between comic strips and modern art, see John Carlin and Sheena Wagstaff, *The Comic Art Show* catalog (New York: Whitney Museum, 1983).

35. Quoted in Greene "Interview with Jacob Lawrence," p. 36.

36. Lawrence, lecture, November 15, 1982.

37. Lawrence, in conversation with the author, January 27, 1983.

38. The development of Social Realism—an art depicting scenes or events of social importance in a naturalistic manner—is discussed below on pp. 37–38.

39. Also in Lawrence's first show, the exhibitors included Gwendolyn Knight, Aaron Douglas, Gwendolyn Bennett, Norman Lewis, Ronald Joseph, and Vertis Hayes. The catalogs for these exhibitions are in the Jacob Lawrence material, Syracuse University, George Arents Research Library, Syracuse, New York.

40. Quoted in Clarence Major, "Jacob Lawrence, Expressionist," *The Black Scholar*, 9:3 (November 1977), pp. 23–34.

41. Bearden and Henderson, *Six Black Masters*, pp. 104–106, discuss Seyfert and the influence on Lawrence of the African show at the Museum of Modern Art.

42. Lawrence, letter to Charles Alan, December 29, 1972. Jacob Lawrence's personal files.

43. Bearden and Henderson, *Six Black Masters*, p. 106. Lawrence says that these two small wood carvings and the papier mâché masks were the only sculptures he recalls doing; in conversation with the author, February 15, 1983.

44. Alain Locke explains his theories in *The Negro in Art* (New York: Hacker Art Books, 1940), pp. 207–208.

45. These theories are summarized in Locke's writings of 1925 *(The New Negro)* and 1936 *(Negro Art: Past and Present* [Washington, D.C.: Associates of Negro Folk Education, 1936]). In the 1940 book, p. 10, he modifies his position slightly to include this qualification.

46. Quoted in Greene, "Interview with Jacob Lawrence," p. 27.

47. Lawrence, lecture, November 15, 1982.

48. Lawrence, in conversation with the author, July 2 and July 24, 1984.

49. Lawrence, in conversation with the author, May 3, 1985.

50. Thomas Craven, *Modern Art: The Men, the Movements, the Meaning* (New York: Simon and Schuster, 1934), pp. 238 and 346.

51. Quoted in Greene, "Interview with Jacob Lawrence," p. 28.

52. Joshua Taylor discusses these cultural redirections in the 1930s in *America as Art* (Washington, D.C.: Smithsonian Institution, 1976), pp. 220–21. Other sources are Oliver Larkin, *Art and Life in America*, 2d ed. (New York: Holt, Rinehart and Winston, 1960); Richard McLanathan, *The American Tradition in the Arts* (New York: Harcourt, Brace and World, 1968); Chipp, *Theories of Modern Art*; and Shapiro, *Social Realism*.

53. Peter Selz, "Art and Politics: The Artist and the Social Order—Introduction," in Chipp, *Theories of Modern Art*, p. 457. See also the *Manifesto Issued by the Syndicate of Technical Workers, Painters, and Sculptors* (1922), published as a broadside and reprinted in Chipp, pp. 461–62.

54. *Manifesto* (1922) in Chipp, *Theories of Modern Art*, p. 462.

55. McLanathan, *American Tradition*, p. 412, discusses the impact of Mexican muralist art on American painting.

56. Quoted in Greene, "Interview with Jacob Lawrence," pp. 10–11.

57. A comprehensive discussion of the growth of American abstract art during the Depression can be found in Susan Larsen's essay, "The Quest for an American Abstract Tradition, 1927–1944," in John R. Lane and Susan C. Larsen's catalog, *Abstract Painting and Sculpture in America, 1927–1944* (Pittsburgh: Carnegie Institute, and New York: Harry N. Abrams, 1983).

58. Lawrence, in conversation with the author, July 24, 1984.

59. Quoted in Bennett Schiff, "The Artist as Man on the Street," *New York Post* (March 26, 1961), p. 2.

60. Quoted in Milton Brown, *Jacob Lawrence*, p. 16.

61. McCausland, "Jacob Lawrence," p. 253.

62. Harmon Foundation, Jacob Lawrence Biographical Sketch (November 12, 1940), Downtown Gallery Papers, Microfilm Roll ND 5 (55/590), Archives of American Art, Smithsonian Institution, Washington, D.C.

63. Bearden and Henderson, *Six Black Masters*, pp. 108–109. Lawrence now says that he has not used this system since the early 1940s, and believes the *Migration* series was the last for which he employed it. Since that time, he has usually worked back and forth on the various panels of a series. Lawrence worked on the *Toussaint* series from October 1937 to May 1938 (in conversation with the author, July 2, 1984).

64. Quoted in McCausland, "Jacob Lawrence," p. 254.

65. Quoted in McCausland, "Jacob Lawrence," p. 254.

66. David Elliott, *Orozco!* (Oxford: Museum of Modern Art, 1980), back cover. For discussion of Orozco's work, see MacKinley Helm, *Modern Mexican Painters* (New York: Harper and Brothers, 1941), pp. 67–87.

67. Quoted in Elliott, *Orozco!*, p. 12.

68. Lawrence, in conversation with the author, February 3, 1984.

69. Quoted in Greene, "Interview with Jacob Lawrence," p. 80.

70. Lawrence, in conversation with the author, February 3, 1984.

71. "Jacob Lawrence," *Ebony*, 6 (April 1951), p. 78.

72. Lawrence, in conversation with the author, February 4, 1983.

73. Lawrence, in conversation with the author, July 2, 1984. For writers who have made this attribution, see, for example, Milton W. Brown, *One Hundred Masterpieces of American Painting from Public Collections in Washington, D.C.* (Washington, D.C.: Smithsonian Institution Press, 1983), p. 170.

74. Exhibition catalog, Jacob Lawrence material, Syracuse University. At his first one-man show, sixteen paintings were shown, including *Bar & Grill*, *Rain*, and *The Butcher Shop*.

75. Exhibition catalog, Jacob Lawrence material, Syracuse University. The show presented twenty-three of his works, including *Funeral*, 1938 (listed as *Dust to Dust*), *Christmas*, and *Street Orator*.

76. J. L., "The Negro Sympathetically Rendered by Lawrence," *Art News*, 37:21 (February 18, 1939), p. 15.

77. Quoted in Fax, *Seventeen Black Artists*, pp. 155–56.

78. A. D. Emmart, *Baltimore Sun* (February 5, 1939).

79. Alain Locke in letter to Lawrence (n.d., probably 1938), Jacob Lawrence material, Syracuse University.

80. For discussion of these exhibitions, see Fax, *Seventeen Black Artists*, pp. 154–56. Milton Brown, *Jacob Lawrence*, p. 11, provides interesting discussion of the provenance of the three early series. They were bought by the Harmon Foundation, and when the foundation was dissolved in 1967, Fisk University received the *Toussaint* series; the other two (*Frederick Douglass* and *Harriet Tubman*) disappeared and later (c. 1973) surfaced at Hampton University in Virginia. The Amistad Research Center in New Orleans now owns the *Toussaint* series.

81. Van Cleve, "Human Views," pp. 33–37.

82. Bearden and Henderson, *Six Black Masters*, p. 107.

83. Quoted in McCausland, "Jacob Lawrence," p. 253.

84. Lawrence, lecture, November 15, 1982. Unfortunately, most of the paintings Lawrence did with the WPA were lost. They were supposed to have been given to institutions but cannot be located. The facts about Lawrence's WPA/FAP experience are elaborated in M. Brown, *Jacob Lawrence*, p. 11, and Bearden and Henderson, *Six Black Masters*, p. 107.

85. Chipp, *Theories of Modern Art*, p. 506.

86. Lawrence's *Frederick Douglass* series is listed in catalogs as having thirty-three panels with thirty-three captions. Curiously, however, one panel has two numbers on the back but only one caption (14–15). Therefore, the series actually has thirty-two panels, although the final one is numbered "33." Lawrence could not provide the answer to this mystery.

87. Quoted in McCausland, "Jacob Lawrence," p. 254.

88. Quoted in Greene, "Interview with Jacob Lawrence," p. 79.

89. Lawrence, lecture, November 15, 1982.

90. Lawrence, in conversation with the author, July 24, 1984.

91. Lawrence, lecture, November 15, 1982.

92. Quoted in Greene, "Interview with Jacob Lawrence," p. 74.

93. Jacob Lawrence, "The Artist Responds," *The Crisis* (August–September, 1970), pp. 266–67.

3. Early Maturity: 1940 to 1949

1. Lawrence's first Rosenwald Fellowship was for $1,500; subsequent renewals (1941, 1942) were for $1,200 each.

2. Lawrence, in conversation with the author, June 7, 1984. Lawrence's studio was at 33 West 125th Street.

3. Lawrence, in conversation with the author, June 7, 1984. McKay's book (1937) is an autobiographical account; he gave it to Lawrence in the summer of 1941. The inscription reads: "To Jacob Lawrence, A token of appreciation of a fine artist and peerless delineator of Harlem scenes and types."

4. Lawrence, in conversation with the author, May 3, 1985.

5. McCausland, "Jacob Lawrence," pp. 253–54.

6. Quoted in Van Cleve, "Human Views," p. 34.

7. Jacob and Gwen Lawrence, in conversation with the author, July 2, 1984.

8. This thriving organization had been opened in 1937 with the support of WPA funds at a ceremony hosted by Eleanor Roosevelt. Schomburg Center for Research in Black Culture, File on "Art in New York—1942," Alyse Abrams's notes (November 27, 1939) on the opening of the Harlem Community Art Center, December 20, 1937. Schomburg Center, New York.

9. Letter (dated April 24, 1940) to Lawrence from Franck Mechare, School of Architecture, Drawing, Painting, and Sculpture, Columbia University, New York. In Jacob Lawrence material, Syracuse University.

10. Jacob Lawrence material, Syracuse University.

11. Quoted in Fax, *Seventeen Black Artists*, p. 158.

12. Lawrence, in conversation with the author, July 24, 1984.

13. Edmund B. Feldman, *The Artist* (Englewood Cliffs, New Jersey: Prentice-Hall, 1982), p. 116.

14. Lawrence, in conversation with the author, May 3, 1985.

15. Quoted in Schiff, "The Artist as Man on the Street."

16. Carol Troyen, in Theodore E. Stebbins, Jr., and Carol Troyen, *The Lane Collection: 20th Century Paintings in the American Tradition* (Boston: Museum of Fine Arts, 1983), pp. 35–55, provides an in-depth discussion of Halpert's Downtown Gallery. Troyen's valuable account would be enhanced by providing more information on the Social Realist painters Halpert supported in the thirties and forties, particularly Lawrence (pp. 44–45). The Downtown Gallery was located at 43 East 51st Street in the 1940s.

17. Lawrence's beginnings with the Downtown Gallery are discussed in Fax, *Seventeen Black Artists*, pp. 157–58, and Bearden and Henderson, *Six Black Masters*, p. 110.

18. The exhibition at the Downtown Gallery was held December 9, 1941, to January 3, 1942. The Lawrence works in the show were the sixty *Migration* panels, *The Green Table* (1941), and *Catholic New Orleans* (1941). Charles Sheeler purchased *Catholic New Orleans* for $35. Halpert set $50 for the other individual works. The *Migration* series sold for $2,000: the even-numbered panels went to MOMA through donation from Mrs. David Levy, and Duncan Phillips bought the odd-numbered ones for the Phillips Memorial Gallery, under the condition that when one institution wanted to exhibit the whole series, the other would lend its half. Phillips exhibited the entire series in February 1942; it then went to MOMA for exhibition. Edith Halpert letters to Lawrence (December 15, 1941, February 21, March 12, 1942); Jacob Lawrence material, Syracuse University.

19. *Fortune* (November 1941), pp. 102ff. As agreed with *Fortune*, the *Migration* series was also shown at the Downtown Gallery in early November, to coincide with the publication of this issue of the magazine.

20. *Fortune* (November 1941), p. 102.

21. Quoted in Greene, "Interview with Jacob Lawrence," pp. 63–64.

22. Lawrence, in conversation with the author, July 2, 1984.

23. Edith Halpert letters to Lawrence (February 12 and March 12, 1942). Jacob Lawrence material, Syracuse University.

24. Lawrence, in conversation with the author, July 2, 1984.

25. Lawrence, in conversation with the author, July 2, 1984.

26. Gwen Lawrence, in conversation with the author, July 2, 1984.

27. Downtown Gallery Papers, Microfilm Roll ND/60:1–10, Archives of American Art.

28. Berman, "Jacob Lawrence," p. 84.

29. Jacob Lawrence, in conversation with the author, July 2, 1984.

30. Horace Pippin did a *John Brown* series in 1942. He also did a *Crucifixion* (1943) and an *Abe Lincoln* series (1943), both with content similar to Lawrence's. Pippin might have known of Lawrence's *John Brown* series, but there is some confusion in the literature as to when the *John Brown* series was first shown. According to McCausland, "Jacob Lawrence" (1945), the series was exhibited in Boston in 1944 but had not been shown in New York at the time of her article. According to M. Brown, *Jacob Lawrence* (1974), p. 14, it was exhibited at the gallery in 1945, and then traveled to Boston and was circulated nationally. It is clear, however, that the series, which was completed by the end of 1941, was not exhibited until several years later, which was unusual for Lawrence, who always exhibits work soon after completion. Lawrence does not recall the related circumstances.

31. B. W., "Saga of John Brown," *Art Digest*, 20 (December 15, 1945), p. 17. The Detroit Institute of Arts owns the series, a gift of Mr. Lowenthal.

32. *Art News*, 44 (December 15, 1945), p. 23. This reviewer is obviously unfamiliar with Lawrence's other early series that were both "removed from real life" and full of passionate statement.

33. The show was reviewed by Rosamund Frost, "Encore by Popular Demand: The Whitney," *Art News*, 22 (December 1, 1943), p. 21. Frost singled out *Tombstones* as "exceptional." The Whitney purchased *Tombstones* for $75.

34. Lawrence, in conversation with the author, July 2, 1984.

35. The "Artists for Victory" show was discussed by Alfred M. Frankfurter, *Art News*, 41 (January 1–14, 1943), pp. 9–12. The dates of the exhibition were omitted from the article.

36. Lawrence, in conversation with the author, February 24, 1983.

37. Jacob Lawrence, written statement to the author, September 20, 1984. Many paintings of Lawrence's series with long narrative captions have acquired shorter nicknames through time. Therefore, it is often difficult to establish the identity of a painting when doing research. For the *Harlem* series, Panel 1 is often called *Rooftops*; Panel 2, *Coins*; Panel 15, *Bootleg Whiskey*; and Panel 19, *Harlem Society*.

38. Larkin, *Art and Life*, pp. 437–38.

39. The 1982 purchase of *The Apartment* (1943) was discussed in Carol Lawson, "A Group Shopping Spree Stocks a Museum with Art," *The New York Times* (June 20, 1982), p. 28. *The Apartment* sold for $25,000 (before a 10 percent museum discount).

40. Quoted in Van Cleve, "Human Views," p. 36.

41. Quoted in Louchheim, "An Artist Reports," p. 36.

42. Bearden and Henderson, *Six Black Masters*, p. 111.

43. M. Brown, *Jacob Lawrence*, p. 11.

44. Gwen Lawrence, in conversation with the author, July 24, 1984.

45. The "experiment" was discussed by Carlton Skinner, in conversation with the author, July 22, 1984, and in a newspaper article, Fall 1944, of unknown source, Jacob Lawrence personal files.

46. Quoted in Louchheim, "An Artist Reports," p. 38.

47. Skinner, in conversation with the author, July 22, 1984.

48. Rosenthal received a painting from Lawrence when the artist's term of service ended in 1945. Rosenthal has said that this painting "was preferred, I have always suspected, in gratitude, but what Jacob Lawrence may not know, accepted in humility and admiration" (*The New York Times Magazine*, in a letter from Rosenthal to the editor, October 29, 1950).

49. According to M. Brown, *Jacob Lawrence*, pp. 13–14, the Coast Guard documented forty-eight such works, which were probably dispersed among Coast Guard installations by 1961. The whereabouts of most of Lawrence's *Coast Guard* works are unknown. Works done during the period 1943–45 are signed with an accompanying "U.S.C.G."

50. The two most informative (and illustrated) articles on the *Coast Guard* works are McCausland, "Jacob Lawrence," pp. 250–51 (the source of this Lawrence quote), and Louchheim, "An Artist Reports." At the MOMA exhibition, eight of the seventeen *Coast Guard* works done at that date were exhibited, along with the sixty *Migration* paintings.

51. McCausland, "Jacob Lawrence," p. 251.

52. The event took place on January 14, 1946, at the Hotel Commodore, New York. Jacob Lawrence material, Syracuse University.

53. Notice for the exhibition, Jacob Lawrence material, Syracuse University.

54. Jacob Lawrence, written statement, January 21, 1979, in response to the request of the Toledo Museum, Ohio, which owns the painting. Jacob Lawrence Papers (1949–1979), Archives of American Art.

55. This interpretation of the plants in *The Lovers* was suggested to the author by Seattle painter Michael Spafford in 1983.

56. Jacob Lawrence, in conversation with the author, February 22, 1983.

57. Black Mountain College Records, Faculty Files, 1946, Microfilm Roll 199, Archives of American Art.

58. Lawrence, in conversation with the author, October 15, 1983. Josef Albers had come to the U.S. in 1933 when the Bauhaus was dissolved by the German National Socialist regime. Lawrence taught at Black Mountain during the third session of the Summer Institute. During the session, Walter Gropius gave lectures on architecture and planning, John McAndrew on art and architecture, Balcomb Greene on painting, and Beaumont Newhall on photography (husband of Nancy Newhall, photographer of fig. 41). Sixty students were enrolled in the summer program. *Art Digest* (May 19, 1946).

59. Quoted in Elsa Honig Fine, *The Afro-American Artist* (New York: Holt, Rinehart and Winston, 1973), p. 150.

60. Quoted in Greene, "Interview with Jacob Lawrence," pp. 30–31.

61. Gwen Lawrence, in conversation with the author, July 2, 1984.

62. Lawrence, lecture, November 15, 1982. Lawrence's Guggenheim was for $2,000; Jacob Lawrence material, Syracuse University.

63. Lawrence, in conversation with the author, July 2, 1984. After the *Migration* series Lawrence no longer made his own gessoed panels but purchased them. Then he began to get defective boards because the gesso composition was faulty. He has therefore used paper (or illustration board) almost exclusively since the 1960s.

64. Jacob Lawrence, statement written for Downtown Gallery, New York, October 1947. Downtown Gallery Papers, Microfilm Roll ND5 (55/590), Archives of American Art.

65. F. P., "Reviews and Previews," *Art News*, 51 (February 1953), p. 73.

66. Robert Rauschenberg, quoted in Calvin Tomkins, *The Bride and the Bachelors: Five Masters of the Avant Garde* (New York: Penguin Books, 1968), p. 199.

67. Jacob Lawrence, lecture, November 15, 1982.

68. A private collector, Roy Neuberger, purchased the *War* series. The fourteen works became so popular as loan items that the owner got tired of packing and mailing them to museums; in 1951 he donated them to the Whitney Museum. Avis Berman, taped interview with Lawrence, Metropolitan Museum, February 6, 1983, Jacob Lawrence personal files.

69. "Art: Strike Fast," *Time*, 50 (December 22, 1947), p. 61.

70. *New York Telegram* (February 22, 1947), Jacob Lawrence material, Syracuse University.

71. Walker Evans, "In the Heart of the Black Belt," *Fortune*, 37:2 (August 1948), p. 88.

72. Lawrence, lecture, November 15, 1982.

73. Jacob Lawrence, statement written for Downtown Gallery, New York, April 1949. Downtown Gallery Papers, Microfilm Roll 1845, Archives of American Art.

74. Frank Lloyd Wright viewed the exhibition and reportedly said of Lawrence's work: "This fellow would make a great architect. It is the only good stuff in the show." Letter (no date, probably November 1948) to Edith Halpert from Peter Pollack, Public Relations Counsel, The Art Institute of Chicago. Jacob Lawrence material, Syracuse University.

75. Sam Hunter, "Work by Equity Artists," *The New York Times* (March 28, 1948).

76. Frans Masereel's woodcuts, *La Ville*, Pierre Vorms, ed. (Paris: Galerie Billiet, 1928).

4. MID-CAREER IN NEW YORK: 1949 TO 1968

1. Quoted in Bearden and Henderson, *Six Black Masters*, p. 113. Lawrence says that in his opinion this account is still accurate; in conversation with the author, February 24, 1983.

2. Louchheim, "An Artist Reports," p. 15. According to Louchheim, Lawrence did ten paintings in the hospital and one after his release, thus the eleven paintings shown at the Downtown Gallery, October 24, 1950.

3. Quoted in Louchheim, "An Artist Reports," p. 35. The hospital, in the urban area of Queens, was surrounded by its own parklike grounds; to Lawrence, it seemed like the country.

4. Quoted in Greene, "Interview with Jacob Lawrence," p. 74.

5. Quoted in Louchheim, "An Artist Reports," p. 15.

6. Quoted in the *New York Post* (March 26, 1961). During this period Gwen went to work at Condé Nast Publishers, where she remained for about ten years.

7. This painting is entitled *Photos* in early catalogs of Lawrence's work.

8. Jacob Lawrence, in conversation with the author, July 2, 1984. Lawrence still has the Capablanca book in his library.

9. Jacob Lawrence, in conversation with the author, February 24, 1983.

10. Jacob Lawrence, lecture, November 15, 1982. His dealer at that time was Charles Alan. When this series was exhibited, it was called *Performance* in the brochure. Lawrence says that this title was preferred by Charles Alan, but he has always called the series *Theater*. In conversation with the author, December 2, 1985.

11. Jacob Lawrence, quoted in "Art: Stories with Impact," *Time* magazine, 53 (February 2, 1953), p. 50.

12. *The New York Times* (February 1, 1953). The paintings sold for between $350 and $500. F. P., "Reviews and Previews" (1953), p. 73.

13. Jacob Lawrence, written statement to author, September 20, 1984.

14. Gwen Lawrence, in conversation with the author, July 24, 1984.

15. Alan Gallery Papers, Microfilm Roll 1390, Archives of American Art.

16. Letter from Lawrence to Charles Alan (n.d., probably Fall 1955), Jacob Lawrence material, Syracuse University. About eight other artists were working there. Gwen visited her husband occasionally at Yaddo but continued her work with Condé Nast.

17. Lawrence, in conversation with the author, May 3, 1985.

18. Quoted in Schiff, "The Artist as Man on the Street."

19. Quoted in "Jacob Lawrence," by Frederick S. Wight, in John I. H. Baur, ed., *New Art in America* (Greenwich, Connecticut: New York Graphic Society, 1957), p. 275.

20. Quoted in Greene, "Interview with Jacob Lawrence," p. 32.

21. Quoted in Greene, "Interview with Jacob Lawrence," pp. 74–75.

22. Lawrence, lecture, November 15, 1982.

23. "Birth of a Nation," *Time* (January 14, 1957), n.p. The owner of Number 11 of the *Struggle* series reports that his records call the painting *Secrets*. Number 27 of the series often is referred to as *Slave Rebellion* by the artist.

24. Lawrence, in conversation with the author, July 24, 1984.

25. Emily Genauer, "New Exhibit Proves Art Needn't Be Aloof," *New York Herald Tribune* (June 6, 1957), p. 10.

26. Quoted in Louise Elliott Rago, "A Welcome from Jacob Lawrence," *School Arts* (February 1963).

27. Lawrence speech text (n.d. or title, probably c. 1953), Jacob Lawrence material, Syracuse University.

28. Lawrence letter to Charles Alan (n.d., probably Fall 1955), p. 3, Alan Gallery Papers, Microfilm Roll 1380, Archives of American Art.

29. Gwen Lawrence, in conversation with the author, July 24, 1984.

30. The monograph, *Jacob Lawrence*, was written by Aline Saarinen (formerly Louchheim). Fax, *Seventeen Black Artists*, p. 162, and Bearden and Henderson, *Six Black Masters*, p. 117, mention this exhibition.

31. From clippings on Microfilm Roll D268:1–216, Archives of American Art, a collection of Lawrence's papers 1958–66. This clipping appears to be from an exhibition catalog for the Mbari Club show, October 1964.

32. Irma Rothstein Papers, Microfilm Roll D286, Archives of American Art. It is possible that Lawrence's statement regarding African artistic influence is based more on diplomacy than on desire.

33. Clipping (October 1964), Irma Rothstein Papers, Microfilm Roll D286, Archives of American Art.

34. Since pre-colonial times, *calaveras* have been used in many indigenous art forms, most recently to celebrate the Day of the Dead, when even sugar-candy skulls on sticks are sold on the streets of Mexican towns. Posada did not invent this imagery in Mexico, but he did popularize it. Lawrence has had a favorite book of Posada prints in his library since 1960; the example reproduced here is contained in that volume: Frances Toor, Paul O'Higgins, and Blas Vanegas Arroyo, *Monografia: Las Obras de José Guadalupe Posada* (Mexico: Mexican Folkways, 1930).

35. Gwen and Jacob Lawrence, in conversation with the author, July 24, 1984, and May 3, 1985.

36. Letter to Lawrence from painter Jack Levine (no date, probably 1963), Jacob Lawrence material, Syracuse University.

37. See his cover illustration for *Motive* (October 1963), for example. *Wounded Man* (1969) was reported lost in a fire by *Freedomways* magazine. Lawrence gives the title *Struggle—Man on Horseback* to the drawing *Struggle No. 2* (1965), to distinguish it from another 1965 drawing, *Struggle—Assassination* (pl. 105).

38. Lawrence, in conversation with the author, February 24, 1983.

39. "The Black Artist in America: A Symposium," *Metropolitan Museum of Art Bulletin*, 27:5 (January 1969), p. 246.

40. M. Brown, *Jacob Lawrence*, p. 9.

41. An expanded discussion of American black art can be found in Chapter IV of the author's master's thesis, "Jacob Lawrence, American Painter" (1983). Ultimately, most insights came from the writings of Alain Locke (*The New Negro*; *Negro Art*; *The Negro in Art*), who established Afro-American art awareness in this country. Discussions of the history of black art can be found in David C. Driskell, *Two Centuries of Black American Art* (New York: Knopf, 1976); Butcher, *The Negro in American Culture*; Fine, *The Afro-American Artist*; and James A. Porter, *Modern Negro Art* (New York: Dryden Press, 1943). On black art of recent decades, most helpful are Fine, *The Afro-American Artist*; Carroll Greene, Jr., "Perspective: The Black Artist in America," *The Art Gallery*, 13:7 (April 1970), pp. 1–29; Samella Lewis, *Art: African American* (New York: Harcourt Brace Jovanovich, 1978); Edmund Barry Gaither's introductory essay in the exhibition catalog, *Afro-American Artists, New York and Boston* (Boston: The Museum of the National Center of Afro-American Artists, 1970); and Fax, *Seventeen Black Artists*.

42. Locke, *The Negro in Art*, p. 9

43. Locke, *Negro Art*, pp. 34–36, 43–45.

44. Locke, *Negro Art*, pp. 34–36, 43–45; Locke, *The Negro in Art*, discusses the work of William Sydney Mount, p. 206.

45. Locke, *The Negro in Art*, p. 139, discusses Winslow Homer as initiator of this attitude change and recognizes the contribution of Eastman Johnson.

46. Locke, *Negro Art*, pp. 34–36, 43–45.

47. Fax, *Seventeen Black Artists*, p. 8.

48. Locke, *Negro Art*, p. 47.

49. William E. B. DuBois, "Criteria of Negro Art," *The Crisis*, 32 (October 1926), p. 296.

50. Locke, *The Negro in Art*, p. 10.

51. Locke, *Negro Art*, p. 93.

52. Locke, *Negro Art*, pp. 60–61.

53. Gaither, *Afro-American Artists*, p. 2.

54. Jacob Lawrence joined the Downtown Gallery in 1941; Horace Pippin began showing with the Carlen Galleries in Philadelphia in 1940 and the Downtown Gallery in 1944.

55. Greene, "Perspective," p. 21.

56. Greene, "Perspective," p. 23.

57. Gaither, *Afro-American Artists*, p. 2.

58. The three aims were originally set forth by Roger Mandle in his introduction to the catalog for the exhibition "30 Contemporary Black Artists," Minneapolis Institute of Art, 1968. Quoted in Fine, *Afro-American Artists*, p. 194.

59. Quoted in Greene, "Interview with Jacob Lawrence," p. 56.

60. Gaither, *Afro-American Artists*, pp. 3–4.

61. Locke, *The Negro in Art*, p. 10.

62. "Black Art: What Is It?" *The Art Gallery*, 13 (April 1970), pp. 32–35.

63. Grace Gleuck, "Sharing Success Pleases Jacob Lawrence," *The New York Times* (June 3, 1974), p. 38.

64. Gleuck, "Sharing Success," p. 38.

65. "The Black Artist: A Symposium," p. 260.

66. Quoted in Van Cleve, "Human Views," pp. 36–37.

67. Quoted in "The Black Artist: A Symposium," p. 256.

68. Grace Gleuck, "The Best Painter I Can Possibly Be," *The New York Times*, Section 2 (December 8, 1968), p. 4.

69. Lawrence, in conversation with the author, June 7 and June 21, 1984.

70. Lawrence, in conversation with the author, June 7, 1984.

71. Quoted in Stan Nast, "Painter Lawrence is Honored for a 'Protest' That Was Life," *Seattle Post-Intelligencer* (April 5, 1980).

72. From Bearden and Henderson, in the title of their book, *Six Black Masters*.

73. Fine, *The Afro-American Artist*, describes Lawrence's decorative manner on p. 150, and Bearden's position as a black activist, pp. 92ff.

74. Edmund Barry Gaither, excerpts from a statement solicited by the author about American black art in the 1980s, September 25, 1984.

75. Lawrence, in conversation with the author, June 21, 1984.

76. Fine, *The Afro-American Artist*, p. 281.

77. Gaither, statement to author, September 25, 1984.

78. Letter to Lawrence from Philip Evergood (February 5, 1965), Irma Rothstein Papers, Microfilm Roll D286, Archives of American Art.

79. All his self-portraits have been done on request. While teaching at Brandeis, he was asked to do this work by a woman who was collecting artists' portraits. Lawrence, in conversation with the author, June 7, 1984.

80. Lawrence, in conversation with the author, April 21, 1983.

81. Lawrence, lecture, November 15, 1982.

82. Gwen Lawrence composed the original story in prose from from her husband's notes; it was cast into ballad form, the publisher's idea. Lawrence, lecture, November 15, 1982.

83. Lawrence, lecture, November 15, 1982.

84. Quoted in Barbara Seese, "The Black Experience—Pictures Tell the Story," *University of Washington Daily* (October 10, 1978).

5. At Home in the West: 1968 to Present

1. The Spingarn Medal has been awarded annually since 1914 to a black American for distinguished achievement. The 1970 medal was awarded to Lawrence "in tribute to the compelling power of his work, which has opened to the world beyond these shores a window on the Negro's condition in the United States; and in salute to his unswerving commitment, not only to his art, but to his black brother within the context of society." This comment and the statement made by Lawrence on receiving the medal was published in the NAACP's *The Crisis* (August–September 1970), pp. 266–67.

2. Jacob Lawrence, written statement to the author, September 20, 1984.

3. Jacob Lawrence, lecture, November 15, 1982.

4. Berman, taped interview of Jacob Lawrence, February 6, 1983.

5. Quoted in Bonnie Hoppin, "Arts Interview: Jacob Lawrence," *Puget Soundings* (February 1977), p. 6.

6. Lawrence, lecture, November 15, 1982.

7. Robert Pincus-Witten, "Jacob Lawrence: Carpenter Cubism," *Artforum*, 13:16 (September 1974), pp. 66–67.

8. Glueck, "Sharing Success," p. 38.

9. Quoted in Hoppin, "Arts Interview," pp. 6–7.

10. Lawrence, in conversation with the author, July 2, 1984.

11. Lawrence, in conversation with the author, March 10, 1983.

12. Hilton Kramer, "Art: Lawrence Epic of Blacks," *The New York Times* (June 1974).

13. Letter (September 19, 1974) to critic R. M. Campbell of *The Seattle Post-Intelligencer* from Spencer Moseley, Director, School of Art, University of Washington. Jacob Lawrence's personal files.

14. Letter to the author from Joanne Chuba, Skowhegan School of Painting and Sculpture, Maine, dated July 30, 1984, in which she describes the circumstances under which *Builders* (1974) was presented to the Pope.

15. The twenty-two original gouaches of the *John Brown* series were reproduced in the book with their captions, and the print portfolios were sold in an edition of sixty.

16. The official American Freedom Train Program, Bicentennial Celebration, 1975–76.

17. Ploski and Brown, *The Negro Almanac*, describe the Birmingham incidents on pp. 22 and 27. The serigraph of *Confrontation at the Bridge* is 19 1/2 × 25 7/8 inches.

18. Jacob Lawrence, written statement, September 20, 1984.

19. Lawrence, lecture, November 15, 1982.

20. Lawrence, lecture, November 15, 1982. Lawrence has a book of reproduced Vesalius woodcuts in his library: J. B. de C. M. Saunders and Charles D. O'Malley, *The Illustrations from the Works of Andreas Vesalius* (New York: World Publishing Co., 1950). Figure 68 is contained in that volume.

21. Jacob Lawrence, lecture, November 15, 1982.

22. Lawrence, drawing class lecture, February 15, 1983.

23. For information on this event, see Delores Tarzan, "Lawrence Set to Paint Inaugural," *The Seattle Times* (January 25, 1977), as well as Marjorie Hunter, "Carter Meets 5 American Artists Who Portrayed His Inauguration," *The New York Times* (June 15, 1977), and Benjamin Forgey, "Carter Thanks Five Artists for Inaugural Works," *The Washington Star* (June 15, 1977).

24. Jacob Lawrence, informal talk at the University of Washington soon after Carter's inauguration (January 25, 1977).

25. Tarzan, "Lawrence Set to Paint Inaugural."

26. Jacob Lawrence, in conversation with the author, February 18, 1983.

27. Jacob Lawrence, written statement to the author, September 20, 1984.

28. A discussion of the *Images of Labor* work can be found in Kimberly Campbell, "Artist's Labor Is of Love and Social Consciousness," *University District Herald*, Seattle (November 4, 1981). The Twain quotation came from his speech "The Right of Labor—The New Dynasty."

29. *The Arts*, Newsletter of the King County Arts Commission, Washington, August 1979.

30. Paul Richard, "The Artist's Universe: Jacob Lawrence's Mural Unveiled at Howard," *The Washington Post*, December 4, 1980, pp. D1 and D7.

31. Benjamin Forgey, "A Masterpiece of Mural Art," *The Washington Star* (December 4, 1980).

32. Jacob Lawrence, in a letter to Charles Alan, January 15, 1973. Jacob Lawrence's personal files.

33. This organization produces elegant leather-bound editions; previous works were illustrated by artists including Robert Motherwell, Picasso, and Matisse.

34. "The Monthly Letter of The Limited Editions Club," Series 47, 2:535 (December 1983), p. 3.

35. John Russell, "Illustrated Books Are Making a Comeback," *The New York Times* (August 28, 1983), p. 24A. The book is bound in black analine-dyed leather and the text pages are hand-set in Univers foundry type on cream-white 100-pound wove letterpress paper. Russell expressed amazement at such a reasonable price for the book ($400 for this one), because so much care goes into every detail of the book's production that the publisher exhibits a "touch of sacred frenzy." The eight silkscreens are printed in eleven colors that bleed off the edges of the pages. An additional portfolio of the silkscreens with the same image size and the signed poem was also produced.

36. Lawrence, in conversation with the author, July 2, 1984.

37. Lawrence, in conversation with the author, January 6, 1986.

38. The academy was established in 1904 as an elite group within the National Institute of Arts and Letters, established in 1898 to "foster, assist, and sustain an interest in literature, music, and the fine arts." Members of these related groups qualify through their achievements in the humanities. New members are elected to fill the chairs of deceased ones: Lawrence inherited chair 41, formerly occupied by Chicago artist Ivan Albright. Geoffrey T. Hellman describes the Academy and the Institute in "Profiles: Some Splendid and Admirable People," *The New Yorker* (February 23, 1976), pp. 43ff.

39. M. Brown, *Jacob Lawrence*, p. 15.

6. CONCLUSION

1. Greene, "Interview with Jacob Lawrence," p. 10.

2. Rago, "A Welcome from Jacob Lawrence." Lawrence, in conversation with the author, September 18, 1984, said that he made a few works with oil paint in the early years (late 1930s, early 1940s) but he does not know where they are.

3. Van Cleve, "Human Views," p. 37.

4. Greene, "Interview with Jacob Lawrence," pp. 32–33.

5. Emily Genauer, newspaper article of unknown source, Alan Gallery Papers, Microfilm Roll 1390, Archives of American Art.

6. Kramer, "Art: Lawrence Epic of Blacks."

7. Berman, interview with Jacob Lawrence, February 6, 1983.

8. Berman, interview with Jacob Lawrence, February 6, 1983.

9. Jacob Lawrence, "Philosophy of Art," statement solicited by the Whitney Museum to relate to the Lawrence painting *Depression* (1950) which they own, May 30, 1951. Whitney Museum Library, Jacob Lawrence Artist File.

CHRONOLOGY

1917	Jacob Armstead Lawrence born September 7, to Jacob and Rose Lee (Armstead) Lawrence, Atlantic City, New Jersey.
1919	Family moved to Easton, Pennsylvania. Sister Geraldine born.
1924	Parents separated. Mother moved family to Philadelphia. Brother William born.
1930	Mother brought family to New York. Jacob attended Utopia Children's Center after school; Grammar School, P.S. 68; Frederick Douglass Junior High School, P.S. 139; High School of Commerce (1932–34).
1932	Studied with Charles Alston at College Art Association classes, Harlem Art Workshop, 135th Street Public Library.
1934–37	Studied with Charles Alston and Henry Bannarn, WPA art classes, Harlem Art Workshop, 306 West 141st Street studio. Rented studio space there (until 1940).
1936	Worked in Civilian Conservation Corps camp, near Middletown, New York (six months).
1937	Obtained scholarship to American Artists School (two years); studied with Anton Refregier, Sol Wilson, Philip Reisman, Eugene Moreley.
	Began *Toussaint L'Ouverture* series.
1938	First one-man exhibition, Harlem YMCA, sponsored by James Weldon Johnson Literary Guild (February).
	Joined WPA Federal Art Project easel section (late in year) and worked eighteen months.
	Began *Frederick Douglass* series.
1939	*Toussaint* series exhibited, Baltimore Museum of Art.
	Began *Harriet Tubman* series.
1940	Awarded second prize, American Negro Exposition, Chicago (*Toussaint* series).
	Received Julius Rosenwald Fund Fellowship.
	Moved to studio at 33 West 125th Street.
	Began *Migration of the Negro* series.
1941	Married Gwendolyn Clarine Knight, painter (July 24).
	First trip to the South; in New Orleans (August 1941–January 1942).
	Rosenwald Fund Fellowship renewed.
	First major one-man exhibition, Downtown Gallery, New York (November); *Migration* series. Joined Downtown Gallery.
	Began *John Brown* series.
1942	In Lenexa, Virginia (two or three months). Returned to New York (June). Moved to 72 Hamilton Terrace, New York.
	Rosenwald Fund Fellowship renewed.
	Began *Harlem* series.
	Awarded Sixth Purchase Prize, "Artists for Victory" Exhibition, the Metropolitan Museum of Art, New York.
	Summer Art Instructor (with wife), Wo-Chi-Ca (Workers' Children's Camp), Hackettstown, New York.
1943	Moved to 385 Decatur Street, Brooklyn.
	Inducted into United States Coast Guard as Steward's Mate (October 20). Boot training, Curtis Bay, Maryland. Officer's Training Station, St. Augustine, Florida.
1944	First Coast Guard assignment, USS *Sea Cloud*, weather patrol ship; home port, Boston. Promoted to Petty Officer 3rd Class, Public Relations Branch, to paint Coast Guard life; assigned to USS *General Richardson*, troop carrier, to Europe, Near East, India.
	One-man exhibition, thirty paintings from the *Migration* series and *Coast Guard* paintings, the Museum of Modern Art, New York; *Migration* paintings circulated nationally by the Museum of Modern Art.
	Death of sister.

1945 One-man exhibition, *John Brown* series, Boston Institute of Modern Art; circulated nationally by the American Federation of Arts.

Discharged from Coast Guard (December 6).

1946 Received John Simon Guggenheim Post-Service Fellowship (January 1946–January 1947).

Taught at Black Mountain College, North Carolina (Summer Art Institute, July 2–August 28).

Began *War* series.

1947 Ten paintings of the South *(In the Heart of the Black Belt)* commissioned by *Fortune* magazine. Traveled to Vicksburg, Mississippi; Tuskegee, Alabama; New Orleans, Louisiana; Memphis, Tennessee (June, July).

1948 Made illustrations for *One Way Ticket* by Langston Hughes.

Received Norman Wait Harris Silver Medal and Prize ($500), International Water Color Exhibition, Art Institute of Chicago.

Certificate of Recognition, *Opportunity* magazine.

First Prize in Watercolor, Brooklyn Society of Artists.

Purchase Award, "Seventh Annual Exhibition of Contemporary Negro Art," Atlanta University; Honorable Mention, Pennsylvania Academy of Fine Arts.

1949 Admitted to Hillside Hospital, Queens, New York, for psychiatric treatment (October).

Began *Hospital* paintings.

1950 Discharged from Hillside Hospital (July).

1951 Began *Theater* paintings.

Named member, Artists Equity Board of Directors.

1952 Received Honorable Mention, "Biennial Exhibition of Brooklyn Artists," The Brooklyn Museum.

Death of father.

1953 Received citation and grant, National Institute of Arts and Letters.

Became associated with Alan Gallery, New York.

1954 Received Chapelbrook Foundation Fellowship.

Appointed Fellow, Yaddo Foundation, Saratoga Springs, New York (May 31–July 19).

Taught at Skowhegan School of Painting and Sculpture, Maine (Summers, 1954, 1968–72).

Elected National Secretary, Artists Equity Association (until 1956).

1955 Began *Struggle: From the History of the American People* series.

Appointed Fellow, Yaddo Foundation, Saratoga Springs, New York (September 19–November 17); Instructor, Pratt Institute, Brooklyn, New York (until 1970).

Shared First Prize, Mural Competition, United Nations Building, National Council of United States Art, with Stuart Davis (November).

Taught at the Five Towns Music and Art Foundation, Cedarhurst, Long Island (until 1962, 1966–68).

Moved to 130 St. Edwards Street, Brooklyn.

1957 Elected President, Artists Equity Association of New York.

1959 Works exhibited in Soviet Union, part of cultural exchange exhibit sponsored by U.S. State Department.

1960 Retrospective exhibition, The Brooklyn Museum; circulated nationally by American Federation of Arts.

c. 1961 Began paintings on *Civil Rights* theme.

1962 Became associated with Terry Dintenfass Gallery, New York.

Made trip to Nigeria, *Migration* series exhibition at Mbari Artists and Writers Club, Lagos and Ibadan, Nigeria.

1963 Participated in Johnson Wax Company World Tour Group Exhibition, circulated worldwide.

Participated in group exhibition sponsored by U.S. State Department in Pakistan.

1964 Returned to Nigeria with wife to live and work (April–November). Completed *Nigerian* paintings.

1965 Appointed Artist-in-Residence, Brandeis University, Waltham, Massachusetts (February–May).

Moved to 211 West 106th Street, New York.

1966　Appointed Instructor, New School for Social Research, New York (about three years).

Represented in United States Exhibition of Visual Art, First World Festival of Negro Arts, Dakar, Senegal, West Africa.

Served on Fulbright Art Committee (1966–67).

Death of brother.

1967　Appointed Instructor, Art Students League, New York (about two years).

Made paintings for *Harriet and the Promised Land* (Windmill Books/Simon and Schuster), a children's book about Harriet Tubman, written in collaboration with his wife.

1968　Began paintings on *Builders* theme.

Commissioned by *Time* magazine, cover portrait of Colonel Ojukwu of Biafra (August 23).

Death of mother.

1969　Appointed Visiting Artist, California State College, Hayward (September 1969–March 1970).

Became member, Black Academy of Arts and Letters.

1970　Appointed Visiting Artist, University of Washington, Seattle (April–June).

Appointed Full Professor, Coordinator of the Arts and Assistant to the Dean of the Art School, Pratt Institute, New York; Member, Board of Governors, Skowhegan School of Painting and Sculpture, Maine.

Produced illustrations for *Aesop's Fables* (Windmill Books/Simon and Schuster).

Awarded Spingarn Medal by the NAACP; Honorary Doctor of Fine Arts, Denison University, Granville, Ohio.

Commissioned by *Time* magazine, Jesse Jackson cover portrait (April 6).

1971　Appointed Full Professor, University of Washington; moved to Seattle. Member, Washington State Arts Commission, for two three-year terms.

Sixty reunited paintings of the *Migration* series are included in the "Artist as Adversary" exhibition, Museum of Modern Art, New York.

1972　Commissioned by Edition Olympia 1972 to design poster for the 1972 Olympic Games in Munich.

Awarded Honorary Doctor of Fine Arts, Pratt Institute.

1973　Commissioned by State of Washington to do *George Washington Bush* series. Exhibited at the State Capital Museum, Olympia, Washington.

Awarded Citation, National Association of Schools of Art; The Brooklyn Arts Books for Children Citation for 1973, presented by the Brooklyn Museum and the Brooklyn Public Library (for *Harriet and the Promised Land*).

1974　*Builders* (1974) presented to Pope Paul VI by Skowhegan School of Painting and Sculpture for Vatican Gallery of Modern Art, Vatican Museum, Rome.

Major retrospective exhibition, Whitney Museum of American Art, New York. Exhibition traveled (May 1974–March 1975) to St. Louis Art Museum, Missouri; Birmingham Museum of Art, Alabama; Seattle Art Museum, Washington; William Rockhill Nelson Gallery of Art and Atkins Museum of Fine Arts, Kansas City, Missouri; New Orleans Museum of Art, Louisiana.

1975　Portfolio of screenprints based on *John Brown* series commissioned by Founders Society, Detroit Institute of Arts.

1976　*Bumbershoot* Festival poster commissioned by Seattle Arts Commission.

Silkscreen print for U.S. Bicentennial commissioned by Transworld Art, New York.

Work included in Freedom Train Traveling Exhibition, U.S. Bicentennial; and, along with eleven other American artists, in Bicentennial Portfolio, Kent Lorillard Collection, touring exhibition.

Awarded Honorary Doctor of Fine Arts, Colby College, Waterville, Maine.

Works shown as part of "Two Centuries of Black American Art," Los Angeles County Museum, major group exhibition circulated nationally.

Appointed Elector, Hall of Fame for Great Americans.

On the West Coast, became associated with Francine Seders Gallery, Seattle.

1977　Silkscreen print of impressions of President Carter's inauguration in Washington, D.C., commissioned by the Presidential Inauguration Committee, with Andy Warhol, Robert Rauschenberg, Jamie Wyeth, and Roy Lichtenstein (portfolio).

Elected Associate, National Academy of Design.

Three editions of lithographs on *Builders* theme (300 in each edition) commissioned by Himan Brown, New York.

1978 Mural for the Kingdome Stadium, Seattle, commissioned by King County Arts Commission (installed 1979).

Nominated Commissioner, National Council of the Arts, by President Carter; confirmed by the U.S. Senate (six-year term).

Selected as Third Annual Faculty Lecturer, University of Washington, October 5 (Lecture, "Search").

John Brown series published as a book, *The Legend of John Brown,* by the Detroit Institute of Arts.

1979 Mural, *Exploration,* commissioned by Howard University, Washington, D.C. (installed December 3, 1980).

Awarded Honorary Doctor of Fine Arts, Maryland Institute of Art.

1980 *Labor Day* poster, *Builders* theme, commissioned by President Carter.

Images of Labor work commissioned by Bread and Roses Project, District 1199, National Union of Hospital and Health Care (exhibited July 1981, Smithsonian Museum of American History, and traveled nationally).

Awarded citation, Washington State Bar Association, for Black Elders of Visual Arts.

Invited by President and Mrs. Carter to White House reception honoring ten black artists.

1981 Awarded Honorary Doctor of Fine Arts, Carnegie-Mellon University.

Received Washington State Governor's Award of Special Commendation, Olympia, Washington.

Poster for the Pacific Northwest Arts and Crafts Fair, Bellevue, Washington, commissioned by PNAC Association.

Eight Builders commissioned by Seattle Arts Commission for City of Seattle 1% for Art Seattle City Light Collection (completed December 1982).

Began drawings on *Builders* theme, graphite on paper.

1982 Retrospective exhibition, Clark Humanities Museum, Scripps College, Claremont, California, and Santa Monica College, California.

Silkscreen prints pertaining to *Hiroshima* by John Hersey commissioned by Limited Editions Club, New York, to illustrate a special edition of the book (published December 1983).

1983 Elected Member, American Academy of Arts and Letters (inducted May 1984).

1984 Commissioned by University of Washington to execute mural for campus site of his choosing. *Theater* installed in Meany Hall (June 1985).

John Hersey, Jacob Lawrence, and Robert Penn Warren honored for their collaboration on the special edition of *Hiroshima,* at Japan Society, New York City (April 4).

Awarded Honorary Doctor of Fine Arts, State University of New York, Albany.

Group exhibition, "Artists of the Thirties and Forties," the Museum of African Art, Santa Monica, California (participated in symposium, June 29–July 1, related to show).

Awarded Washington State Governor's Arts Award.

Poster design on the *Builders* theme commissioned by the National Urban League for their 1985 seventy-fifth anniversary.

1985 Awarded Honorary Doctor of Humane Letters, Howard University, Washington, D.C.

Reception, Washington State Senate, to honor his gift of narrative painting. Exhibition of work, Washington State Capital Museum.

CHECKLIST OF THE EXHIBITION
JACOB LAWRENCE, AMERICAN PAINTER

Dimensions are given in inches—height precedes width. Information in parentheses indicates other titles by
which a work has been identified.

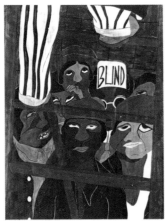

1. *Street Orator*, 1936
Tempera on paper
23½ × 18
Collection of Gwendolyn and Jacob Lawrence
Pl. 2

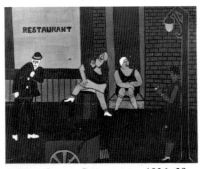

2. *Street Scene—Restaurant*, c. 1936–38
Tempera on paper
26¼ × 35
Collection of Mr. and Mrs. Philip J. Schiller
Pl. 1

3. *Bar 'n Grill*, 1937
Tempera on paper
22¾ × 23¾
Collection of Gwendolyn and Jacob Lawrence

4. *Interior Scene*, 1937
Tempera on paper
28½ × 33¾
Collection of Mr. and Mrs. Philip J. Schiller
Pl. 4

5–11. *Toussaint L'Ouverture* Series, 1937–38
(41 paintings)
Tempera on paper
Amistad Research Center's Aaron Douglas
Collection. Special arrangements through the
Southern Arts Federation.

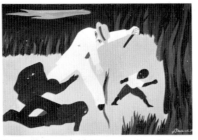

5. No. 7: *As a child, Toussaint heard the twang
of the planter's whip and saw blood stream
from the bodies of slaves.*
11 × 19

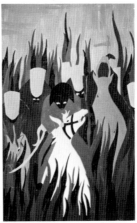

6. No. 17: *Toussaint captured Marmalade, held
by Vernet, a Mulatto, 1795.*
19 × 11
Pl. 7

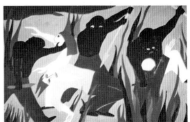

7. No. 19: *The Mulattoes had no organization;
the English held only a point or two on the
island, while the Blacks formed into large
bands and slaughtered every Mulatto and white
they encountered. The Blacks had learned the
secret of their power. The Haitians now
controlled half the island, and took their
revenge on their enemies.*
11 × 19

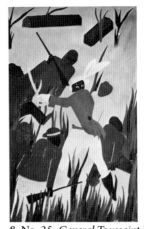

8. No. 25: *General Toussaint L'Ouverture
defeats the English at Saline.*
19 × 11

9. No. 35: *Yellow fever broke out with great
violence, thus having a great physical and moral
effect on the French soldiers. The French sought
a truce with L'Ouverture.*
19 × 11

10. No. 36: *During the truce Toussaint is deceived and arrested by LeClerc. LeClerc led Toussaint to believe that he was sincere, believing that when Toussaint was out of the way, the Blacks would surrender.*
11 × 19
Pl. 8

11. No. 38: *Napoleon's attempt to restore slavery in Haiti was unsuccessful. Desalines, Chief of the Blacks, defeated LeClerc. Black men, women, and children took up arms to preserve their freedom, November, 1802.*
11 × 19

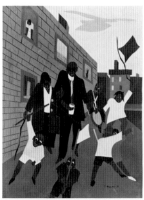

12. *Blind Beggars,* 1938
Tempera on paper
20 × 15
Metropolitan Museum of Art, gift of the New York City Works Progress Administration, 1943

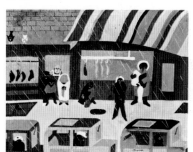

13. *The Butcher Shop,* 1938
Tempera on paper
18 × 23¾
Courtesy of Terry Dintenfass Gallery, New York

14–24. *Frederick Douglass* Series, 1938–39 (32 paintings)
Casein on hardboard
Hampton University Museum, Hampton, Virginia

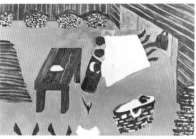

14. Part I, The Slave, No. 4: *In the slaves' living quarters, the children slept in holes and corners of the huge chimneys; old and young, married and single, slept on clay floors.*
12 × 17⅞

15. Part I, The Slave, No. 5: *The master's quarters or the great house was filled with luxuries. It possessed the finest of foods from Europe, Asia, Africa and the Caribbeans. It contained fifteen servants. It was one of the finest mansions in the South.*
17⅞ × 12

16. Part I, The Slave, No. 9: *Transferred back into the Eastern Shore of Maryland, being one of the few Negroes who could read or write, Douglass was approached by James Mitchell, a free Negro, and asked to help teach a Sabbath-School. However, their work was stopped by a mob who threatened them with death if they continued their class—1833.*
12 × 17⅞

17. Part I, The Slave, No. 10: *The master of Douglass, seeing he was of a rebellious nature, sent him to a Mr. Covey, a man who had built up a reputation as a "nigger breaker." A second attempt to flog Douglass by Covey was unsuccessful. This was one of the most important incidents in the life of Frederick Douglass. He was never attacked again by Covey. His philosophy: A slave easily flogged is flogged oftener—a slave who resists flogging is flogged less.*
17⅞ × 12

18. Part I, The Slave, No. 12: *It was in the year 1836 that Douglass conceived a plan of escape, also influencing several slaves around him. He told his co-conspirators what had been done, dared and suffered by men to obtain the inestimable boon of liberty.*
17⅞ × 12

19. Part I, The Slave, No. 13: *As the time of their intended escape drew nearer, their anxiety grew more and more intense. Their food was prepared and their clothing packed. Douglass had forged their passes. Early in the morning they went into the fields to work. In mid-day they were all called off the field only to discover they had been betrayed.*
12 × 17⅞

20. Part II, The Fugitive, No. 16: *Frederick Douglass' escape from slavery was a hazardous and an exciting 24 hours. Douglass disguised as a sailor, best he thought because he knew the language of a sailor, he knew a ship from stem to stern. On he traveled through Maryland, Wilmington, Philadelphia and his destination, New York. Frederick Douglass was free.*
17⅞ × 12

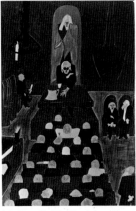

21. Part II, The Fugitive, No. 18: *Douglass listened to lectures by William Lloyd Garrison. He heard him denounce the slave system in words that were mighty in truth and mighty in earnestness.*
17⅞ × 12

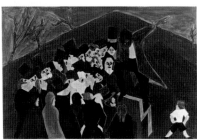

22. Part II, The Fugitive, No. 19: *It was in the year 1841 that Frederick Douglass joined the forces of Lloyd Garrison and the abolitionists. He helped secure subscribers to the Anti-Slavery Standard and the Liberator. He lectured through the Eastern counties of Massachusetts, narrating his life as a slave, telling of the cruelty, inhumane and clannish act of the slave system.*
12 × 17⅞

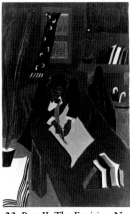

23. Part II, The Fugitive, No. 22: *Leaving England in the Spring of 1847 with a large sum of money given him by sympathizers of the anti-slavery movement, he arrived in Rochester, New York and edited the first Negro paper, "The North Star." As editor of "The North Star," he wrote of the many current topics affecting the Negro such as the Free Soil Convention at Buffalo, the nomination of Martin Van Buren, the Fugitive Slave Law, and the Dred Scott Decision.*
17⅞ × 12

Pl. 9

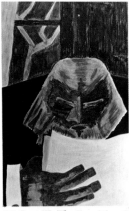

24. Part III, The Free Man, No. 31: *An appointment to any important and lucrative office under the United States Government usually brings its recipient a large measure of praise and congratulations on one hand and much abuse and disparagement on the other. With these two conditions prevailing, Frederick Douglass was appointed by President Rutherford B. Hayes, United States Marshall of the District of Columbia, 1877.*
17⅞ × 12

25–38. *Harriet Tubman* Series, 1939–40
(31 paintings)
Casein on hardboard
Hampton University Museum, Hampton, Virginia

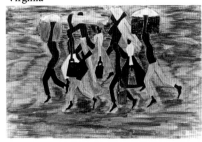

25. No. 1: *"With sweat and toil and ignorance he consumes his life, to pour the earnings into channels from which he does not drink."* Henry Ward Beecher
12 × 17⅞

Pl. 12

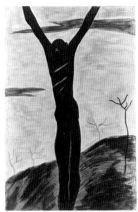

26. No. 2: *"I am no friend of slavery, but I prefer the liberty of my own country to that of another people, and the liberty of my own race to that of another race. The liberty of the descendants of Africa in the United States is incompatible with the safety and liberty of the European descendants. Their slavery forms an exception (resulting from a stern and inexorable necessity) to the general liberty in the United States."* Henry Clay
17⅞ × 12

Pl. 14

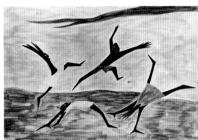

27. No. 4: *On a hot summer day about 1821 a group of slave children were tumbling in the sandy soil in the state of Maryland—and among them was one, Harriet Tubman. Dorchester County, Maryland*
12 × 17⅞

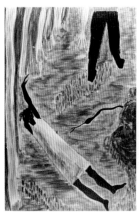

28. No. 5: *She felt the first sting of slavery, when as a young girl she was struck in the head with an iron bar by an enraged overseer.* 17⅞ × 12

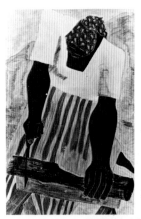

29. No. 7: *Harriet Tubman worked as a water girl to cotton pickers; she also worked at plowing, carting and hauling logs.* 17⅞ × 12
Pl. 13

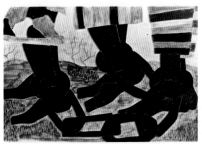

30. No. 9: *Harriet Tubman dreamt of freedom—("Arise! Flee for your life!") and in the visions of the night she saw the horsemen coming, beckoning hands were ever motioning her to come, and she seemed to see a line dividing the land of slavery from the land of freedom.* 12 × 17⅞

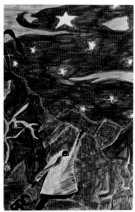

31. No. 10: *Harriet Tubman was between twenty and twenty-five years of age at the time of her escape. She was now alone, she turned her face toward the north, and fixing her eyes on the guiding star, she started on her long lonely journey.* 17⅞ × 12

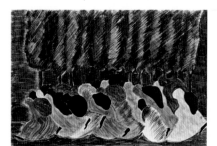

32. No. 16: *Harriet Tubman spent many hours at the office of William Stills, the loft office of the antislave vigilance committee in Philadelphia. Here she pored over maps and discussed plans with the keen, educated young secretary of that mysterious organization, The Underground Railroad, whose main branches stretched like a great network from the Mississippi River to the coast.* 12 × 17⅞

33. No. 19: *Such a terror did she become to the slaveholders that a reward of $40,000 was offered for her head; she was bold, daring and elusive.* 17⅞ × 12

34. No. 22: *Harriet Tubman, after a very trying trip north in which she hid her cargo by day and traveled by boat, wagon and foot at night, reached Wilmington where she met Thomas Garret, a Quaker who operated an Underground Railroad station. Here they were fed and clothed and sent on their way.* 12 × 17⅞

35. No. 23: *The hounds are baying on my tracks,*
Old master comes behind,
Resolved that he will bring me back,
Before I cross the line.

12 × 17⅞

36. No. 27: *Governor Andrew of Massachusetts, knowing well the brave, sagacious character of Harriet Tubman, sent for her and asked her if she could go at a moment's notice to act as a spy and scout for the Union Armies, and if need be, to act as a hospital nurse. In short, to be ready for any required service for the Union cause.* 12 × 17⅞

37. No. 28: *Harriet Tubman went into the South and gained the confidence of the slaves by her cheerful words and sacred hymns; she obtained from them valuable information.* 17⅞ × 12

38. No. 29: *She nursed the Union soldiers and knew how, when they were dying by large numbers of some malignant disease, with cunning skill to extract from roots and herbs which grew near the source of the disease, the healing drought, which allayed the fever and restored numbers to health.*
12 × 17⅞
Pl. 15

39–48. *The Migration of the Negro* Series, 1940–41 (60 paintings)
Casein on hardboard

39. No. 1: *During the World War there was a great migration North by Southern Negroes.*
12 × 18
The Phillips Collection, Washington, D.C.
Pl. 17

40. No. 3: *In every town Negroes were leaving by the hundreds to go North to enter into Northern industry.*
12 × 18
The Phillips Collection, Washington, D.C.

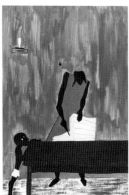

41. No. 11: *In many places, because of the war, food had doubled in price.*
18 × 12
The Phillips Collection, Washington, D.C.

42. No. 22: *Another of the social causes of the migrants' leaving was that at times they did not feel safe, or it was not the best thing to be found on the streets late at night. They were arrested on the slightest provocation.*
12 × 18
Museum of Modern Art, New York, gift of Mrs. David M. Levy

43. No. 42: *They also made it very difficult for migrants leaving the South. They often went to railroad stations and arrested the Negroes wholesale, which in turn made them miss their trains.*
18 × 12
Museum of Modern Art, New York, gift of Mrs. David M. Levy

44. No. 48: *Housing for the Negroes was a very difficult problem.*
18 × 12
Museum of Modern Art, New York, gift of Mrs. David M. Levy

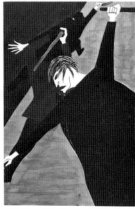

45. No. 50: *Race riots were very numerous all over the North because of the antagonism that was caused between the Negro and white workers. Many of the riots occurred because the Negro was used as a strikebreaker in many of the northern industries.*
18 × 12
Museum of Modern Art, New York, gift of Mrs. David M. Levy

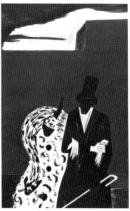

46. No. 53: *The Negroes who had been North for quite some time met their fellow men with disgust and aloofness.*
18 × 12
The Phillips Collection, Washington, D.C.

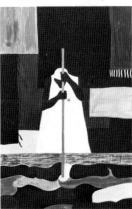

47. No. 57: *The female worker was also one of the last groups to leave the South.*
18 × 12
The Phillips Collection, Washington, D.C.

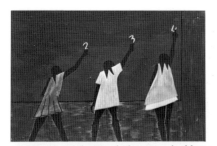

48. No. 58: *In the North the Negro had better educational facilities.*
12 × 18
Museum of Modern Art, New York, gift of Mrs. David M. Levy

49. *The Green Table*, 1941
Gouache on paper
22½ × 16½
Collection of Mr. and Mrs. John C. Marin, Jr.

50–52. *John Brown* Series, 1941 (22 paintings)
Gouache on paper
Detroit Institute of Arts, gift of Mr. and Mrs. Milton Lowenthal

50. No. 4: *His adventures failing him, he accepted poverty.*
19⅞ × 13⅝

51. No. 20: *John Brown held Harpers Ferry for 12 hours. His defeat was a few hours off.*
13⁹⁄₁₆ × 19¹³⁄₁₆

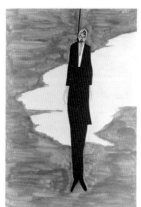

52. No. 22: *John Brown was found "Guilty of treason and murder in the 1st degree" and was hanged in Charles Town, Virginia on December 2, 1859.*
19¹³⁄₁₆ × 13⅝
Pl. 22

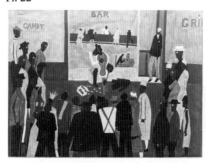

53. *Beggar*, 1942
Gouache on paper
21 × 29
Collection of Dr. and Mrs. Harold Rifkin

54. *Cafe Scene (Diners)*, 1942
Gouache on paper
19½ × 27
University of Arizona Museum of Art, Tucson, gift of C. Leonard Pfeiffer

55. *Tombstones*, 1942
Gouache on paper
28¾ × 22½
Whitney Museum of American Art, New York, Purchase
Pl. 24

56–61. *Harlem* Series, 1942–43 (30 paintings)
Gouache on paper

56. No. 1: *This is Harlem.*
15⅜ × 22¹¹⁄₁₆
Hirshhorn Museum and Sculpture Garden, Smithsonian Institution, Washington, D.C.
Pl. 26

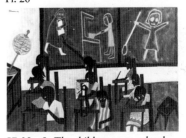

57. No. 8: *The children go to school.*
14¼ × 21¼
Collection of Mr. and Mrs. C. Humbert Tinsman

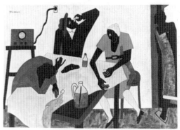

58. No. 15: *You can buy bootleg whiskey for twenty-five cents a quart. (Bootleg Whiskey)*
14½ × 21
Portland Art Museum, Oregon, purchase from the Helen Thurston Ayer Fund
Pl. 28

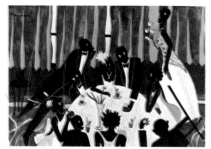

59. No. 19: *And Harlem society looks on.*
(Harlem Society)
14 × 21
Portland Art Museum, Oregon, purchase from
the Helen Thurston Ayer Fund
Pl. 29

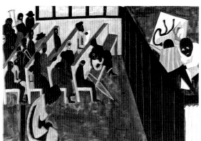

60. No. 23: *Harlem Hospital's free clinic is*
crowded with patients every morning and
evening. (Free Clinic)
14⅛ × 21¼
Portland Art Museum, Oregon, purchase from
the Helen Thurston Ayer Fund

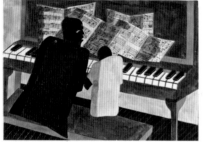

61. No. 27: *Mothers and fathers work hard to*
educate their children. (The Music Lesson)
14¼ × 21¼
New Jersey State Museum Collection, Trenton,
gift of the Friends of the New Jersey State
Museum

62. *The Apartment,* 1943
Gouache on paper
21¼ × 29¼
Hunter Museum of Art, Chattanooga,
Tennessee, purchase from the Benwood
Foundation and the 1982 Collectors' Group
Funds
Pl. 31

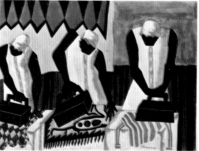

63. *Ironers,* 1943
Gouache on paper
21½ × 29½
Private collection

64. *Sidewalk Drawings,* 1943
Gouache on paper
22⅜ × 29½
Collection of Mr. and Mrs. Jan de Graaff

65. *Woman with Grocery Bags,* 1943
Gouache on paper
29¾ × 21
Collection of Mr. and Mrs. Charles Gwathmey
Pl. 30

66. *Seaman's Belt,* 1945
Gouache on paper
21 × 29
Albright-Knox Art Gallery, Buffalo, New York,
The Martha Jackson Collection

67. *Antiques,* 1946
Gouache on paper
22 × 30
Collection of Susan and Alan Patricof

68. *Barber Shop,* 1946
Gouache on paper
21⅛ × 29⅜
Toledo Museum of Art, Ohio, gift of Edward
Drummond Libbey
Pl. 37

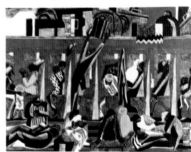

69. *Going Home,* 1946
Gouache on paper
21½ × 29½
Collection of IBM Corporation, Armonk,
New York

70. *The Lovers,* 1946
Gouache on paper
21½ × 30
Collection of Mrs. Harpo Marx
Pl. 39

71. *The Seamstress*, 1946
Gouache on paper
21⅝ × 29⅞
Southern Illinois University Museum,
Carbondale, gift of the National Academy
of Art
Pl. 35

72. *Shooting Gallery*, 1946
Gouache on paper
21½ × 29½
Walker Art Center, Minneapolis, gift of Dr. and
Mrs. Malcolm McCannell, 1953

73–76. *War* Series, 1946–47 (14 paintings)
Egg tempera on hardboard
Whitney Museum of American Art, New York,
gift of Mr. and Mrs. Roy R. Neuberger

73. No. 2: *Shipping Out*
20 × 16
Pl. 41

74. No. 3: *Another Patrol*
16 × 20

75. No. 12: *Going Home*
16 × 20
Pl. 43

76. No. 13: *Reported Missing*
16 × 20

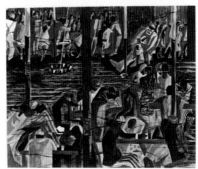

77. *Beer Hall*, 1947
Egg tempera on hardboard
19½ × 23⅜
Collection of Max Gordon

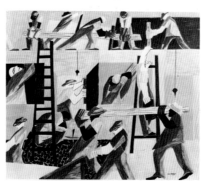

78. *The Builders*, 1947
Egg tempera on hardboard
19¼ × 23½
Private collection

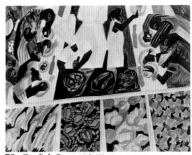

79. *Catfish Row*, 1947
Egg tempera on hardboard
18 × 24
Collection of Carol and Robert Straus

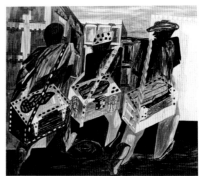

80. *Shoe Shine Boys*, 1948
Egg tempera on hardboard
20 × 24
Collection of Mr. and Mrs. Selig S. Burrows

81–84. *Hospital* Series, 1950 (11 paintings)
Casein on paper

81. *Square Dance*
22 × 30
Private collection

82. *Occupational Therapy No. 2*
23¾ × 31¾
Herbert F. Johnson Museum of Art, Cornell
University, Ithaca, New York, Dr. and Mrs.
Milton Lurie Kramer Collection, gift of Helen
Kroll Kramer

83. *Sedation*
31 × 22⅞
Museum of Modern Art, New York, gift of
Mr. and Mrs. Hugo Kastor

84. *Depression*
22 × 30½
Whitney Museum of American Art, New York,
gift of Mr. David M. Solinger
Pl. 47

85. *Tie Rack*, 1951
Egg tempera on hardboard
29¾ × 20
Collection of Gwendolyn and Jacob Lawrence

86. *Magic on Broadway*, 1951
30¼ × 22⅛
Collection of Evelyn and Leonard Cohen

87–89. *Theater* Series, 1951–52 (12 paintings)
Egg tempera on hardboard

87. No. 2: *Tragedy and Comedy*
23⅜ × 29⅜
Collection of Priscilla and Alan Brandt
Pl. 51

88. No. 7: *Marionettes*
18¼ × 24½
High Museum of Art, Atlanta, purchased with
funds from Edith G. and Philip A. Rhodes and
the National Endowment for the Arts, 1980

89. No. 8: *Vaudeville*
27⅞ × 19¹⁵⁄₁₆
Hirshhorn Museum and Sculpture Garden,
Smithsonian Institution, Washington, D.C.
Pl. 52

90. *Village Quartet*, 1954
Egg tempera on hardboard
9 × 12
Private collection
Pl. 57

91–93. *Struggle: From the History of the
American People* Series, 1955–56
(30 paintings)
Egg tempera on hardboard

91. No. 4: *I alarumed almost every house till I
got to Lexington.—Paul Revere (The Night
Rider)*
12 × 16
Courtesy of Terry Dintenfass Gallery,
New York

92. No. 5: *We have no property!*
We have no wives! No children!
We have no city! No country!
—Petition of many slaves, 1773
(Slave Revolt)
16 × 11¾
Collection of Mrs. Oscar Rosen

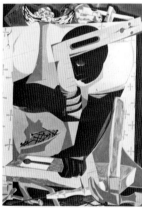

93. No. 27: *... for freedom we want and will*
have, for we have served this cruel land long
enuff ... A Georgia Slave, 1810. (Slave
Rebellion)
12 × 16
Collection of Gwendolyn and Jacob Lawrence
Pl. 56

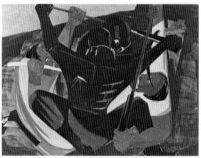

94. *Cabinetmaker*, 1957
Casein on paper
30½ × 22½
Hirshhorn Museum and Sculpture Garden,
Smithsonian Institution, Washington, D.C.
Pl. 76

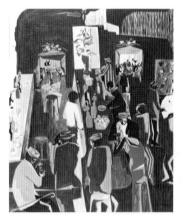

95. *The Brown Angel*, 1959
Egg tempera on hardboard
24 × 20
Collection of F. B. Horowitz Fine Art Ltd.,
Hopkins, Minnesota

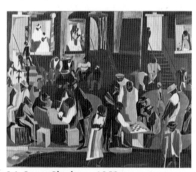

96. *Street Shadows*, 1959
Egg tempera on hardboard
24 × 30
Collection of Mrs. Lewis Garlick

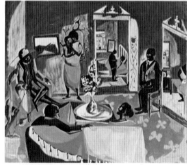

97. *The Visitors*, 1959
Egg tempera on hardboard
20 × 24
Dallas Museum of Art, General Acquisitions
Fund

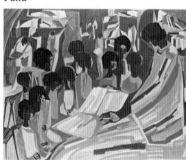

98. *Library II*, 1960
Egg tempera on hardboard
23½ × 29½
Collection of Martin and Sarah Cherkasky
Pl. 58b

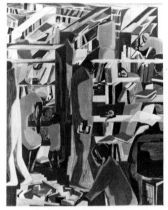

99. *Library III*, 1960
Egg tempera on hardboard
30 × 24
Collection of Citibank, N.A., New York

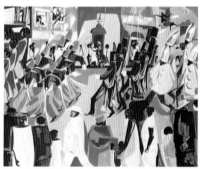

100. *Parade*, 1960
Egg tempera on hardboard
23⅞ × 30⅛
Hirshhorn Museum and Sculpture Garden,
Smithsonian Institution, Washington, D.C.
Pl. 61

101. *The Family*, 1964
Egg tempera on hardboard
24 × 20
Collection of Arthur and Sara Jo Kobacker

102–107. *Nigerian* Series, 1964–65
(8 paintings)
Gouache on paper

102. *Antiquities*
30¾ × 22
Gallery of Art, Morgan State University,
Baltimore

103. *Four Sheep*
22 × 30¾
Collection of Harry and Freda W. Schaeffer

104. *The Journey*
21¾ × 29½
Collection of Joel Tranum

105. *Meat Market*
30¾ × 22
Collection of Judith Golden
Pl. 62

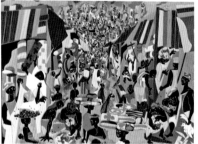

106. *Street to Mbari*
22¼ × 30⅜
Courtesy of Terry Dintenfass Gallery,
New York
Pl. 63

107. *Three Red Hats*
22 × 30¾
Collection of Honor Tranum

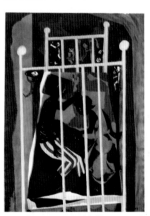

108. *Dreams #1*, 1965
Gouache on paper
35 × 28
Collection of Ruth and Jack Wexler

109. *Typists*, 1966
Gouache on paper
22 × 30
Collection of Isabel and William Berley

110–12. *Harriet and the Promised Land* Series,
book illustrations, 1967 (17 paintings)
Gouache on paper

110. No. 9: *Walking by Night, Sleeping by Day*
16¼ × 23¼
Collection of June Kelly

111. No. 12: *Fugitives*
17 × 9
Private collection

112. No. 15: *Canada Bound*
14 × 25
Collection of Dr. and Mrs. James L. Curtis
Pl. 70

113. *Daybreak—A Time to Rest* (Harriet
Tubman theme), 1967
Egg tempera on hardboard
30 × 24
National Gallery of Art, Washington, D.C., gift
of an anonymous donor, 1973
Pl. 72

114. *Forward* (Harriet Tubman theme), 1967
Egg tempera on hardboard
24 × 35¾
North Carolina Museum of Art, Raleigh,
Museum Purchase Fund
Pl. 71

115. *A Foothold on the Rocks* (Harriet Tubman
theme), 1967
Egg tempera on hardboard
30 × 24
Private collection

116. *Ten Fugitives* (Harriet Tubman theme),
1967
Egg tempera on hardboard
24½ × 36½
Collection of Mr. and Mrs. Meyer P. Potamkin

117. *Wounded Man*, 1968
Gouache on paper
29½ × 22
Collection of Gwendolyn and Jacob Lawrence
Pl. 67

118. *Builders No. 1*, 1970
Gouache on paper
22 × 30
Henry Art Gallery, University of Washington,
Seattle
Pl. 78

119. *The Pool Game*, 1970
Gouache on paper
22 × 30
Museum of Fine Arts, Boston, Emily L. Ainsley
Fund
Pl. 74c

120. *Builders No. 1*, 1971
Gouache on paper
30 × 22
Birmingham Museum of Art, Alabama

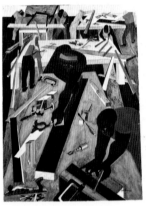

121. *Builders No. 2*, 1971
Gouache on paper
30 × 22
Collection of Richard B. Nye

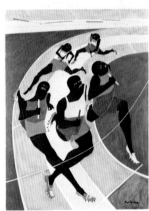

122. *Munich Olympic Games*, poster design,
1971
Gouache on paper
35½ × 27
Seattle Art Museum, purchased with funds
from PONCHO

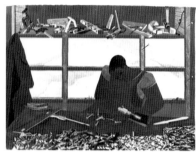

123. *Builders No. 1,* 1972
Gouache on paper
22¼ × 30½
St. Louis Art Museum, Eliza McMillan Fund
Pl. 79

124–25. *George Washington Bush* Series, 1973
(5 paintings)
Gouache on paperboard
Washington State Capital Museum, Olympia

124. No. 3: *The hardest part of the journey is yet to come—the Continental Divide, stunned by the magnitude of roaring rivers.*
35½ × 43½

125. No. 5: *"Thank God All Mighty, home at last!"—the settlers erect shelter at Bush Prairie near what is now Olympia, Washington, November 1845.*
31½ × 19½

126. *Confrontation at the Bridge,* 1975
Gouache on paper
22½ × 30¼
Private collection

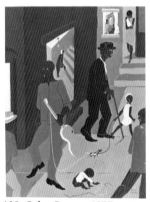

127. *Bumbershoot '76,* poster design, 1976
Gouache on paper
34¼ × 26¼
Seattle City Light 1% for Art Portable Works Collection

128. *Other Rooms,* 1977
Gouache on paper
24 × 18
Collection of Gwendolyn and Jacob Lawrence

129. *Self-Portrait,* 1977
Gouache on paper
23 × 31
National Academy of Design, New York
Pl. 93

130. *The Studio,* 1977
Gouache on paper
30 × 22
Collection of Gwendolyn and Jacob Lawrence
Pl. 94

131. *The Swearing In #2,* 1977
Gouache on paper
20 × 30
Collection of Stephens Inc., Little Rock, Arkansas

132. *University,* 1977
Gouache on paper
32 × 24
Collection of Gabrielle and Herbert Kayden
Pl. 92

133. *Man with Square*, 1978
Gouache on paper
24½ × 16
Courtesy of Terry Dintenfass Gallery,
New York

134. *Games*, study for the Kingdome mural,
Seattle, 1978
Gouache on paper
24½ × 51¾
Courtesy of Francine Seders Gallery, Seattle

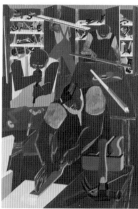

135. *Workshop*, 1978
Gouache on paper
27½ × 19½
Courtesy of Terry Dintenfass Gallery,
New York

136. *Explorations*, study for the first Howard University mural, 1980
Gouache on paper
9¾ × 78
Collection of Howard University, Washington, D.C.
Pl. 98

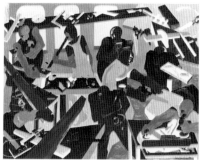

137. *Eight Builders*, 1982
Gouache and casein on paper
33 × 44¾
Seattle City Light 1% for Art Portable Works
Collection
Pl. 104

138–44. *Hiroshima* Series, book illustrations,
1983
(8 paintings)
Gouache on paper
23 × 17½
Collection of Gwendolyn and Jacob Lawrence

138. No. 1: *Farmers*

139. No. 2: *Family*

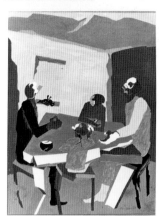

140. No. 3: *People in the Park*

141. No. 4: *Man with Birds*
Pl. 106

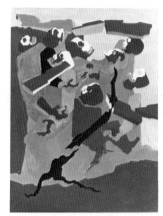

142. No. 5: *Street Scene*

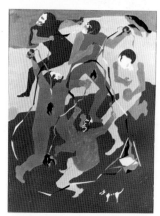

143. No. 6: *Playground*

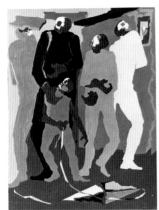

144. No. 7: *Boy with Kite*
Pl. 107

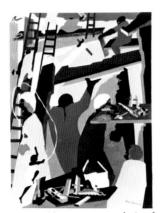

148. *Building #1*, poster design for National
Urban League 75th Anniversary, 1985
Gouache on paper
30 × 22¼
Courtesy of Francine Seders Gallery, Seattle

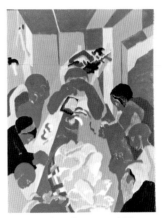

149. *Bread, Fish, Fruit*, 1985
Gouache on paper
30 × 22½
Courtesy of the artist and Francine Seders
Gallery, Seattle
Pl. 109 and cover illustration

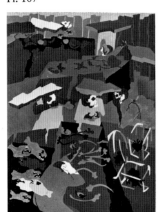

145. No. 8: *Market*

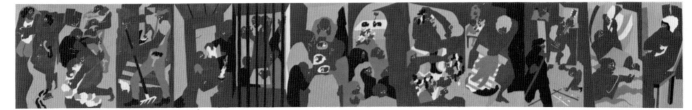

146. *Origins*, study for the second Howard
University mural, 1984
Gouache on paper
12 × 79¾
Collection of Howard University, Washington,
D.C.
Pl. 99

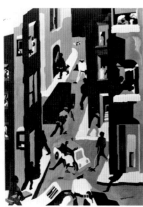

147. *Street Scene*, 1985
Gouache on paper
29½ × 21¾
Courtesy of Francine Seders Gallery, Seattle

PAINTINGS WITH RESTRICTED VENUES:

No. 12: Seattle, Oakland, and Brooklyn venues only

Nos. 42–45, 48: Seattle, Oakland, and Atlanta venues only

Nos. 50–52: Seattle venue only

No. 54: Seattle, Oakland, Atlanta, and Washington, D.C., venues only

No. 114: Seattle, Oakland, Atlanta, and Washington, D.C., venues only

No. 119: Seattle, Oakland, and Atlanta venues only

EXHIBITION HISTORY

ONE-MAN EXHIBITIONS

1938 Harlem YMCA, New York, sponsored by James Weldon Johnson Literary Guild.

1939 De Porres Interracial Center, New York (*Toussaint L'Ouverture* series).

1940 Columbia University, New York (*Toussaint L'Ouverture* series).

1941 Downtown Gallery, New York (*Migration* series).

1942 Phillips Memorial Gallery, Washington, D.C. (*Migration* series).

1943 Downtown Gallery (*Harlem* series).

1944 The Museum of Modern Art, New York (*Coast Guard* paintings and thirty *Migration* series paintings).

1945 Downtown Gallery (*John Brown* series).
Boston Institute of Modern Art (*John Brown* series), circulated by the American Federation of Arts (1946–48).

1946 Art Institute of Chicago.

1947 Downtown Gallery (*War* series).
New Jersey State Museum, Trenton.

1950 Downtown Gallery (*Hospital* paintings).

1953 Downtown Gallery (*Theater* paintings).

1957 Alan Gallery, New York (*Struggle* series).

1960 Washington Federal Savings and Loan Association of Miami Beach, Florida.
Retrospective, The Brooklyn Museum, sponsored by the Ford Foundation and circulated by the American Federation of Arts to sixteen United States cities.

1962 American Society of African Culture's West African Cultural Center, Lagos, Nigeria, and Mbari Artists and Writers Club Cultural Center, Ibadan, Nigeria (twenty-five *Migration* series and ten *War* series works).

1963 Terry Dintenfass Gallery, New York.

1965 Terry Dintenfass Gallery, New York (*Nigerian* paintings).
Brandeis University, Waltham, Massachusetts.

1968 Terry Dintenfass Gallery (paintings for *Harriet and the Promised Land*).
Fisk University, Nashville, Tennessee (*Toussaint L'Ouverture* series).

1969 Studio Museum in Harlem, New York (*Toussaint L'Ouverture* series).

1970 Henry Art Gallery, University of Washington, Seattle.

1973 Terry Dintenfass Gallery (*Builders* paintings).
State Capital Museum, Olympia, Washington (*George Washington Bush* series).

1974 Major Retrospective, Whitney Museum of American Art, New York, circulated to five other museums in the United States.

1976 Francine Seders Gallery, Seattle, Washington.

1978 Terry Dintenfass Gallery, New York.
Francine Seders Gallery, Seattle, Washington.
Spelman College, Atlanta, Georgia.
Detroit Institute of Arts (*Frederick Douglass*, *Harriet Tubman*, and *John Brown* series).

1979 Francine Seders Gallery, Seattle, Washington.
Wentz Gallery, Portland, Oregon.
Chrysler Museum, Norfolk, Virginia (*Frederick Douglass* series).

1980 Francine Seders Gallery, Seattle, Washington.

1981 Brockman Gallery, Los Angeles, California (prints and posters).

Portsmouth Community Art Center, Portsmouth, Virginia.

New Visions Gallery, San Diego, California (*The Legend of John Brown* series of prints).

Reynolda House, Winston-Salem, North Carolina.

1982 Retrospective, Clark Humanities Museum, Scripps College, Claremont, California; Art Gallery, Santa Monica College, Santa Monica, California. Along with Gwendolyn Knight, recent drawings and paintings.

Francine Seders Gallery, Seattle, Washington.

Crystal Britton Gallery, Atlanta, Georgia (*The Legend of John Brown* series of prints).

1983 Terry Dintenfass Gallery, New York.

Stockton State College Art Gallery, Pomona, New Jersey.

Benedum Gallery, Morgantown, West Virginia (*Toussaint L'Ouverture* series).

Stewart Center Gallery, Purdue University, Indiana (*Harriet Tubman* series).

1984 Thompson Gallery, Massachusetts College of Art, Boston.

Fifty-Year Retrospective, Jamaica Arts Center, Jamaica, New York.

Portland Art Museum, Portland, Oregon (*Toussaint L'Ouverture* series and selections from the *Harlem* series).

1985 Francine Seders Gallery, Seattle, Washington (*Builders* paintings and drawings).

1986 Albright-Knox Art Gallery, Buffalo, New York (*Harriet Tubman* series).

SELECTED GROUP EXHIBITIONS

1937 "An Exhibition of the Harlem Artists Guild," 115th Street Public Library (April–May).

"An Exhibition of the Harlem Artists Guild," American Artists School (May).

1939 "Jacob Lawrence and Samuel Wechsler," American Artists School (February).

"An Exhibition of Contemporary Negro Art," Baltimore Museum of Art (February).

1940 "Exhibition of the Art of the American Negro, 1851–1940," American Negro Exposition, Chicago (Second Prize) (July–September).

1941 "American Negro Art: 19th and 20th Centuries," Downtown Gallery, New York (December 9–January 3, 1942).

1942 "New Paintings," Downtown Gallery, New York (April–May).

"Artists for Victory" (Sixth Purchase Prize), Metropolitan Museum of Art, New York (December–February).

1943 "Whitney Museum of American Art Annual Exhibition," New York.

1945 "New Paintings and Sculpture by Leading American Artists," Downtown Gallery, New York (November–December).

1946 "Modern American Paintings from the Collection of Roy R. Neuberger," Samuel M. Kootz Gallery, New York (April–May).

"Six Out of Uniform," Veterans Show, Downtown Gallery, New York (May).

"American Paintings," Tate Gallery, London, organized by the National Gallery, Washington, D.C. (summer).

1947 "Three Negro Artists" (Jacob Lawrence, Horace Pippin, Richmond Barthé), Phillips Memorial Gallery, Washington, D.C.

"Social Art Today," A.C.A. Gallery, New York.

"Annual Exhibition of Contemporary American Sculpture, Watercolors and Drawings," Whitney Museum of American Art, New York (March–April).

"Painting in the United States," Carnegie Institute Annual, Pittsburgh, Pennsylvania (October).

"59th Annual American Exhibition: Watercolors and Drawings," Society for Contemporary American Art, Art Institute of Chicago.

1948 "Twenty-fourth Venice Biennale," Venice, Italy.

"Painting in the United States," Carnegie Institute Annual, Pittsburgh, Pennsylvania.

1949 "Painting in the United States," Carnegie Institute Annual, Pittsburgh, Pennsylvania.

1951 "Exhibition of Works by Candidates for Grants in Art," National Institute of Arts and Letters, American Academy of Arts and Letters, New York.
"São Paulo Biennial," São Paulo, Brazil.

1955 "Contemporary American Paintings and Sculpture," University of Illinois, Urbana.
"Painting in America: The Story of 450 Years," Detroit Institute of Arts.
"U.N. Competition Mural Sketches and Sculpture Models," Whitney Museum of American Art, New York (October–November).

1959 Exhibition in the Soviet Union, sponsored by the U.S. State Department.

1963 Exhibition in Pakistan, sponsored by the U.S. State Department.
"Johnson Wax Company Exhibition," circulated world-wide.

1966 "Ten Negro Artists from the United States" (four paintings), Dakar, Senegal.

1966–67 "Annual Exhibition," Pennsylvania Academy of Fine Arts, Philadelphia.
"Protest Painting U.S.A., 1930–45," A.C.A. Gallery, New York.

1967 "Evolution of Afro-American Artists," City College, New York.

1968 "Carnegie Annual," Carnegie Institute, Pittsburgh, Pennsylvania.

1970 "Five Famous Black Artists," Museum of the National Center of Afro-American Artists, Roxbury, Massachusetts.
"American Scene, 1900–1970," Indiana University, Bloomington.

1971 "The Artist as Adversary," Museum of Modern Art, New York.
"Contemporary Black Artists in America," Whitney Museum of American Art, New York (April).

1976 "An American Portrait: 1776–1976," Carpenter Center, Harvard University.

1976–77 "Two Centuries of Black American Art," Los Angeles County Museum of Art; traveled to the High Museum of Art, Atlanta, the Museum of Fine Arts, Dallas, and the Brooklyn Museum.

1977 "President Carter's Inaugural Ceremony (1977)," limited edition of prints, Henry Art Gallery, University of Washington, Seattle.
"Black American Painters," Brooklyn Museum, New York (August).

1979 "The Black Experience in Prints," State Capitol Museum, Olympia, Washington.
"50 Contemporary American Artists," Orléans, France, sponsored by Wichita Art Museum.
"Selections from Skowhegan" (work of twelve artists on Skowhegan's Board of Governors), University of Maryland Art Gallery, Baltimore (November).

1980 "Six Black Americans," New Jersey State Museum, Trenton.

1981 "Governor's Invitational Art Exhibition," Olympia, Washington.
"Decade of Transition: 1940–50," Whitney Museum of American Art, New York.

1981–82 "Jacob Lawrence: Paintings, Prints, and Posters," circulated through Washington State by the State Capitol Museum, Olympia.

1982 "Washington Year," Henry Art Gallery, University of Washington, Seattle.
"An Urban Vernacular: Narrative American Art," Henry Art Gallery, University of Washington, Seattle.

1983 "Social Concern and Urban Realism: American Painting in the 1930s," sponsored by the American Federation of Arts, traveling exhibition.

1984 "Black History Month Exhibition," University of the District of Columbia (thirty panels of *Migration* series owned by The Phillips Collection, Washington, D.C.) (February).
"Governor's Invitational Exhibition of Washington State Artists," State Capitol Museum, Olympia (March 8–April 22).
"African-American Art in Atlanta: Public and Corporate Collections," High Museum, Atlanta, Georgia (May 11–June 17).
"Artists of the Thirties and Forties," The Museum of African American Art, Santa Monica, California.

1985 "Hidden Heritage: The Art of Black America," Bellevue Art Museum, Bellevue, Washington (September–November).
"Tradition and Conflict: Images of a Turbulent Decade 1963–73," The Studio Museum, New York (January–June). Exhibition to travel nationally 1986–87.

WORK IN PUBLIC AND CORPORATE COLLECTIONS

Addison Gallery of American Art, Andover, Massachusetts
Albright-Knox Art Gallery, Buffalo, New York
American Academy of Arts and Letters, New York
Amistad Research Center, Aaron Douglas Collection,
 New Orleans, Louisiana
Atlanta University, Atlanta, Georgia
Baltimore Museum of Art, Baltimore, Maryland
Birmingham Museum of Art, Alabama
Benedict College, Columbia, South Carolina
Bennett College, Greensboro, North Carolina
Brooklyn Museum, Brooklyn, New York
Carolina Art Association/Gibbes Art Gallery, Charleston, South Carolina.
Citibank, N.A., New York
Container Corporation of America, Chicago, Illinois
Dallas Museum of Art, Texas
Detroit Institute of Arts, Michigan
Evansville Museum of Arts and Science, Indiana
First Pennsylvania Bank, Philadelphia
Fisk University, Nashville, Tennessee
George Washington Carver Museum, Tuskegee, Alabama
Hampton University Museum, Hampton, Virginia
Henry Art Gallery, University of Washington, Seattle
High Museum of Art, Atlanta, Georgia
Hirshhorn Museum and Sculpture Garden, Smithsonian Institution,
 Washington, D.C.
Howard University, Washington, D.C.
Hunter Museum of Art, Chattanooga, Tennessee
IBM Corporation, Armonk, New York
Herbert F. Johnson Museum of Art, Cornell University, Ithaca, New York
King County 1% for Art Collection, Washington
William H. Lane Foundation, Leominster, Massachusetts
Marymount College, Tarrytown, New York
Metropolitan Museum of Art, New York
Milwaukee Art Center, Wisconsin
Morgan State University Gallery of Art, Baltimore, Maryland
Museum of Fine Arts, Boston

Museum of Modern Art, New York
Museum of Modern Art, São Paulo, Brazil
National Academy of Design, New York
National Collection of Fine Arts, Smithsonian Institution, Washington, D.C.
National Gallery of Art, Washington, D.C.
New Jersey State Museum, Trenton
New Orleans Museum of Art, Louisiana
North Carolina Museum of Art, Raleigh
PACCAR, Inc., Seattle, Washington
Philadelphia Museum of Art, Philadelphia, Pennsylvania
The Phillips Collection, Washington, D.C.
Portland Art Museum, Portland, Oregon
Museum of Art, Rhode Island School of Design, Providence
Rose Art Museum, Brandeis University, Waltham, Massachusetts
SAFECO Insurance Company, Seattle, Washington
St. Louis Art Museum, Missouri
Seattle City Light 1% for Art Portable Works Collection,
 Seattle, Washington
Seattle Art Museum, Seattle, Washington
Sheraton Corporation, Seattle, Washington
Southern Illinois University Museum, Carbondale
Spelman College, Atlanta, Georgia
Toledo Museum of Art, Ohio
Tougaloo College, Tougaloo, Mississippi
University Art Museum, Berkeley, California
University of Arizona Museum of Art, Tucson
University of Georgia, Athens
University of Nebraska at Lincoln
University of Washington, Seattle
Vatican Gallery of Modern Art, Vatican Museum, Rome
Virginia Museum of Fine Arts, Richmond
Walker Art Center, Minneapolis, Minnesota
Washington State Capitol Museum, Olympia
Whitney Museum of American Art, New York
Wichita Art Museum, Wichita, Kansas
Worcester Art Museum, Worcester, Massachusetts

Bibliography

Archival Material

Archives of American Art, Jacob Lawrence Material, Smithsonian Institution, Washington, D.C.

Museum of Modern Art, Library, Jacob Lawrence Artist File, New York.

Schomburg Center for Research in Black Culture, Artist File, New York.

Syracuse University, George Arents Research Library, Jacob Lawrence Material, Syracuse, New York.

University of Washington Archives, Jacob Lawrence Material, Seattle, Washington.

Wheat, Ellen Harkins. Taped Interviews with Jacob Lawrence, 1982–85; also taped, Lawrence's lecture to students, University of Washington, Seattle, January 25, 1977 (courtesy of Gervais Reed); November 15, 1982; and February 15, 1983.

Whitney Museum of American Art, Library, Jacob Lawrence Artist File, New York.

Books and Theses

Bearden, Romare, and Harry Henderson. *Six Black Masters of American Art*. Garden City, N.Y.: Doubleday and Co., 1972.

Brown, Jacqueline Rocker. "The Works Progress Administration and the Development of an Afro-American Artist, Jacob Lawrence, Jr." Master's Thesis, Howard University, Washington, D.C., 1974.

Brown, Milton W. *American Painting from the Armory Show to the Depression*. Princeton: Princeton University Press, 1955.

Butcher, Margaret Just. *The Negro in American Culture*. 2d ed. New York: Alfred A. Knopf, 1972.

Chipp, Herschel B., ed. *Theories of Modern Art: A Source Book by Artists and Critics*. Berkeley: University of California Press, 1968.

Chwast, Seymour, and Steven Heller. *The Art of New York*. New York: Harry N. Abrams, 1983.

Craven, Thomas. *Modern Art: The Men, the Movements, the Meaning*. New York: Simon and Schuster, 1934.

Elliott, David. *Orozco!* Oxford: Museum of Modern Art, 1980.

Fax, Elton C. *Seventeen Black Artists*. New York: Dodd, Mead and Co., 1971.

Feldman, Edmund B. *The Artist*. Englewood Cliffs, N.J.: Prentice-Hall, 1982.

Fine, Elsa Honig. *The Afro-American Artist*. New York: Holt, Rinehart and Winston, 1973.

Goodrich, Lloyd, and John I. H. Baur. *American Art of Our Century*. New York: Praeger Publishers, 1961.

Goodyear, Frank H., Jr. *Contemporary American Realism since 1960*. Boston: New York Graphic Society, 1981.

Gordon, Allan Moran. "Cultural Dualism on the Themes of Certain Afro-American Artists." Ph.D. Dissertation, Ohio University, August 23, 1969.

Grosz, George. *Ecce Homo*. New York: Dover Publications, 1976.

Guenther, Bruce. *50 Northwest Artists*. San Francisco: Chronicle Books, 1983.

Helm, MacKinley. *Modern Mexican Painters*. New York: Harper and Brothers, 1941.

Huggins, Nathan Irvin. *Harlem Renaissance*. New York: Oxford University Press, 1971.

Hughes, Langston, and Milton Meltzer. *A Pictorial History of the Negro in America*. New York: Crown Publishers, 1968.

Igoe, Lynn M., and James Igoe. *250 Years of Afro-American Art*. New York: R. R. Bowker Co., 1981.

Larkin, Oliver W. *Art and Life in America*. 2d ed. New York: Holt, Rinehart and Winston, 1960.

Lewis, Samella. *Art: African American*. New York: Harcourt Brace Jovanovich, 1978.

Locke, Alain. *The New Negro: An Interpretation*. New York: Albert and Charles Boni, 1925.

_____ . *Negro Art: Past and Present*. Washington, D.C.: Associates of Negro Folk Education, 1936.

_____ . *The Negro in Art* (1940). Reprint, New York: Hacker Art Books, 1968.

McKenzie, Richard D. *The New Deal for Artists*. Princeton: Princeton University Press, 1973.

McLanathan, Richard. *The American Tradition in the Arts*. New York: Harcourt, Brace and World, 1968.

Mendelowitz, Daniel M. *A History of American Art*. 2d ed. New York: Holt, Rinehart and Winston, 1970.

Mondale, Joan. *Politics in Art*. Minneapolis: Lerner Publications, 1972.

Moritz, Charles, ed. *Current Biography*. New York: H. W. Wilson, July 1965.

O'Connor, Francis V. *The New Deal Art Projects: An Anthology of Memoirs*. Washington, D.C.: Smithsonian Institution Press, 1972.

_____ . *Art for the Millions: Essays from the 1930s by Artists and Administrators of the WPA Federal Art Project*. Greenwich, Conn.: New York Graphic Society, 1973.

Pearson, Ralph M. *Experiencing American Pictures*. New York: Harper and Brothers, 1943.

Ploski, Harry A., and Roscoe C. Brown, Jr. *The Negro Almanac*. New York: Bellwether Publishing Co., 1967.

Porter, James A. *Modern Negro Art*. New York: Dryden Press, 1943.

Reed, Alma. *José Clemente Orozco*. New York: Delphic Studios, 1932.

Richardson, Ben Albert, and William A. Fahey. *Great Black Americans*. New York: Thomas Y. Crowell, 1976.

Rodman, Selden. *Horace Pippin*. New York: Quadrangle Press, 1947.

_____ . *Conversations with Artists*. New York: Devin-Adair, 1957.

Rosenblum, Paula R. "A Film Study of Jacob Lawrence." Ph.D. Dissertation, University of Oregon, September 1979.

Saunders, J. B. de C. M., and Charles D. O'Malley. *The Illustrations from the Works of Vesalius*. New York: World Publishing Co., 1950.

Shapiro, David, ed. *Social Realism: Art as a Weapon*. New York: Frederick Ungar Publishing Co., 1973.

Skowhegan School of Painting and Sculpture. *28th Anniversary Awards Dinner Program*. April 30, 1974.

Taylor, Joshua. *America as Art*. Washington, D.C.: Smithsonian Institution Press, 1976.

Toor, Frances, Paul O'Higgins, and Blas Vanegas Arroyo. *Monografia: Las Obras de José Guadalupe Posada*. Mexico: Mexican Folkways, 1930.

Tyler, Ron, ed. *Posada's Mexico*. Washington, D.C.: Library of Congress, 1979.

Von Blum, Paul. *The Critical Vision: A History of Social and Political Art in the United States*. Boston: South End Press, 1982.

Weinberg, Meyer, ed. *W. E. B. DuBois: A Reader*. New York: Harper and Row, 1970.

Wheat, Ellen Harkins. "Jacob Lawrence, American Painter." Master's Thesis, University of Washington, Seattle, May 1983.

_____ . "Jacob Lawrence." Ph.D. Dissertation, University of Washington, Seattle, June 1986.

Wight, Frederick S. "Jacob Lawrence." In John I. H. Baur, ed., *New Art in America*. Greenwich, Conn.: New York Graphic Society, 1957.

Wilmerding, John. *American Art*. New York: Penguin Books, 1976.

Exhibition Catalogs

American Bicentennial Freedom Train Program, 1975–76.

The Art Gallery, Fisk University. *The Toussaint L'Ouverture Series*. Nashville, Tennessee, 1968.

Brown, Milton W. *Jacob Lawrence*. New York: Whitney Museum of American Art, 1974.

_____ . *One Hundred Masterpieces of American Painting from Public Collections in Washington, D.C.* Washington, D.C.: Smithsonian Institution Press, 1983.

Cahill, Holger. *New Horizons in American Art*. New York: Museum of Modern Art, 1936.

Campbell, Mary Schmidt. *Tradition and Conflict: Images of a Turbulent Decade 1963–1973*. New York: The Studio Museum, 1985.

Driskell, David C. *Two Centuries of Black American Art*. New York: Alfred A. Knopf, 1976.

Foner, Moe, ed. *Images of Labor*. New York: Pilgrim Press, 1981.

Gaither, Edmund B. Introductory essay in catalog, *Afro-American Artists, New York and Boston*. Boston: The Museum of the National Center of Afro-American Artists, 1970.

Greene, Carroll, Jr. Introductory essay in catalog, *In Celebration: Six Black Americans*. Trenton: New Jersey State Museum, January 26–March 30, 1980.

Harmon Foundation Art Center. *Exhibition of the Work of Negro Artists*. New York, 1931.

——————. *Exhibition of the Work of Negro Artists*. New York, 1933.

Hills, Patricia, with an essay by Raphael Soyer. *Social Concern and Urban Realism: American Painting of the 1930s*. Boston: Boston University Art Gallery, 1983.

Lane, John R., and Susan C. Larsen. *Abstract Painting and Sculpture in America, 1927–1944*. Pittsburgh: Carnegie Institute, and New York: Harry N. Abrams, 1983.

Lemakis, Emmanuel. *Jacob Lawrence: An Exhibition of His Work*. Pomona, N.J.: Stockton State College Art Gallery, February 1983.

Lewis, Samella. *Jacob Lawrence*. Santa Monica, California: The Museum of African American Art, 1982.

Perry, Reginia A. Introductory essay to *Golden Opportunity* catalog. New York: Gallery 62, September 18–November 30, 1978.

Saarinen, Aline L. *Jacob Lawrence*. New York: American Federation of Arts, 1960. Reprinted in David Shapiro, ed., *Social Realism: Art as a Weapon*. New York: Frederick Ungar, 1973.

Sharp, Ellen. Introductory essay in catalog, *The Legend of John Brown*. Detroit: Detroit Institute of Arts, 1978.

Stebbins, Theodore E., Jr., and Carol Troyen. *The Lane Collection: 20th Century Paintings in the American Tradition*. Boston: Museum of Fine Arts, 1983.

The Washington Year: A Contemporary View, 1980–1981. Seattle: The Henry Art Gallery, University of Washington, 1982.

Books Illustrated by Jacob Lawrence

Aesop's Fables. New York: Windmill Books, Simon and Schuster, 1970.

Hersey, John. *Hiroshima*. New York: The Limited Editions Club, 1983.

Hughes, Langston. *One-Way Ticket*. New York: Alfred A. Knopf, 1948.

Lawrence, Jacob. *Harriet and the Promised Land*. New York: Windmill Books, Simon and Schuster, 1968.

Selected Films

"The City Is Ours," Profile of Three Seattle Artists, Channel 9, Seattle. Jean Walkinshaw, producer, Wayne Sourbeer, filmmaker. January 27, 1980.

"Jacob Lawrence: The Man and His Art," Channel 9, Seattle. Gary Gibson, producer. November 13, 1974.

"Were You There?" Nguzo Saba Films, San Francisco, Seven-part Series on Afro-American History, PBS, January 12, 1982.

Articles, Reviews, and Interviews

"Afro-American Art: 1800–1950." *Ebony* 23 (February 1968): 116–22.

Ahola, Nola. "Two Major Murals Dedicated February 27 at Kingdome." *The Arts*, Newsletter of the King County Arts Commission, Washington (January–February 1980): 4.

"American Struggle: Three Paintings by Jacob Lawrence." *Vogue* 130 (July 1957): 66–67.

Anderson, Jervis. "IV: Harlem, Hard Times and Beyond." *The New Yorker* (July 20, 1981): 42–77.

"Arizona Art Collecton." *Life* 20 (February 18, 1946): 76.

"Art." *Time* 53 (April 11, 1949): 57.

"Art: Birth of a Nation." *Time* 69 (January 14, 1957): 82.

"Art: Bright Sorrow." *Time* 77 (February 24, 1961): 60–63.

"Art: John Brown's Body." *Newsweek* 26 (December 24, 1945): 87.

"Art: Stories with Impact." *Time* 53 (February 2, 1953): 50–51.

"Art: Strike Fast." *Time* 50 (December 22, 1947): 61.

"Artist in Harlem." *Vogue* 102 (September 15, 1943): 94–95.

"Artist Jacob Lawrence Garners Annual Faculty Lecturer Honor." *The University of Washington Report* (Summer 1978).

"Artist Who Stuck to His Story: Jacob Lawrence's *John Brown*." *The Seattle Post-Intelligencer* (December 20, 1978): A8–A9.

"Artist's Paintings Rely Heavily on Black Experience as Backdrop: Show in Portland." *The Portland Oregonian* (October 14, 1979): C5.

"Attractions in the Galleries." *The New York Sun* (May 14, 1943): 26.

C. B. "In the Art Galleries." *New York Herald Tribune* (December 7, 1947): 4.

R. B. "Reviews and Previews." *Art News* 17 (February 1965): 17.

W. B. "In the Galleries: Jacob Lawrence." *Arts* 40 (May 1966): 66.

Berenson, Ruth. "A Different American Scene." *National Review* (August 16, 1974): 930.

Berman, Avis. Interview with Jacob Lawrence (taped). Jacob Lawrence personal files, February 6, 1983.

——————— . "Jacob Lawrence and the Making of Americans." *Artnews* 83 (February 1984): 78–86.

"Birth of a Nation." *Time* (January 14, 1957).

"The Black Artist in America: A Symposium." *The Metropolitan Museum of Art Bulletin* 27:5 (January 1969): 245–61.

"Black Art: What Is It?" *The Art Gallery* 13 (April 1970): 32–35.

"The Black Experience: Pictures Tell the Story." *The University of Washington Daily* (October 10, 1978): 4.

Bourdon, David. "Washington Letter." *Art International* 16 (December 1972): 37–38.

Burnett, W. C. "Black Painter Explores Revolt by Slaves in Handshake Series." *Atlanta Journal and Constitution* (September 30, 1970): 2-E.

Campbell, Kimberly. "Artist's Labor Is of Love and Social Consciousness." *University District Herald*, Seattle, Washington (November 4, 1981).

Campbell, Lawrence. "Jacob Lawrence." *Artnews* 73 (September 1974): 114.

Campbell, R. M. "Seattle Discovers Jacob Lawrence." *The Seattle Post-Intelligencer* (November 17, 1974): H7.

——————— . "The New Art of Jacob Lawrence." *The Seattle Post-Intelligencer* (October 22, 1976).

Canaday, John. "The Quiet Anger of Jacob Lawrence." *The New York Times* (January 6, 1968): 261.

"Carter Tabs University of Washington's Lawrence to Serve on National Council on the Arts." *The Seattle Post-Intelligencer* (November 15, 1977): A-3.

Chin, Sue. "Jacob Lawrence: Expressing Life and Visions through Art." *Seattle Arts* 6:4 (December 1982): 1.

"City Buys Lawrence Poster." *Seattle Arts* (May 1977): 4.

Coates, Robert M. "In the Art Galleries." *The New Yorker* 19 (May 29, 1943): 15.

G. D. "In the Galleries: Jacob Lawrence." *Arts* 42 (February 1968): 65.

Devree, Howard. "A Reviewer's Notebook." *The New York Times* (November 9, 1941).

——————— . "From a Reviewer's Notebook." *The New York Times* (May 16, 1943).

Driskell, David C. "Black American Art." *Art and Artists* 11 (October 1976): 15.

DuBois, William E. B. "Criteria of Negro Art." *The Crisis* 32 (October 1926): 296.

Emmart, A. D. Review of Lawrence's *Toussaint* Series (*Baltimore Sun*, February 5, 1939).

Evans, Walker. "In the Heart of the Black Belt." *Fortune* 37:2 (August 1948): 88–89.

Fagan, Beth. "Black Painter Jacob Lawrence Opens One-Man Show at Wentz Gallery." *The Portland Oregonian* (October 12, 1979): E7.

"First Generation of Negro Artists." *Survey Graphic* 28 (March 1939): 224.

Fisher, Patricia, and Carey Quan Gelernter. "Does Seattle 'Work' for Blacks?" *The Seattle Times* (August 28, 1983): A16.

Forgey, Benjamin. "Carter Thanks Five Artists for Inaugural Works." *The Washington Star* (June 15, 1977).

——————— . "A Masterpiece of Mural Art." *The Washington Star* (December 4, 1980).

Frankfurter, Alfred. "Artists for Victory Exhibition: The Paintings." *Art News* 41 (January 1, 1943): 8.

Frost, Rosamund. "Encore by Popular Demand: The Whitney." *Art News* 22 (December 1, 1943): 21.

J. G. "Jacob Lawrence's Migrations." *Art Digest* 19 (November 1, 1944): 7.

Gall, Barbara. "Social Art in America: 1930–1945." *Arts Magazine* (November 1981).

Genauer, Emily. "Surrealist Artists Show Similar Trend." *New York World-Telegram* (May 22, 1943): 9.

——————— . "Navyman Lawrence's Works at Modern Art." *New York World-Telegram and Sun* (October 14, 1944): 9.

——————— . "Jacob Lawrence War Paintings Are Tragic." *New York World-Telegram* (December 6, 1947): 4.

_____ . "New Exhibit Proves Art Needn't Be Aloof." *New York Herald Tribune* (June 6, 1957): 10.

Ghent, Henri. "Notes to the Young Black Artist: Revolution or Evolution?" *Art International* 15:6 (Summer 1971): 31–35.

_____ . "Quo Vadis Black Art?" *Art in America* 62 (November-December 1974): 41–43.

Gibbs, Jo. "Lawrence Uses War for New Sermon in Paint." *Art Digest* 22 (December 15, 1947): 10.

Glueck, Grace. "Who's Minding the Easel?: New Show at the Terry Dintenfass Gallery." *Art in America* 56 (January 1968): 113.

_____ . "The Best Painter I Can Possibly Be." *The New York Times* (December 8, 1968): (2)4.

_____ . "Sharing Success Pleases Jacob Lawrence." *The New York Times* (June 3, 1974): 38.

_____ . *The New York Times* (April 22, 1983).

Greene, Carroll, Jr. "Interview with Jacob Lawrence." Washington, D.C.: Archives of American Art, Smithsonian Institution, October 25, 1968.

_____ . "The Afro-American Artist." *The Art Gallery* 11 (April 1968): 12–25.

_____ . "Perspective: The Black Artist in America." *The Art Gallery* 13:7 (April 1970): 1–29.

Greene, Marjorie E. "Jacob Lawrence." *Opportunity* (Winter 1945): 26–27.

Grillo, Jean Bergantino. "The Studio Museum in Harlem—A Home for the Evolving Black Esthetic." *Art News* 72 (October 1973): 47–49.

Hackett, Regina. "A Master's Mural: Top Artist Does a Big Job for UW." *The Seattle Post-Intelligencer* (August 19, 1985): C5.

_____ . "A Match of Form and Content." *The Seattle Post-Intelligencer* (August 24, 1982): D3.

_____ . "Activist Protests Review of Exhibit." *The Seattle Post-Intelligencer* (December 17, 1983): D7.

"Hersey, Hiroshima, and Hell." *The Monthly Newsletter of the Limited Editions Club* 2 (December 1983): 3–4.

Hess, Thomas B. "Veterans: Then and Now." *Art News* 45 (May 1946): 45.

Hoffman, Donald. "Pathos and Poignancy: Paintings by Jacob Lawrence." *The Kansas City Star* (January 12, 1975): D-1.

Hoppin, Bonnie. "Arts Interview: Jacob Lawrence." *Puget Soundings* (February 1977): 6.

Hunter, Marjorie. "Carter Meets 5 American Artists Who Portrayed His Inauguration." *The New York Times* (June 15, 1977).

Hunter, Sam. "Work by Equity Artists." *The New York Times* (March 28, 1948).

"Jacob Lawrence." *Ebony* 6 (April 1951): 73–78.

"Jacob Lawrence." *Motive* 22 (April 1962): 16–24.

"Jacob Lawrence to Receive Spingarn." *The Berkeley Post* (July 2, 1970).

Jones, Glory. "Jacob Lawrence: The Master Nobody Knows." *Washington* 1:3 (November/December 1984): 54–58ff.

Kramer, Hilton. "Art: Lawrence Epics of Blacks." *The New York Times* (June 1974).

_____ . "Chronicles of Black History." *The New York Times* (May 26, 1974): 17.

J. L. "The Negro Sympathetically Rendered by Lawrence." *Art News* 37 (February 18, 1939): 15.

M. L. "Paintings for $250." *Art Digest* 23 (August 1, 1949): 15.

Lawrence, Jacob. "The Artist Responds." *The Crisis* (August–September 1970): 266–67.

"Lawrence. Aesop's Fables." *Library Journal* (January 1971): 43.

"Lawrence Honored with Inaugural Selection." *Washington Arts* (February 1977): 7.

Lawson, Carol. "A Group Shopping Spree Stocks a Museum with Art." *The New York Times* (June 20, 1982): 28.

Lee, Virginia. "Jacob Lawrence—Storyteller." *Northwest Art, News and Views* (March–April 1970): 16–21.

Lewis, JoAnn. "An Artful Thank-You from President Carter." *The Washington Post* (June 15, 1977): B4.

Lewis, Samella, and Lester Sullivan. *Black Art* 5:3 (1982), issue devoted to Jacob Lawrence.

"Life of Toussaint." *Art Digest* 15 (December 15, 1940): 12.

Lippard, Lucy. "Passionate Views of the '30s." *In These Times* (June 1–14, 1983): 20.

Locke, Alain. ". . . And the Migrants Kept Coming." *Fortune* 24 (November 1941): 102–109. Color portfolio reprinted separately.

Loercher, Diana. "Jacob Lawrence—World's Painter of the Black Experience." *Christian Science Monitor* (June 6, 1974).

Louchheim, Aline B. "Lawrence: Quiet Spokesman." *Art News* 43 (October 15, 1944): 14.

——————. "An Artist Reports on the Troubled Mind." *The New York Times Magazine* (October 15, 1950): 15, 16, 36, 38.

J. R. M. "In the Galleries: Jacob Lawrence." *Arts* 31 (January 1957): 53.

Mainardi, Pat. "Jacob Lawrence at Whitney." *Art in America* 62 (July 1974): 84.

Major, Clarence. "Jacob Lawrence, Expressionist." *The Black Scholar* 9:3 (November 1977): 23–34.

Mann, Joan. "Artist Jacob Lawrence Commissioned by KCAC to Create His First Mural This Fall at King County Domed Stadium." *The Arts*, Newsletter of the King County Arts Commission, Washington (February 1978): 1–2.

McCausland, Elizabeth. "Jacob Lawrence." *Magazine of Art* 38 (November 1945): 250–54.

Miller, Barbara. "Painter Garners Top Honors." *The University of Washington Report* 6 (Spring 1975): 3.

Milloy, Courtland. "Capturing the Builder: Jacob Lawrence's Theme, People in Motion." The Washington Post (May 13, 1978): C1.

Molchior, Carol. "Jacob Lawrence." *The University of Washington Daily* (April 24, 1975).

"The Monthly Letter of the Limited Editions Club." Series 47, 2:535 (December 1983): 3.

Moss, Howard. "The Cream that Rises to the Top: Parnassus on Upper Broadway." *Vanity Fair* (August 1983): 59–66.

Nast, Stan. "Painter Lawrence Is Honored for a 'Protest' That Was Life." *The Seattle Post-Intelligencer* (April 5, 1980).

"Negro Art Scores without Double Standards." *Art Digest* 19 (February 1, 1945): 8.

"Negro Artists." *Life* 21 (July 22, 1946): 65.

"New Yorkers to See Jacob Lawrence Exhibit Christmas Week." *Design* 49 (December 1947): 15.

Oliver, Stephanie Stokes. "Jacob Lawrence: A Master in Our Midst." *The Seattle Times* (October 27, 1985): Pacific 14–17.

F. P. "Reviews and Previews." *Art News* 51 (February 1953): 73.

R. P. "Reviews and Previews." *Art News* 66 (January 1968): 15.

"Painter of Life: Jacob Lawrence." *Scholastic News Time* (January 26, 1970): 12–14.

"The Passing Shows." *Art News* 44 (December 15, 1945): 17.

"Picture Story of the Negro's Migration." *Art News* 40 (November 15, 1941): 8.

Pincus-Witten, Robert. "Jacob Lawrence: Carpenter Cubism." *Artforum* 13:66 (September 1974): 66–67.

"Pope Accepts Presentation of Painting by Noted Jake Lawrence." *The Westchester County Press* (March 14, 1974): 7.

"Poverty, Politics, and Artists: 1930–1945." *Art in America* 53:4 (August–September 1965): 88ff.

"Praise for UW Artist." *The Seattle Post-Intelligencer* (June 9, 1974).

"Prints and Paintings by Jacob Lawrence." *The Seattle Weekly* (December 13–19, 1978): 42–47.

"Professor Named to Academy." *The Seattle Times* (December 3, 1983).

"Publisher's Bias: A Tradition of Excellence—Announcing the First Annual *Pacific Northwest Magazine* Awards." *Pacific Northwest Magazine* (January/February 1984): 5–6.

M. R. "Effective Protest by Lawrence of Harlem." *Art Digest* 17 (May 15, 1943): 7.

V. R. "In the Galleries: Jacob Lawrence." *Arts* 35 (January 1961): 54.

Rago, Louise Elliott. "A Welcome from Jacob Lawrence." *School Arts* (February 1963).

Raynor, V. "In the Galleries: Jacob Lawrence." *Arts* 37 (May 1963): 112.

"Reviews and Previews." *Art News* 46 (December 1947): 44.

"Reviews and Previews." *Art News* 49 (November 1950): 65.

Richard, Paul. "The Artist's Universe: Jacob Lawrence's Mural Unveiled at Howard." *The Washington Post* (December 4, 1980): D1, D7.

Rumley, Larry. "Art from the Black Experience." *The Seattle Times* (November 12, 1972): 34.

Russell, John. "Illustrated Books Are Making a Comeback." *The New York Times* (August 28, 1983): 24A.

Rustin, Bayard. "The Role of the Artist in the Freedom Struggle." *The Crisis* 77 (August–September 1970): 260–63.

Schiff, Bennett. "The Artist as Man on the Street." *New York Post* (March 26, 1961): 2.

"Seattle Artist to Paint Inaugural." *The Seattle Times* (December 30, 1976).

Seese, Barbara. "The Black Experience—Pictures Tell the Story." *University of Washington Daily* (October 10, 1978).

Slater, Jack. "A Spousal Odd Couple: Personalities in Paint." *The Los Angeles Times* (April 26, 1982): IV-1

Smallwood, Lyn. "The Art and Life of Jacob Lawrence, Seattle's Old Master." *The Seattle Weekly* (January 18–24, 1984): 35–36.

Smith, Roberta. *Artforum* 13 (January 1975): 64–65.

P. T. "Reviews and Previews." *Art News* 55 (January 1957): 24.

Tarzan, Delores. "Seattle's Best Kept Secret." *The Seattle Times* (June 14, 1974).

——————. "Great Paintings by Jacob Lawrence." *The Seattle Times* (October 22, 1976): Tempo 1.

——————. "Lawrence Set to Paint Inaugural." *The Seattle Times* (January 25, 1977): A11.

——————. "Washington and Lawrence Headline Shows." *The Seattle Times* (December 22, 1980).

Tate, Mae. "Husband, Wife Artists at Scripps." *Progress Bulletin*, Claremont, California (March 21, 1982).

"A Tribute to the Art of the University of Washington's Jacob Lawrence." *The Seattle Post-Intelligencer* (December 16, 1974): A14.

Tsutakawa, Mayumi. "Taking Risks and Sharing Hopes." *The Seattle Times* (July 1, 1979): L12–13.

Valente, Alfredo. "Jacob Lawrence." *Promenade* (December 1947).

Van Cleve, Jane. "The Human Views of Jacob Lawrence." *Stepping Out Northwest* 12 (Winter 1982): 33–37.

"Vogue Presents Fifty-Three Living American Artists." *Vogue* 115 (February 1, 1950): 150–53.

B. W. "Saga of John Brown." *Art Digest* 20 (December 15, 1945): 17.

Wallace, Henry. "Violence and Hope in the South." *New Republic* 117 (December 8, 1947): 14–15.

Weisberger, Bernard. "The Migration Within." *American Heritage* 22 (December 1970): 30–39.

"What Is Black Art?" *The Art Gallery* 13:7 (April 1970): 32–35.

Williams, Milton. "America's Top Black Artist." *Sepia* 23 (August 1974): 75–78.

Wilson, William. "Lawrence: Folk Roots Grow Slick." *Los Angeles Times* (April 26, 1982): IV-1.

Wright, C. "Jacob Lawrence." *Studio* 161 (January 1961): 26–28.

INDEX

Photo Credits

Photographs of art works generally have been provided by owners or custodians, as cited in captions; exceptions are specified below.

James A. Allen: Figs. 6, 8, 9.

Bill Anderson: Fig. 57.

The George Arents Research Library, Syracuse University: Figs. 28, 30.

Oliver Baker: Pls. 48, 55.

Sid Bernstein, Riordan Studios: Fig. 47.

Bryan S. Berteaux, *The Times-Picayune*, New Orleans: Fig. 64.

J. Bradley Burns: Cat. No. 62.

Reuben V. Burrell: Pls. 9, 12.

Gary Ciadella: Cat. No. 111.

Geoffrey Clements: Pl. 24; Cat. Nos. 55, 70, 73–76, 79, 80, 83, 84, 112.

Joseph Crilley: Cat. No. 60.

Bill Cunningham: Fig. 65.

Devenny-Wood, Ltd.: Pls. 1, 4; Cat. No. 2.

Courtesy of Terry Dintenfass Gallery: Pls. 46, 59, 61, 62, 68, 70, 77, 81.

Downtown Gallery Papers, Archives of American Art, Smithsonian Institution, Gift of Nathaly Baum, Photographer, Oliver Baker: Fig. 48.

Jerome Drown: Cat. No. 88.

Chris Eden: Frontispiece, Pls. 2, 3, 5–8, 56, 73, 74(a), 83–85, 87–90, 95–97, 99, 100, 102, 103, 105–108; Figs. 45, 46, 53, 56, 59–61, 67–69, 73–78, 80; Cat. Nos. 134, 148; back cover, flyleaf.

C. Edgington: Cat. Nos. 58, 59, 61.

Halley Erskine: Fig. 49.

Louis Faurer: Fig. 34.

Ray Foster: Pls. 10, 11, 13–15; Cat. Nos. 14–38.

Joseph Freeman, University of Washington Photographic Services: Figs. 70, 79.

Arthur J. Horowitz: Cat. No. 95.

Marvin T. Jones: Pl. 98; Cat. No. 136.

Peter A. Juley & Son: Pls. 20, 58(a); Figs. 51, 63.

Lawrence family photographs: Pls. 27, 50, 53, 54, 69, 80, 104; Figs. 1–3, 10, 12, 36, 37, 39, 41, 44, 47, 49, 52, 55, 57, 58, 62, 64–66, 70, 71.

From *Life* magazine (March 17, 1952): Fig. 34.

From Alain Locke (1940): Figs. 14–16, 18.

John O'Hern: Cat. No. 66.

Paul Macapia: Pls. 30, 51, 58(b), 63, 65, 67, 78, 92, 94, 109; Cat. Nos. 1, 3, 13, 63–65, 77, 81, 85–87, 92, 93, 98, 105, 106, 110, 117, 118, 122, 128, 130, 132, 133, 135, 138–46.

Cindy Momchilov: Pl. 38; Cat. No. 131.

Museum of Modern Art: Figs. 25, 31.

Nancy Newhall: Fig. 41.

Arnold Newman: Fig. 36.

North Carolina Division of Archives and History: Fig. 40.

North Carolina Museum of Art, Raleigh: Pl. 48.

Bryan Page: Pl. 91.

Iving Penn, Courtesy of VOGUE, Copyright © 1947 (renewed 1975) by Condé Nast Publications Inc.: Fig. 44.

Eric Pollitzer: Pls. 20, 60; Cat. Nos. 53, 126.

From James A. Porter (1943): Fig. 19.

Mary Randlett, ©1979: Fig. 72.

From Alma Reed (1932): Figs. 33, 43, 50.

Christopher Reynolds: Pl. 64.

Walter Rosenblum: Cat. Nos. 101, 103, 104, 107, 109, 114.

J. H. Schaefer & Son: Cat. No. 47.

John D. Schiff: Pl. 80; Cat. Nos. 54, 67.

Schomburg Center for Research in Black Culture: Figs. 4–9, 11, 13, 18(b), 26, 38.

School of Art Slide Library, University of Washington: Pl. 86.

Courtesy of Francine Seders Gallery: Pls. 87, 96, 102, 103, 108; Figs. 76, 77.

Skowhegan School of Painting and Sculpture: Pl. 82.

Marvin and Morgan Smith: Fig. 12.

John Tennant: Pl. 74(b).

From Toor *et al.* (1930): Fig. 54.

Estate of Carl van Vechten, Joseph Solomon, Executor: Fig. 1.

Wagner International Photos: Fig. 55.

Every effort has been made to reach the owners of the rights to reproduce works shown in Pls. 20, 46, 59, 68, 69, and Figs. 14, 16, 19, 49, 50.

Jacob Lawrence
American Painter

Ellen Harkins Wheat
with a contribution by Patricia Hills

WHEN JACOB LAWRENCE WAS A BOY GROWING UP IN HARLEM, RATS gnawed at the table legs and roaches crawled the floor. You see them in his art. He remembers the Depression, when bootleg whiskey cost 25 cents a quart. He will not let us forget race riots and chain gangs, war, misery and lynchings. Yet his pictures do not chide us. They evoke more pride than pity, more cheer than bitter rage. . . . Lawrence loves humanity. You see that in his imagery, in the kindness of his smile and in the patience with which he signs autographs for kids. An aura of affection, goodwill and respect, both given and received, shines around the man, and like armor round his art." *—Washington Post*

For nearly five decades, Jacob Lawrence has been widely regarded as America's most important black artist. His work is known throughout the world for its depiction of the black American experience from the Civil War to the civil rights movement and beyond. But Lawrence's paintings are more than a chronicle of this history. He has created a uniquely American vision that affirms the place of all individuals in our society and honors the struggle for independence. Jacob Lawrence has given us powerful, lasting images which, when seen as a whole, constitute a narrative of epic proportions.

This major book celebrates the creative genius of Jacob Lawrence. It is the most comprehensive survey ever made of his work and traces his development as an artist as well as places his work within the tradition of American modernism. The paintings reproduced here range from fond portraits of Harlem street life in the 1930s to angry depictions of racial injustice during the 1960s, from images of people working in harmony to bleak depictions of civilization shattered by nuclear war. Yet together they reveal an essential unity in Lawrence's work. His distinctive cubist-expressionist style and his basic humanist credo remain intact throughout fifty years of changing artistic fashion.

Throughout these pages Lawrence speaks of his work and development in the first person. Ellen Wheat draws on her numerous interviews with the artist since 1982, as well as other sources. This chronological overview of Lawrence's career is enhanced by over 150 illustrations of his work, 85 in color, and a generous selection of photos that place him in his studio, in the art world at large, and among his friends and colleagues.

Ellen Wheat received her doctorate in art history from the University of Washington. She specializes in twentieth-century American art and has lectured widely on Jacob Lawrence's work. She is also the recipient of the Pacific Northwest Booksellers Association Book Award and the Washington State Governor's Writers Award. Patricia Hills is associate professor of art history at Boston University and director of the Boston University Art Gallery.

UNIVERSITY OF WASHINGTON PRESS
Seattle and London
in association with the
SEATTLE ART MUSEUM